THE VISUAL DIALOGUE

reproduced on the cover
HENRI MATISSE. *Ivy in Flower.* 1953. Collage, 9'4"
(2.8 m) square. Dallas Museum of Fine Arts
(Foundation for the Arts Collection, gift of the
Albert and Mary Lasker Foundation). Photo-
graph: Bill J. Strehorn, Dallas.

cover design
KAREN SALSGIVER

THE VISUAL DIALOGUE
Third Edition

An Introduction to the Appreciation of Art

Nathan Knobler
Philadelphia College of Art

Holt, Rinehart and Winston
New York Chicago San Francisco Atlanta
Dallas Montreal Toronto London Sydney

TO S. H. K.,
WHO WAS A GENTLE MAN

RITA GILBERT
editor

JOAN CURTIS
picture editor

KAREN DUBNO
developmental editor

KAREN MUGLER
project editor

BARBARA CURIALLE
project assistant

NANCY MYERS
production manager

MARLENE ROTHKIN VINE
associate designer

KAREN SALSGIVER
designer

Library of Congress Cataloging in Publication Data

Knobler, Nathan.
 The visual dialogue

 Bibliography: p.
 Includes index.
 1. Aesthetics 2. Art appreciation. 3. Art
—Technique. I. Title.
N7475 K55 1980 701′1′8 79-27102
ISBN 0-03-049316-1

Composition and camera work by York Graphic
 Services, Inc., Pennsylvania
Printing and binding by Capital City Press,
 Vermont

4 5 6 046 8 7 6 5 4

Preface

Each year the body of art grows. Living artists produce new work. The art of the past is stored and preserved. Archaeologists, anthropologists, art historians and curators and collectors search cultural attics for artifacts that increase our knowledge of ourselves, reaffirming the extraordinary capacity of the human species to invent and produce forms and images.

The immeasurable number of objects is a testament to the need that exists in human beings to shape material in ways that provoke pleasure and wonder. Both the creators of visually satisfying objects and those who are responsive to them appear to be fulfilling needs that are deeply rooted in their natures. But if the visual arts come naturally out of the essence of our humanity and if our response to them seems so pervasive, why is it necessary to write a book that is intended to help readers "appreciate" art?

The answer is to be found, in part, in the great diversity of visual imagery we find in contemporary life. In contrast to previous periods in history our global culture often appears inconsistent and confusing. Though we may know more about past and present societies than our forebears did, that knowledge does not ensure our understanding and response. Differences of time, place, religion, and social and economic condition can lead to misunderstanding and limit reactions to images and forms immediately accessible to members of smaller, integrated groups sharing similar values and experiences. There are so many ways to be human—and to express that humanity—and these alternatives can disguise the essential unities common to all the arts. Responses that were once natural to most people are now difficult for many. The arts of the past and many of those currently produced speak in different tongues.

Their appreciation requires that viewers bridge the language differences between themselves and each foreign art object that they may encounter.

The title of this book, *The Visual Dialogue,* expresses my belief that the appreciation of the visual arts is similar in many ways to written and spoken forms of communication; that a dialogue takes place between a work of art and each person who attends to it. We are given information by art objects. They may describe objects or events. They may express opinions. They may present us with puzzles that challenge our intelligence or confuse our senses. But an art object is inanimate; it cannot respond to the observer. How then is it possible for a dialogue to occur between art objects and the people involved with them if a dialogue requires, by definition, the active participation of two parties? The answer to this question is to be found in each person's capacity to project meaning onto objects and experiences that offer varying possibilities for interpretation. In effect, we carry on a dialogue with ourselves. A puzzling set of clues or series of events can lead us to provide both the questions and the answers to the puzzle in an effort to satisfy our intellectual and emotional need to give order to life.

Does this concept of communication suggest that works of art can mean anything we wish them to mean, that everyone's interpretation is equally valid? It does so only if we are satisfied to remain ignorant of the motivations, intentions, and processes of the artists who produced the works. For the more that can be known about a work and the way in which it was formed, the more restricted are our interpretive options. No work is completely knowable; even the creator of a work of art is unable to explain every aspect of it. There are always opportuni-

ties for the individual observer to introduce unique, personal values and meanings into a dialogue, and, in a sense, to shape both sides of the discussion.

The more experiences we have with similar objects or events, the more confidence we can develop in our interpretations. And when our conclusions are shared by others, we become even more secure in the belief that our assessments are legitimate.

The lack of certainty about the meaning of works of art can be troubling if it is assumed that the primary reason for art appreciation is to reach a precise understanding of the artist's intention. Readers may avoid this discomfort if they come to accept my argument, that although speculation on the motivation and intentions of the artist may be useful and interesting, the major reason for the appreciation of art is the generation of experiences that are satisfying and pleasurable, experiences rewarding enough to encourage repetition.

The value of any dialogue can be measured by our desire to continue it. We may enjoy communicating because we are stimulated by the information that we receive; we may enjoy it because it arouses emotions and provokes thought; we may delight in the skill and grace with which the language has been used. But our perceptions and our responses are valuable only in as much as they are preferred to other, competing experiences. The effort required for the appreciation of art is sustained by the promise of a compensating reward; and the achievement of satisfaction commensurate with the effort encourages continued involvement with the process.

During the period of time since the publication of the first edition of *The Visual Dialogue* in 1967, the contemporary visual arts have gone through a number of significant changes requiring adjustments in portions of the book. The distinction traditionally drawn between decoration, crafts, and the fine arts of painting and sculpture is less convincing now than it once was. The values and design concepts in architecture are in transition. These changes have been reflected in both the text and illustrations of the third edition.

Though it is impossible to cover every style and period in the history of art in a volume of this scope, I have tried to provide readers with an approach to the visual arts that will prepare them to continue their own visual education. I hope their ability to find satisfaction in the arts will grow, that they will be encouraged to find and react to art forms that are unfamiliar without fear of liking the "wrong" things: there is no need to apologize for responding to unpopular or devalued works of art if one finds satisfaction in them. But it is predictable that many works of art admired by connoisseurs will prove their worth to many new appreciators. For different as we are from each other, we are also very much alike, and our responses to the arts are dependent on both our similarities and our uniqueness.

The text is divided into four parts, beginning with an introductory section that considers the nature of art appreciation, the art object, and the communication systems used in the visual dialogues. Part Two expands the study of the visual languages in the two-dimensional arts of painting, drawing, and printmaking. The languages of sculpture and architecture are discussed in Part Three. The expressive content to be found in the visual arts and the viewer's response to it is the basis for the concluding section.

In the preface to the second edition of *The Visual Dialogue* I wrote:

> Even . . . in despair, the artist acts positively. To produce an object that is intended to speak to others implies a belief in the value of communication. To produce an object that is intended to last implies a belief in the continued existence of a society composed of people able to respond to the efforts of the creator. It is my hope that this book will help foster such a responsive community, for by accepting the challenge of the arts people may affirm their most human and humane qualities.

The statement needs no revision.

Acknowledgments

Many individual talents have been joined to complete this edition of *The Visual Dialogue*. I still owe a debt to Dan Wheeler, who was the editor of the previous editions. His provocations and high expectations have left their mark on me. Rita Gilbert has offered encouragement, expert advice, and an infectious vitality. Karen Dubno and Karen Mugler have my thanks for

their considerate and professional oversight of the manuscript and the production of this revision. The responsibility for acquiring the illustrations has been carried by Joan Curtis. I admire and have benefited from her knowledge and industry. I would also like to thank Karen Salsgiver, who designed the text and cover, and Barbara Curialle, who assisted in various ways throughout the production process. The following teachers read the manuscript and offered many useful suggestions: Liana Cheney of the University of Lowell; Norma S. Davis of Brigham Young University; Terence Grieder of the University of Texas at Austin; Diane Johnson Handloser of Santa Barbara City College; Mary Lou Marien of the State University of New York at Cortland; and Siham Osman of York College of Pennsylvania. The text reflects the sympathetic editing of my long-time friend Theresa Brakely, who has contributed her skill, intelligence, and experience to this book.

Philadelphia N.K.
February 1980

Contents

Part One

ART AND EXPERIENCE

Art Appreciation
and the
Aesthetic Experience

Image making is an essential human characteristic. Since Paleolithic times the unique ability to transform physical material into icons and illusions, signs and symbols, has affirmed the deeply rooted need of our species to arrange combinations of marks and colors, solids and voids for the satisfaction of individuals and their social groups (Figs. 1, 2).

Families, tribes, and nations have erected buildings and monuments, some to fall quickly, leaving only meager clues to their purpose and appearance, others to remain as witness to people's efforts to protect themselves and to glorify their heroes, societies, and gods.

This combination of visual symbols and architectural structures illuminates the past and provides instruction on the nature of our present condition. Many of these artifacts continue to offer present-day observers insights and pleasures that are rewarding in

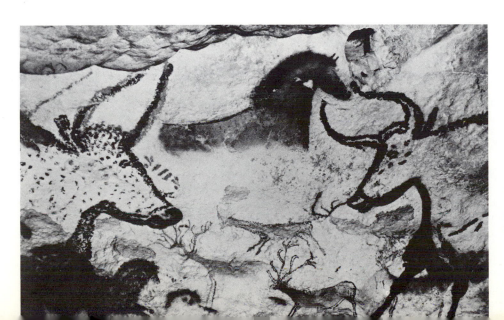

1. Rock painting, detail. 15,000–10,000 B.C. Lascaux Cave (Dordogne), France.

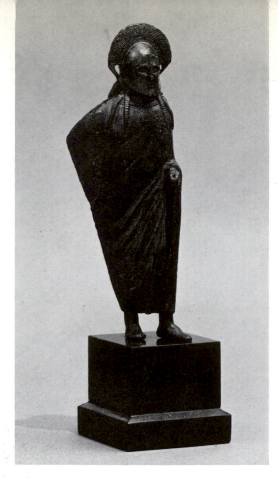

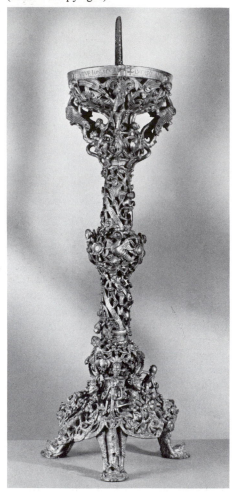

their own right, even without historical implications. The meaning of art does not lie exclusively in its function as a key to the lives of individuals and societies now gone or as a reflection of today's life; for some viewers art serves primarily as a source of sensual and intellectual satisfaction that needs no external referent. In the form of a twelfth-century candlestick (Fig. 3), the color of a Renoir painting (Pl. 1, p. 7), or the structure of a great bridge 5 miles, or about 8 kilometers, long (Fig. 4), there is a potential for awe and delight unrelated to practical value or cultural and historical background.

For those who produce the paintings, sculpture, and architecture of their time, the arts may have a variety of meanings. A work of art may serve as an exercise in skill and manual dexterity. Perhaps it is a comment on society and morality, wrenched out of the personal involvement of the artist. Perhaps it tells a simple story. Possibly it satisfies the need to create a mystical token or icon. Whatever the reason for creating it, the work of art has, for many artists, served its purpose when it is completed. Other rewards may come when the work has found a responsive audience, but the response of the public is so unpredictable that its acceptance can provide only a secondary level of satisfaction for the artist.

For the observers, the consumers of the arts, the meaning of art begins with the work itself. The observers begin where the artist has stopped. The meaning the audience finds in the art object is dependent upon the work of art, but it is also dependent on the intellectual and emotional condition of the viewers, as well as on their ability to perceive the work before them.

The artist fashions a visual statement which in turn becomes the subject matter for a response or reaction from the observer. In this sense the visual arts may be considered a language. As in other lan-

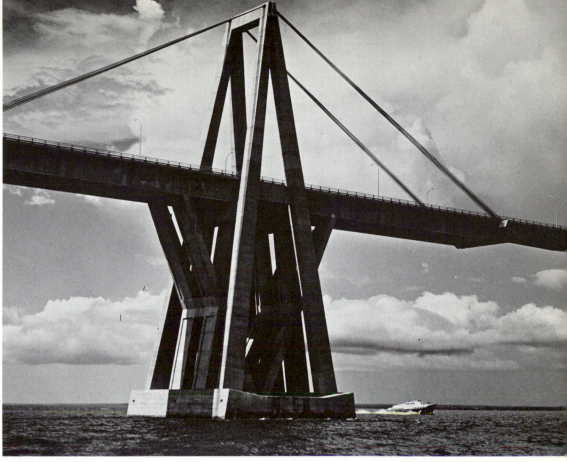

4. Riccardo Morandi. Rafael Urdaneta Bridge. Lake Maracaibo, Venezuela. 1959–63.

guages, there is a source for the communication, the artist; there is a medium that carries the information originating at the source, the work of art; and finally there is a receiver, the observer. Like the reader of a written text, the observer must recognize and decipher the symbols and the pattern of symbols before understanding can occur. Of course, reading and enjoyment are not synonymous. Just as no one reader will find pleasure in each book on a library shelf, so no beholder should expect to find pleasure in every art object or to understand each work of art encountered. Library shelves are filled with volumes beyond the comprehension even of highly educated individuals, and the walls of museums are hung with some paintings which have a similarly limited audience.

It is possible for the average person to have an immediate aesthetic response to some works of art, but it is probable that many paintings, pieces of sculpture, and buildings will offer little pleasure. In fact, there may be works of art which seem disturbing, even provoking anger or repulsion. Aesthetic satisfaction is the result of a complex combination of subjective attitudes and perceptual abilities. No one can be sure why certain objects elicit positive responses while others do not, but if observers wish to increase the number of art objects to which they can

respond with satisfaction, they must alter the conditions that affect their responses.

The philosopher Albert R. Chandler, in his book *Beauty and Human Nature,* discusses the satisfaction to be found in the arts. He calls this satisfaction "the aesthetic experience."[1] For Chandler the aesthetic experience is "a satisfaction in contemplation or a satisfying intuition." He distinguishes between a contemplative response and one that is intended to serve practical or intellectual needs. The appearance of clouds and the quality of light in the sky offer him the possibility of an aesthetic experience only when he suspends his interest in them as evidence of future weather conditions.

What is meant by "satisfaction?" In Chandler's view it is a state of mind that one wishes to prolong or repeat, even though the event that stimulated it may not have been pleasant. Emotionally draining drama, disturbing visual images may not be pleasant, but they may satisfy; their effect may be desirable, so that we return to them again and again.

It takes very little special training to react to the colors of a sunset or the forms of clouds or mountains, yet many people find it difficult to enjoy some works

[1] See "Bibliography and Notes," page 301.

of art. Why? An examination of the factors which can lead to an aesthetic experience may develop an understanding of this problem and provide a guide for the discovery of satisfaction in art objects that offered little to the observer before.

Initially, the aesthetic experience is the result of an interaction between an art object and an observer. This interaction requires certain conditions before it can occur. These conditions include *the ability of the observer to perceive and comprehend those aspects of the object or experience which contribute to aesthetic satisfaction* and *a receptive attitude on the part of the observer.*

Before going on, let us agree on the definition of the aesthetic object. Objects and events found in nature and objects and events produced by human beings can move and stimulate us aesthetically. The study of the aesthetic response in all its forms is a formidable task which has concerned philosophers for two thousand years. It is not the purpose of this text to deal with this broad subject. We are concerned here with the response to works of visual art, and we shall limit our study to the experience which may result from the stimulation provided by the product of human imagination and skill. Though this restriction eliminates many possible areas of discussion, it leaves a large body of work for examination.

Since the end of the seventeenth century, the visual arts have commonly been divided into the *fine arts* and the *practical* or *applied arts.* These categories once separated the work of the *artist* from that of the *artisan.* With the growth of the number of machine-made objects, this division has become threefold: works of art, works of handcraft, and manufactured or mass-produced products. The distinction between the crafts and the arts was expressed by the German philosopher Immanuel Kant, who wrote in his *Critique of Judgment,* in 1790, that, among other requirements, it was necessary for an object of beauty to be seen apart from its utilitarian function and that therefore nonutilitarian objects had the potential for the highest aesthetic content. In the past few years, as the media of the crafts—ceramics, needlecraft and weaving, woodworking, and metalcraft among others—have been separated from purely utilitarian needs, the work of ceramists, weavers, and woodworkers has assumed increased aesthetic importance. It is possible to argue that there is a potential for aesthetic satisfaction in all manufactured objects. A teapot, a ceiling mural in a great church, each from the hands of an individual creator; a phonograph turntable or a skyscraper, each the result of cooperative efforts by many individuals employing complex technologies—all may elicit aesthetic satisfaction.

Because it is not our purpose to develop arguments for assigning degrees of beauty to objects or experience, we shall not presume to question Kant's value system. We are concerned with the achievement of an aesthetic experience, an *appreciation of art.* We wish to bridge the space between a potentially satisfying object and the observer who desires to experience that satisfaction. To this end we shall center our attention on the basic problems which arise in the appreciation of the visual arts, emphasizing sculpture, painting, and architecture. Our concern is the process of aesthetic response, and when this process can be clarified by using an appropriate example of the crafts or the product of a machine, we shall do so. It is our belief that the process of art appreciation is applicable to all the visual arts and that development of the ability to respond to one art form will inevitably contribute to a corresponding ability to respond to other art forms.

The Receptive Attitude

What is the attitude essential for an aesthetic experience? First, it is necessary that *the observer's attention be directed toward the object.*

Some degree of interaction with a work of art is possible without the complete attention of the observer. Many people who live in rooms hung with paintings may rarely stop to contemplate them. Others listen to music while performing their household chores. In each instance there is contact with a work of art, but the experience does not engage the respondent in a direct, "face-to-face" relationship. Other examples are less obvious but produce similar results: the casual stroll through a museum or gallery without taking the time for a reflective pause; interference of noise and crowds, which hampers concentration; bad lighting; conflicting backgrounds—all these may create a partial barrier between the work of art and the viewer. Pleasurable as some casual experiences may be, they are not comparable to the commitment necessary if a serious dialogue is desired by the involved viewer.

Some complicated and highly ornate compositions seem to overload the sensory channels of involved observers. Such complex arrangements form a *system* of stimuli which may be satisfying when experienced as a whole. The response of the person involved in the experience cannot be traced to any single part of the total stimulation. The hiker who passes through a wooded grove may be delighted by the accumulated effects of many sensory inputs. The filtered light and moving leaves, the rhythmic spacing of repeated verticals offer satisfying visual perceptions. And the pleasures that depend upon the eye may have an aural counterpoint from the sound of the twigs and branches stirred by moving air. In the same way the visitor to the Mirror Room in the

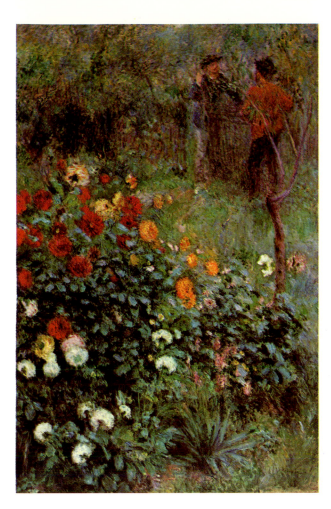

left: **Plate 1.** AUGUSTE RENOIR.
The Garden in the Rue Cortot, Montmartre.
1878. Oil on canvas, 4'11¾" × 3'2⅜"
(1.52 × .97 m). Museum of Art,
Carnegie Institute, Pittsburgh.

below: **Plate 2.** PABLO PICASSO.
Girl Before a Mirror. 1932.
Oil on canvas. 5'4" × 4'3¼"
(1.63 × 1.3 m). Museum of Modern Art,
New York (gift of Mrs. Simon R. Guggenheim).

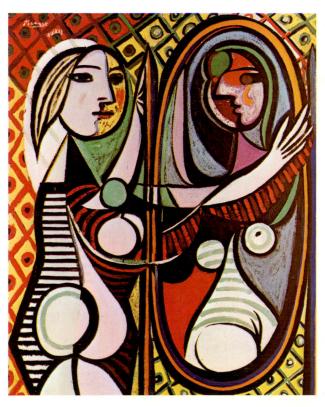

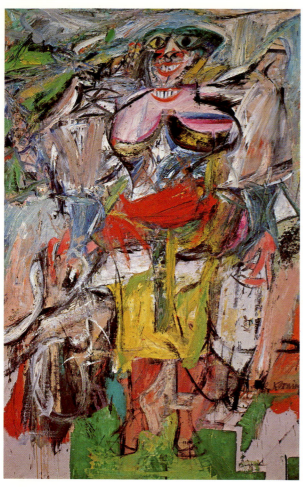

Plate 3. WILLEM DE KOONING.
Woman and Bicycle.
1952–53. Oil on canvas, 6′4½″ × 4′1″
(1.94 × 1.24 m). Whitney Museum
of American Art, New York.

Plate 4. AGNES MARTIN.
Night Sea. 1963.
Gold leaf and oil on canvas,
6′ (1.83 m) square. Collection
Mr. and Mrs. S. I. Newhouse,
New York.

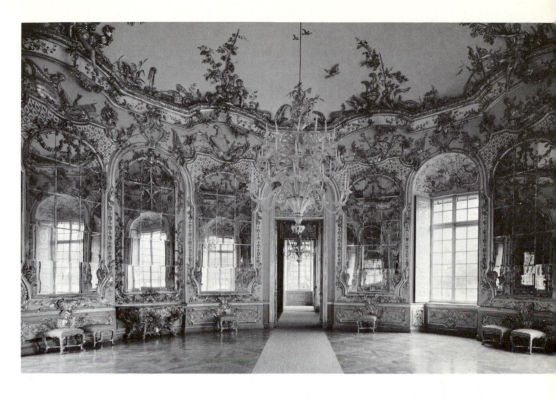

5. JOHANN BAPTIST ZIMMERMAN. Mirror Room, Amalienburg Pavilion. Nymphenburg Park, Munich. 1754–59.

Amalienburg Pavilion (Fig. 5) at the eighteenth-century palace of Nymphenburg, outside Munich, may respond to the combined effects produced by the architect and his decorators. Light, reflected images in the mirrored walls, gilt, color, and the extraordinary sculptural enrichment of the walls divert attention from the individual parts of the interior design.

6. Detail of Figure 5.

The diffused pleasure of the wood is recreated in an indoor environment.

For the persistent observer there are hidden pleasures to be found. Like a bird discovered within a maze of tree branches, or a single brilliant flower half covered by fallen leaves, small sculptural details can work their way into the consciousness of a guest at the Amalienburg (Fig. 6). The viewer who desires to concentrate upon the nude in the illustrated detail must *attend* to it, try to isolate this part from the whole decorative scheme; and in an environment like the Mirror Room this is no easy task.

Like the detail in Figure 6, every work of art exists in a larger context. It is always surrounded by diversions, even when a museum curator tries to place it in a sympathetic location within the institution. The competing demands on the viewer's attention may be external, or they may result from an inability to concentrate because of more pressing intellectual or emotional concerns. A forester working in the woods may disregard the sensory satisfactions while concentrating on cutting trees for lumber. The tourist visiting Nymphenburg may pass through the Mirror Room unmoved while searching for a lost child. Though not so obvious an example, the person returning wearily home after a difficult day at work may not wish to be stimulated or disturbed by a demanding confrontation with a work of art. The often-heard comment, "I wouldn't want that in my living room," is an expression of the desire to provide

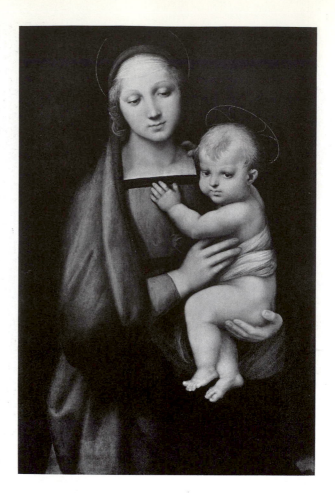

7. RAPHAEL. *"Madonna del Granduca."* c. 1504–05. Oil on panel, 33 × 21¼″ (54 × 34 cm). Pitti Palace, Florence.

a home environment without conflict and discomfort, and that attitude requires no defense so long as it does not become the criterion for evaluating the aesthetic worth of an art object.

To what does the casual observer respond in a peripheral or partial contact with an art object? It appears that the response is to the familiar, the obvious, the comfortable qualities in the work. Experiments in psychology indicate human and animal preference for experiences that are familiar and therefore cause a minimum of tension. The *familiar* is acceptable and comfortable; the *unfamiliar,* uncomfortable, often disagreeable. It is reasonable to assume that pleasurable responses to partial interaction with a work of art are produced by factors the respondent finds familiar, either because of previous exposure to the specific art object under contemplation or because of qualities in the work that recall other responses of pleasure. If the work contains unfamiliar elements that tend to cause inner tension, those portions may be neglected, unperceived, and therefore comfortably passed over. Of course, some art works, because of their general exposure or similarity to other, well-known productions, may be so familiar that they offer little or no possibility for discomfort and can therefore satisfy the limited requirement of "background" aesthetics.

Most works of art contain elements that are now, or were at one time, both familiar and unfamiliar, innovative, or unexpected. The ratio of the familiar (F) and the innovative (I) differs for each object as perceived by each individual who interacts with it. What is familiar to one person may be unusual or even undecipherable to another. The $F:I$ ratio can vary with time, with differing social or cultural conditions, and with those personal experiences that contribute to the distinctions among individuals. Most viewers find the paintings by Raphael and Copley reproduced in Figures 7 and 8, to be consistent with a familiar and traditional form of representation in which little appears innovative. For many, Pablo Picasso's *Girl Before a Mirror* (Pl. 2, p. 7), though almost fifty years old, is more heavily weighted on the experimental side of the $F:I$ ratio than the three earlier figure paintings. Here Picasso represents a standing female figure and her reflection in a mirror, but the simplified drawing, the arbitrary division of the form into patterned areas, and the heightened and nonrepresentational use of color set this composition apart from the other three. To those who have seen other Picasso paintings, or works by other Cubist

painters, the innovational values in the *Girl Before a Mirror* will seem lower in the $F:I$ ratio; or they may find compositional inventions, unnoticed by the more naïve spectator, that affect the $F:I$ balance in still another way.

Similarly, some observers may perceive significant and important differences between the paintings of Raphael and Copley in comparison with one another or with other examples of figurative art by artists of the same period. The color and form relationships, the qualities of surface, the psychological content in each work, and even the sentimental or nostalgic connections between the work and the observer may be seen as an extraordinary and unanticipated variation of a familiar approach to painting.

Repeated exposure to a work of art seems, in and of itself, to produce an increasingly pleasurable response, even without a conscious effort to understand or like the work. However, people are rarely forced to examine repeatedly art objects they do not care to experience, so that this gradual accommodation happens infrequently. Those who desire to extend their responses to complex and demanding art objects have

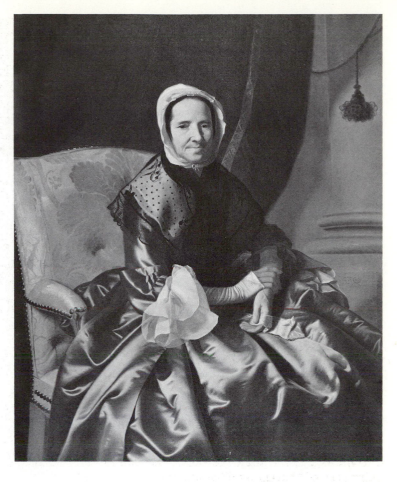

8. JOHN SINGLETON COPLEY.
Mrs. Thomas Boylston. 1766.
Oil on canvas, 4′1″ × 3′2″ (1.24 × .97 m).
Fogg Art Museum, Harvard University,
Cambridge, Mass.
(bequest of Ward N. Brown, 1828).

to involve themselves with the works as completely as possible. No doubt, the unfamiliar aspects will cause discomfort—even, on occasion, too much discomfort for continued involvement. Inevitably the motivation of the seeker after insight into the visual arts will be measured against the effort—emotional and intellectual—required to come to terms with demanding art objects. For some persons, motivation and capacity may be insufficient for sustained interest in a particular body of work, but this need not deter them from experiencing and enjoying such art as may satisfy their needs. Also, art that is now seen as too demanding or too disturbing may in time become familiar enough, at least in part, to permit a stimulating and satisfying interaction with the innovative portions.

Among the most important requirements for obtaining a satisfactory aesthetic experience from unfamiliar art is the willingness to take each work at its face value; that is, to accept it as a serious, rational effort of a serious, rational person. At one time this requirement would have seemed unnecessary, because the public concept of serious art closely paralleled the appearance of paintings and sculptures.

During the past century this condition has changed. The consistency between public expectation and artistic production no longer exists. We need only compare a group of paintings spanning the period from the fifteenth century to the beginning of the nineteenth with a group from the end of the nineteenth century to the present to see evidence of the remarkable expansion of artists' concepts of the nature of a painting.

The two traditional works already cited—Raphael's *"Madonna del Granduca"* (Fig. 7) of about 1505, and John Singleton Copley's *Mrs. Thomas Boylston* (Fig. 8), painted in 1766—share a common mode for the representation of form, space, and texture as found in nature. The methods of painting differ stylistically, but in each instance it seems that the artist wanted the viewer to be concerned with the representational image and not with the means employed to produce that image. For the materialization of all these works, paint was applied to a surface, but the painting methods specific to each work remain unimportant relative to the significance of the subject matter illustrated.

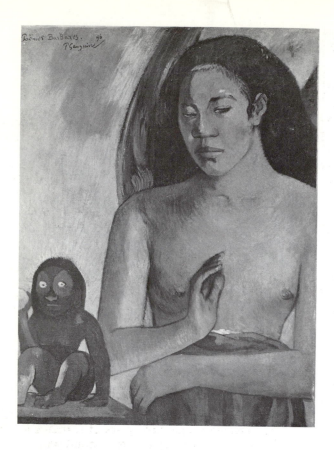

9. PAUL GAUGUIN. *Poèmes Barbares*. 1896.
Oil on canvas, 25½ × 19″ (65 × 48 cm).
Fogg Art Museum, Harvard University, Cambridge, Mass.
(Maurice Wertheim bequest).

photographically representational images by Martha Erlebacher (Fig. 10) and the videotaped images of Nam June Paik (Fig. 11) might be seen.

The reasons for these differences in the visual arts will be discussed elsewhere, but the fact remains that works of art now being offered to the public by established institutions and individual artists often arouse confusion and antagonism. When faced with objects which at first glance may seem meaningless, the observer who seeks to understand contemporary art must give the artist the benefit of the doubt—must grant the possibility that inability to comprehend the image in question may be due to an inadequacy in the beholder and not in the work. At least temporarily, the viewer must assume a certain humility, a willingness to reserve judgment until it becomes quite clear that a negative attitude toward a work is founded upon real understanding of what the artist intended. What is there to lose? Whatever the possible loss, it should be measured against the enrichment that can occur when the gap is closed and the observer finds in the work of art a meaning that was once elusive. Questions such as "What are the standards for judgment?"; "Which technique demonstrates a skillful use of materials?"; perhaps even "Am I being hoaxed?" are typical expressions of the present division between producing artists and potential consumers. A bridge over this chasm can be built, but it must be preceded by an attitude on the part of the observer that will allow the introduction of seemingly foreign aesthetic forms.

The Perception of the Observer

The deaf cannot react to the sounds of a Brahms symphony. The blind cannot know the sensation of a bright-red area juxtaposed to a green one of equal brilliance. Between the observer and the objects are limitations imposed by the ability to perceive. Except for the blind, perception of the visual arts would seem to pose no difficult problems, but few persons of normal vision realize how limited their perception really is.

Perception, our awareness of the world around us, based on information that comes through the senses, is too often considered a natural, matter-of-fact attribute of the human being. The assumption is made that everyone sees the same things, that the world, as we know it through sight, hearing, touch, and ability to smell, is the same for all. This is not so.

Paul Gauguin's *Poèmes Barbares* (Fig. 9), painted in 1896, *Girl Before a Mirror* by Pablo Picasso (Pl. 2, p. 7), dated 1932, and Willem de Kooning's *Woman and Bicycle* (Pl. 3, p. 8), of 1952–53, were all painted within a span of less than sixty years. Methods of representation and the application of paint differ markedly in these three works. It is possible to discuss stylistic differences in the paintings of Raphael and Copley, but those differences seem slight when compared to the dramatic contrasts between one and another of these later works.

Comparison of the de Kooning with a 1978 canvas by Agnes Martin (Pl. 4, p. 8) reveals a distinction even greater than that existing between de Kooning's painting and Picasso's. Martin appears to reject every attitude and method employed by the other artists. Her unmodulated ground color, with its superimposed measured grid of rectangles, confuses and often disturbs many gallery visitors; and though many of her contemporaries are working in a similarly nonrepresentational manner, others debate the validity and importance of this approach to painting.

On any given day in a major city, a museum or a group of galleries may be exhibiting examples of the work of each of the artists previously mentioned. In addition, current paintings of precisely rendered,

10. MARTHA MAYER ERLEBACHER.
The Triumph of Nature. 1978.
Oil on canvas, 27 × 22″ (69 × 56 cm).
Courtesy Robert Schoelkopf Gallery, New York.

For some time psychologists and physiologists have known that there is a considerable difference between the raw information given to the brain by the senses (sensations) and our awareness of the world based on this information (perceptions). Professor J. Z. Young, an English physiologist, describes a number of experiments performed with individuals born blind who, in their later years, were enabled to see.[2] Under these conditions the scientist has an opportunity to study the phases of visual training normally passed through by children, because adults, unlike children, can describe with accuracy what is happening to them. The once-blind person, now physiologically normal, does not "see" the world immediately. The patient finds that seeing is painful and unpleasant. Lights and colors spin, and the identification of objects is impossible. There is no conception of a visual space filled with forms, although the forms may have been known previously through the sense of touch. Because the brain has not been trained in the *rules of seeing*, the development of the patient's visual perception may take years, if it occurs at all.

Young goes on to say that once-blind persons can learn to "see" only by training the brain. By expending a considerable amount of effort, they can gradually understand the visual experiences of color, form, space, and textures.

Some experimenters have expressed doubt concerning the use of the evidence given by adults who have gained their sight after being blind from birth. These psychologists believe that the experience of mature subjects cannot be assumed to parallel the perceptual development of infants because adults, in the process of aging, have had other sensory experiences that affected the development of their visual perception. Agreement does exist, however, that visual perception at all age levels is the result of a learning process; that men and women can alter their perceptual abilities and develop special forms of perception. Therefore, what these experiments suggest is that the sensations we receive have no meaning for us until they are ordered into a coherent perception.

Sensation is only one part of perception. The formation of a percept, or sense impression, also includes our past experience and our ability to com-

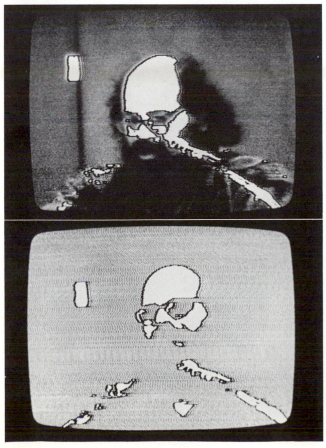

11. NAM JUNE PAIK with SHIGEKO KUBOTA.
Allen Ginsberg, from *Suite 212.* 1976. Video.
Courtesy the artist.

bine sensations into a meaningful form. To perceive something we must separate a limited number of sensations from a greater kaleidoscopic array all being received at any one time. We must attend to those sensations which may join to form a particular experience; the others we must disregard.

It is not clear how much training and what kind of learning must go on, but many kinds of visual training take place in the normal course of growing up in a world already organized into a particular physical and cultural structure. Children learn to see objects that obstruct their movements. They learn, after falling numerous times, to step over their toys. They learn to recognize their parents and to interpret other visual experiences which are a part of living in their world. Visual information combines with other sensory data and interacts with emotional and intellectual functions of the brain to shape their perceptions. As they mature, the perceptual process appears to become automatic. Certainly, individuals are unaware that it is taking place; only when special perceptual demands are made on them do they become conscious of an effort to develop abilities they do not possess. Biology students, who learn to interpret microscopic data, and medical students, who learn to perceive small changes in the sounds of heart and lungs, have much in common with the novice in the visual arts, who must become aware of relationships that an untrained observer would pass over.

The perception of pictorial images which are a part of everyday activity—photographs and drawings of ordinary objects and their function in daily life—develops in the first years of childhood. But when a person trained to perceive the ordinary visual symbols is confronted by Cubist paintings (Fig. 12), the experience that applies to the perception of a photograph does not work to give meaning to the picture. Juan Gris used different structural patterns from those which would appear in a photograph, and these patterns cannot be understood if the observer's visual training has been limited to that required for the perception of photographs. The confusion that may seem to appear in Cubist painting can be reduced or eliminated if the viewer has learned to "read" Cubist art. This kind of learning may result from formal training, or it may occur, for some persons, unaided, as a result of repeated contact with this pictorial style.

The process of perception may be diagrammed in the following way (Fig. 13): *O* represents an object or experience existing in the world outside the observer. It may be a single work of art or a complex pattern of connected events. Information about this object is gathered by the sense organs, *S*. In the case of the visual arts the organ would most often be the eye, but it could also be the fingertips, which might move across the surface of a piece of sculpture; or it might

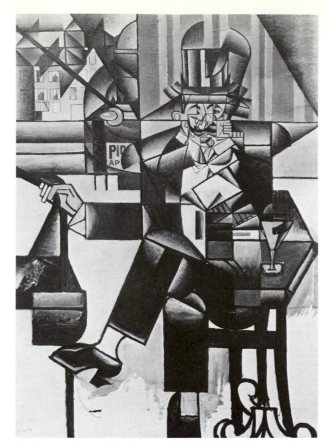

12. JUAN GRIS. *The Man in the Cafe.* 1912. Oil on canvas, $4'2\frac{1}{2}'' \times 2'10\frac{5}{8}''$ (1.28 × .88 m). Philadelphia Museum of Art (Louise and Walter Arensberg Collection).

be the ears, sensing the sound of rippling water or rustling leaves which is part of the intended effect.

The sensory input, *S*, travels to the brain, where it is interpreted. The interpretation depends upon the past experience of the observer, labeled *E*. This experience would include the accumulation of daily interactions with the environment in which the observer has lived, embracing geographical location, economic and political background, religious involvement, friends, and formal training acquired in schools. Past experience is not a static quantity or quality. It changes with time as the observer lives, reads, observes, and is taught. *E* is different for every person; though there may be great similarities between the past experience of individuals within a common cultural environment, no two persons can ever have identical past experiences.

Interpretation of the sensory input also involves factors other than past experience, including intelligence (*I*), as well as the emotional attitude of the

moment and the intensity of concentration. Even the observer's physical state may color the input in one way or another. Thus, a combination of sensory input, past experience, intelligence, and attitude operate to produce the perception (*P*) that was initially stimulated by the object (*O*).

The primary value of this brief analysis lies in the steps indicated between the originating object and the final perception. Too often the assumption is made that the object and the perception are one—that "what you see is what is there," that our sense of an object remains constant, and that different individuals will *see* an object identically. Of course, this is just not so. The complicated process which transforms vision into perception assures that perceptual differences will occur among individuals, and similarly changes will take place within a person over a period of time. A difference in experience or a more sympathetic attitude may alter a perception so that a new vision or insight occurs.

The perception of meaning in a work of art is not automatic, even though it appears to be so in some cases. Often the training and effort required for the production of the artist's work calls for a parallel preparation on the part of the public which expects to respond to it. The artist begins the chain that leads to aesthetic experience, but that responsibility ends in the studio. The responsibility then shifts to the observers. If they believe that their perceptual training is equal to the demands made by the artist, then they can question the content and the values implicit in the objects under consideration. If not, they can react only to what they find meaningful; many paintings and pieces of sculpture will remain enigmatic to them until they have sufficient preparation to respond.

Appreciation and Values

We are continually making judgments—deciding which action is right, what to wear for a particular social situation, whose opinion is valid. This concern for values finds its expression in the public response to the visual arts as it does in other areas of activity. Frequently heard questions are: "How do you know it's good?" and "Who decides what is good or bad?" In a society that places a premium on making the *proper* choices there is a natural desire to establish a basis for choice in the area of the arts. Should the goal of art appreciation be the development of the ability to make aesthetic judgments, to tell a bad painting from a good one, to recognize a poor building, a mediocre piece of sculpture? What do words that indicate value—"great," "good," "bad," "poor," "mediocre"—mean when applied to the visual arts?

If it is assumed that there are universal, precise criteria for evaluating the visual arts, then the appli-

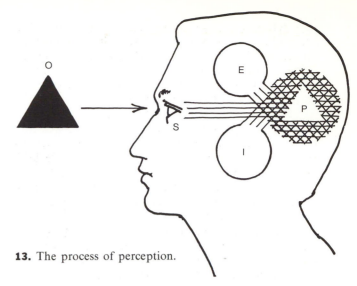

13. The process of perception.

cation of value terms such as "good" and "bad" suggests that the critic who uses them is familiar with the terms, is capable of analyzing the work in question, and can apply the terms with objectivity. The question of absolute values in the area of aesthetics has concerned philosophers for centuries. Many aestheticians have attempted to construct value systems for the arts. None of them has proved adequate. Inevitably, when the judges try to apply the rules they have constructed, major problems arise, for it is impossible to eliminate the personal responses of the viewer from the function of judging.

It is also difficult to apply rules that were adequate in the past to new works of art, which appear to deny, or even to defy, tradition. A classic example of the confusion that can occur when traditional values are applied to new art forms is to be found in the general critical response to the works of the Impressionist painters in the latter half of the nineteenth century. The paintings of these artists were rejected by the large mass of the public, the critics, and museums because they introduced methods of paint application and color usage which were not consistent with previous practice. Paintings by Renoir (Pl. 1, p. 7), Vincent van Gogh (Pl. 5, p. 25), and others, which now seem unquestionably fine works of art, were reviled as the products of charlatans or madmen.

Some aestheticians deny the importance of external criteria. They insist on personal, subjective responses as the basis for judgment in the arts, so that their judgment becomes a form of communion between the work and the observer. If the observer is moved—feels an emotional, an aesthetic, or a moral response to a painting, a building, or a statue—it becomes good. Works which do not fulfill this expectation fail and are therefore placed in the lower levels of aesthetic achievement. Here again the assignment of values to art objects has obvious difficulties. The

very personal responses of one critic carry with them no assurance of similar reactions in others. Even if all those who examine the body of work to be found in the visual arts are assumed to have a similar educational and social background, there must be differences of intellect, personality, and physical makeup which will affect attitudes and judgments.

Obviously, the assignment of values in art is a complex, often confusing business. Yet critics do operate in the visual arts, and though an examination of their writings reveals many areas of conflict, points of agreement do exist. Certain works of art can be valued more highly than others as aesthetic objects. Recognition of such productions is achieved because, over an extended period of time, many persons with broad experience in art have considered them to be the examplars of their kind. This judgment is the evaluation of specialists who have made the study of art their life's work. Whatever the criteria these judges employ, some common understanding of quality emerges. They say, as a body, "This work is good," and their opinions joined in a composite judgment constitute a significant comment upon the arts.

Of course, these are opinions and no more than that. They represent individual, personal attitudes, whether taken singly or as a part of the judgment of history. These experts have examined many works of art and can compare any specific work with thousands of other paintings and pieces of sculpture. When they say that a work of art is good or great, they are, in effect, saying that, compared to the many similar works they have seen before, this particular example communicates its message in a manner equal to or better than the others. Nevertheless, not even experienced critics can make absolute judgments, though their opinions may sometimes carry great weight. Their statements are subject to review, as are the opinions of all of us. Tastes and values can change. All aesthetic judgments may eventually be reexamined and reevaluated in terms of new cultural relationships. Yet the attitudes of the trained critics are valuable. Because of their preparation and experience, they can guide the untrained observer to an understanding of art of the past and the present by enlightened comment and a cultivated choice of exhibition material. They can say to the novice, "Here are the works of art which have given me an aesthetic experience. In my considered opinion they are the best of their kind. Perhaps you, too, may find in them the satisfaction they have provided me."

Many of the battles that were fought to establish the legitimacy of late-nineteenth and twentieth-century art have been won. Our most important museums now collect and exhibit art that once would have been considered unacceptable. Still there remains a gap between many of the choices made by professional staffs in our cultural institutions and the taste of large segments of the public. Conscious of the limitations of earlier critics, contemporary critics, as well as museum and gallery directors, have come to accept and often to pursue innovative and provocative forms of visual art. There is a greater diversity of images now issuing from artists' studios than has ever before confronted an interested public, and many of these confusing works are finding their place in public collections. This growth in the numbers and kinds of aesthetic objects has made the matter of appreciation and judgment even more troubling for many viewers who have had a limited or casual exposure to the arts.

Should art appreciation have as its goal the development of the ability to make aesthetic judgments? The answer to this question must be "No," and it is this attitude that supports much of what is to be found in this book. The confusion and uncertainty that surround the problem of values in the arts when specialists deal with it would be compounded when left to the nonspecialist. Of course, no one is barred from the game of awarding critical praise to the particular works of art which strike the individual's fancy, but the significance of the award is doubtful.

One should not confuse art appreciation with art evaluation. The goal of art appreciation should be the achievement of an aesthetic experience. An individual may be guided toward this experience by the knowledge and sensitivity of others; one may help oneself by learning the language of art; but in order to achieve this experience, one should look at art to react to it, rather than to judge it. If people respond to works of art which experts consider mediocre, or even bad, the works can still have value for them. Given the opportunity to see a large number of paintings and pieces of sculpture, and given the training to perceive the significant relationships within them, observers may eventually find that the objects once important to them no longer satisfy their aesthetic needs. The forms, colors, and images that prompted favorable initial reactions may in time lose their impact. The familiar, comfortable portion of certain works may, indeed, become commonplace and possibly boring. The strange, enigmatic aspects of some works may appear less formidable, no longer alien to the viewer's experience and now susceptible to examination and contemplation. At this point the example of trained observers can prove valuable, for if their aesthetic needs have been satisfied by certain art objects, it is possible that, in time, the less experienced observer will find satisfaction there too.

The importance of an evaluation depends on the experience and the ability of the judge. Intelligent evaluation may be a guide to appreciation of the visual arts, but it should not be the ultimate goal of the person who seeks meaning in the arts.

The Art Object

2

Figures 2 and 14 both show examples of the art of the ancient Greeks. One is a bronze figurine; the other, a great temple dedicated to the goddess Athena, the Parthenon. Both are considered works of art, and yet they display obvious differences in size, material, and function. Compare these two illustrations with a painting by Pablo Picasso (Pl. 2, p. 7), a sculpture by Duane Hanson (Pl. 43, p. 176), and a construction by Kenneth Snelson (Fig. 15), all produced in the twentieth century, and the potential differences between works of art appear even more striking.

What is a work of art? What common qualities join these very different objects and permit us to identify them with the same term?

14. ICTINUS and CALLICRATES. The Parthenon, Athens. 447–432 B.C.

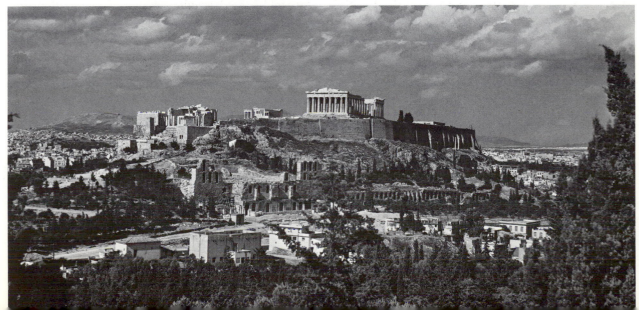

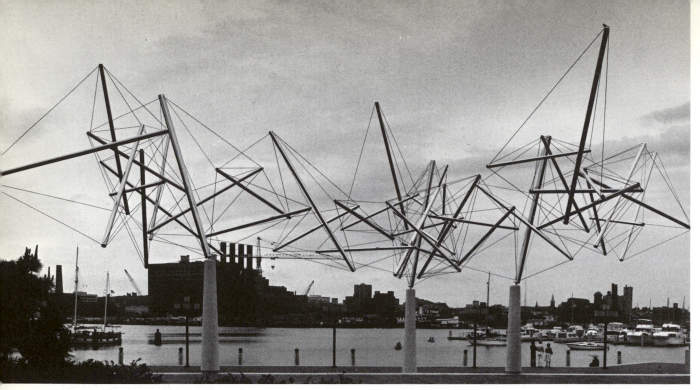

15. KENNETH SNELSON. *Easy Landing.* 1977. Stainless steel,
30 × 85 × 65′ (9 × 25.5 × 19.5 m). Commissioned by the City of Baltimore.

Definitions of Art

A definition of *art object* requires a definition of *art.* Dictionaries and encyclopedias list many usages of the word "art," which are typically neutral in point of view, with little or no area for argument. In addition, individual writers and philosophers have presented numerous personal definitions and theories. These aestheticians tend to define their own individual concepts of art and its functions, often stressing some particular facet of the definition that seems important to them in the context of their philosophical preferences. The great variety of meanings attributed to the word "art" emphasizes the desire to explain what appears to be a universal human activity. Social groups throughout time, in every part of the earth, have channeled some of their energies into the production of aesthetically satisfying objects. Why do they do this, and what qualities inherent in such objects separate them from purely utilitarian products? These questions and others intended to define the nature of the aesthetic object and our response to it have yielded no absolute conclusions, but certain concepts do recur in most definitions, so that it may be possible to develop a single definition broad enough to include most of the individual concepts.

Differences in the definition of art are concentrated in two major conceptual positions: There are those who see the work of art primarily as a means of expressing and communicating ideas and emotions,

and then those who look at the work of art as an object to be perceived as a thing in itself, with little or no reference to other areas of experience. The first group of writers considers the storytelling or imitative aspects of art to be its essential characteristic. "What is the artist saying?" "What sort of picture of the world does the artist present?" These are questions the writers ask. Often the aestheticians in this group expect the artist's message to have special qualities, "moral" or "real." They expect to find in art a meaning with a reference to the life and experience of its observers. Lev Tolstoi, a nineteenth-century Russian author, reflected this point of view in his book *What Is Art?* (1896) when he said: "To evoke in oneself a feeling one has experienced, and having evoked it in oneself, then by means of movements, lines, colors, sounds, or forms expressed in words, so to transmit that feeling that others may experience the same feeling, that is the activity of art."

In direct contrast to the position taken by Tolstoi and those who agree with him is that of Clive Bell, an English aesthetician. Bell is known for his defense of the young European artists of the early twentieth century who rejected the traditional, academic storytelling art that was then held in high regard. These artists deemphasized the importance of representational subject matter and stressed formal design. They were more concerned with the appearance of the objects they were making than with what the objects represented. Bell wrote:

What quality is shared by all objects that provoke our esthetic emotions? . . . Only one answer seems possible—significant form. In each [object], line and colors combined in a particular way, certain forms and relations of forms, stir our esthetic emotions. These relations and combinations of lines and colors, these esthetically moving forms, I call "Significant Form"; and "Significant Form" is the one quality common to all works of visual art. . . .

Let no one imagine that representation is bad in itself; a realistic form may be as significant, in its place as part of a design, as an abstract. But if a representative form has value, it is as form, not as representation. The representative element in a work of art may or may not be harmful; always it is irrelevant.[1]

In the painting *Starry Night* by Vincent van Gogh (Pl. 5, p. 25) Tolstoi might have emphasized the expression of emotion, which seems to have filled Van Gogh prior to or during the painting of this picture; the swirling movements of the sky, which pulsates with the excited imagination of a mystic who searches the heavens, aware of the invisible forces in the vastness of the universe; the sense of the contrast between this drama in the heavens and the peaceful unawareness of the sleeping village on earth. For Clive Bell the facts of the sky, the moon, the cypress tree, and the village would have been unimportant in comparison with his own excitement as he reacted to the spiral forms, the repeated curved movements, and the contrast of the rich blues and the yellows juxtaposed in agitated brush strokes.

Tolstoi's approach emphasizes the expressive, or communicative, side of art; Clive Bell's attitude emphasizes the formal side of art. Aestheticians agree that these two points of view are not mutually incompatible. It is possible, perhaps even necessary, to have both these elements in a single work of art.

There is increasing evidence that the insistence on formal and expressive principles in art is based upon something more substantial than the personal intuition of philosophers. Psychological studies in recent years have given new insights into the human aesthetic impulses, relating them to the human need to communicate and to structure experience, to arrange some portion of our perceptions into an orderly pattern that demonstrates our capacity to control our environment.

The growing catalogue of psychological studies of creative activity suggests that all men and women have within them the seed of this forming process which we have labeled "art." The difference between artists and many other people is their ability to bring forth what others find difficult to produce. The artist, motivated for one reason or another, develops the manual facility and the intellectual and emotional

16–17. Children's street drawings. Chalk.

above: 16. Barred and shuttered window, Ronda, Andalusia, Spain. 1958.

17. Sidewalk, Cornelia Street, New York. 1955.

capacity to fulfill a need which, in its essence, is a part of every human being.

Children draw naturally (Figs. 16, 17). They use drawing and painting to communicate a growing awareness of themselves and their expanding universe. They relish the manual activity and the responses from admiring family and friends. However, social pressure and the priorities of our educational programs often take their toll on the pictorial expression of the maturing child. The need for proficiency in other communication skills directs the child's energies and interest away from the use of visual communication. Unless special motivation and encouragement exist, picture-making ability and activity lessen and for many seem to disappear. These natural qualities do not die; they can reappear later in life, after a

dormant period. The exploitation of creative opportunities in otherwise routine work; the time, energy, and craft invested in hobbies; and the empathic enjoyment of the art of others are all demonstrations of the innate human need for artistic activity.

The visual arts may be considered as communication, as formal organization, or as a combination of both, but it is also possible to examine the products of the artist as the results of a skilled manipulation of materials. Artists find pleasure in the act of applying paint or cutting into the resistant surface of a granite block, and the viewer can also respond to or empathize with the manner in which materials have been controlled and combined in the process of forming the art object.

No art object can exist unless someone has formed it. The wood or stone which eventually becomes the statue, the paint and canvas which fuse to form the painting, and certainly the many materials which are combined to construct even the simplest building must be worked, manipulated, and managed to produce the forms that constitute the work of art. As masters of materials, artists become craftsmen. They must know their materials and how to work them.

Artisans differ from artists in that artisans are concerned almost exclusively with the handling of the materials. They learn to control their media and to exploit surfaces, structures, and forms. Artists require these skills too, but only as a part of their art. The skills must remain the means by which artists achieve the end of their work, which is communication and/or aesthetic organization.

How much skill is required? Obviously, enough to do the job. The measure of the skilled use of materials in a work of art is directly related to the intention of the work. When a limited skill in drawing, painting, or carving obscures the artist's intent, when incomplete knowledge of the structural and visual qualities of the materials limits the resolution of the architect's design, then the artist is inadequate as an artisan.

On the other hand, a viewer must recognize that fulfillment of the artist's intention may require a use of materials that departs from tradition. The application of minute areas of paint to a smooth surface with almost invisible brush strokes may indicate a consummate skill on the part of the painter, but it does not set an absolute standard for the measurement of quality in painting. In another time, for another pur-

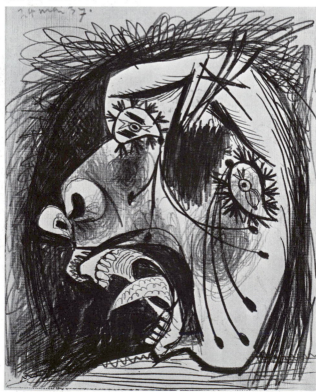

left: 18. PABLO PICASSO.
Girl with Necklace. 1944. Pen drawing.
Private collection.

left: 19. PABLO PICASSO.
Head (composition study
for *Guernica*). 1937.
Pencil and gouache
on white paper,
$11\frac{1}{2} \times 9\frac{1}{4}''$ (29 × 23 cm).
Museum of Modern Art,
New York (on extended loan
from the artist's estate).

pose, the skilled artist may require an application of paint in large, obvious splashes, or perhaps surfaces of paint dripped or sprayed. The choice of the technical means to produce a particular work is the artist's.

The two drawings by Picasso illustrated here are examples of the extremes to which the manipulation of material can be carried. In the drawing *Girl with Necklace* (Fig. 18) the flowing, graceful line is carefully and accurately inscribed. The sensuous, curved forms are traced without a single misstep. No superfluous mark detracts from the continuity of the edge. In total, the quality of the line adds to the image of serenity and grace. The artist's virtuosity is obvious in the control of the line and in the economy with which it is used to represent the form and express the attitude of the figure.

Contrast this figure drawing with the study *Head* (Fig. 19). The scrawled, crude areas are shocking in their apparently careless forms. Gone is the controlled, studied grace, and in its stead is an example of what appears to be a drawing produced in an undisciplined emotional frenzy. We know that Picasso could draw with control and accuracy. Can both drawings be the result of a skillful use of the materials? The answer is to be sought in the intent of the artist. What was Picasso attempting to do in the second drawing? Could he have produced the anguish he wished to communicate by drawing his forms with a graceful, flowing line? The drawn line has the potential of being used in many ways. The choice Picasso made in each of the two drawings was based upon his awareness of the material he was using. The employment of that material in one drawing is no more skillful than its use in the other. It is the intention that controls the technique, and it is difficult to separate intention from technique.

The Question of Decorative Art

When an artist uses materials with little apparent concern for representation or expression but with a perceived primary intention of pleasing the senses of the viewer, the resultant work is often called "decorative." Decorative art, or decoration, can take many forms. Two-dimensional decoration may rely on repetitive patterns that divide spaces into easily understood systems of colored units (Fig. 20). Figural images may be used, but often the treatment of the figures emphasizes patterns and rhythms developed by placement of elements and by linear continuities. Three-dimensional decorative art may emphasize the tactile and reflective qualities of the materials that shape the object (Fig. 21).

The word "decoration" is often applied pejoratively to characterize a less important art form than that which has the serious and demanding intention of

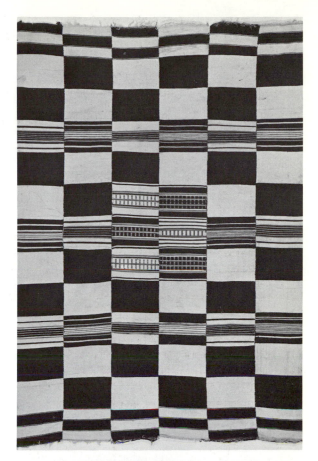

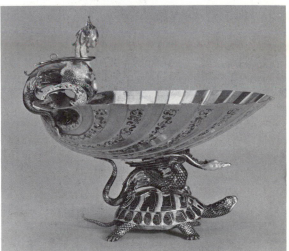

top: 20. *Men's Weave.* Woven fabric from Guinea, 8'3" × 5'6" (2.51 × 1.68 m). American Museum of Natural History, New York.

above: 21. JACOPO BILIVERT (?). *The Rospigliosi Cup.* 1550–55. Gold and enamel, 7¾ × 8½" (20 × 22 cm). Metropolitan Museum of Art, New York (bequest of Benjamin Altman, 1913).

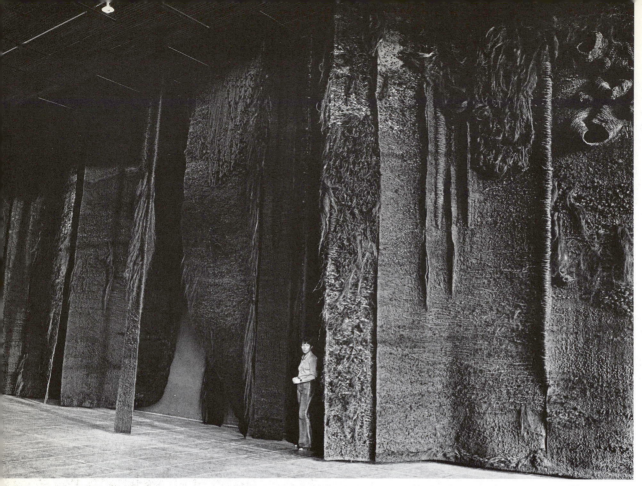

22. MAGDALENA ABAKANOWICZ. *Bois Le Duc* (environmental wall). 1970–71.
Sisal, wool, and flax, especially spun for the project; 24′9″ × 81′3″ (7.54 × 24.76 m).
State Building, North Brabant, S'Hertogenbosch, Netherlands.

communicating human experience. The implication is made that the lack of expressive content in the work reduces its complexity and, therefore, its demands on both artist and respondent. But decorative art, at its best, can stimulate aesthetic responses with an intensity equal to that of many "fine arts" objects. Even when there appears to be no intended subject matter, no specifically representational or expressive content, a superb example of decoration can communicate the commitment, the skill, and the devotion of the artist who made the work. The empathy that a viewer can feel for the attitude and the ability of the craftsman can serve as sufficient content to elicit aesthetic satisfaction comparable to that found in the arts which have a more obvious communicative intention. At times the efforts of a consummate craftsman seem magical, filling an admiring viewer with awe at the capacity to shape cloth, wood, or metal into stunning inventions beyond the limits of normal expectations (Fig. 22). At other times the innovative use of color in combinations that provoke and intrigue our imagination can stir us to delight.

Art Defined by Artists

The American painter and teacher Robert Henri wrote in his book *The Art Spirit* (1923):

> *Art Is the Attainment of a State of Feeling:* The object of painting a picture is not to make a picture—however unreasonable this may sound. The picture, if a picture results, is a by-product and may be useful, valuable, interesting as a sign of what has passed. The object, which is back of every true work of art, is the attainment of a state of being, a state of high functioning, a more than ordinary moment of existence. In such moments activity is inevitable, and whether this activity is with brush, pen, chisel, or tongue, its result is but a by-product of the state, a trace, the footprint of the state.
>
> These results, however crude, become dear to the artist who made them because they are records of states of being which he has enjoyed and which he would regain. They are likewise interesting to others because they are to some extent readable and reveal the possibilities of greater existence.[2]

Henri's statement is that of the artist who says, "Art is what I produce when I am performing my function as an artist, an activity I can distinguish from the many others I engage in because it makes me feel fulfilled and elated." This highly subjective definition is in accord with the thought of the eighteenth-century German Romantic poet-dramatist Friedrich Schiller as well as that of Herbert Spencer, the late-nineteenth-century English philosopher of the theory of evolution. It regards art as the result of play, which is conceived of as activity pursued for itself, not intended for direct application.

Artists' definitions of their own art have particular relevance when we consider the work of those innovators who reject the traditional art forms of their time as a basis for new expression. If artists are motivated to create objects or experiences that fulfill and satisfy them and yet appear to have no precedents, they cannot use established criteria for justifying the aesthetic value of their work. It does not matter that at some later date an artist, or someone else, may find significant connections or parallels between the new work and earlier art forms, for the avant-garde artist, at the time of creative activity, must act as directed by inner necessity.

Michael Heizer is a contemporary artist who has dug giant trenches on the flatlands of Nevada and California, using a variety of excavation tools. Some of these trenches (Fig. 23) stretch intermittently for distances in excess of 600 miles (about 960 kilometers). Heizer has been described as being at odds with an art world that is impossibly "full of objects already." He is quoted as saying, "Artists have been misled into thinking that you have to create something in order to contribute to art. . . . I want to create without creating a thing. I want to create without mass and volume." Of his work he says, "I make it for myself and for art but for no one else. . . . Art is only memory anyway." [3]

Heizer's earthworks have antecedents in the distant past. One such example, in Adams County, Ohio, is a construction in the form of a serpent (Fig. 24), the work of a people identified with the Adena culture. Measuring 1,254 feet (376.2 meters) in length, the

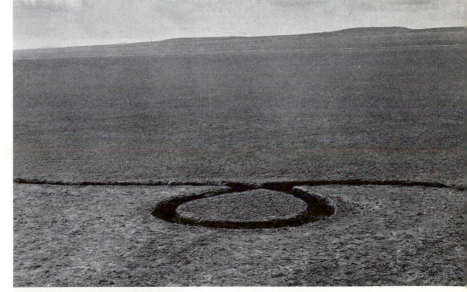

right: 23. MICHAEL HEIZER.
Isolated Mass/Circumflex. 1968. Earthwork,
Massacre Dry Creek Lake, Vya, Nev.;
120 × 12 × 1′ (36 × 3.6 × .3 m).
Courtesy Xavier Fourcade, Inc., New York.

below: 24. Great Snake Mound,
Adams County, Ohio.
c. 900–1300.
Length 1,254′ (376.2 m).

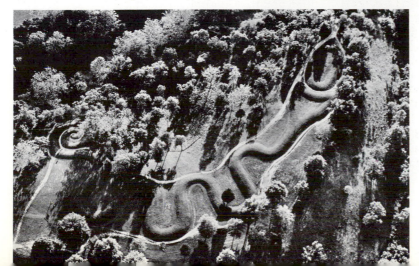

mound has an average width of 20 feet (6 meters) and a height that varies from 4 to 5 feet (1.2 to 1.5 meters). The two crescent walls that form the open jaws are 17 feet (5.1 meters) wide and 75 feet (22.5 meters) across. The Adena people are thought to have lived over two thousand years ago and to have used the mound as a ritual object, for it does not seem to serve any practical purpose. At a great expenditure of time and energy this people shaped the earth into a monument. Their motivation must have been strong, for their effort certainly was prodigious. Once completed, the serpent could not have been seen as a whole, for there was no high ground from which to observe it. Today, visitors to the site climb a tower constructed for this purpose, and they can see what the builders could know only in their minds.

Of course, it cannot be suggested that prehistoric peoples were motivated by the same subjective needs that energize a contemporary artist such as Heizer, but in a purely physical way his efforts are related to

25. CHRISTO. *Valley Curtain.* 1970–72. Nylon polyamide, steel cables; height 185–365′ (55.5–109.5 m), span 1250′ (375 m). Grand Hogback, Rifle, Colo. Project Director: Jan van der Marck. Courtesy the artist.

monumental projects constructed at various sites throughout the world by societies that gave an aesthetic order to large topographic compositions.

When Michael Heizer said that he wanted to create without creating a thing, to create without mass and volume, he went beyond the art forms he has produced in the desert. His trenches are, in fact, material entities. They do exist; they have measurable dimensions. Heizer is not alone in his desire to achieve a nonmaterial art. A number of artists believe that the creation of art is possible without the production of an object or an event. Identified as *Conceptual artists,* these members of the avant-garde are challenging the primary traditional assumption that artists are object makers. They deny the importance of the work of art except as it exists in the mind of the creator.

The Conceptual artist insists that all art objects are essentially information systems; a painting, a building, a statue, or a photograph is a physical equivalent for a conception or a state of mind. Conceptualist Joseph Kosuth says, "Physical things deteriorate, art is strength of idea, not material." The idea is the form. After the conception, any form of communication expressive of the idea—pictorial, diagrammatic, symbolic, or verbal—is legitimate.

There is no conflict or contradiction between Heizer's project and the basic proposition put forward by Robert Henri, though Henri probably could not have anticipated this extension of his ideas.

There are those who contend that much, if not all, is lost in the arts if the production of real objects does not result from the creative process. In fact, many of the conceptual projects have been documented by drawings and photographs which have been exhibited in galleries with all the associated visual characteristics of traditional physical art objects, thus raising some doubts about the theoretical foundations of Conceptualism and its actual implementation. To this observation Heizer might respond that, once the idea is formed, drawings and photographs are as good a way of communicating that idea as any other. But when those drawings and photographs are appreciated for their own aesthetic qualities, as they often are, the Conceptualist's images fall in line with the images of other object makers throughout history.

For some artists the once clear-cut division between the visual arts and other forms of expression no longer exists. How does one describe Christo's *Valley Curtain* (Fig. 25), a 250,000-square-foot (22,500-square-meter) drape of nylon cloth that was hung across a canyon in Colorado over a distance of 1,250 feet (375 meters)? Was it a monumental painting? A gigantic sculpture? A demonstration of bridge engineering? Or an ephemeral event that dramatically affected the lives of all who took part in the project during the months that were required to complete it?

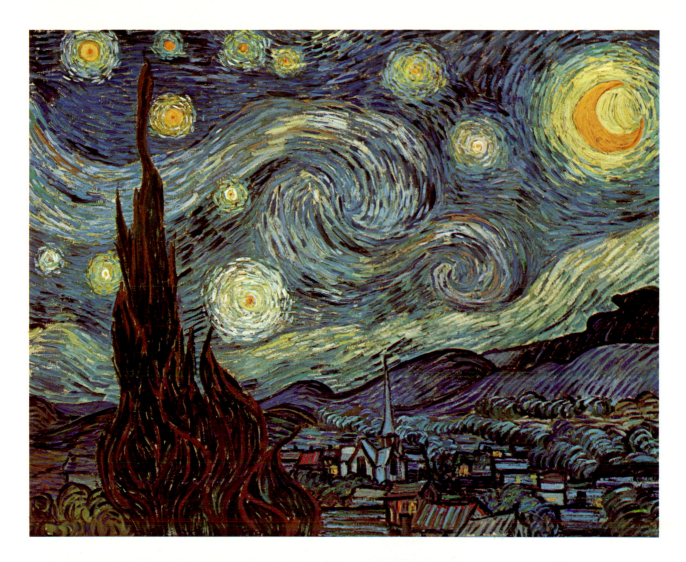

above: Plate 5.
VINCENT VAN GOGH.
Starry Night. 1889.
Oil on canvas,
29 × 36¼″ (74 × 92 cm).
Museum of Modern Art,
New York
(acquired through the
Lillie P. Bliss bequest).

left: Plate 6.
Detail of Figure 33,
Rembrandt's
Portrait of a Young Man.

left: **Plate 7.** CLAUDE MONET.
Rouen Cathedral: Full Sunlight.
1894. Oil on canvas, 36 × 24¾″
(91 × 63 cm). Louvre, Paris.

below: **Plate 8.** CLAUDE MONET.
Rouen Cathedral: Sunset. 1894.
Oil on canvas, 42 × 29″ (106 × 74 cm).
Museum of Fine Arts, Boston
(Juliana Cheney Edwards Collection;
bequest of Hannah Marcy Edwards
in memory of her mother).

26. A scene from the dance performance *Glacial Decoy*. 1979. Choreography by Trisha Brown; visual presentation and costumes by Robert Rauschenberg.

Theater combines with both painting and sculpture in the so-called "performance arts." Sculptors and painters have often been asked to design settings and costumes for actors and dancers, but now some visual artists have become directly involved in theatrical events, either performing themselves or employing film and television as a medium for personal expression (Fig. 26).

Christo's curtain is obviously a different kind of object from the sixth-century B.C. Greek warrior illustrated in Figure 2, and yet both result from the mental and manual efforts of human beings; they are, in fact, organizations of material which fulfill an apparent intention. And even when it becomes difficult to distinguish the performance arts from the efforts of poets, choreographers, and dancers, film makers, and television producers, the visual aspects of these events may be understood as extensions of the three-dimensional arts of sculpture and architecture, which utilize space, time, and sometimes sound, as a part of their compositions.

Summarizing then, we may say that a work of art can be described as *the result of human effort that has a defined form or order communicating the experience of the creator or the experience of others.* To this may be added that it is *affected by the skilled control of the materials used in its construction to project the formal and communicative concepts that the artist wishes to present in the work.*

Such a definition is broad enough to include a great many objects and events formed by men and women. Commercial advertising design, interior decoration, industrial design of commercial and personal objects, sewing, pottery making, and other crafts—even the writing of a letter—can fall within the definition. It can include the unmodified, intuited images of the highly subjective artist and the works of decoration that are evidence of the consummate skill and commitment of the decorator.

In addition, every work of art has physical limitations, though these do not necessarily comprise a part of the definition. Two-dimensional and three-dimensional objects can be measured, whether they be miniatures or great building complexes; works that include time as a part of their construct have a beginning and an end. To comprehend an art object as a physical entity is to be aware of these dimensions.

Equally important is a comprehension of the difficulty that exists in defining the limits of the symbolic or metaphoric content in a single art object. Because the symbolic and/or metaphoric meaning is, in large part, dependent upon the response of each observer, there is an infinite number of possible responses and interpretations for any one painting or piece of sculpture. The work of art can therefore be said to have

limited physical dimensions that can create an unlimited variety of metaphysical responses in those who interact with it.

The inclusiveness of our definition recognizes the potential for aesthetic experience in many products of human activity, but no attempt is made in the definition to provide a guide for the establishment of value in the visual arts. The definition does not separate great art from the mediocre, and it does not offer the reader the consolation of an approved list of works of art that *should* be appreciated. Each of the art forms within the definition has the potential for an aesthetic content that can reward persons who seek satisfaction in the contemplation of objects and events created by other human beings. This search does not guarantee a reward each time the effort is made. The successful union between a stimulating work of art and an individual depends too much upon personal factors that influence the outcome. Like any adventure, the search may fail; but if there is to be a successful conclusion to the effort and the satisfaction that can come from the appreciation of art is to be achieved, each person must find an individual way, taking pleasure in the process itself as well as in the hoped-for reward.

Beauty

Nowhere in this definition of "art" is the idea of beauty included. This may seem a strange oversight, for the word "beauty" is almost always found in conjunction with art in casual discussions of the subject. For many people a work of art must be beautiful, but, faced with some contemporary paintings, buildings, or sculpture characterized as works of art, these people feel confused and disturbed, for what they see before them they consider not beautiful, but ugly. Since it is ugliness they recognize, how can they reconcile this disturbing conflict between art and the absence of beauty?

The questions that must be asked are: "What is meant by the words 'ugly' and 'beautiful'?" and "Must these qualities be present in a definition of a work of art?"

There are two basic concepts of the meaning of beauty. In one point of view beauty lies in the subjective response of a person upon contact with an external stimulus: the sense of the beautiful lies within us. Something outside ourselves can make us feel this sense of beauty, but the feeling is not a part of the object that triggered this response; it is solely and completely within the onlooker. In the second point of view beauty is an inherent characteristic of an object or an experience. It is the relationship of the individual parts in their combination that the viewer recognizes as beauty.

These two definitions appear to approach beauty from two opposite poles. Those who think of beauty as existing solely in the unique responses of the individual are examining the experience from an observer's point of view. Those who think of beauty as inherent in an object or experience are seeing it from the point of view of the creator, the person who must decide how to make the work beautiful.

The first attitude was expressed by the English aesthetician Edgar Carritt, about 1914: "We cannot reflectively think of beauty as an intrinsic quality in physical objects or even in human actions or dispositions, but only as a relation of them to the sensibilities of this or that person." Following in the tradition of Immanuel Kant and George Santayana, Carritt considers beauty a response to a visual, aural, or tactile sensation that gives pleasure.

What of those who are trying to produce a beautiful object, sound, or movement? For them it is not enough to know that beauty is a subjective reaction within the observer. Such a definition leaves the artist helpless before the wish to create something beautiful. The choreographer who must plan a ballet finds it necessary to decide how to group dancers so that the ensemble will arouse a feeling of delight in the members of the audience. The composer must select, from the resources of orchestral sound, those particular tones and rhythms which can give the listener the satisfaction of an aesthetic experience. The painter, within the limits of the canvas, must place color and textures so that the viewer will experience a surge of delight, which in turn will elicit the response, "Beautiful!" To recognize beauty is one thing, but to produce it is another.

"I shall define Beauty to be a harmony of all the parts, in whatsoever subject it appears, fitted together with such proportion and connection, that nothing could be added, diminished or altered, but for the worse."[4] Leon Battista Alberti, an Italian architect, wrote this definition of beauty in the fifteenth century. Today, the same attitude prevails within a large group of the working artists and many of the foremost writers on art. They believe that beauty is the result of a controlled relationship among the separate parts of a work. This definition does not tell artists how to create beauty, but it does direct their energies toward that goal. It can also direct the observer to the essential elements in a work of art, which in turn may give that experience of beauty which is called the "aesthetic experience."

Both points of view noted above seem valid. It is difficult to refute the argument that beauty, for the observer, is a personal, subjective response, but it can be maintained, on the other hand, that the response requires an initial stimulus with the potential to trigger the aesthetic experience.

Formerly, the aesthetic experience was almost always equated with a reaction to beauty. In discussing the sources of aesthetic sensation, writers were interested in the aspects of beauty and in what produced it. Since the turn of the century, under the influence of psychology, the term "aesthetic experience" has more often been interpreted to mean something more than a response to the beautiful.

As noted in Chapter 1, an aesthetic experience can be, at the same time, unpleasant and disagreeable—it can include the ugly, the repulsive, and the painful. In effect, many contemporary aestheticians and psychologists say that our reaction, pleasant or unpleasant, to art, a reaction we may wish to repeat over and over again because it gives us emotional satisfaction, need not be limited to a recognition of beauty in the work; it may also encompass whole realms of human sensibility and response that are almost the polar opposite of what generally would be thought of as beautiful.

With reference to the two questions, "What is meant by the words 'ugly' and 'beautiful'?" and "Do these qualities belong in a definition of a work of art?" it can be stated that the identification of the ugly and the beautiful is recognized as a personal, subjective response to outside stimuli. Therefore, the recognition of the beautiful by different persons may be motivated by different experiences. Experience, effective at one particular time as an aesthetic stimulus for a particular person, may, in time, lose its efficacy, to be supplanted by other aesthetic stimuli. This evolution affects both the observer and the creating artist who attempts to produce something beautiful by controlling the relationships among the parts of a work in progress. However, the creation of beauty in the usual sense is not the artist's sole consideration. The creative person may sometimes relate the parts of a work to produce something that is not beautiful. It may be an image more expressive than those created before; it may be a combination of forms or colors in an unexpected and startling composition. The word "beautiful" is tied to the past. It harks back to the established and accepted images and aesthetic orders. The new, the startling, the disturbing is rarely seen as beautiful. When observers approach a work of art with the attitude that beauty and art are one, they may be imposing upon that work a restrictive demand, forged by tradition, which cannot be fulfilled. In consequence, the observers may be cutting themselves off from an aesthetic experience which could offer rich rewards.

The conclusion of philosophers that the identification of beauty varies from person to person has been reinforced by psychological studies showing that the aesthetic reaction is similar to other emotional reactions and that individual reactions differ considerably. From infancy on, each person receives innumerable sensations which form an internal potential response to certain stimuli. Some of these responses will be identified as a perception of beauty. Because these emotional reactions are so varied, because there are so many unknown quantities in the creation of the sense of beauty within all people, it is impossible to establish absolute criteria for the identification of the beautiful. The questions always arise: "Beautiful to whom?" "Beautiful when?" To demand that a work of art be beautiful is to reduce the definition of the word to such a personal level as to render it virtually meaningless.

We return, therefore, to our original definition: *Art is the result of human effort in which materials are skillfully ordered to communicate human experience.* Within these limitations it is possible for some observers to find beauty, for others to find intellectual and emotional satisfaction, and for still others to discover a disturbing enigma.

Art as Communication

Communication between persons of wholly dissimilar backgrounds can occur only on an elementary level; separated by language barriers and by the absence of shared customs and attitudes, the participants in the dialogue may find their only basis for communication in their common experience of the immediate physical world.

Even between individuals with the same heritage the exchange of ideas, information, and feelings is often difficult. How many arguments result from a confused transfer of information? Who has not felt frustrated in trying to express the taste of food, the scent of a garden, or the love of a child? Inadequacy of communication is often the result of a limited ability to use the available language, but at times the language itself is incapable of transmitting the information desired.

Nevertheless, communication does take place. The complex process of living in social groups requires a continuing interaction among the members. We seem always to be telling someone something or listening to someone. To keep a society functioning, its members must exchange a great deal of practical information, but it is just as important for each member to be able to express those intimate, personal reactions to life which give a sense of the individual's humanity. Wilbur Urban, in *Language and Reality* (1939), expressed the same idea as follows: "We may have a direct apprehension or intuition of life, but the meaning of life can neither be apprehended nor expressed except in language of some kind. Such expression or communication is part of the life process itself." [1] To point or to scream is to communicate, but the need for more complex communication requires a process or method which is itself more complex.

Communication is a transfer of information or ideas from a source to a receiver. Some vehicle or medium is required for this exchange. We often refer to this vehicle as a "language." Two persons, looking at the same object, share the consciousness of it. By a series of hand signals they may refer to that object and exchange a limited amount of information about it. The movements of their fingers and hands, perhaps reinforced by changes in facial expression, become their language. Once these individuals are separated, or the object of their reference is removed, some systematic combination of sounds or marks must be formulated to span the distance between them. This more complicated "language" requires the development of equivalents which stand for the ob-

ject, or the information about it, so that the message may be carried from the speaker to the listener. In communication these equivalents are called "symbols." All those persons who wish to take part in the process of communication, to speak together or read the same paper, must have a knowledge of the language and the symbols that are a part of it. As the communication becomes more complex, as the descriptions become more precise, the language must be developed to represent the specific information and express it. This process requires a language of many individual symbols and a systematic means for combining them into significant relationships that are easily understood.

27

28

To understand a system of language it is necessary to know the specific sounds that have been assigned a definite meaning in it. When it becomes necessary to communicate these sounds beyond the limits of hearing, written symbols, a combination of lines or marks, must be used; and these, too, require a common understanding on the part of the communicators. Thus, the sound represented by the word CAT refers to a particular species of four-legged animal. The sound itself is not an attempt to imitate the noise made by the animal. The word that identifies this particular animal in the English language differs from the one used in Swedish or Hindustani. It acquires its significance only because we, who speak English, agree to its meaning.

When we wish to express the sound that stands for this quadruped, we combine the lines shown in Figure 27 to produce the symbol shown in Figure 28.

Note that, just as the sound does not imitate the cry of the animal, the lines do not portray it visually. Their meaning exists because it has been arbitrarily assigned and we have been taught to use it. When children learn to read, they go through this process of combining separate elements into a single meaningful unit. At first the separate parts of a letter must be consciously combined to form its shape: a T is laboriously constructed with a horizontal mark placed rather precariously over a vertical mark. Then the separate letters are combined to form a word which carries another kind of meaning. In time, the elements forming the letters C-A-T and then the word CAT lose their separate identities and are seen as a pattern that is readily identified and associated with the animate object in the experience of the child. A good reader will rarely have to consider the separate letters that are combined to form words, usually reacting to the pattern of the letters and recognizing the entire word as a single unit. It is not unusual for rapid readers to identify whole groups of words as a unit, because of the pattern they create. Whether the size of the pattern is large or small, it is the ability to recognize it which allows the reader to understand the meaning of that particular combination of elements.

The sentence THE CAT IS ON THE FENCE is a grouping of separate elements that the reader has learned to combine in a particular way. If the accustomed pattern is broken, even though the individual elements are unchanged, confusion can result:

THEC ATIS ONTH EF ENCE
THE CAT FENCE ON IS THE

Both of the above letter groupings can be confusing for they do not fall into a familiar pattern. To understand the meaning carried by these elements, a reader must stop the normal reading flow and attempt to puzzle out the proper relationships for the separate parts. In effect, the reader must place them in a new order which makes sense.

A clever typographic designer can add levels of meaning to a word or sentence by a careful selection of the type face or by the arrangement of letters. In Figure 29 the letters CENS are separated from the letters RED by a solid black block. Taken at face value, the combination of the letters and the block is meaningless. It is only when the reader assumes that the block covers the capital letter O that the combi-

29. ROBERT CAROLA. Graphic word play. 1964.

nation of letters is joined in the spelling of "censored." Once that assumption has been made, the black block no longer acts as a deterrent to legibility. It becomes a symbol for the censor's act and a self-fulfilling visual sign. Similarly, in the arts, when confronted by a new experience one must fit it into the pattern of one's previous experience if it is to be understood. Some form of meaning is sought and always in familiar terms.

In painting and sculpture the terms are frequently those of the representation of the physical world, the shape and color of a tree or the size and proportion of a house in its surrounding landscape. The question is often asked by untrained observers of a painting or sculpture, "What is it supposed to be?" These two art forms traditionally have been concerned with the physical appearance of things, and a viewer quite understandably may try to fit the several parts of a painting or piece of sculpture into a pattern based upon the appearance of familiar objects. People have been trained to do this from childhood, just as they have been trained to read.

The Language of Visual Arts

As in the case of reading a written language, untrained observers are usually quite unaware of the separate elements which make up the symbol of the object they recognize, nor are they conscious of the way in which these elements have been combined. Like the reader who has progressed from the tiresome process of consciously combining letters into words and words into sentences, the untrained person before a painting or sculpture often assumes that "reading" a work of art should be a natural, automatic ability of all who can see.

In actuality, artists use separate elements to construct pictorial symbols in much the same way as writers combine parts of the written language to produce their method of communication. The diagrams reproduced here will demonstrate the similarity between these two processes.

The ten linear elements in the first group in Figure 30 are similar to those used to construct the word CAT. When they are combined as in the second group, their identities as separate parts give way to a new group identity as a pictorial symbol—a house. As in the case of the word formed by separate elements,

the new pattern takes on a meaning of its own, which does not normally require the viewer to go through the relatively laborious process of consciously organizing the elements.

Again, as in the instance of the word symbols, this pictorial symbol can be combined with others—see the third group—to form a larger unit, and this unit, too, has a meaning, because the viewer is able to sense a pattern, a set of relationships, which means something.

Like the jumbled sentence, this pattern, once broken (as in the last group), may result in confusion. Because the parts are not arranged in a pattern which has a meaning for the viewer, communication is interrupted; and, as in the word puzzle, no communication can occur again until these elements find their place in a new pattern.

The example of the pictorial symbol used above is a simple demonstration of the organization of one of the artist's plastic elements, *line*. Every work of art, no matter how complex, which uses line as its sole or primary element derives its meaning from the way the lines have been combined. At times the patterns of lines are so complex that the viewer may not consider them as separate and distinct parts. The etching by Rembrandt in Figure 31 is a picture of Dr. Faustus. Within a darkened room the aging man turns from his desk to see a glowing inscription. He is dressed in heavy robes, his face modeled by the ghostly light. Form, light, the textures of cloth are all the result of the artist's use of the etching needle. In an enlarged detail of the etching (Fig. 32) the folds of cloth lose their identity and are seen for what they really are—groups of lines. Each of these lines was placed in its particular position by the artist so that it joined with others to create the desired effect. Just as the ten lines of the demonstration drawing were combined to form a house (Fig. 30), the lines of the Rembrandt etching are organized to produce their more complex meaning.

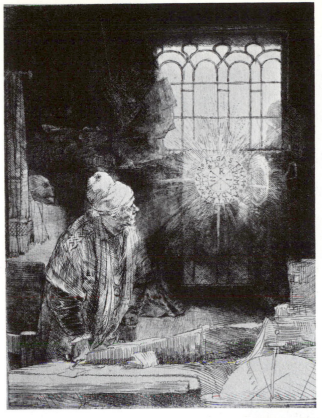

left: 31. REMBRANDT. *Dr. Faustus.* c. 1652. Etching, $8\frac{1}{8} \times 6\frac{1}{4}''$ (21 × 16 cm). Metropolitan Museum of Art, New York (Sylmaris Collection; gift of George Coe Graves, 1920).

above: 32. Detail of drapery in Figure 31.

right: 33. REMBRANDT. *Portrait of a Young Man.* 1655. Oil on canvas, $38 \times 32\frac{1}{2}''$ (97 × 83 cm). Wadsworth Atheneum, Hartford, Conn. (Ella Gallup Sumner and Mary Catlin Sumner Collection).

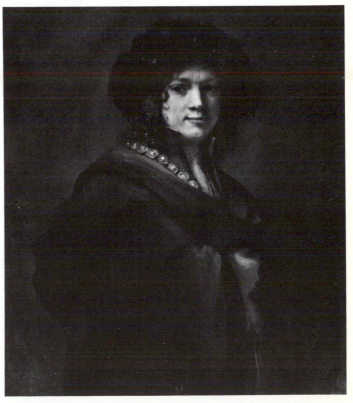

What holds true for line is equally true for other plastic elements, including *color, form,* and *texture* Another work by Rembrandt can serve to demonstrate the creation of a symbol used to express the appearance of objects. The *Portrait of a Young Man* in Figure 33 is an oil painting. When seen from a short distance, the chain that circles the shoulders of the figure appears to be constructed of separate metal segments, glistening in the light. A detail of the painting (Pl. 6, p. 25) shows a portion of the chain as it was formed by the artist, actually a number of rather broad strokes of a brush loaded with pigment, which combine to mean "metal chain." Both examples emphasize a basic fact of representation in the visual arts: *A representation of an object is not the object.* The artist did not glue a chain on the canvas when he wished one there. Like the writer, who uses words which are symbols for the things to be communicated, the artist uses the elements of painting and sculpture for communication. The combination of these elements produces *equivalents,* visual signs that stand for the subject matter.

Equivalents

Equivalents are combinations of line and color woven into an arrangement, with an order that must be recognized before the subject can be perceived.

Our understanding of equivalency will benefit if the following three points are remembered:

1. *There may be a number of equivalents for the same object in nature.*

Two artists standing in the same position may paint different equivalents of the same subject. The images they produce, which represent that subject, can be affected by the medium employed; by the attitude of the individual artist; by the artists' previous training; or by their different interpretations of the identical subject, in reaction to different portions of the thing they see.

left: **34.** Façade, Rouen Cathedral. Begun 1210.

above: **35.** Side view, Rouen Cathedral.

2. *The appearance of an equivalent may be affected by factors that have nothing to do with the subject matter represented.*

Just as an individual's handwriting makes loops and curves that can be distinguished from the handwriting of others, even though the words are identical, so equivalents in the visual arts may say similar things but have different appearances. Sometimes these differences are due to the artist's style—a preference for certain colors and/or a way of moving the hand when applying paint. At other times representation, the equivalent use of a form, color, or linear tracing, may only be one aspect of the artist's intention. It is possible that the aim is to have those visual elements function in two concurrent ways: as an equivalent and as a design. When understood one way, the elements will represent an object or event. But another perception may be that the areas of color have been created because they complement each other, and lines which previously were seen as having a representational function will be rediscovered as parts of a linear web, interesting in its own right without reference to subject matter.

3. *Each object or event in nature can be understood or seen in a number of ways, but it is impossible for an artist to express, simultaneously, all the potential meanings in the subject matter.*

At some stage the expression of one aspect of a subject will in some way reduce, interfere with, confuse, or contradict the expression of other perceptions of the same subject.

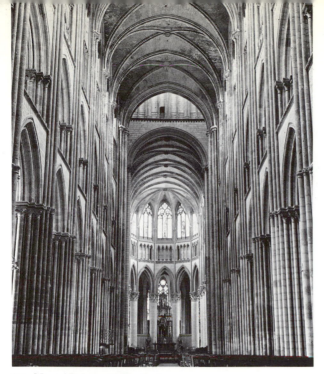

36. Nave, Rouen Cathedral.

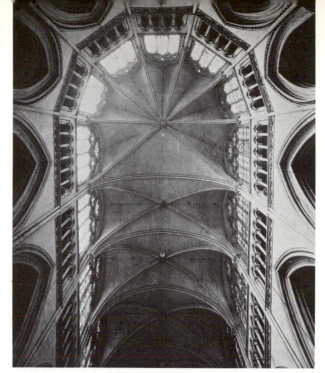

37. Vaulting, Rouen Cathedral.

Figure 34 is a photograph of the west wall, the façade of Rouen Cathedral. This image gives a great deal of information about the appearance of the building, but it cannot provide all the visual data available to a person visiting the site. The photograph does not show the side of the exterior (Fig. 35); neither does it reveal the interior (Figs. 36, 37). Details of the carved masonry surfaces can be recorded only by a set of separate close-up images (Fig. 38). Still other kinds of information, not available to the visitor but important for understanding the building and its structural systems, can be communicated by drawings of the plan and sections of the building (Figs. 39, 40).

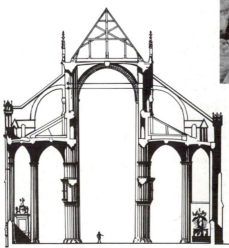

38. Exterior detail, Rouen Cathedral.

far left: 39. Plan, showing nave, aisles, and choir, Rouen Cathedral.

left: 40. Section through nave and aisles, Rouen Cathedral.

41. PIET MONDRIAN.
Tree II. 1912.
Black crayon on paper,
9⅝ × 22¼″ (24 × 57 cm).
Gemeentemuseum, The Hague.

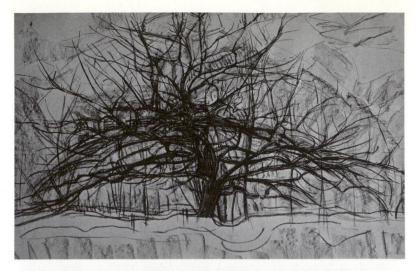

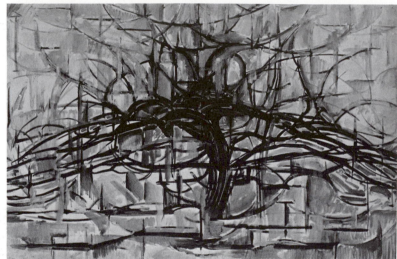

42. PIET MONDRIAN.
Horizontal Tree. 1911.
Oil on canvas, 29⅝ × 43⅞″ (75 × 111 cm).
Munson-Williams-Proctor Institute,
Utica, N.Y.

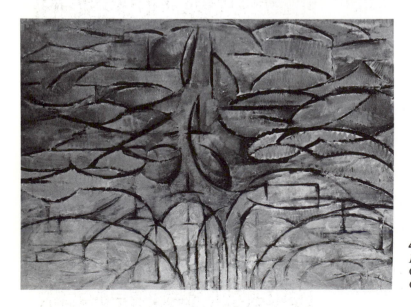

43. PIET MONDRIAN.
Flowering Apple Tree. 1912.
Oil on canvas, 27½ × 41¾″ (70 × 106 cm).
Gemeentemuseum, The Hague.

In addition, should it become desirable to know the location of the cathedral in the city of Rouen, or the location of the city in the country of France, yet other visual representations, such as general and detailed maps, would be necessary.

The French painter Claude Monet saw the cathedral of Rouen in still another way. For him and for other late-nineteenth-century painters who, like Monet, were called Impressionists, light reflected from the surfaces of buildings and landscape was the major factor contributing to the perception of the real world. The physical objects might remain constant, but their appearance changed radically under different conditions of light and atmosphere. Monet took the façade of Rouen Cathedral as his subject in a series of paintings, two of which are reproduced as Plates 7 and 8 (p. 26). In each of them, using technical devices that helped to create a painted equivalent for the effects of light, the artist communicated information about the cathedral that could not have been comparably expressed in any of the other visual forms mentioned above.

It is not possible for a single work of art to furnish complete information about any three-dimensional object that the observer can view from all angles. This is especially true of art in two-dimensional forms, but it holds equally true for three-dimensional forms that are not exact replicas in size and material of already existing objects.

Frequently the communication of one kind of visual data prevents the transmission of other kinds of information. Monet's technique of applying paint to his canvas in small, distinctly separate brush strokes was employed to create a luminous surface of color more vibrant and evocative of the actual light he perceived than would have been possible if he had applied the paint in smooth, even surfaces. However, because he was concerned about the representation of light, he could not at the same time represent the detailed carving of the stone to be seen in the photograph (Fig. 34). The two kinds of information were mutually incompatible, given the limitations of the medium, the manner of applying the paint, and the artist's choice of light reflection, rather than the specifics of modeling, as the salient feature of his response to the building.

On the other hand, the photographer who shot the interior of Rouen Cathedral could not possibly have recorded a complete view of the nave with the full side walls and the vaults above. Here the limitation exists in the optical system of the camera, which did not include within the range of its lens as much area or detail as the artist's eye and experience can encompass and condense.

All the images discussed above, including Monet's paintings, are concerned with the physical appearance of the cathedral. Information related to the historical or the religious aspects of the structure could be the basis for many other visual statements. Artists may try to isolate those limited bits of information which seem to them most expressive of the object or experience they have perceived in the subject and then attempt to realize equivalents for them.

Three studies by the Dutch painter Piet Mondrian are examples of the response of this artist to a tree (Figs. 41–43). What is the tree to Mondrian? Is it a complex arabesque of silhouetted branches, stirring with the forces of life within it; or is it a logical series of rhythms, movement against countermovement, an organic structure? Each study isolates a portion of the many possibilities that the tree presents to a viewer. By selecting and emphasizing certain parts of the object before him, by reducing the importance of other parts, eliminating details that tend to obscure the statement he wished to make, Mondrian was able to form three different equivalents for one object.

It is impossible to say that one of the renderings of the tree is more accurate than the other. Is the plan of a house more accurate than a photograph of its exterior? Does the painting of an animal (Fig. 44) by an

44. Kangaroo-like animals, tribal painting from Arnhemland, Northern Territory, Australia. 19th century (?). Painted bark, height 40¾″ (104 cm). Metropolitan Museum of Art, New York (Michael C. Rockefeller Collection of Primitive Art, bequest of Nelson Rockefeller, 1979).

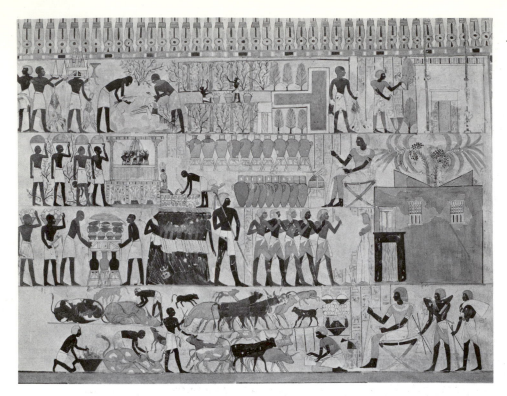

45. *Neb-Amun's Gratitude for His Wealth.* Egyptian wall painting, from the tomb of Neb-Amun, Thebes. 18th Dynasty, c. 1415 B.C. Painted copy, tempera. Metropolitan Museum of Art, New York.

aborigine of Australia tell more or less of the truth about that animal than could be shown by a detailed scientific drawing? The detailed drawing might delineate an exterior view of the animal, but the native has tried to combine what is seen of the outside with what can be seen within the animal.

Anyone wishing to produce a visual symbol for an experience must be selective. From the consciousness of color, light, form, texture, movement, and even the nonvisual experiences of sound, touch, and smell, the individual must choose those few characteristic qualities which suggest the essentials of the reality apparent at the time of beginning to work. This choice may be complicated even further if the artist decides that subjective responses to the world outside are important factors in the "real" world and that they, too, should be a major constituent of the work.

The Role of Tradition

The decision to choose one aspect of reality rather than another as the basis for a representational image is not always a matter of free choice. Enmeshed with their own times, artists perceive and react in a manner controlled in part by the traditions and patterns of the cultural environment. The artist who composed the Egyptian wall painting in Figure 45 was part of a tradition that existed before that painting was done

and continued, essentially unchanged, for hundreds of years afterward. The medium, the symbols employed to represent human forms, even the subject matter itself, all were transmitted as part of a tradition. In seventeenth-century Holland, the painter Vermeer van Delft worked within quite a different tradition, one closer to present-day photographic forms of representation (Fig. 46), but he, too, was faced with technical and symbolic precedents and passed them on with little alteration to those who followed him.

Comparing the work of Vermeer with paintings by his contemporaries and with subsequent Western art, one can identify similarities in the representation of form and space that link these artists into a long, continuing tradition. This tradition has much in common with the visual equivalents made by a camera.

In Europe, for four hundred years prior to the nineteenth century, the methods for representing form and space in the visual arts had remained essentially unchanged. Though there were stylistic differences between artists and between national or cultural groups, the similarities among the methods of representation outweighed the differences. Linear perspective, aerial perspective, and shading were the prime methods for conveying a sense of natural space and three-dimensional form in two-dimensional works such as paintings and drawings. These methods

(or conventions) had been used so long and so widely that few questioned them as the most accurate, most *realistic* equivalents for form, space, and light in the real world. Late in the eighteenth century photography was invented, and it was subsequently developed in the nineteenth century into a practical and relatively simple method of creating a visual equivalent for the "real" world. The photograph gave additional importance to perspective as the standard method for representing the artist's perception of form and space in the physical world. That the camera recorded an image in linear perspective by an optical-chemical process seemed to be a scientific confirmation of the validity of the perspective system.

During this same period of time a minority of artists began to experiment with new methods of representation. Influenced by art from the East, from Africa, and from the Americas, these painters and sculptors sought to extend the traditional equivalent forms beyond their familiar representational and expressive limits.

At the end of the nineteenth century Henri de Toulouse-Lautrec found in the flat color and the linear arabesques of Japanese prints a basis for the invention of compositions that seemed radical to his times. In his paintings and posters the influence of the East is clearly evident. Compare *Le Divan Japonais* (Fig. 47) with the Japanese print in Figure 195. Paul

Gauguin's self-imposed exile to the islands of Tahiti and the Marquesas in the South Pacific came after his enthusiastic visit to a Japanese village exhibit at the Exposition Universelle in Paris in 1889. A reflection of the art of the islanders can be found in Gauguin's painting, sculpture, and prints. A very direct influence is revealed in the woodcut *Crucifixion* (Fig. 48). In style and composition it has a clear connection with the carved club head from the Marquesas Islands that is illustrated in Figure 49.

European artists of the twentieth century have been continuously fascinated and influenced by non-Western art forms. Very early in his career Amedeo Modigliani (Fig. 50) demonstrated interest in the sculpture of west Africa (Fig. 51), and a comparison of the work of the sculptor Henry Moore (Fig. 52) with pre-Columbian art (Fig. 53) suggests the debt the Englishman owes to the collections of "primitive" art assembled by the British Museum.

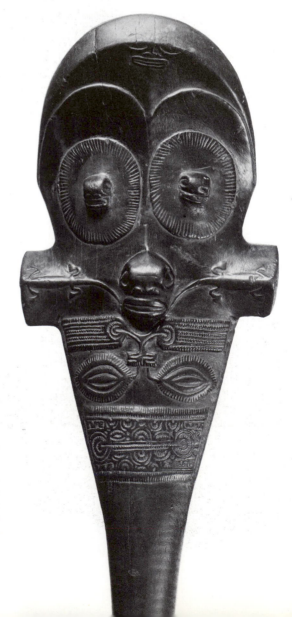

above: 48. PAUL GAUGUIN. *Crucifixion.* c. 1889. Woodcut, 15⅞ × 5⅜″ (40 × 14 cm). Metropolitan Museum of Art, New York (Harris Brisbane Dick Fund, 1929).

right: 49. Carved head of club, from the Marquesas Islands. 19th century (?). Wood, entire length 5′ (1.52 m). University Museum, University of Pennsylvania, Philadelphia.

right: 50. Amedeo Modigliani. *Head.* c. 1915. Limestone, 22¼ × 5 × 14¾″ (57 × 13 × 38 cm). Museum of Modern Art, New York (gift of Abby Aldrich Rockefeller in memory of Mrs. Cornelius J. Sullivan).

far right: 51. Mask, from Itumba region, border of Gabun and Congo Republic (Brazzaville), Africa. c. 1775. Wood, height 14″ (36 cm). Museum of Modern Art, New York (anonymous gift).

left: 52. Henry Moore. *Mask.* 1929. Concrete, height 8½″ (22 cm). Collection Lady Hendy, Oxford.

above: 53. Mask of the god Xipe Totec. Mexican Aztec, 14th century. Basalt, height 8¾″ (22 cm). British Museum, London (reproduced by courtesy of the Trustees).

left: 54. DAVID KESSLER.
Light Struck Cadillac,
from *Ruined Slide Series.* 1976.
Acrylic on canvas,
5'1" × 7'1" (1.55 × 2.16 m).
Courtesy Gallery 4, Alexandria, Va.

below: 55. EDUARDO PAOLOZZI.
Conjectures to Identity. 1963.
Color serigraph,
29¾ × 19½" (76 × 49 cm).
Museum of Modern Art, New York
(Joseph G. Mayer Foundation Fund).

The Role of Science and Technology

Other artists have found themselves stimulated by scientific and technological developments which evolved at a startling pace as the century progressed. New theories of light and color, a growing sense of change and movement in social orders, and studies in human psychology have affected the arts in ways both direct and indirect. Color photography, film, television, and computers have provided new images which in turn have become new subjects for painters, printmakers, and sculptors.

The subject of David Kessler's painting *Light Struck Cadillac* (Fig. 54) is not the automobile but a *color slide* of the automobile. One of a series of paintings based on "ruined" slides, Kessler's image depends, in part, on the representation of the special visual effects that can occur on film—effects that alter the intended, standard representational image we have come to expect when our slides return from the processor. These "mistakes" may ruin the *picture,* but they may also form new images that are surprising and provocative.

Eduardo Paolozzi's silk-screen print (Fig. 55) was produced from stencils photographically processed from an original collage composition. The artist used fragments of illustrations borrowed from scientific and technical journals and from catalogues of tools and hardware, combining them with elements of geometric patterns. In other prints this artist has experimented with compositions generated by computers and then photographically transferred to the screens from which the final images are produced.

above: Plate 9. ANDRÉ DERAIN. *London Bridge*. 1906. Oil on canvas, 26 × 39″ (66 × 99 cm). Museum of Modern Art, New York (gift of Mr. and Mrs. Charles Zadok).

below: Plate 10. GEORGES BRAQUE. *Violin and Pipe with the Word "Polka."* 1920–21. Oil and sand on canvas, 17 × 36½″ (43 × 93 cm). Philadelphia Museum of Art (Louise and Walter Arensberg Collection).

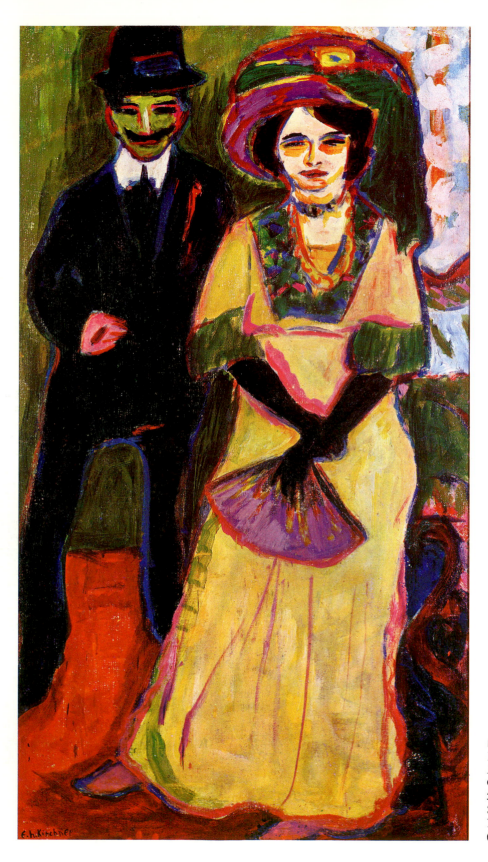

Plate 11.
ERNST LUDWIG KIRCHNER.
Dodo and Her Brother. 1908–20.
Oil on canvas,
5′7⅛″ × 3′1½″ (1.7 × .95 m).
Smith College Museum of Art,
Northampton, Mass.
(purchased 1955).

In 1972 Shigeko Kubota traveled to Rouen, France, where she video-taped the family grave of the artist Marcel Duchamp. She used this tape in a memorial to Duchamp which was exhibited in 1975 (Fig. 56). Consisting of an 8-foot (2.4-meter) high wooden tower which housed ten video monitors, the memorial was placed in a gallery, and the floor around it was partially covered with mirrors. Each of the monitors was fed her 30-minute tape, no two monitors beginning at the same time, so that when all the images were seen together, different portions of the tape were visible concurrently. Electronic adjustments were made to the image on each tube to alter its color. This visual array of multiple, chromatically altered images which seemed to dance from monitor to monitor, was accompanied by the visual counterpoint of the reflected images on the floor. A taped sound track of sobs and incantations was barely audible, adding to the ritualistic character of the experience.

Visual artists have often adopted new technologies to extend their image-making capabilities. In the fourteenth century the development of woodcut prints was affected by innovations in papermaking and ink manufacture. Later, the introduction of etching and, still later, the development of lithography resulted from the exploitation of technical advances by printmakers looking for improved alternative methods of multiple image making. Oil paint, when it was introduced in the fifteenth century, offered the painter greater flexibility for representational and expressive purposes than had been available in tempera or fresco paint. The invention of the metal collapsible tube as a container for paint permitted the Impressionist painters of the nineteenth century to leave their studios and work in the fields under the open sky.

The development of new metals and methods of cutting, forming, and joining them has had a major impact on sculpture. The introduction of plywood and new adhesives has been similarly influential. And the availability of plastics for direct forming and casting has provided major opportunities for experimentation in three-dimensional imagery.

Architecture has probably made the most dramatic response to the availability of new materials and building techniques. The connection between design and construction materials and processes is so important that it will be discussed independently in Chapter 12.

Notwithstanding the importance of technological advances in the visual arts, *new* is not necessarily *better,* or even to be equated with *good.* Many qualities in a work of art may contribute to its capacity to move people aesthetically. The introduction of a new medium cannot ensure that a work employing it will be automatically more relevant and affecting than

56. SHIGEKO KUBOTA. *Duchamp's Grave.* 1975.
Videotape, monitors, mirrors;
8 × 30′ (2.44 × 9.14 m).
Courtesy the artist.

57. UMBERTO BOCCIONI. *The Forces of the Street.* 1911.
Oil on canvas, 39⅛ × 31⅝″ (99 × 81 cm). Kunstmuseum, Basel.

works in more traditional methods and materials. Nor does the use of "old-master" techniques ensure that a contemporary work will have greater artistic merit than images formed in nontraditional modes.

The Observer and Art Today

The artists of this age do not see differently, for the process of sight remains the same: reflected light from forms positioned before the eyes focuses on the retina, and this information is transmitted through the optic nerve to the brain. Perceptions, however, are different, and new equivalents for those perceptions are possible.

New subjects, new means of producing images, and new equivalences have extended the artist's options, but they have not eliminated many traditional forms of image making. There has never before been

a comparable situation in the visual arts (perhaps in all the arts) in which so many options were available. This freedom carries with it an enormous burden, for with the possibility of so many choices comes the necessity of choosing the personally relevant mode of expression, and often this choice cannot be made without a great many false starts.

Imagine yourself an artist sitting on a hillside watching a child flying a kite. The wind is blowing, the leaves shiver on the trees, and some of them, loose in the sky, circle the kite. As the run is made down the hill, the kite rises, pulling against the string. The string is taut, and still it arcs into space. The late afternoon sun turns the kite into a jiggling light and the hillside into contrasting forms of shadowed and clear green. The excitement of the launch passes, and both child and kite become a part of a slower, almost contemplative ritual, in which a movement by one

pulls the other into a responsive gesture. Fifteen minutes have passed, and you remember your own triumph on another hill on a day that had been forgotten until now.

In this imagined scene there is an awareness of color, light, movement, form, space, time, and the memory of past experience. Your own response and the responses of the child are tied to sensory experiences that resulted from the time, the place, and the conditions of weather. What portion of this reaction is to become the essential portion—the luminosity of the sunlight; the movements of the wind, the child, and the kite; your relationship to the child; the shape of the triangle made by the land, the kite string, and

the kite as it hangs vertically above the horizon? You may be able to make this decision consciously, but it is more likely that the decision is not yours to make, for you will be directed by forces you do not understand to find the images that correspond to your intuited realization.

In the relatively short period of time from the middle of the nineteenth century to the present, there have arisen in succession the Impressionists (Pl. 1, p. 7; Pls. 7 and 8, p. 26), the Post-impressionists (Pl. 5, p. 25), the Fauves (Pl. 9, p. 43), the Cubists (Pl. 10, p. 43), the Expressionists (Pl. 11, p. 44), the Futurists (Fig. 57), the Surrealists (Fig. 58), the Abstract Expressionists (Pl. 3, p. 8), the Pop Artists (Fig. 59), and

58. Max Ernst. *Celebes.* 1921. Oil on canvas, 4′1⅜″ × 3′6½″ (1.25 × 1.08 m). Tate Gallery, London.

others—groups of artists all attempting to find adequate equivalents for the communication of the world they perceived about them. Each group found it necessary to change the visual vocabulary and grammar, because the languages currently in use were inadequate to meet their needs. Each of these new forms of expression at first met with misunderstanding and criticism. Their differences in the application of paint, in the use of color, in the representation of form and space were frequently attributed to lack of ability, frivolous intent, even madness.

Now, however, it is possible to see all these approaches, including that of artists who work in a tradition corresponding to photographic representation, as legitimate attempts to reduce the perception of the three-dimensional world of actual experience to the symbolic expression of paint, clay, and stone. The present-day viewer of art can no longer assume that the photographic image is a language acting as the measure of other communication systems, for this is a multilingual visual world, in which all languages have value measured by their capacity to communicate a significant image of some part of human experience. Both the artist and the viewing public today face problems of communication which rarely affected their counterparts in the past. Because they are aware of so much of the world, because they can perceive it historically, scientifically, psychologically, and because the personal perception has been given a value which it did not have in the past, the representation of that perception and the comprehension of what has been represented become complex processes. The artist who initiates the communication must use a system that is adequate to convey the personal experience, and if existing methods of visual communication are not adequate for the job, one must be devised. The viewer comes to the work of art with the knowledge that there are many ways of looking at the world and of communicating what has been experienced. If the artist has used a familiar system of visual communication, an exchange of information will probably occur, but should the artist adopt a method of expression foreign to the viewer, confusion can be and often is the consequence.

59. RICHARD HAMILTON. *Just What Is It That Makes Today's Home So Different, So Appealing?* 1956. Collage on paper, 10⅛ × 9¾″ (26 × 25 cm). Kunsthalle, Tübingen, West Germany.

Subject Matter

What can the artist communicate? This question is related to another: What does the artist wish to communicate? To judge by the evidence of works of art throughout history, the subject matter can be broken down into four categories: *the world of perceptual reality; the world of conceptual reality; the personal response to experience;* and, finally, *the communication of order.* Many works of art combine all four of these, but there are art forms which appear to emphasize one to the exclusion of the others, and when confronted by a painting, a sculpture, even a building, the spectator should attempt to identify the initial artistic intention.

The World of Perceptual Reality

Human beings have certain basic similarities: the shape and function of their bodies, their primary human drives, and, within the limits of their geographical locations, responses to those aspects of nature which have significance in their lives.

The seas, the land, the skies, and the creatures living in them are a large part of the common inheritance; they are physical aspects of the world around us. They can be seen, touched, heard, and smelled.

People have added to the physical world structures demonstrating their ingenuity and industry—buildings, bridges, roads, and machines—which seem to increase in numbers by the hour, until in some places they fill the land to the exclusion of grass and trees. Much of the world also shares the images which have been made by still and motion-picture cameras. These representations differ from drawings and paintings produced by individual artists who work within cultural or ethnic styles. Photographers and film makers who are primarily concerned with recording human experience and the appearance of the environment share in their work representational characteristics which are so universally accepted that they constitute a form of international language. Photographs, motion pictures, and the pictures on television tubes are, for many, another category of manufactured reality that can be perceived as real physical objects, rather than as equivalents for objects and events that have existed at times and locations independent from the recorded image.

The physical world is known to each human being through the senses. The retina of the eye reacts to light energy reflected from objects. Vibrations of air on the drums of the ears are received as sound. The

skin reacts to changes of temperature and to contacts with other surfaces. Odors are registered and responses are made to them. In total, this stimulation of the sensory organs provides the raw material for a personal perception of the external world.

Coming into a new world as children, we do not experience ordered sensations. We slowly learn to see as our forebears did, so that we can get along in their world. For this we are in their debt. At the same time, by teaching us to see their world, they have restricted our vision. Children are denied the freedom of ordering their own sensations (if that were possible) and seeing the world in their own way. Their reactions to colors and sounds are limited, and, since the pattern of sensation to perception is set in a specific mold, it is difficult to change.

A thousand or even five hundred years ago, people were more isolated from one another than they are today. Separated by the miles and days of difficult travel, they lived their lives insulated from others who were alien to their culture. The world about them was a small place, and all those who were a part of it were much like themselves. When other people from "another world" did enter their own, they were recognized as different, but the differences did not suggest other worlds, with other ways of living and other ways of seeing; they were seen essentially as eccentricities, in contrast with the "normal" way of saying or doing things. Even the differences that had existed in the past history of the group were not generally understood. Books were available to only a few, and those which were in circulation could not accurately describe the world and manners of former times.

Changes in perception and its representation did occur as ideas and experiences interacted, but at a pace much slower than that of today. An example can

below: 60. ALBRECHT DÜRER. *The Nativity.* 1504. Engraving, 7¼ × 4¾″ (18 × 12 cm). Metropolitan Museum of Art, New York (Fletcher Fund, 1917).

below right: 61. Analysis of Figure 60.

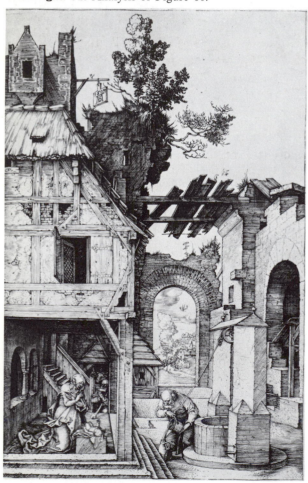

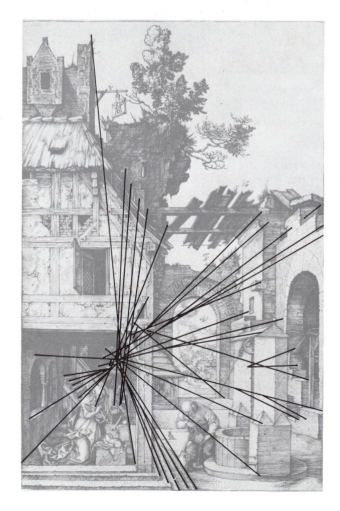

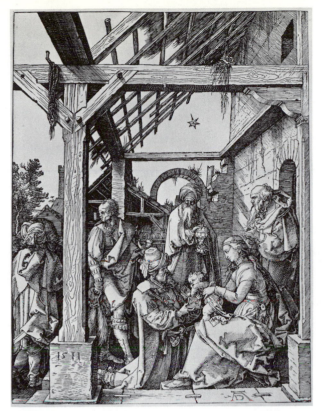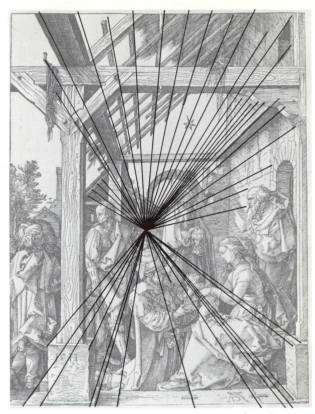

above: **62.** ALBRECHT DÜRER. *The Adoration of the Magi.* 1511. Woodcut, 11½ × 8⅝″ (29 × 22 cm). Metropolitan Museum of Art, New York (gift of Junius S. Morgan, 1919).

above right: **63.** Analysis of Figure 62.

be seen in the work of the German artist Albrecht Dürer. Born in 1471, Dürer was an established artist by the year 1505. His paintings and woodcuts were highly regarded, and they remain so today. But in that year Dürer went to Venice, which he had visited about a decade earlier, and there he worked until 1507, winning major commissions and achieving the esteem of Italian masters. Before his return to Germany, Dürer undertook a 100-mile (160-kilometer) trip to Bologna to receive instruction in "the secret art of perspective," for, despite his success, the artist recognized what he considered a deficiency in his work and sought to eliminate it. He was concerned about the method of representing space in the two dimensions of painting. This problem was of major interest to artists then as now.

An examination of an engraving entitled *The Nativity* (Fig. 60), completed by Dürer in 1504, will show that the edges of parallel constructed forms—steps, the meeting of walls with floor and ceiling, window ledges, portions of the well in the courtyard—are drawn so that the lines, if extended, appear to converge. Such convergence is partially based on

traditional methods in northern European art of reproducing the illusion of three-dimensional form and space. For the rest it is based on the perception of the artist, who must have noticed that edges actually parallel with the horizontal axis appear to recede into space diagonally. As Dürer drew it, the print conveys a feeling of depth, but he must have sensed that the spatial representation worked out by Italian masters was superior to his own. Though not yet widely published, *linear perspective* (see Chap. 8) had been employed for almost three-quarters of a century by the Italians, the originators of this method of simulating form and space. In linear perspective, converging lines were used as a device for expressing the recession of parallel rectangular forms into space away from the observer, but the system was organized around specific points of convergence related to the positions of the spectator and the objects that were to be represented.

When Figure 60 and its analysis, Figure 61, are compared with Figures 62 and 63, the effect of Dürer's studies in Bologna can be seen. In *The Adoration of the Magi*, the later print, the artist organized

above: **64.** Map from Pietro Coppo's *Portolano*. Venice, 1528.

right: **65.** The earth, photographed from a satellite 22,300 miles in space.

below right: **66.** Electromicrograph, section of the nerve ending on an electric cell of a Narcine (torpedo fish). Magnification 19,000 diameters.

all the indicated parallels in the ruined courtyard so that they converge at a single point as they appear to recede. In the earlier print there is no such consistency. Points of convergence are created without any orderly relationship to one another. This difference may seem slight, but it was noticeable to the artist and was sufficient to motivate Dürer to travel in quest of more satisfactory representational methods.

Today, there are few places on this earth which are hidden. Through the media of mass communication—television, the movie camera, radio, newspapers, and books—all so readily available, the world has become smaller and smaller. Anthropologists, archaeologists, and explorers have roamed the earth to examine humanity and its environment. Outer space, once only the stage for science fiction, is probed by our investigation, and heavenly bodies that could be reached only in our imagination, or by our amplified vision, are now awaiting our footsteps.

The past as well as the present lies open to investigation. Men and women are revealed as creatures of many faces, with many ways of seeing the world. Concepts of morality, of social and economic order, and of the relationship of human beings to their habitat differ widely. The concept and the expression

of beauty take many forms. Even the casual reader cannot fail to recognize the vast differences typically separating one cultural group from another.

Developments in the sciences and the expansion of technology have now extended the limits of the senses beyond imagination. As late as the sixteenth century, knowledge of the physical world was confused, limited, and inaccurate. The crude, small woodcut map in Figure 64 was published in Venice in 1528. A sixteenth-century scholar studying this map could marvel at the extension of geographical knowledge. We see it as an indication of the naïveté of the Renaissance cartographer, an illustration of the limited view of the earth held only five hundred years ago. Compare this image with a satellite photograph (Fig. 65) or the photographs from weather satellites shown on television every day, and the differences between the physical reality of the past and our present consciousness of our environment are made dramatically obvious. The eye, aided by the microscope, can see into a world of complex and amazing forms (Fig. 66). The X ray permits exploration of the intricate inner forms of familiar objects and creatures (Fig. 67). The motion-picture camera is able to capture even the swiftest of movements. The telescope can reach into the heavens to examine the vast spaces among the stars and nebulae (Fig. 68).

The landscape of today is not restricted to a view from a hilltop; it can be seen from a plane far above the earth (Fig. 69) or from a bathyscaphe a mile be-

67. Radiograph of the human body.

left: 68. Telescope photograph of the Great Nebula in Orion. Mount Wilson and Palomar Observatories.

above: 69. Aerial photograph of contour farming, Nottingham, Pa.

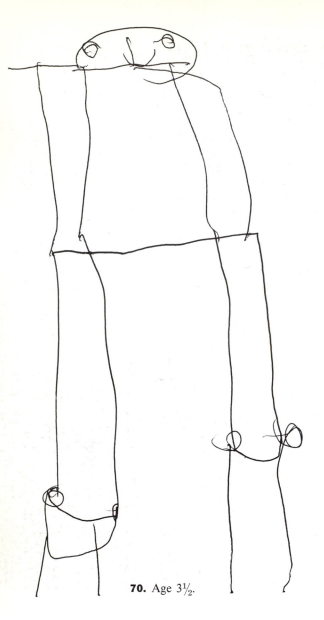

70. Age 3½.

neath the surface of the sea. The dimensions of the perceptual world have been increased many times over in the last few years, and they now continue their expansion into outer space. Each day appears to bring with it a new world to see, visual information that confronts our previous concepts and perceptions with alternatives for our once-secure belief in the established appearance of things.

During the Renaissance the forms of the outer world seemed restricted to what could be seen with the unaided eye. When the painter of the sixteenth century conceived of a landscape, it was in terms of trees growing overhead and mountains rising up over the fields in distant blues (Pl. 12, p. 61). Today, the world is a different place for the artist. Vision is no longer confined to the limits of the earth. The artist may paint what can be seen, but now that is extended beyond 20/20 vision and limited only by the ingenuity of physicists and the nature of matter itself.

The World of Conceptual Reality

There are many approaches to the representation of what we perceive. We all have conceptions of things. These conceptions may vary from time to time, but at any given time we can visualize images of a great many objects. Some of these images may be the result of careful study; some perhaps are the result of a careless, passing observation. Some conceptual images have been acquired without direct observations but, instead, by contact with images already conceived and produced by others. Photographs, paintings, sculpture, motion pictures, and other image-making media can create ready-made conceptions of objects and experiences for those who cannot create their own.

The world can be thought of as a series of objects which exist only in certain defined and static shapes

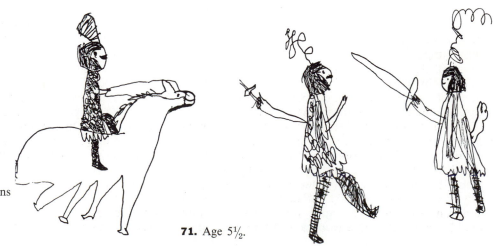

70–71. Changing conceptions of the human being in a child's drawings. Courtesy Lisa Terenzio.

71. Age 5½.

72. *Priest of Osiris.* Egyptian, Middle Kingdom, 12th dynasty. Relief. Museo Barracco, Rome.

and positions. A person who conceives of the world in this way sees it in terms of stereotyped concepts. It is often quite difficult in this case to recognize representations of physical reality unless they closely approximate those conceptual images. A tree is always *the* tree, a bird is always *the* bird, grass is green, and the sky is blue.

Children conceive of the world in this way, and their art is an excellent example of *conceptual representation* (Figs. 70, 71). As they grow and become aware of themselves and their social groups, their art changes to include the new concepts they develop. The preschool child's perceptions are strongly influenced by home environment and are altered when the youngster leaves home to spend a large portion of the day in extensive contact with teachers and other children in school.

Television viewing has changed our apprehension of the real world. Not only does it bring into the home information that was once unavailable, but also it provides moving images as equivalents for the real world rather than the still images that formerly served so often to shape concepts of the world about us. Consider the experience of adults who saw still photographs of Niagara Falls, never having seen the falls with their own eyes. The photographs recorded the cascading water as though time had stopped and the motion and forms of the falls were frozen. It is possible that someone could have had an empathic response to the static images, projecting onto the picture past experiences of the direct observation of large masses of falling water. But this is very different from the experience of the young child who sees television images of the moving flood of waters that spray into the air as they churn over the rocks of the Niagara bluffs. The movement, the patterns that change in time, the swirling mist shifting in continuous flux are represented on the television screen. The kinetics of reality are now as important as, or perhaps more important than, the static statement of the shape of the physical elements observed.

For the average child, exposed to thousands of hours of moving images, the motion of forms in space can become more significant than the appearance of the forms themselves. The growing interest of young people in motion pictures, both in seeing and producing cinematic art, suggests the effect of exposure to the kinetic image at an early age. Nevertheless, it would be unreasonable to assume that cinematography will completely replace still images in the lives of children. So long as a paper and pencil are more readily available than a camera and film, the drawn

image will remain important to the child and to the adult. Yet even the still image can be altered by our growing perception of motion as a significant factor in our *real* world, and changes in our conceptions and the equivalents for those conceptions must inevitably take place.

Much in the visual arts is based upon conceptual images. The artist may represent what is known about reality rather than what is seen. Like the child's imagery, the painter's imagery may be a composite of separate but related details, perceived at different times, from different points of view, to form a unified representation of an experience. Early Egyptian art is conceptual (Fig. 72). To depict a man the Egyptian artist selected the most representative concepts of the separate parts of the body and then combined them

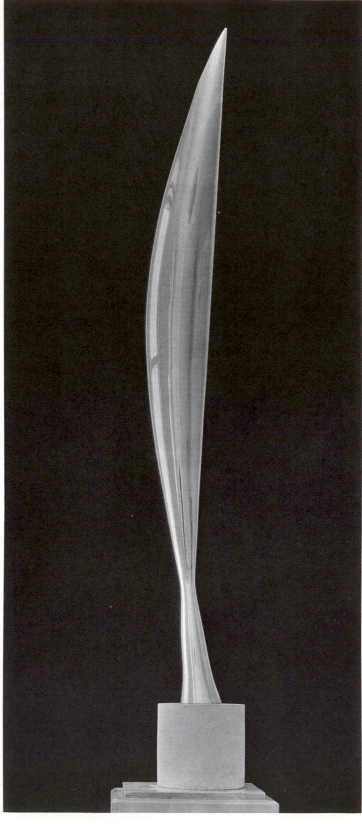

below: 73. DOROTHY DOUGHTY.
Male Redstart. 1935.
English Royal Worcester bone china;
height 9″ (23 cm).
Metropolitan Museum of Art, New York
(gift of Mr. and Mrs. Thomas F. Staley, 1960).

right: 74. CONSTANTIN BRANCUSI.
Bird in Space. 1928 (?).
Bronze (unique cast), height 4′6″ (1.37 m).
Museum of Modern Art, New York (anonymous gift).

to form the complete figure. A profile view of a head was chosen, and placed within it was a front view of an eye. The artist usually indicated the shoulders in a frontal position and the hips and legs from the side view. The resulting image may not satisfy the demands of other cultures for the representation of a human figure, but its conventions were accepted by the artists and their patrons in Egypt, so that variations became the exception rather than the rule.

The conceptual representation of physical reality contrasts with a system intended to reproduce the perceptual experience derived from careful observation of the physical world. In this approach a bird is not always *the* bird. It may be a dot, or a flash of light, or perhaps even the path of a spiraling flight as seen in the sky. Physical experience is communicated in *perceptual representation* as a visual image which, under certain conditions, may be interpreted as a bird, or a man, or an ocean. The senses give the viewer the raw material of the concept. The world is never at rest, and nothing in it appears twice in exactly the same way. The variables of distance, time, light, movement, and background affect the appearance of all objects, so that they may be represented differently at different times. Even the attitude of the observer at the time of the observation can make a difference in the image created. The resultant representation of this perception may be a three-dimensional replica of the subject or it may be as simplified as a single flashing piece of metal, in which the artist attempts to express the movement, the grace, and the speed of a bird in flight (Figs. 73, 74).

Neither conceptual nor perceptual representation of the physical world is in itself superior to the other; both exist and are to be found in the art of the past and the present.

Personal Response to Experience

The physical environment comprising the world of actual experience is considered to be the *real* world. In this context the word "real" is used to differentiate that part of experience which seems to occur outside ourselves from that which is confined to our inner *subjective* being. But the separation of reality from what is unreal is often an artificial division, for there are many subjective attitudes, responses, and images which carry as great a sense of reality as that part of life which is confined to external experience.

The world of subjective reality has been a major influence on much of the visual arts. Constructed of human thoughts and feelings, it is shaped by social values, emotions, ideas on life, and individual existence. As William James put it: "Every exciting thought in the natural man carries credence with it. To conceive with passion is *eo ipso* to affirm." For

many persons their subjective consciousness is more vital, more meaningful, than their contact with the perceptual environment about them, but the communication of this consciousness, this inner reality, often creates problems which are not associated with the communication of experience grounded in the physical world. When we wish to say something about a tree, or a cloud, or perhaps even personal relationships, we know that we are dealing with material common to the conscious experience of many within our society. When we wish to communicate our own inner experiences, we can never be sure that the images we produce to represent this subjective reality will have meaning for others. In the attempt to create what is real but unseen, the lack of universal symbols creates ambiguity and limits comprehension and acceptance of a work of art.

Museums abound with examples of painting and sculpture which communicate the forms and experiences of the physical world. The arts that the public generally associates with the communication of intense, inner experiences are music, poetry, and some forms of prose. Less widely understood is the use of the visual arts to serve a similar purpose. For centuries painters and sculptors have sought to express their personal reactions to their subject matter; and in recent times the artists' intention to communicate their innermost feelings has become accepted and commonplace. But for much of the inexperienced public, even those who accept the legitimacy of the intention, the means of expressing a reality that has no actual visual presence are viewed with uncertainty and suspicion.

Artists continue to seek effective methods of expressing these unseen realities in visual terms. The drawings by Picasso discussed in Chapter 2 (Figs. 18, 19) may be used again to exemplify the differences between art which has a representational emphasis and art which emphasizes the expressive, subjective response of the artist. The differences in these drawings are dramatically obvious. The head for *Guernica* does more than describe; it involves the viewer in the passion that the artist must have felt as he produced the drawing. One cannot imagine Picasso as an uninvolved observer when he began this study. It is much easier to assume a certain detachment on his part when he executed the nude study. Yet an argument could be made that here, too, the artist was emotionally involved and that the drawing is expressive of a quite different concern. Often it is difficult to isolate the representation of perceptual reality from the subjective response of the person who records that perception. Complete objectivity is an impossible goal, and even in the art of such a cool and courtly painter as Bronzino (Fig. 75), one can find a sense of the involvement of the artist.

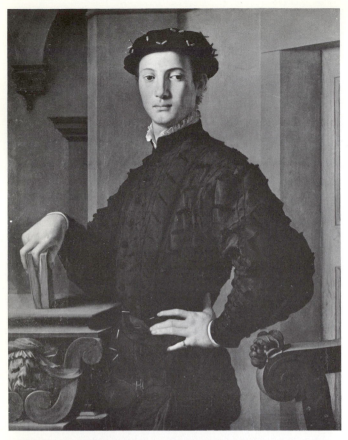

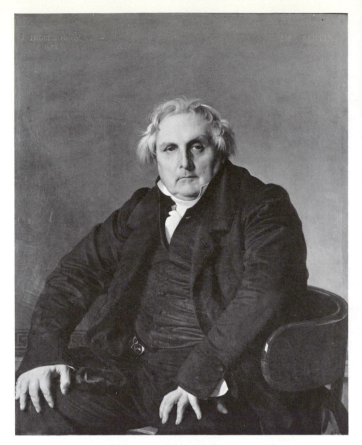

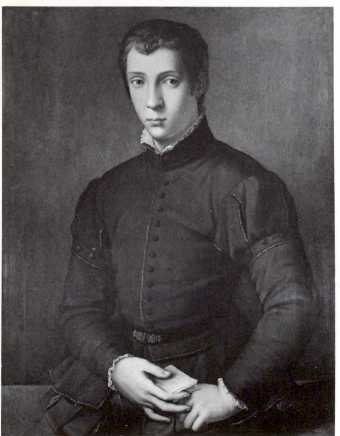

above left: 75. BRONZINO.
Portrait of a Young Man (possibly Guidobaldo II,
Duke of Urbino). 1530–32.
Oil on panel, $37\frac{5}{8} \times 29\frac{1}{2}''$ (96 × 75 cm).
Metropolitan Museum of Art, New York
(bequest of Mrs. H. O. Havemeyer, 1929,
H. O. Havemeyer Collection). (See also Figure 93.)

above 76. JEAN AUGUSTE DOMINIQUE INGRES.
Louis Bertin. 1832.
Oil on canvas, 46 × $35\frac{1}{2}''$ (117 × 90 cm).
Louvre, Paris.

left: 77. BRONZINO.
Portrait of a Young Man. c. 1537–38.
Oil on panel, $33\frac{7}{8} \times 26\frac{3}{8}''$ (86 × 67 cm).
Staatliche Museum, Berlin.

Compare that sixteenth-century Bronzino with Ingres' portrait of Louis Bertin (Fig. 76), which appears to be an attempt at objective representation. Though quite similar in style, they have differences which indicate that the two works are the products of different hands. Both produce sharply focused studies of the physical appearance of the subject. Very little opportunity seems available for the expression of the artists' attitude toward the men portrayed. But what of the posture of the subjects? Their poses could have been reversed. Imagine the response of a viewer had Louis Bertin been posed, like Bronzino's aristocratic youth in Figure 75, standing with his hand on his hip and the other hand gracefully marking a place in a book, or if Bronzino's subject were seated, like Bertin, in a chair, legs apart, with his fingers resting on his thighs. Consider the absence of architectural environment behind the Ingres figure and the geometric division of the spaces that divide the area in the sixteenth-century work.

The second Bronzino *Portrait of a Young Man* (Fig. 77) offers an interesting comparison with the adjacent painting by the same artist. Though the hard-edged, precisely painted style in both attests that the paintings came from the same hand, the differences between them contribute to the sense of the artist's response to his subject. Figure 75 is angular and full of sharp contrasts of dark and light, with a strong, elegant emphasis on the vertical composi-

tion. Figure 77 is much more even in tone, with a rounder, more fluid linear structure, less elegant but contributing to the representation of a sitter who appears more sensitive than the subject of Figure 75.

The personal responses of artists to experience can be demonstrated in a more obvious and direct manner. They can act as commentators on contemporary society. By the use of caricature or dramatic emphasis they can depict people and events in a way that indicates a political, moral, or ethical opinion.

In 1835, France was in a state of social unrest. Many of her citizens felt the lack of the personal and political freedom that they had expected as a result of the French Revolution of 1789 and the Republic that was formed in 1792. The successive regimes of Napoleon Bonaparte, Louis XVIII, Charles X, and finally Louis-Philippe had left French citizens hungry for the economic and political rights to which they believed themselves entitled. The rule of Louis-Philippe saw continued conflicts between the government and various groups in the country. Honoré Daumier lived during this period. As an artist, he identified with the republican ideals of the Revolution and spent much of his life commenting, in visual images, on the social injustice and the hypocrisy he saw about him. The artist's intention was to stir responses in his viewers that would encourage them to resist governmental acts that Daumier despised. One drawing (Fig. 78), published in 1835, referred to a trial of Lyons workers

78. HONORÉ DAUMIER.
You Have the Floor, Explain Yourself.
1835. Lithograph,
$8\frac{1}{8} \times 11\frac{1}{8}''$ (21 × 28 cm).
Museum of Fine Arts, Boston
(bequest of William P. Babcock).

who had struck the previous year. Its caption reads: "You have the floor, explain yourself." The scene and the caricatured faces, combined with the caption, leave no doubt about the artist's reaction to the condition of law in his country.

The contemporary cartoonist who wishes to make a relevant social or political comment often employs images that are simpler and less pictorial than those drawn by Daumier. Instead of producing a picture or a tableau, the artist may invent a symbol that communicates its meaning to the reader by distorting the recognizable features of a well-known subject so as to dramatize a salient characteristic or idiosyncrasy. The caricaturist David Levine's ink drawing of British author W. Somerset Maugham (Fig. 79) is rapidly executed in a calligraphic shorthand. Both the author's personality and the artist's attitude toward his subject are revealed in this portrait.

Photography lends itself admirably to the production of telling images that reveal social and political attitudes on the part of the photographer. By the selection of subject matter, or by isolating posture or action of the subject, a photographer can make a subjective comment on the world. An excellent example is to be found in the photograph by WeeGee entitled *The Critic* (Fig. 80). Though not caricatured in the manner of Daumier, the subjects in this picture are stopped, in time, by the camera in a moment of self-caricature that is both revealing and amusing.

above: **79.** DAVID LEVINE. *W. Somerset Maugham.* 1978. Pen and ink. Reprinted with permission from *The New York Review of Books* (copyright © 1978 NYREV, Inc.).

right: **80.** WEEGEE (ARTHUR FELLIG). *The Critic.* 1943. Photograph. Museum of Modern Art, New York.

Plate 12.
NICCOLÒ DELL'ABATE.
Rape of Proserpine.
16th century. Oil on canvas,
6'5⅛" × 7'1⅞"
(1.95 × 2.18 m).
Louvre, Paris.

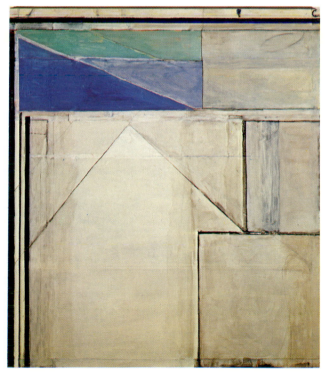

Plate 13.
RICHARD DIEBENKORN.
Ocean Park Series No. 94.
1976. Oil on canvas,
7'7" × 6'9"
(2.31 × 2.06 m).
Courtesy the artist.

Hue

Value

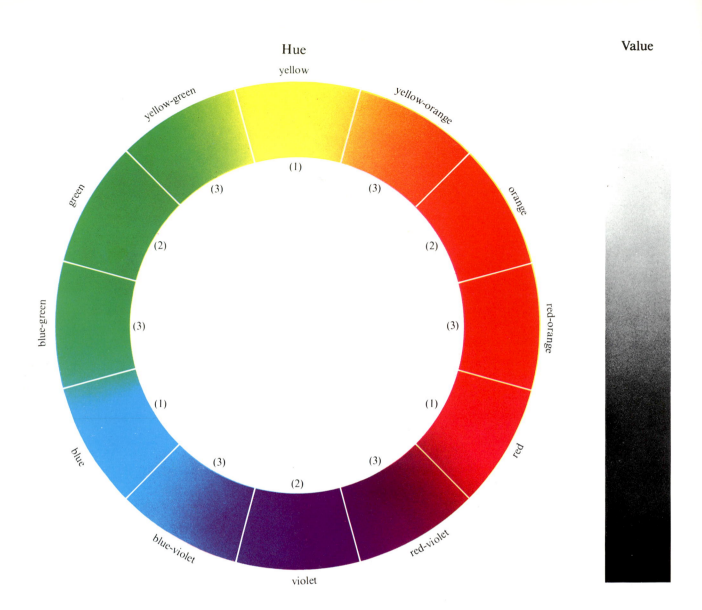

Intensity

Plate 14.
Charts showing the ranges in the
three dimensions of color—
hue, value, and saturation (intensity).

62

A more poignant statement is made in the photograph of a migrant woman and her children by Dorothea Lange (Fig. 81). This intimate study can be seen as a sympathetic record of an event in the life of one family, or it can become a commentary on the misery and moral fortitude of many people throughout the world, whose heavy burden leaves its evidence in their anonymous faces.

Duane Hanson uses rubber molds of live models to cast his remarkable figures (Fig. 82; Pl. 43, p. 176). This procedure replicates every pore and wrinkle of the original, and it would appear to be the ultimate form of objective representation. Hanson paints the plastic figures with meticulous attention to each minute change in skin color, then drapes them in real clothing to increase the illusion of reality. And yet he insists that he is concerned with commentary, not just replication. He chooses the subject and the pose and makes minor changes of position during the assembly of the separate parts of the casting. All these choices are directed at intensifying a point of view held by the artist. When viewers discover that one figure in the gallery with them is not breathing (and this discovery is often long in coming), Hanson hopes that the shock of recognition will heighten the response to the conditions that helped to produce the appearance of the original model.

The Communication of Order

Many works of art present no parallels with the experience of some observers, having been produced in a period, geographical location, or culture remote from their own. What can such works mean to the contemporary person who does not share the background of the artist responsible for them? A study of history may supply some of the meaning. The similarity of emotions which humanity has shared throughout time may reveal other meanings. The ability to recognize the representations of physical reality may seem to give another kind of understanding.

82. DUANE HANSON.
Man on a Bench, detail. 1977.
Polyester and fiberglass, life-size.
Collection Richard and Gloria Anderson,
Overland Park, Kans. (See also Plate 43.)

below: 83. *Bahram Gur in the Turquoise Palace on Wednesday.* Persian miniature, Herat school, 16th century. Metropolitan Museum of Art, New York (gift of Alexander Smith Cochran, 1913).

right: 84. Chi-Rho monogram, from the *Book of Kells.* 8th–9th centuries. Various pigments in tempera, on vellum support; $12\frac{3}{4} \times 9\frac{1}{2}''$ (32×24 cm). Trinity College Library, Dublin.

An examination of Figure 83 can give a revealing insight into this problem. This work is from the Herat school of painting in Persia, and it dates from the sixteenth century. What does it really mean to a contemporary Western museum visitor? Certainly it is possible to recognize the representation of figures, a paved court, and what appears to be a building with two figures dining within it, even though the manner of representation does not conform to that commonly seen in Western painting. Once this level of understanding is achieved, what other meaning is to be found in this work? The painting is titled *Bahram Gur in the Turquoise Palace on Wednesday.* Who is Bahram Gur? Who are the others in the courtyard? Is this a simple private meal between two friends, two lovers, two philosophers? The sixteenth-century Persian miniaturist wanted to convey some meaning to the audience of that time. Can the meaning derived by a contemporary viewer who passes the work in a gallery make this painting a significant artistic statement in the last half of the twentieth century? It may be suggested that much of the narrative meaning and the historical setting of this work can be gathered by research in libraries, and this kind of information will offer the viewer some satisfaction of a literary order. Yet even without such background knowledge, the painting can give a high degree of aesthetic satisfaction to present-day persons. The differences of time, place, and culture have not markedly affected the human response to color, form, and texture, which constitute the primary reality of the object. The contemporary viewer can find pleasure and meaning in these elements and in the recognition of the way they have been organized.

It is just this sense of order to which Alberti referred in the definition of beauty quoted in Chapter 2 (p. 28), and it can be, for the observer, a special communication bridging the gaps of time and geography to give satisfaction and pleasure.

left: 85.
Initials JVE, LL, and PNME,
from *The Universal Penman*. 1743.

below: 86.
Poster for The Electric Circus. 1967.
Design: Chermayeff & Geismar Associates.

Rarely do we find a system of communication without provision within it for an aesthetic elaboration of the symbols that are used. In the spoken language the choice of words for their sound and rhythm becomes a natural part of dramatic and poetic speech. Decorative writing, the use of illuminated initials in manuscripts, and the arrangement of type on a page are examples of the union of symbolic function with aesthetic function in written communication (Figs. 84, 85). Often, in the combination of these two functions, the concern for aesthetic elaboration reduces the readability of the message. In the reproduction of illuminated initials from the *Book of Kells* (Fig. 84), an early Celtic Biblical manuscript, the Greek letters χρι, the first three letters of the name of Christ, have been used as the basis for an intricate design. The design is so complex that it all but eliminates the symbolic significance of the form. One aspect of communication gives way to another.

A contemporary example of the reduction of legibility to increase the decorative aspect of type is found in Figure 86, in which the designers created a poster using letters to form both words and an optical illusion that serves as a visual analogue for the concept of electric energy.

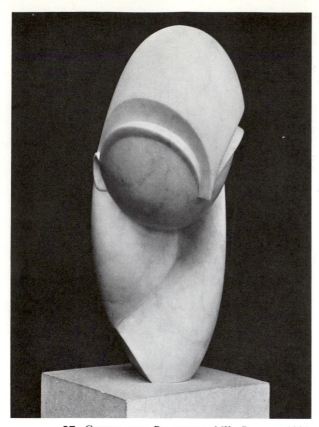

87. CONSTANTIN BRANCUSI. *Mlle Pogany.* 1931.
Marble on limestone base, height 17½″ (44 cm).
Philadelphia Museum of Art
(Louise and Walter Arensberg Collection).

and form combine to produce a three-dimensional design; or, finally, it can be "read" as both symbol and object, the qualities of the object taking on a meaning directly related to the subject symbolized. Meaning in the visual arts may occur on any of these three levels or on all of them.

Some works of art seem to make no reference to subject matter of any sort. Often, these are characterized by an extremely sensitive exploitation of the potentials of color, form, or texture. In the common use of the word "meaning" it might be argued that these works are meaningless, even though they may draw an aesthetic response from the viewer, but it is possible to conceive of works of art in this group as their own subject matter. They "speak" *of* themselves. Their meaning lies in the complex formal relationships built into them. To understand them is to recognize the manner in which they have been constructed, to sense their order and the intellectual and emotional character of the person who produced them (Pl. 4, p. 8; Pl. 13, p. 61).

This discussion began with the question, "What can the artist communicate?" To sum up, art as communication has much that is common to all systems of communication; symbols and groups of symbols are combined in structured relationships to achieve equivalents for human experience. The symbols that are developed are separate and distinct from the actual objects and experiences they represent. Often these symbols and their organization are based upon a previous tradition, but just as often they are the result of an individual artist's attempt to find the means of communicating those aspects of experience that cannot be expressed with the inherited visual language. Because of the new breadth of subject matter now a part of the environment in which we live, because of the relatively recent emphasis on one's subjective attitudes and responses to experience, artists are continually searching for visual equivalents expressive of their inner world and of their consciousness of the world they perceive about them. Parallel with that concern for the visual equivalent is the interest in the aesthetic structure of the artist's work. At times it is the symbolic meaning which dominates an artist's work, at times the aesthetic, but most often it is a fusion of the two.

As in verbal or written communication, there is a need for adequate preparation on the part of both the sender and the receiver of the information that is transmitted; and for those who wish to engage in the visual dialogue with painting, sculpture, and architecture, this means recognition of the problems of communication in the visual arts and active participation in the study of the new languages which appear as artists strive for an adequate expression of contemporary life.

Constantin Brancusi's marble head *Mlle Pogany* (Fig. 87) is an example of sculpture in which the aesthetic relationships of the forms seem to dominate the symbolic function of these forms. The carved marble object represents a human female head, but because the repetition and continuity of flowing, curved lines was of major concern to Brancusi, the recognition of the object as a head becomes more difficult. In a manner similar to that employed by the designer of a beautifully written word the artist reduces symbolic meaning for what might be called an aesthetic effect. Yet it should not be assumed that emphasizing the aesthetic qualities of a work of art will automatically reduce its ability to communicate symbolically. The very simplification of the natural details of the head so as to produce an elegant marble object enabled Brancusi to make a statement about the subject through the use of the material and the aesthetic relationship of the forms.

The portrait of Mlle. Pogany can be "read" as a simplified human head; it can be "read" as an aesthetically pleasing marble object, in which surface

Part Two

THE LANGUAGE AND VOCABULARY OF
THE VISUAL DIALOGUE
Two-Dimensional Forms

Two-Dimensional Plastic Elements

5

The visual arts are often conveniently divided into two-dimensional and three-dimensional objects. Three-dimensional art forms, sculpture and architecture preeminently, occupy real space with real forms—measurable and having actual weight and substance. The two-dimensional arts of painting, drawing, and printmaking also require actual materials—paper, cloth, and other surfaces that carry marks or areas of color produced by pigment-bearing substances—but generally the visual and aesthetic meaning of these art forms depends upon relationships and images created within the dimensions of width and length. However, artists working in two dimensions often make use of three-dimensional illusions based upon optical and symbolic relationships established upon the flat surface of the drawing or painting.

Though these two categories may be considered totally distinct art forms, many contemporary works of art seem to straddle the two extremes. Three-dimensional elements occur in essentially two-dimensional objects, and flat, painted or engraved two-dimensional areas or linear elements are incorporated into predominantly three-dimensional constructions.

Rembrandt's painting of a young woman bathing in a stream (Fig. 88) is really a great many areas of colored paint applied to a canvas surface (Fig. 89). The color in each area was mixed by the artist and brushed, stroke by stroke, beside other areas to produce the image of a figure standing in the space that she occupies. She appears to be three-dimensional, inhabiting a lighted area, and the viewer has the impression of seeing a living person in a real environment. Rembrandt, as he painted the picture, surely understood that he was creating an illusion, and the observer is aware that the woman is only an image. The painter knew how to realize this image by making the appropriate decisions as to color, to size and shape of color areas, and to their relative positions. Rembrandt was not satisfied to represent the physical details of the scene. Also important to him were the woman's attitude, her lack of self-consciousness, the intimacy of the moment, the sensuous quality of the cloth contrasted against her skin. The dramatic, unnatural light illuminating the figure gives the subject a theatrical quality that the artist consciously forced. In addition to focusing our attention on the figure, it also offers him an opportunity to keep the lower-left

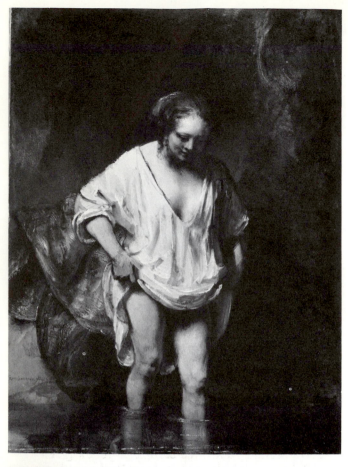

section of the composition unified as a light area framed by the surrounding dark background.

Richard Diebenkorn's decisions which resulted in his painting *Ocean Park No. 94* (Pl. 13, p. 61), have left a record that becomes a part of the appearance of the completed painting. Lines and areas of color have been tested, shifted, partially removed, and then set in their final states during the process of the painting's development.

The canvas may be considered as a subtle division of the two-dimensional area defined by the outer edges of the composition. Rectangular and triangular shapes seem to arrange themselves in alternating combinations: at one time forced from the center of the painting to the outer perimeter; at another time, locked into a Chinese puzzle of joined units. Then again, the viewer may perceive a balanced union of unequal parts in which the dark triad of blues in the upper left is restrained from dominating the visual field as the forces created by the linear construction of the right-hand portion of the painting demand attention. On this two-dimensional screen there is an undulating rhythm as first one combination of elements is perceived, then another.

Diebenkorn's decisions were not based solely on his concern for a two-dimensional division of the surface of his painting. Three-dimensional illusions, a sense of planes positioned at different distances from the surface of the canvas, and a quality of transparency appear. The marks of earlier states of the work were partially obscured, leaving ghosts that float behind the darker final grid. The dark upper corner is seen as though through a window, behind the white wall, a bit of "landscape" moving back diagonally to a final plane of warm blue.

The Rembrandt painting is primarily an illusionary representation of lighted form similar to others seen often by any observer. Richard Diebenkorn's composition offers few illusions tied to specific representational intentions and memories, though it is possible to imagine connections between his image and certain perceptions of nature.

Both artists, separated by centuries and by important differences of intention, produced images that belong to the same category, as paintings, for they have employed two-dimensional elements to arrive at a complex system of signs and symbols both expressive and aesthetically satisfying.

The observer can walk about and within a building. The material of a statue occupies actual space, casts shadows, and offers itself to be touched. A painting or drawing, on the other hand, exists in a world without physical depth. Two-dimensional art stops at the frame or edge of the paper or canvas and at the depth of the coloring or tonal agent on a flat surface. It is this difference which divides the media of painters from those of sculptors and architects.

The marks made by paint or drawing materials can be described in the following terms: the color of the marks; the areas they fill; the distances or space between them; and their texture, or surface quality. These are the essential plastic elements of two-dimensional art: *color, form, space,* and *texture.* The element of *line* is often added to the other four. Line is a special aspect of form that is basic to many kinds of drawing and painting. We might say that a line is actually a form so long in proportion to its width that we tend to overlook the dimension of width and assume that the element has only the one dimension of length. It is also possible to consider line as the edge of a form. In either case—as the evidence of the gestural act of drawing or as the boundary of a form—line plays an important role in the two-dimensional arts, whether it is considered a separate plastic element or a component of the element of form.

Color

The painter, the draftsman, and the printmaker all begin with color as their basic plastic element. Color in the arts of two dimensions is the means for the development of all the other elements. Two-dimensional form cannot exist without differentiation of color; even a black form on a white background is dependent upon the *contrast* between white and black for its existence. No form can be produced unless it is in some color. No form can be seen unless it is on some different color.

To understand why an artist makes specific color choices, it will be necessary to consider the nature of the choices available.

Any discussion of color depends upon the ability to identify and describe the qualities which give each color its distinctive appearance. In painting, these qualities are a function of the source of illumination used to light the surface of the work and the coloring matter in or on that surface. Color theory, as applied to light from a direct source, is somewhat different from that applied to color as perceived from reflected surfaces. Most of the present-day use of color in the visual arts is reflected color, and this discussion will concentrate on a description of this theory.

Many systems have been developed for the description of color. Most of them employ a theoretical model of a three-dimensional solid as a graphic device for the representation of the three chromatic qualities which, it is generally agreed, affect the appearance of any individual color. These qualities are identified as *hue,* the visual distinction of, for instance, red from blue; *value,* the relative darkness or lightness of a color; and *saturation, intensity,* or *brilliance*—the vividness of the pure color progressively dimmed or dulled toward neutrality, a state in which the specific character of the color is lost and it is perceived as a gray.

Hue

The *hue* of a color is a function of the wavelength of the light that is reflected from a surface to the retina of the eye. The spectrum of wavelengths and their corresponding hues varies from waves about 1/33000 inch (.0007 centimeter) long, which are seen as red, to those about 1/67000 inch (.00004 centimeter) long, which are seen as violet. At certain points along the spectrum most people with normal vision will identify narrow bands at which the change of wavelengths appears to produce a change in the quality of the color. These bands have been identified by the commonly used words "red," "orange," "yellow," "green," "blue," and "violet" (Pl. 14, p. 62). Actually, many people can identify intermediate bands which seem to differ enough from the bands juxtaposed to them to require separate identities, so that "yellow-orange" and "red-orange," "yellow-green" and "blue-green," "blue-violet" and "red-violet" are also used to make distinctions of color quality. For the trained color observer, even more precise identifications of isolated wavelength bands are possible, and each identifiable band is called a "hue."

Color theorists have recognized that it is possible to obtain most of the colors in the spectrum from a combination of a limited number of hues, known as *primary hues* and identified as yellow, red, and blue (Pl. 14, p. 62). Different proportional mixtures of two of the primaries will produce the spectral range between them. Thus, combinations of red and yellow will include a great variety of yellow-reds and red-yellows. At a point along the scale the yellow-reds and red-yellows appear to take on an identity separate and distinct from the parent hues. This *intermediate,* or *secondary, hue* is called "orange," which can appear to vary from a red emphasis (red-orange) to a yellow emphasis (yellow-orange). Blue and yellow can also be combined in varying proportions to produce a scale that includes green at some point in the progression, with modifications comparable to those on the red-yellow scale, ranging through blue-greens and yellow-greens, bluish yellows, and yellowish blues. On the scale made by combinations of blue

and red we find violet, with variations of reddish blues, red-violets, blue-violets, and bluish reds.

Theoretical combinations of hues are used as guides by painters, but the mixtures are modified according to characteristics of the paints available. Most of the manufactured paints take their hues from the colored powder, the pigment, that is used in them. Such pigments are processed from raw materials of mineral and chemical origin. For example, a whole range of reds and yellows results from treatment of the metal cadmium, which changes color in this range as it is heated. Cadmium yellow, cadmium yellow light, cadmium yellow pale, cadmium orange, cadmium red light, cadmium red, and even cadmium purple are available from most paint manufacturers. Some of the pigment hues closely approximate spectrum colors, but few are identical to them. Painters learn to combine pigments so as to arrive at the hues they want, for theory does not always match reality, and they cannot mix from primary hues all the colors they want and need. For this reason paint is manufactured in a great number of hues combined from many different pigment materials and bearing color names not found in the description of the spectrum, giving artists a wide range of choices.

Value

On a scale beginning with black and progressively lightening to white, a hue such as yellow is seen to have a degree of lightness close to the white end (Pl. 14, p. 62). Other hues in the blue or violet family match points on the scale nearer black. This measure of lightness in a color is called its *value*. As noted, not all hues have the same value; each of them may be altered in value to be lighter or darker. With opaque paint, it is possible for the artist to raise the value of a color by the direct addition of white. When transparent paints are being used, the artist can add vehicle (that is, the liquid with which the pigment is mixed) and thin the paint, dispersing the particles of pigment so that more of the white canvas or paper (the ground) shows through the paint film. This gives the optical effect of a lighter value. Similarly, hues can be darkened to a lower value through the admixture of black, or, in the case of transparent paint, by applying the thinned paint over a dark surface.

Saturation

It is possible to produce an area of color which is yellow in hue, very light in value, and extremely bright. This same light-hued yellow can also be made to appear dull and grayed. The difference in brilliance is said to be a difference in the degree of *saturation,* or *intensity*, in a color (Pl. 14, p. 62).

In paint, each hue has a different ultimate degree of saturation, for the brilliance of color is limited by the available pigments and the binding medium (that is, the ingredient in the paint mixture that holds the particles together and adheres to the painting surface). All hues, however, can be reduced in brilliance until they reach the lowest levels of saturation. At that point they become neutralized and appear as grays, no longer identifiable with any family of hues.

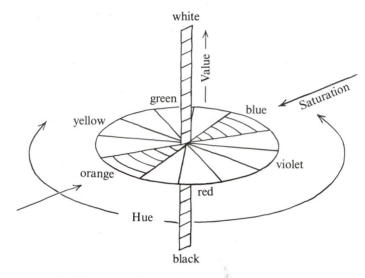

above: 90. Diagram of hue, value, and saturation.

below: 91. If Figure 90 is conceived of as a sphere, a segment representing a single hue diagrams the changes in that hue's value and saturation.

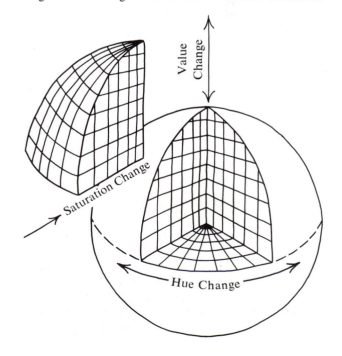

When two hues of paint are combined and their combination produces a neutral gray, the hues are said to be *complementary*. Some disagreement exists about the precise identification of complementary hues, but in broad terms red is complemented by a hue in the green or blue-green range, yellow by violet or blue-violet, and blue by orange or red-orange. By varying the proportions of a complementary mixture of hues, it is possible to realize many different degrees of saturation.

The German physical chemist Wilhelm Ostwald suggested another basis for producing saturation changes. He established his color system upon the combination of hue, white, and/or black. That is, he used additions of white *or* black to change value, but he produced saturation changes by combining a hue with a proportional mixture of white *and* black.

Many of the colors produced by raising or lowering the value of a hue are known by names not used in color theories. Brown results from lowering the value of the hues in the red, orange, and yellow section of the spectrum. Navy blue and forest green are also low-value forms of the basic hue. Pastel colors such as pink, aquamarine, and lemon yellow are found at the high end of the value range.

The Color Solid

A theoretical model of the three color qualities—hue, value, and saturation—that is similar to one developed in the early nineteenth century by the German artist Philipp Otto Runge can be constructed so that the hues are represented as circling a vertical axis (Fig. 90). This axis represents a value scale with black at the bottom and white at the top. Change in saturation are expressed across the circle, so that the blue-orange complementary group is shown with the most brilliant color at the outer edge of the hue circle and neutrality is indicated at the center point, a step on the vertical axis. The orange and blue segments become progressively grayer as they move toward the center of the circle.

Figure 90 may be conceived of as a sphere (Fig. 91). A segment representing a single hue, cut from the sphere, would be most intense on the outer surface at the midpoint of the arc. The color would be progressively neutralized as it moved toward the central core of the sphere, and its value would change with a vertical progression. The position of any spot on the surface of the sphere, or within it, would then have a specific hue, value, and saturation.

The model just described is a simplified concept. It does not accurately represent the differences in value and saturation between pure hues. A more precise model could be constructed, but it would not differ in essentials from that drawn here.

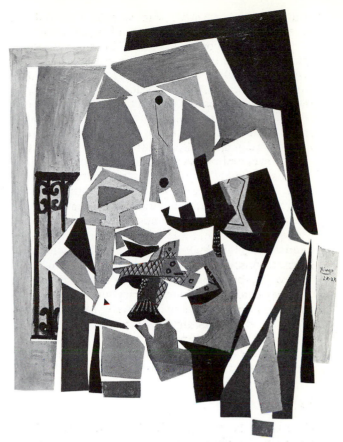

92. Analysis of Plate 15 (p. 79), Picasso's *Still Life with Fishes.*

Form

The word "form" is used in many ways in discussions of art works. It may mean the overall composition of a painting or three-dimensional construction: "The *form* of the painting is based on diagonal movement." It may refer to the representation of a subject: "The *form* of that arm is painted convincingly." As one of the plastic elements, the word "form" is used to identify an area containing color: "The black *form* in the upper right-hand corner of the painting by Picasso in Plate 15."

The forms in Picasso's painting *Still Life with Fishes* (Pl. 15, p. 79) could be traced from the surface to a piece of paper and cut out to become a kind of jigsaw puzzle, each shape fitting into those adjacent to it (Fig. 92). If every puzzle piece were given a color different from that in the painting, certainly the appearance of the work as a whole would change; the forms, however, would still communicate much of the original content.

Sometimes, as in the paintings of Renoir (Pl. 1, p. 7) and Rembrandt (Fig. 88), the edges of the forms are imprecise; it is difficult to say exactly where one form ends and the adjacent form begins. The edges seem to exist within a loosely defined boundary area at the outer limits of a coherent color shape. One can sense where the forms seem to end without being able to distinguish a definite point of change between one form and the next.

In some paintings, composite forms are created by groups of smaller forms. Close study of the Renoir painting in Plate 1 (p. 7) will reveal a progression of form groupings that begins with the primary units, individual brush strokes organized into small areas, which then become parts of a larger compositional structure.

Moon, an 8½-by-9-foot (2.55-by-2.7 meter) painting by Milton Resnick (Pl. 16, p. 79), is a richly articulated surface of many individual forms, closely related in both hue and value. Depending upon dense layers of color to build up a seemingly formless composition, Resnick's work rewards the person who studies it persistently. The smaller forms fuse into larger forms that seem to rise to the surface of the canvas and then give way to others. Partially hidden tonal and complementary accents wait to be discovered, like patches of living blossoms beneath a layer of fallen autumn leaves.

Several kinds of form are often found concurrently in a single painting. In Bronzino's *Portrait of a Young Man* (Fig. 75) the represented *form* of the subject's clothing is detailed, with its sewn decoration and folds; but the dark *form,* the tonal area of the costume, is joined with the low-value *form* above it that stands for the shaded side of the man's face and his hat. At the lower left the major central *form* is joined to another dark *form* that represents the shadowed side of the table. If the viewer squints so that the details of the *represented forms* are obscured, the larger dark, light, and intermediate values of the areas that divide the painting will fuse, and the simpler formal division of the portrait will be emphasized (Fig. 93).

Space

The artist who works in two dimensions begins by making marks on a flat surface. This surface is the *space,* the world in which the plastic order of the work must be constructed. Limited by the size and proportions of the two-dimensional plane, the painter arranges forms in this space to make them satisfy the aesthetic, representational, and expressive needs of the overall concept.

The analogy of the jigsaw puzzle can serve here, too. If the space of the painting is taken to be a sheet of paper the size and shape of the completed puzzle, the forms, or parts of the puzzle, can be placed in their required positions on the paper. Imagine the paper partially covered by pieces of the puzzle. The paper shows through between the separated parts; that is, the *forms* are seen sitting in the *space.* The combination of forms and intervening spaces comprises a composition in which it is possible to distinguish forms from spaces and still find the organization satisfying. It is also possible for the entire paper, or space, to be covered by interlocking forms so that no void is revealed. The only space the observer is aware of is the total area of the paper, as indicated by the outer dimensions of the entire puzzle. In the first instance the composition has positive, important elements of form set in measurable positions relative to one another on a limited ground or space. In the second example all the forms have a similar importance; they are interdependent. This compositional statement does not refer to the representational content of the painting. The parts of the puzzle can combine to create the illusion of any number of pic-

93. Analysis of Figure 75, Bronzino's *Portrait of a Young Man.*

94. JACK YOUNGERMAN.
Anajo. 1962.
Oil on canvas,
6′2″ × 6′ (1.87 × 1.82 m).
Courtesy the artist.

torial images; or they can be joined, without representational intent, to produce a visual effect that depends solely upon the response of the observer to combinations of color areas.

In Jack Youngerman's *Anajo* (Fig. 94), are the forms separated spatially, one in front of another, or are they locked together to create a single flat, multicolored plane? If the light area in the center seems to be dominant, it will tend to come forward. If the dark areas demand more attention, they will appear to overlap the light portion, pushing back. Both responses are possible to the viewer. We may even sense a reversal of spatial positions as we study a painting if our perception of dominance changes.

An untrained viewer may be disconcerted by the idea of responding in a number of ways to ambiguous elements in a work of art. Judgments regarding the importance of form-space relationships, or even regarding the point at which a soft-edge form ends and adjoins another form, involve psychological and physiological states within each observer. For some works of art there is a high degree of certainty that

other viewers will have similar responses, but other art objects are far less precise in their construction. There is no way to be assured that one's own reading of an ambiguous visual composition is the "right," the "true," relationship as intended by the artist. When the expressive, representational, or aesthetic intention requires imprecision in a work of art, the artist has no alternative but to introduce ambiguity, even though this may elicit an unanticipated interpretation of the work by observers who have different perceptual, intellectual, and emotional sets.

Texture

The illusionistic representation of tactile surfaces has long been a concern of painters and draftsmen. By the sixteenth century, European painters, particularly those in the north, had developed representational skills and techniques to extraordinary levels. No tactile surface was too difficult for them to simulate. There is a magical quality in the painted illusions of glistening silks, transparent and reflective glass, bur-

above: **95.** JANET FISH. *Dark Mirror.* 1976.
Oil on canvas, 4'2" (1.27 m) square.
Cleveland Museum of Art
(gift of Barbara G. Bradley).

left: **96.** KURT SCHWITTERS. *Cherry Picture.* 1921.
Collage and gouache on cardboard,
36⅛ × 27¾" (92 × 70 cm).
Museum of Modern Art, New York
(Mr. and Mrs. A. Atwater Kent, Jr., Fund).

nished metal, and the intricately woven patterns of Oriental rugs that are to be found in the paintings of artists such as Hans Holbein (Pl. 17, p. 80). The artist's observation of these materials is as keen and insightful as his examination of the facial and figurative character of his subject.

The fascination with the representation of surfaces and textures and with the light that is reflected by them continues to the present in painters such as Janet Fish, who uses her technical virtuosity to produce large canvases of precisely observed commonplace objects (Fig. 95). Often aided by photographs, these contemporary artists may be less interested in simulating the "real" world than the artists of the past. Instead, they find, in the minute details of the subjects they study, colors and forms offering new compositional possibilities.

The pictorial effects achieved in paintings that stress the surfaces of objects are the result of consistent and precise drawing, accurate perception and rendition of small differences in tonality, painting techniques that utilize opaque and transparent applications of pigment, and the ability of the painter to form both sharp, hard contours and edges that are blurred and atmospheric. The physical surface on which such a master as Holbein painted was conventionally flat, and his brush strokes were smoothed to an even, glassy finish, for the artist conceived of his work as the creation of an illusion, and he did not wish to attract the viewer's attention to the medium, the paint, which is the real tactile surface of painting.

Some painters may wish to escape from the reality of the paint they use and the surfaces that carry their images, but this is not entirely possible. They seek to create an illusion that diverts the attention of a viewer from a perception of the image as a manufactured object to a perception of the pictorial content of that object, and they measure their success by their ability to achieve this transformation. Other painters accept the undeniable nature of the materials, exploiting their decorative and expressive potentials, and inviting attention to the way the materials have been used. For such artists the image depends upon a response to both the physical and the symbolic character of the work of art.

In many periods throughout the history of art, painters have enriched the surfaces of their works and even developed them into the third dimension. Painted areas have been combined with gold leaf and with modeled three-dimensional relief in religious and secular images and decorations. Plate 18 (p. 97) reproduces a detail from a painting by the Italian fifteenth-century artist Carlo Crivelli which combines mounted jewels with painted and sculptural sections. Incised decoration in the gilded surface surrounding the figure serves to increase our awareness of the

97. Antoni Tàpies. *Material and Rag on Cardboard.* 1974. Cloth and cardboard mounted on panel, 41¼ × 29¾″ (105 × 76 cm). Private collection.

painting's dual character as both religious symbol and precious artifact.

The works of many painters, among them Rembrandt (Fig. 89; Pl. 6, p. 25), exhibit the use of thick paint that protrudes from the plane of the painting. Sometimes such *impasto* areas may function on both an illusionistic and a physical level, creating an equivalent for a real object and simultaneously acting as a three-dimensional surface variation in contrast to areas of flat paint. Vincent van Gogh (Fig. 101; Pl. 5, p. 25; Pl. 52, p. 261), among others, enriched the surfaces of his canvases with applications of thick paint and made impasto an integral part of his art.

Early in the twentieth century the elaboration of the surface was extended even further by combining paint with other materials—painted paper, cloth, wood—which were attached to the surface of the canvas, in works called "collages" (Fig. 96). Contemporary painters such as the Spanish artist Antoni Tàpies (Fig. 97) have continued the exploitation of the element of texture; and Robert Rauschenberg's

"combines" (Fig. 98) joined actual three-dimensional objects to the two-dimensional painted surface, bridging the differences between painting and sculpture, and between object and image.

Line

Figure 99 is a black mark that would be described as a "line" by almost anyone looking at it. When this same mark is enlarged to five times its original size (Fig. 100), it becomes a "form." The difference is based upon our perception of the dimensions. In the first, the length of the mark and its undulating direction so dominate our perception that we tend to ignore the width. In the second, though identical in proportion and shape, the size is so greatly increased that the dimension of width becomes significant.

above: 98. ROBERT RAUSCHENBERG.
Rodeo Palace. 1975–76.
"Combine" painting,
12′ × 16′ × 5½″ (3.66 × 4.88 × .14 m).
Collection Mr. Sidney Singer, Mamaroneck, N.Y.

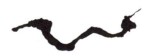

above: 99. A "line."

below: 100. Figure 99 enlarged five times to emphasize its form.

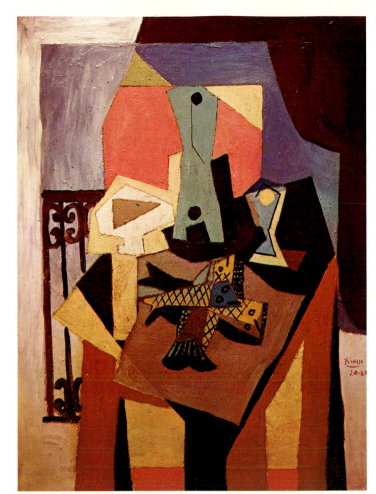

right: **Plate 15.** PABLO PICASSO.
Still Life with Fishes. 1922–23.
Oil on canvas,
4′3″ × 3′2½″ (1.3 × .98 m).
Private collection. (See Fig. 92.)

below: **Plate 16.** MILTON RESNICK.
Moon. 1976.
Oil on canvas,
8′7½″ × 9′1½″ (2.63 × 2.78 m).
Courtesy Max Hutchinson Gallery, Inc.,
New York.

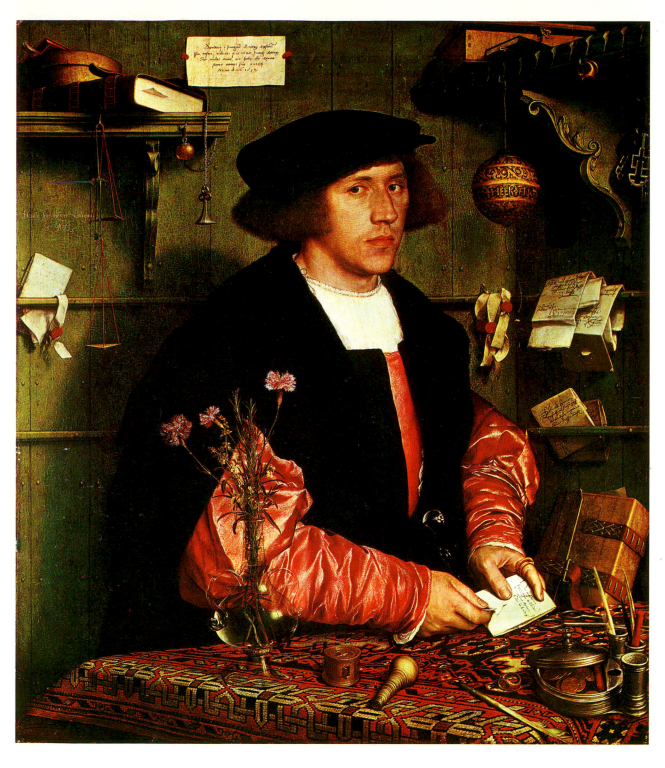

Plate 17. HANS HOLBEIN THE YOUNGER.
Georg Giesze. 1532.
Oil on panel,
37¾ × 33″ (96 × 84 cm).
Gemäldegalerie, Staatliche Museen, West Berlin.

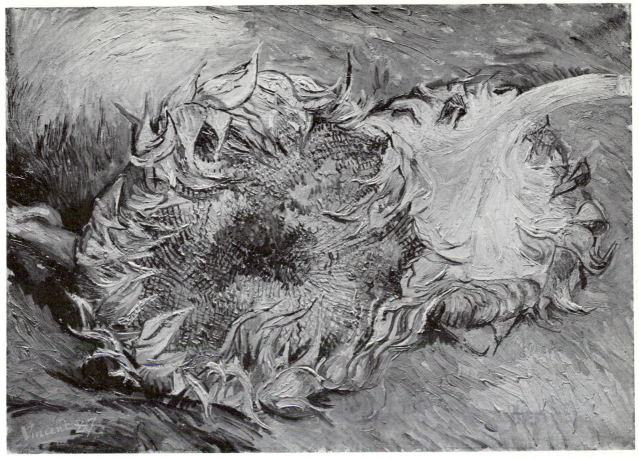

101. VINCENT VAN GOGH. *Sunflowers.* 1887. Oil on canvas, 17 × 24″ (43 × 61 cm). Metropolitan Museum of Art, New York (Rogers Fund, 1949).

The artist produces lines with instruments—pens, pencils, etching needles, crayons, brushes loaded with paint. The marks made by these instruments are measurable in two dimensions, but when they result in what we call "lines," one of the dimensions is disregarded. This is particularly true of a line that maintains a fairly constant thickness, as in Picasso's *Girl Before a Mirror* (Pl. 2, p. 7). The linear elements in de Kooning's *Woman and Bicycle* (Pl. 3, p. 8) are more varied in size and have a kinetic character, a sense of the artist's action or gesture, especially when compared to the more restrained quality of the lines in the Picasso painting. The viewer should consider the linear elements in these two paintings as both lines and forms. As lines, they provide two-dimensional webs in each painting, forming an arabesque over much of the canvas surface; they may be a record of the movements that created the marks, but they also act as slender forms

of color, contributing to a complex, interdependent color-form composition.

The scale of linear elements in painting can be large and obvious, as in these two examples, or it can be fine-drawn in sharply focused detail, like that in the dark accents on the forms representing leaves in Van Gogh's *Sunflowers* (Fig. 101). Careful examination of this painting will reveal short linear forms that combine to make up the broader and larger forms. These smaller lines of color have both a cumulative effect—giving a directional character to the large forms and suggesting movement, growth—and a depth that would not be expressed by flat, undifferentiated areas.

As noted earlier in this chapter, another type of line perceivable in a work of art results not from a mark inscribed by a drawing instrument but from the division of two adjacent color forms along a clearly defined edge. Vertical, diagonal, and horizontal edges

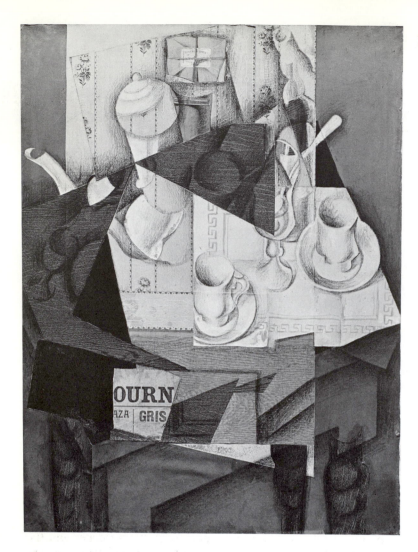

left: 102. JUAN GRIS. *Breakfast.* 1914.
Pasted paper, crayon, and oil on canvas;
$31\frac{7}{8} \times 23\frac{1}{2}''$ (81 × 60 cm).
Museum of Modern Art, New York
(Lillie P. Bliss bequest).

below: 103. Analysis of Figure 102.

in Juan Gris' painting *Breakfast* (Fig. 102) can be
seen as linear elements dividing the spatial composi-
tion of the painting, similar to a drawn grid like that
in Figure 103.

In painting, then, the artist may work with the
plastic elements of color, form, space, texture, and
line. Each element may be analyzed individually, but
each can contribute to the effect of one or more of the
others. Frequently all of them may be used in the
expression of the artist's intention. Thus, for most

painters, form and space cannot be separated from
color. Line and form are often the same thing. The
impasto of the brush stroke can be texture, form, and
color simultaneously.

Beginning students of painting and design are
often given a specific problem intended to deal with
one or two of these elements at a time, but before
long they realize that a work of art results from the
interaction of these means, rather than from their
operation as independent parts of the whole.

Two-Dimensional Media and Processes

6

In the visual arts, as in all the arts, artists must manipulate material or utilize a process or group of processes to carry out their work. Colors in a painting result from the application of colored materials to a surface. The spectator may see a red area which is an integral part of an ordered aesthetic relationship, but the artist had to manipulate paint to produce the area. The artist had to control the physical properties of paint to achieve the intended aesthetic results.

Though a work of art may be discussed in the theoretical terms of its plastic elements, it must be recognized that these elements are products of, and therefore affected by, the physical media and processes used to create them.

Each medium offers certain possibilities; each has its limitations. An aesthetically satisfying image is affected frequently by qualities in the material that either resist or respond readily to the artist's needs and craft. The choice and range of color; the capacity to provide smooth chromatic and linear transitions; the final surface; the differences between the way the material looks during the image-making process and in its final state; the permanence of the medium; the length of time during which the paint may be manipulated before it sets; the ability of the artist to correct unsatisfactory passages; the cost and availability of the material; and, finally, the personal response of the individual artist to all the medium's characteristics—all these factors will influence the final appearance of any one work of art.

There is a great difference between the visual effects created by a painter or a printmaker and the way in which those effects were achieved. The appearance of transparency may be produced by opaque paints. Light appearing to radiate from the surface of a canvas may actually result from the optical mixture of color applied in adjacent strokes of complementary hues.

The craft of art is passed on from artist to artist, from teacher to student. Skills and technical information are transferred, and the accumulation of knowledge is joined to the ingenuity of each practitioner. Each image maker adapts the traditional use of a medium to personal needs. At times individual problems of expression and the desire for innovative visual effects may require experiments, for when the legacy of craftsmanship cannot serve their needs, artists reach for alternative technical solutions to their problems.

The introduction of new materials or technical advances in reproduction have often provided extraordinary opportunities for changes in style and

104. The "Four First Dancers"
of the Navajo Night Chant Ceremony.
20th century. Sandpainting, 8′ (2.44 m) square.
Wheelwright Museum of the American Indian,
Santa Fe, N.M.

extensions of expressive content in the visual arts. Just such a change occurred late in the fifteenth century with the development of oil paint. The new medium was much more flexible than the previously employed tempera and fresco paints and artists were encouraged to adopt it. The last half of the twentieth century has seen a similar development of a new painting medium with the introduction of acrylic, vinyl, and polyester plastic paints. Oil paint remains quite popular among painters, but the polymer plastics have many adherents who find the intense color and the rapid drying characteristics of the new medium ideal for their purpose.

In the past the selection of a medium was often based upon the desire to produce a "permanent" image that would retain its original appearance for many years. For many contemporary artists this concern still influences their choice of medium and the procedures used in applying it to a supporting surface. Others, however, find the controlled craftsmanship of traditional painting too restrictive. They prefer to satisfy their immediate expressive and aesthetic needs, leaving the conservation of the objects they produce to the museum curators and specialists whose concern will be to prolong images that owe their character, in part, to the casual materials and techniques that encourage spontaneous invention.

Paint: Pigment, Vehicles, and Media

As noted earlier, color in painting is dependent upon chromatically different substances called *pigments.* These pigments are regularly available in the form of powders produced from finely ground earths, minerals, and chemical elements. American Indian sand paintings (Fig. 104) are among the few examples of the use of pure pigment as an image-making material. The colored sands and clays are permitted to stream through the clenched fist of the artist. The color pours out into the desired forms as the hand moves over the surface of the growing composition. After it is completed, a sudden wind or rainstorm or the careless action of a passerby can erase in moments the efforts of hours, for the loose pigment cannot be attached permanently without the use of an adhesive to bond the separate grains of color to each other and to a supporting ground.

Many binding agents, or *vehicles,* differing widely in their chemical and physical properties, have been used in paint formulas. The ideal vehicle would form a permanent colorless film binding the pigment without significantly affecting its chromatic character. It would be suitable for use on any surface. It would permit the paint to be applied in thick layers without

cracking and would adhere to layers previously applied. It would be usable in thinly brushed transparent areas, enabling the painter to build one film of color over another. Also, the perfect vehicle would stay wet long enough for the painter to make all necessary changes and achieve desired effects, but it would dry conveniently, when the work was completed. It would be nontoxic and easily removed from hands, clothing, and brushes.

No such vehicle exists. Each of the many employed throughout the history of painting offers the artist less than might be wished but, in most cases, provides sufficient options to permit the formation of acceptable and satisfying images.

The combination of vehicle and pigment frequently requires a solvent, or thinner, that may be mixed with it to alter the viscosity, providing a means of control for the application of paint or altering its transparency. This third component is called a *medium.* The use of this word is sometimes confusing, for it may also designate the combination of all three components. Thus, it is possible to speak of the "medium of oil paint" at one time and at another to refer to turpentine as the "medium" for thinning the mixture of pigment and linseed oil, which are the primary constituents of oil paint.

Oil Paint

Oil paint has been widely used since the fifteenth century. It responds readily to many different application techniques, satisfying the individual needs of artists who differ dramatically in both style and intention. Brushes may be used to build up small strokes of relatively opaque color, as in the shimmering effects produced by Claude Monet in Plate 7 (p. 26). When necessary, the paint may be thinned into *glazes,* or transparent films that are used over a previously applied underpainting, as in the work of Jean-Antoine Watteau (Pl. 34, p. 156). This artist's use of transparent passages of paint can also be seen in the freely brushed portion of the landscape.

Many alternative surface variations are possible when oil paints are used. One such variation can be seen in *Violin and Pipe with the Word "Polka"* (Pl. 10, p. 43), by Georges Braque. The artist applied oil paint to the canvas in relatively flat areas. The gray-green forms have been overlaid with a painted pattern: diamonds, circles, and broken lines in diagonal movements provide a contrast to the flat areas and, at the same time, repeat the diagonal and curved forms found throughout the composition. Additional variety is introduced by mixing sand with the paint, so that certain areas differ in surface texture. The rough texture tends to modulate the light that falls on the flatly painted surfaces, bringing forth a subtle varia-

tion in the color. The degree of roughness is controlled within specific areas, so that the smoother surfaces, like the white forms, contrast with the more obviously textured blacks in the center of the composition. Besides adding sand, Braque combed the thick film of brown paint covering those forms based on the table top and legs, so that the wavy lines were incised into the paint surface. Within this work the paint substance has been used in several ways, and yet the effect of the whole is one of an ordered composition, because the artist used the technical variations as part of an overall compositional plan.

A comparison between these three examples and paintings by Bronzino (Fig. 75), Picasso (Pl. 2, p. 7), Richard Diebenkorn (Pl. 13, p. 61), Milton Resnick (Pl. 16, p. 79), and Janet Fish (Fig. 95) will suggest the extraordinary versatility of oil paint and help to explain the continuing use of this medium.

Acrylic Paints

Many of the characteristics to be found in oils are also inherent in the paints that have acrylic plastic as a vehicle, and this relatively new medium currently enjoys a popularity rivaling that of oil paint. Acrylics are thinned with water, and, because the resin dries into a colorless film, the pigments fused into the paint layer have an exceptional brilliance. Like oil, the acrylics may be used opaquely or in transparent washes. Note how David Kessler uses acrylics in a representational style that is not significantly different from the way he might have worked using oil paints (Fig. 54).

Acrylics are particularly suitable for large-scale paintings which depend on the chromatic effects of relatively flat surfaces. The range of possibilities open to painters who use acrylics may be grasped by comparing Frank Stella's painting (Pl. 30, p. 136) with *Saraband* (Pl. 19, p. 98) by Morris Louis. The mechanically crisp edges and smoothly applied areas of flat paint in the Stella painting are typical of the manner in which many artists use acrylics. Often the adjoining areas are separated with masking tape prior to the application of paint. When removed, the tape has formed precise, sharply defined divisions between the colors. *Saraband* was produced by pouring successive transparent streams of paint on unstretched canvas while the fabric was held to contain and shape the path of the flowing liquid. Veils of color stained the canvas with fluid, mysterious forms both fragile and brilliant—qualities that only acrylics provide.

Watercolor

When an artist looks for a medium that is compatible with small-scale images, quickly rendered and perhaps brilliantly colored, watercolor is a logical choice.

Pigment combined with a vehicle of gum arabic is thinned with water and brushed on a paper or cardboard surface. Long a popular medium, watercolor also offers the advantage of easy portability. Small watercolor kits, a few brushes, a pad of paper, and a cup of water may be taken anywhere. And whether it is because of this convenience or because of the ease with which watercolor responds to virtuoso manipulation of rapidly flowing paint surfaces, this medium continues to attract many artists (Pl. 20, p. 98).

Encaustic, Fresco, and Tempera

Although the majority of paintings issuing from the studios of contemporary artists throughout the world are painted in oils, acrylics, or watercolors, other media, less popular today, were in common usage in

right: 105. Mummy portrait of an elderly woman, from the Faiyum, Egypt. 1st–2nd centuries A.D. Encaustic on panel, $14\frac{7}{8} \times 9''$ (38 × 23 cm). Ägyptische Staatssammlung, Munich.

below: 106. MICHELANGELO. *Creation of Adam,* detail. 1508–12. Fresco. Sistine Chapel, Vatican, Rome.

the past. An apprentice artist in first-century Egypt would have had to learn the techniques necessary to produce images through the use of *encaustic.* A wax vehicle heated to a liquid state was used to bind the pigment, and while still hot and fluid, the paint was applied to cloth-covered wooden supports (Fig. 105).

Egg tempera, a medium using the yolk of an egg as a vehicle and water as the thinning agent, was commonly employed for centuries to produce a wide range of images (Figs. 200, 203). Large wall and ceiling paintings such as those by Michelangelo in the Sistine Chapel of the Vatican in Rome were painted in *fresco* (Fig. 106). This method required the painter to apply a mixture of pigment and lime water to fresh plaster. It had to be done a section at a time, before the plaster dried out.

More recent examples of the use of these media can be found, for some artists currently use encaustic, tempera, and fresco but they are the exception rather than the rule.

Art students today rarely think it necessary to develop the skills required to master these once popular materials. Why is this so? Why have some of the

media of the past been superseded, while others remain as popular as they once were? Not because of permanence, for there are paintings in encaustic, tempera, and fresco that have remained fresh and virtually unblemished for hundreds of years. Not because of scarcity of the materials, for each of the media uses raw materials readily available throughout the world.

It is difficult to determine a single reason for the substitution of one medium for another. There are many instances in which a painter, reaching for the means to fulfill a representational or expressive intention, has experimented with a medium that might promise greater rewards than those obtainable with the materials usually employed. Leonardo da Vinci left us a tragic record of his experience with an untried medium when he painted *The Last Supper* in the refectory of Santa Maria della Grazia in Milan (Fig. 107). Because he considered fresco incapable of registering the light and color he desired, and because fresco painting requires a rapidity of execution inconsistent with his measured pace, Leonardo undertook his commission with an experimental medium that resulted in deterioration of the painting even during his lifetime. At present, despite heroic efforts of technicians using new restoration techniques, the image that remains is a shadow of the original.

Changes in the scale of paintings or in the amount of time an artist wishes to dedicate to the completion of a single work can contribute to the popularity of one medium and reduced interest in another. Encaustic, tempera, and fresco require preparatory procedures before the image can be completed. If the painter desires to capture the fleeting appearance of sunlight as it illuminates a field, or if a powerful emotion drives the painter to urgent and rapid execution, a time-consuming medium is unsuitable.

In the Western world today, many artists appear to be more concerned with their own needs for expressive and innovative personal imagery than with the production of carefully crafted permanent works of art that will serve social, political, or religious needs. For such artists, the commercially prepared paints now on the market provide color, form, and textural alternatives adequate to satisfy many different demands. Those who wish to maintain a sense of continuity with tradition can still return to the media of past masters. Those who find current and past media wanting can find new opportunities for the exploration of light, electronics, and the computer technologies.

Drawing Media

Because it is so fundamental to, and pervasive in, all that an artist does, drawing evades attempts to define

it precisely. In the narrowest sense, drawings are essentially linear in character and modest in size, formed by a marking implement on a monochromatic support. An expanded definition would include the possible use of tonal areas that supplement or, on occasion, replace the linear elements, as well as a limited use of polychromed variations in both line and tone. But even this more liberal interpretation falls short of the reality of many works that, by general agreement among artists and art historians, should be regarded as drawings. Some pastel drawings (Pl. 28, p. 136) are intensely and variously colored, and there are many examples of drawings conceived and executed on an architectural scale.

107. LEONARDO DA VINCI. *The Last Supper,* detail. 1495–98. Fresco, entire work 14′5″ × 28′1/4″ (4.39 × 8.54 m). Santa Maria della Grazie, Milan.

tures. Ambitious and demanding, they represent a major effort for the draftsman, who considers them serious, fully developed works of art.

Drawings can be remarkably telling, and the non-specialist may freely enjoy them for the many delights they offer. Drawings are an opportunity to see the artist in an immediate, often pleasurable confrontation with the drives generating images that are eventually completed in the finished work. Seen in this light, they can readily become the basis for an empathetic connection between the producer and the consumer of visual art—a relationship filled with promise for aesthetic reward.

Drawn lines can result from two different processes. The first of these produces a mark by depositing minute particles of colored matter on a surface from a stick of material that is drawn against it. The second process leaves a mark as a fluid is allowed to flow from an instrument onto an absorbent surface. Both methods can be used to execute a solid line, without variation from dark to light, or gradually shaded areas of great delicacy.

Dry Media

The *dry* drawing media include silverpoint, pencil, pastel or chalk, charcoal, and wax crayon.

Silverpoint, one of the oldest among the traditional drawing media, is rarely employed today. In this medium a silver wire is drawn over a surface that has been specially prepared, usually with a chalk coating abrasive enough to cause small bits of the metal to adhere to it. Through oxidation, the metal tarnishes, altering the color of the line to a darker, delicately grayed hue. Silverpoint does not lend itself to a shaded line. Each line is as dark as every other line. To develop gradations of tone, the artist must build them up slowly and carefully by making a series of lines so close together that from a short distance the linear notations fuse into a solid area. If a darker tone is desired, the lines are marked in a still tighter relationship or even made, by a technique called "cross-hatching," to intersect at various angles.

Silverpoint lines cannot be easily erased; therefore, the artist must work deliberately, with a firm idea of the ultimate image. The technique encourages precision and clarity. In the fifteenth-century portrait study reproduced as Figure 108, the Flemish master Jan van Eyck left a record of his search for the precise contours he perceived in the subject. Repeated at-

Elusive as a definition of drawing may be, we can say with reasonable certainty that there is a body of two-dimensional art comprised of objects that are characterized by at least two of the following factors:

1. A mark-producing medium has been used in a relatively direct way.

2. Color is, frequently, limited to one or two hues.

3. Most often, though not always, paper has served as the support.

Yet to define drawing on the basis of physical properties alone would fail to grasp an essential truth about it. Of much greater significance to an understanding of drawing is a sense of its purpose—how it serves in the overall enterprise of the practicing visual artist. Painters, sculptors, and architects draw constantly. They draw to study, to record, to clarify their ideas. They draw for pleasure, moving an instrument and producing a line because it pleases the eye and uses the hand in a satisfying rhythmic activity. Many drawings are direct, single-purposed, and spontaneous. Often, they represent an intuitive reaction on the part of the artist to the stimulus of a provocative form, accidentally produced on a sheet of paper. And, finally, there are those drawings which take their place beside completely realized paintings and sculp-

tempts to record those contours appear as a composite line. It is only when the drawing is carefully scanned that the separate contours become evident. Tonal areas have been created by drawing parallel lines unrelated to surface contours. These are deliberate but substantially freer than the lines used to describe the edges of the forms.

The modern *pencil* dates from the end of the eighteenth century, when the manufacturing process was invented in both France and Germany. Graphite dust was mixed with clay, formed into thin rods, and baked to harden the clay, fabricating a rigid drawing material that could be inserted into paper or wooden cases. One of the attractions of the new pencil medium was based on the manufacturer's ability to issue the "leads" in several degrees of hardness. By varying the proportion of clay to graphite it was possible to provide marking characteristics that approximated silverpoint at one end of the scale and at the other extreme the dark, granular quality of black chalk. A drawing by Ingres dated 1806, not too long after the introduction of the pencil, has the general character of a work executed with a metal point (Fig. 109).

Figure 110 is a study for a portrait of the painter Edouard Manet made by Edgar Degas. Rapidly executed, the drawing reveals many ways in which pencil can be handled. There are fine, hard lines left by a sharp point, softer broad strokes made with the side

111. MICHELANGELO. Studies for the Libyan Sibyl
in the Sistine Chapel ceiling. c. 1508.
Red chalk, $11\frac{3}{8} \times 8\frac{1}{4}$" (29 × 21 cm).
Metropolitan Museum of Art, New York
(purchase, 1924, Joseph Pulitzer bequest).

of the pencil, and tones created by grouping parallel
lines or by smudging. Light construction lines indi-
cate trial positions for the arms and legs, and faint
indications of a standing figure are to be seen, par-
tially erased.

Pastel, or *chalk,* is manufactured by combining
pigment with a binder into an easily crumbled stick.
Charcoal is formed by burning, or rather charring,
selected sticks of wood or vine. These media produce
lines in the same physical manner as silverpoint and
pencil. The particles of chalk and charcoal are so
easily dispersed over the surface of a sheet of paper
that they have a tendency to smudge and must be
fixed with a spray of thinned varnish before the
media can be considered permanent.

Chalk drawings have been made for many hun-
dreds of years. The medium is extraordinarily flexi-
ble, so that stylistic individuality can easily be ac-
commodated within its potentials. The "organic"
colors of chalk are as old as cave art, and they range
from the talc white familiar in blackboard use
through ochers and umbers to "sanguine," a red
derived from iron oxide. Associated with drawings
known as "pastels" are hues of the greatest purity,
brilliance, and intensity.

The chalk studies by Michelangelo in Figure 111
include rapid calligraphic sketches as well as ex-
tended, careful linear and tonal drawings. The con-
tours vary in width, and some are much darker than
others. Each stroke retains its clarity, suggesting a
measured involvement with the rhythms of the sur-
face and edges of the model.

Käthe Kollwitz made her drawing (Fig. 112) four
centuries after Michelangelo's Renaissance study,
employing black and white chalk with a broad tonal
emphasis. Edges are soft, contrasts are dramatic, and
the drawn forms suggest more than they describe.
Elegant contours are missing. Instead, areas of tone,
textured by the surface of the paper as the chalk was
drawn against it, give form to the powerful image
reproduced here.

112. KÄTHE KOLLWITZ.
Peasant Woman Sharpening a Scythe. 1905.
Black and white chalk, $17\frac{1}{4} \times 14\frac{3}{8}$" (44 × 37 cm).
Fine Arts Museums of San Francisco,
Achenbach Foundation for the Graphic Arts
(anonymous gift in honor
of Dr. and Mrs. Charles Del Norte Winning, 1960).

Several commercially produced forms of chalk are available. One of the most favored of these is *conté crayon,* a highly compressed pigment and binder combination that originated in France in the nineteenth century. Conté drawings have characteristics generally quite similar to those of drawings made with chalk, but they appear a bit sharper and more precise because the crayons are somewhat harder than traditional pastels. In the drawing entitled *Café Concert* (Fig. 113) Georges Seurat worked black conté over a textured paper to produce a vibrant modulated surface. Using almost no lines, the artist invested both forms and atmosphere with a general suffusion of light and dark that is gradated from velvety black to the brilliance of the untouched paper support.

Charcoal is combined with chalk in the drawing by the contemporary American Jasper Johns (Fig. 114). This painter used the familiar forms of numerals, overlapping them to make a linear division of the picture plane. The areas formed by the linear web are filled with tone and a texture that derives from Johns' highly personal calligraphy. A complex two-dimen-

sional organization combines with a somewhat ambiguous spatial indication. The variety of surfaces that result from different ways of using the medium offers the viewer a rich, sensuous orchestration. This is an aesthetic object that transforms its familiar subject matter in an unexpected way.

Wax *crayons,* like pastels, are a combination of pigment and binder formed into colored sticks or pencils that can be shaped to produce a variety of marks. The wax binder gives crayons a slippery quality as they are moved over the surface of the paper support. Usually associated with children's activities, wax crayons have been adopted by some artists, such as Oskar Kokoschka, who find such a basic, readily available medium inviting (Fig. 115).

Fluid Media

To the draftsman who prefers to draw with brush or pen, certain qualities in a fluid marking medium are useful. The artist normally looks for a material that is fairly permanent and will make opaque black lines and areas at need and will flow from the drawing instrument in a controlled manner, allowing the brush or pen to be manipulated with considerable freedom. Often it is desirable that the medium be diluted to produce marks of different tonalities.

Just as important as the fluid in drawing is the instrument itself. Fluid drawing techniques rely heavily on the characteristics of the brushes and pens used to carry the marking medium to the drawing surface. The flexibility of the instrument, the width of strokes it will permit, and the amount of fluid it can hold all have their effect on the draftsman and the drawing.

The word *calligraphy* is frequently applied to drawings made with fluid media. Originally, the word meant beautiful writing, and it still retains that sense, but it may also refer to any clearly defined linear marks that suggest the movement of the hand and of

above: 115. OSKAR KOKOSCHKA. *Portrait of Olda.* 1938. Blue crayon, 17¼ × 13¾" (44 × 35 cm). Allen Memorial Art Museum, Oberlin College, Ohio (R. T. Miller, Jr., Fund).

right: 116. PAUL KLEE. *Der Dampfer fährt am Botanischen Garten vorbei.* 1921. Pen and ink, 9⅞ × 15⅜" (25 × 39 cm). Paul Klee Foundation, Museum of Fine Arts, Bern.

the instrument—the gestural experience. Paul Klee's ink drawing in Figure 116 is a record of the short, staccato movements of the artist's pointed pen nervously creating arabesques that take the shape of recognizable but rather strange objects. A flexible quill pen was used by Ernst Ludwig Kirchner when he drew the portrait study in Figure 117. As the artist's hand changed pressure on the point of the instrument, it responded by modifying the line width. There is a sense of rapid, excited execution, the hand flickering over the paper in an impassioned calligraphic dance.

Jackson Pollock's *Drawing* (Fig. 118) is a much more recent composition that expresses in the most dynamic way the motion of the artist's hand. Here is a work made by dripping and flicking Duco paint against the surface of a sheet of paper. The viscosity of the medium and the controlled violence in the artist's movement together have produced calligraphic forms in unique and provocative shapes.

A liquid drawing medium can be lightened by adding water or some other dilutant to the basic mixture. It is also possible to dilute the medium by applying it to a wet surface. Using either one of these techniques, or both, an artist can realize a wide range of tonalities in a drawing, exactly as he would in a watercolor painting. Figure 119 a drawing by Claude Lorrain, was painted in large part on dampened

above: 117.
ERNST LUDWIG KIRCHNER.
Frau Erna Kirchner. 1921.
Pen and ink,
12⅛ × 9⅜″ (31 × 24 cm).
Private collection.

above right: 118.
JACKSON POLLOCK.
Drawing. 1950.
Duco on paper,
1′10¼″ × 4′11¾″
(.72 × 1.94 m).
Staatsgalerie, Stuttgart.

right: 119.
CLAUDE LORRAIN.
*The Tiber above Rome:
View from Monte Mario.*
c. 1640. Brush and wash,
7⅜ × 10⅝″ (19 × 27 cm).
British Museum, London
(reproduced by courtesy
of the Trustees).

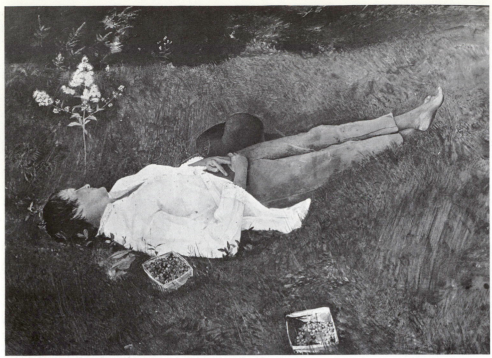

120. ANDREW WYETH. *Sleep*. 1961. Drybrush, 20¾ × 28¾″ (53 × 73 cm). Collection Mrs. Andrew Wyeth, Chadds Ford, Pa.

paper. While the surface was still moist, a brush filled with color was touched to the paper. Where the surface remained very wet, the areas softened along their perimeters, diffusing color into the surrounding field. Where the artist desired harder edges, as in the lower foreground, he waited until the surface dried before applying the color. Interestingly, this drawing is almost completely devoid of calligraphic elements, but brush strokes can be distinguished. They are broad and area-forming strokes, rather than linear marks. The full width of the brush has been utilized and not just the point. The effect is spatial, with the edges of forms overlapping to indicate masses of trees that progress illusionistically from the immediate foreground back to the distant base of the hills.

Drybrush studies such as Andrew Wyeth's *Sleep* (Fig. 120) come from a particular use of paint and instrument that yields tonal surfaces surprisingly similar to those made by pencil or chalk. The liquid medium employed in this technique has a "tacky" consistency. Having selected a stiff brush, the artist touches the bristle tips to the paint and then, with minimum pressure, draws them across the surface of the paper support. Each bristle leaves its trace, and because they are closely spaced, the individual marks fuse visually to suggest tonal continuity. By varying the amount of medium borne on the bristles and by

stroking the paint onto the ground in successive applications, the artist can control the values and textures of tonal areas.

Prints and Printmaking

No two-dimensional image-making method is more dependent on its materials and processes than the art of printmaking.

A *print* is an image, usually one of several essentially identical images, that is produced by creating a master matrix or transferable design on a metal plate, wood block, or stone surface, and then using the master to create multiple impressions, each of which is called an "original" print.

It is misleading to speak of prints and printmaking as though the medium consisted of a single process. Actually, there are many different ways to produce prints, each with different possibilities and limitations. In addition, each technique for the production of prints has gone through an evolutionary change from its invention to the present time, so that prints executed by the same basic processes, at different times in history, may not have much in common.

The evolution of printmaking technology has a pattern that repeats itself with each of several media. Out of a need to produce pictorial or decorative

objects more cheaply or faster there is developed a
process intended to approximate the art forms previ-
ously executed by hand. Gradually, as the artists and
craftsmen experiment with the medium, they learn to
control it and often obtain remarkable approxima-
tions of the processes they are emulating. Finally, as
the printmakers acquire confidence in their medium,
the images they make lose some of the imitative
quality and take on an identity peculiar to the unique
qualities of the printmaking process.

Contemporary printmaking has been shaped by
chemical and mechanical inventions; inks, papers,
presses, matrix material, and, more recently, photo-
graphic and computer technology have been joined to
the conceptual needs of today's artists producing
multiple images. The word *multiple* has been adopted
to extend the concept of the print to other art objects
that use mechanical processes to replicate an original
image in a limited edition of essentially identical
units. Vacuum-formed plastic and cast-paper reliefs
(Fig. 121) as well as metal embossings are to be found
in galleries. They are sometimes joint ventures of
artists and craftsmen who seek to increase the acces-
sibility of "original" works of art to persons who
cannot afford unique paintings, drawings, or sculp-
ture, but are not satisfied with mass-produced repro-
ductions of artworks.

Relief Prints

Many relief-print techniques are available to artists,
and they all share the same image-making process. A
flat surface is cut by gouges and knives. Those areas
in the design that are intended to remain blank are
removed or lowered beneath the level of the original
surface. Ink is applied to the remaining raised areas,
often with a roller that distributes the color evenly
across the block. When the inked image is pressed
against a sheet of paper or cloth, the ink is transferred
and the print results. Any surface prepared in this
manner can be used to make a relief impression.
Though wood has been the traditional relief-print
material for over five hundred years, metal, plastic,
linoleum, cardboard, and plaster relief prints may be
found in galleries and museums (Fig. 122).

122. In blocks used for making woodcuts,
the grain direction is horizontal.

Woodcut Woodcuts are relief prints for which the
flat surface of a wooden board is used as the printing
matrix. Many different kinds of wood are employed.
They are selected for the character of their grain and
their responsiveness to the cutting action of the edged
tools used to work them. By adopting tools of varied
sizes and shapes, the artist can diversify the marks left
in the wood surface and, inevitably, the appearance
of the printed image.

tools is recorded in the contours and broadly treated forms of the prophet's head. A primitive and direct character in the image is due in large part to the physical involvement of the artist as he formed the block's printing surface.

Helen Frankenthaler's seven-color woodcut *Essence Mulberry* (Pl. 21, p. 99) is printed from four separate blocks. The artist is a painter who has concentrated on large canvases stained with thinly applied colors. She depends on subtle chromatic relationships and the contrast between relatively flat passages of color and calligraphic linear elements for the visual imagery in her work. These compositional characteristics are transferred to the smaller format of the color woodcut. They are augmented and given an additional graphic quality by the printed texture of

left: 123. Albrecht Dürer. *The Fall of Man.* c. 1496–97. Pen and ink, $9\frac{1}{8} \times 5\frac{5}{8}''$ (23 × 14 cm). Ecole des Beaux-Arts, Paris.

below: 124. Emil Nolde. *The Prophet.* 1912. Woodcut, $12\frac{5}{8} \times 8\frac{7}{8}''$ (32 × 23 cm). National Gallery of Art, Washington, D.C. (Rosenwald Collection).

Cutting may be meticulous and carefully controlled, as in the early-sixteenth-century woodcut by the German artist Albrecht Dürer (Fig. 62). Certain scholars believe that Dürer cut his own blocks; others disagree but suggest that the craftsman who worked with Dürer must have been closely supervised by him. In any case, the prints fulfill the expectations initiated by the artist's drawings of the period. The calligraphy of the pen line and the tonal variations in Dürer's drawings (Fig. 123) have their counterparts in the print.

There is a startling contrast between the controlled woodcuts of Dürer and the Expressionist prints of Emil Nolde (Fig. 124). Nolde, working early in the twentieth century, attacked the wood with a passionate energy. The cutting action of the artist's

Plate 18. CARLO CRIVELLI.
St. Peter, detail of a wing panel of the *Demidoff Altarpiece.* 1476.
Oil and gold leaf on limewood,
entire panel 4′6¾″ × 1′4″ (1.39 × .41 m).
National Gallery, London (reproduced by courtesy of the Trustees).

right: Plate 19.
MORRIS LOUIS. *Saraband.*
1959. Acrylic on canvas,
8'4½" × 12'5"
(2.55 × 3.78 m).
Solomon R. Guggenheim
Museum, New York.

below: Plate 20.
GEORGE OVERBURY
(POP) HART.
Fireworks. 1926. Watercolor,
21⅞ × 27¾" (56 × 70 cm).
Cleveland Museum of Art
(bequest of
Mrs. Henry A. Everett for
the Dorothy Burnham Everett
Memorial Collection).

left: **Plate 21.** HELEN FRANKENTHALER.
Essence Mulberry. 1977.
Woodcut, 39½ × 18½″ (100 × 47 cm).
Produced and published by Tyler Graphics Ltd.
Copyright 1977 Helen Frankenthaler.

below: **Plate 22.** ROBERT MOTHERWELL.
Bastos. 1975. Lithograph,
5′2⅛″ × 3′4″ (1.58 × 1.02 m).
Produced and published
by Tyler Graphics Ltd.
Copyright 1975 Robert Motherwell.

Plate 23. PIET MONDRIAN.
Composition in White, Black and Red. 1936.
Oil on canvas, 40¼ × 41″ (102 × 104 cm).
Museum of Modern Art, New York
(gift of the Advisory Committee).

below: **125.** Blocks used for making wood engravings are often composed of laminated pieces glued together. The grain is vertical.

right: **126.** THOMAS BEWICK. *Solitary Snipe,* from *Water Birds and British Birds.* 1797–1804. Wood engraving. Metropolitan Museum of Art, New York (Harris Brisbane Dick Fund, 1931).

the wood grain in the block, the knife-cut edges of the calligraphy, and the warm color, surface texture, and uneven outer edges of the Japanese paper on which the blocks are registered.

Wood Engraving When designs are cut on the flat surface of boards, parallel to the grain of the wood, as in the woodcut, the direction and varying densities of the wood affect the cutting of the block. By laminating small sections of wood so that the ends of the glued pieces are aligned and planed flat, a hard and nondirectional surface can be obtained; this is ideal for inscribing many small marks and closely spaced lines (Fig. 125). Blocks of this type are used to make *wood engravings.* Though the wood engraving is inked in a manner identical to that used in woodcuts, the use of great numbers of fine lines can create the illusion of a full range of tonality in the images. This tonal capability is illustrated in Figure 126, the work of the British author, naturalist, and artist Thomas Bewick, whose studies of birds and mammals were published in the late eighteenth and early nineteenth centuries. A careful examination of the illustration will disclose the inventive variations introduced by the artist as he cut the block. The use of the cutting tool added another level of visual detail, offering aesthetic rewards if the print is carefully studied.

Intaglio Prints

Engraving *Engraving,* or cutting lines into soft metals with sharpened tools, was a frequent method of decorating bronze, silver, and gold thousands of years before the birth of Christ. The use of the engraving tool, the *burin,* was known to many excellent draftsmen. They were also familiar with a method of enhancing the engraved decoration of silver and gold with a material called "niello," a black paste filler that was forced into engraved lines to provide contrast against the uncut metal. The effect was an attractive play of the reflective metal surface against the mat black line. Niello engravings were popular throughout Europe and could be found in many places before the twelfth century.

At times the artists who were cutting engraved images took impressions of their work in progress by filling the uncompleted graved lines with niello and then pressing the design on a sheet of paper. It was only a matter of time before they recognized that the metal engraving process used for decorating chalices and cups could be readily adapted to the production of multiple images. By the mid-fifteenth century, engraving became a printmaking process.

In engraving lines are formed by cutting into the metal plate, much as a draftsman draws with a pen. After the lines are cut, the entire plate is covered with a viscous ink and then wiped clean with a nonabsorbent cloth. Excess ink is removed from the surface of the plate but allowed to remain in the cut lines, exactly as in niello decorations. When the plate is covered with paper and subjected to pressure, the ink in the lines is transferred to the paper. This form of printmaking is called *intaglio,* from the Italian word for the engraving process.

Because the painter and the goldsmith often had a common training and frequently were the same per-

son, intaglio printmaking attracted some of the most skilled and talented artists in Europe.

One of the earliest and most celebrated engravings is the *Battle of Naked Men* by the Florentine artist Antonio Pollaiuolo (Fig. 127). Dated only two decades after the earliest known engraving, the print demonstrates the ease with which the medium was employed by Renaissance painters. The artist introduced modeling into the figures and shaded tonal areas into the background. Parallel lines, spaced closely together, create the tonal effects. They are lighter and thinner than the lines defining the contours of the figures. Deeper cutting on the contours ensured that those lines would hold more ink than the secondary parallels. When the ink was transferred to the paper during printing, there occurred a variation in the color of the line consistent with the differences in ink levels.

Drypoint A variant of engraving is *drypoint*. Instead of cleanly removing the metal cut from the grooves by the burin, the engraver manipulates a sharp, heavy needle so that a *burr*, or rough edge, is left on one side of the cut. This burr remains in place during the inking and printing process. As the ink is wiped from the plate, the burr catches some of it; and when the plate is impressed on paper, the trapped ink gives a soft, somewhat blurred appearance to the engraved

lines (Fig. 128). Eventually, if many impressions are made, the burr breaks off and the drypoint line becomes an engraved line.

Etching *Etching*, like engraving, is an intaglio process. The major difference between them is the way in which the lines are sunk into the plate. In an etching the polished surface of a metal plate is covered with an acid-resistant coating (the "resist"), often consisting mainly of wax. When the coating is dry, a needle is used to draw upon it. Little pressure is required, for the etcher wants only to remove lines of resist, not to cut into the metal. Drawing upon the resist is easy, as compared to the pressure and control required to engrave metal. The artist is free to use the needle as if it were a pen. Upon completion of the drawing, the plate is immersed in a "mordant," an acid that eats through the open lines in the resist to bite depressions in the plate. When the plate is taken from the acid and the resist removed, the plate is covered with ink-retaining grooves much like those in an engraving.

As in the case of engraving, darker lines are created by making deeper grooves that hold more ink, but in the etching this change in depth is controlled not by the pressure of the stroke on the plate but by the length of time the metal surface is subjected to the chemical bite of the acid bath. When the etcher wishes to keep some lines light, this can be done by

127. ANTONIO POLLAIUOLO. *Battle of Naked Men.* c. 1465. Engraving, 16¼ × 24¼″ (41 × 62 cm). Metropolitan Museum of Art, New York (purchase, 1917, Joseph Pulitzer bequest).

above: **128.** REMBRANDT.
The Goldweighers' Field. 1651.
Etching and drypoint,
early impression;
4¾ × 12⅞″ (12 × 33 cm).
Pierpont Morgan Library,
New York.

right: **129.** REMBRANDT.
Christ Healing the Sick
("*The Hundred Guilder Print*").
c. 1649. Etching, second state;
10⅞ × 15½″ (28 × 39 cm).
Metropolitan Museum of Art,
New York (bequest of
Mrs. H. O. Havemeyer, 1929,
H. O. Havemeyer Collection).

pulling the plate out of the mordant, covering those lines with acid resist, and then returning the plate to the bath so that the remaining lines may be etched more deeply to print darker.

The etching is printed by exactly the same procedure developed for engravings. Though iron plates were used for early etchings in some parts of Europe, they were quickly superseded by copper, which became the preferred metal for this medium. Current etching practice continues the use of copper, but aluminum and zinc are also frequently employed.

In the prints of Rembrandt van Rijn etching reached extraordinary levels of expressive and aes-

thetic achievement. A great draftsman, Rembrandt was capable of drawing freely on the plate without sacrificing the control required for the creation of a convincing image. In addition, the concern for light that dominated his paintings was transferred to his prints. The dramatic use of dark, transparent areas in his etchings gave them a rich tonality and offered compositional devices not previously exploited in prints. In the etching *Christ Healing the Sick* (Fig. 129) the artist used an impressive variety of linear drawing techniques to convey a sense of light, form, and space. He also inked the plate in an unorthodox manner to enhance the spatial atmospheric effects. By

wiping the plate carefully, he was able to leave a thin coat of ink on some portions of the surface, while cleaning other areas to a high polish. When the plate was printed, the varying tonalities of wiped ink reinforced the etched tones, producing a range of values that could not be obtained with the etched line alone.

Mezzotint and Aquatint Efforts to extend the capacity of intaglio plates to achieve tonal variations without the use of linear cross-hatching led to two technical innovations. The first of these is *mezzotint.* In this process the polished plate is covered with a texture composed of thousands of small depressions created by rocking a multitoothed instrument, called a "hatcher," back and forth over its surface. Inking and printing this surface would produce a deep, uniform black, but the printmaker carefully scrapes and burnishes areas of the plate to be lightened. The scraping operation reduces the depth of the depressions so that they will hold less ink and therefore

left: 130. MARIO AVATI. *Nature Morte à la Danseuse.* 1962. Mezzotint, 11½″ (29 cm) square. Associated American Artists, Inc., New York.

below: 131. BARTOLOMEU DOS SANTOS. *Figure in Space.* 1970. Aquatint, 30 × 16⅜″ (77 × 42 cm). Courtesy Curwen Gallery, London.

below: 132. ALEXANDER COZENS. Blot from *A New Method of Assisting the Invention in Drawing Original Compositions of Landscape.* 1785. Aquatint. Beinecke Rare Book and Manuscript Library, Yale University, New Haven, Conn.

133. Peter Milton.
Daylilies. 1975.
Etching and engraving,
$19\frac{7}{8} \times 31\frac{7}{8}''$
(50 × 81 cm).
Courtesy Impressions
Workshop Inc., Boston.

print lighter. Gradually, the artist produces shallower ink-holding areas for lighter and lighter tones, until finally the portions that are to print white are polished back to the original untouched state of the plate. When the process is completed, the plate is covered with a manually produced surface of minute depressions that vary in depth according to the tonality desired. The mezzotint plate can yield a velvety black that is unobtainable through any other printmaking process, but the method is so laborious that very few artists use it (Fig. 130).

A second method of producing intaglio tonal areas was developed in the last half of the eighteenth century, and it has remained as one of the basic techniques of the contemporary printmaker. Called *aquatint,* possibly because of its early use in imitating wash drawings, the process is relatively simple and quick (Fig. 438). The plate, often with an etched linear image already in place, is covered with an even dusting of powdered rosin. Heat is applied, and the rosin dust melts slightly, causing it to adhere to the metal. The plate is then immersed in acid. Those areas covered by the rosin are protected from the biting action of the mordant, but the spaces between the dust particles admit the acid and the plate is eaten. The length of time the acid works on the plate determines the depth of the bitten texture produced, and this in turn affects the value of the tones printed. To control the bite on areas intended to print as light tones, the plate is removed from the acid bath so that those areas can be covered with an acid-resistant coating. When the plate is returned to the acid, the biting continues except on the protected areas. Suc-

cessive repetitions of the application of protective resist and re-etching finally result in a plate that can be printed with a variety of flat tonal masses incorporated into the composition (Fig. 131).

One final variation on the aquatint is worth mentioning. Called *lift-ground* aquatint or etching, it enables the artist to realize images that have the quality of freely brushed calligraphic drawings (Fig. 132). A rosin coating is applied to a polished plate, just as it is for the standard aquatint. After the plate has been heated, the printmaker paints an image on the rosin surface with a syrup of sugar and water. The dried painting is then covered with the usual acid-resistant coating. When this stage is complete, the plate is immersed in water. The portions of the resist that covered the syrup brush strokes are lifted from the plate as the water dissolves the sugar mixture underneath. As a result of this procedure, when the plate is put into the acid bath, those portions once covered with the syrup are exposed to the mordant, and those originally untouched by the artist's brush strokes are protected. When the plate is removed from the acid, inked, and printed, the image of the brushed composition on the paper has the quality of the broad calligraphy characteristic of brush and ink drawings.

Recent intaglio prints range in style from images similar to some of the earliest examples of the medium to complicated combinations of several intaglio techniques. Both manual and photographic methods were used in *Daylilies* (Fig. 133), a print by the American Peter Milton. Milton began his print by drawing on the surface of an acetate plastic sheet.

above: 134. CURRIER & IVES.
Night Race on the Mississippi. 1860.
Lithograph, $18\frac{1}{8} \times 27\frac{1}{8}''$ (46 × 69 cm).
Museum of the City of New York
(Harry T. Peters Collection).

left: 135. ROBERT RAUSCHENBERG. *Break-Through.* 1964.
Lithograph printed in black, $41\frac{1}{2} \times 29\frac{7}{8}''$ (105 × 76 cm).
Museum of Modern Art, New York
(gift of the Celeste and Armand Bartos Foundation).

This drawing was transferred photographically to a copper plate. Photographic methods were also employed to develop the central portion of the composition. Additional use of hand engraving techniques was required to complete the print.

Lithography

Lithography is a planographic process; that is, unlike relief and intaglio prints, which depend on difference in the height of the inked and noninked surfaces of the master matrix, a lithograph printing surface is essentially flat. The artist draws directly on slabs of limestone ground to a level granular surface. Wax crayons and special inks with a high fat content are used. As the crayon is pulled across the grains of stone, it leaves microscopic pieces of wax behind. Some grains receive large amounts of wax, others are touched lightly, still others are left bare. A thin, light line would touch only a few grains and deposit only

small amounts of wax. A heavy line would leave a wider trail of grains that had been in contact with the drawing medium. In the application of large areas of tone, thousands of separate grains are touched by the crayon. Once the drawing is completed, the stone is dampened with water, and, by reason of the incompatibility of oil and water, those grains holding the wax repel water and accept an oil-based ink, while those grains free of the crayon drawing accept water and repel ink. In this way the drawing image, itself an original work from the artist's own hand, becomes the basis for the inked impression.

Introduced at the beginning of the nineteenth century, lithography quickly became popular. In both its commercial applications and its studio capability it satisfied the stylistic requirements of many artists. Toulouse-Lautrec designed large colored posters to advertise the night life of Paris, using lithography to produce flat, simple areas and a quickly drawn, free line (Fig. 47). In the United States the firm of Currier & Ives printed lithographic posters for "six cents apiece wholesale." For them, carefully shaded drawings were made by anonymous draftsmen, and after the posters were printed in black and white, teams of young women tinted them with paint in assembly-line order (Fig. 134).

Like all the printmaking media, contemporary lithography has taken its place as an important alternative to the other two-dimensional arts. Metal plates, as well as stone, are now used to print editions of lithographs that rival painting in their visual effects. Especially suitable to the printing of flat color fields, lithography offers the painter who uses color-form organizations a method for obtaining multiple images of the color effects developed in paintings (Pl. 22, p. 99). There are printmakers who take pleasure in creating textural and tonal qualities that can be achieved only with this medium. They tease and coax the stone to perform, allowing the image to form out of the process itself (Fig. 135).

Serigraphy

The simplest, most recent, and popular printmaking process is *silk screen*, also called *screen printing* or *serigraphy*. This medium is an extension of the process of stenciling which has been used since the time of cave dwellers as a method for producing multiple images. Hands were stenciled on the walls of caves in Spain in prehistoric times. In Japan, during the seventeenth and eighteenth centuries, intricate stencils, made of layers of laminated paper, were prepared for the printing of fabrics. Strands of hair held the delicately cut interior designs securely in position and tied the center sections to the outer edges. Stencils were used by the Chinese fifteen hundred years ago,

and in Europe, from medieval times, they have functioned to provide printed patterns for wallpaper and fabrics.

Even the most complicated stencils are essentially the same as those made by primitive peoples. Openings are cut in a durable material, which is placed over the area meant to be printed. Paint, usually in a viscous form, is applied to the stencil with a stiff brush or cloth. Wherever the stencil has an opening the paint passes through. Areas that are covered by the stencil remain blank. By using several stencils in succession, registered so that their openings have a planned relationship to one another, and by forcing different colors through each stencil, the printmaker can fashion fairly complicated designs.

In silk-screen printing a gauzelike mesh of silk, nylon, or metal is stretched over an open frame. A stencil is adhered to the mesh. The printmaker uses a rubber-bladed tool called a "squeegee" to force thick, creamy ink or paint through the silk. When the screen is lifted, the image remaining on the ground appears in the form created by the open portion of the stencil. As in the case of other stencil prints, a number of screens can be employed to add colors to the print (Fig. 55).

This process has been used commercially for years to produce signs, labels, and printed fabrics. In the 1930s printmakers began to work with silk screen in their studios. Their prints were called "serigraphs" to distinguish them from the products of the commercial silk-screen plants. The medium has many attractions for the printmaker. Perhaps the most important of these is the limited expenditure of funds needed to set up a print shop. No press is required; almost any flat table can serve as a suitable printing surface. Screens are easily made, and almost any kind of paint can be used for printing.

The comment is often made that the arts are expressions of their time. To understand fully the implications of this statement it is necessary to consider not only *what* has been formed by the artists but also *how* the images have been formed.

If, for some, an understanding of the artist and the artist's environment is the key to achieving an aesthetic response, a knowledge of these processes will be useful. For those who seek a more direct interaction with a work of art, who are less interested in explanations than they are in responding to the stimulus of an immediate experience, a knowledge of the processes may be less important. But even for them there is the increased possibility of experiencing delight when they approach a work of art with a perception enhanced by sensitivity to the demands, limitations, and possibilities of a medium and the processes required to control it.

Two-Dimensional Organization

An artist constructs each work by organizing its plastic elements into a unique compositional arrangement that satisfies the intention. A painter may, in one instance, combine color, form, texture, and line to produce a representational image; in another, these same elements may be combined in an entirely different way to express a personal response to a highly emotional experience. Basic to every art object is a central intention, a focus, which requires the artist to make decisions about the number and kind of elements to be used and the way they will be arranged within the edges of the composition.

Ideally, every element in a work of art should be an essential component of the artist's intended representational, functional, expressive, or aesthetic meaning. It is this unified combination of selected elements which gives the work its meaning, and an observer who approaches a work of art must be able to recognize that the elements are unified in order to understand or appreciate their significance. In all art, unity and meaning are closely related. The appearance of a work of art rarely results from a purely expressionistic or representational intention on the part of the artist. Most often it is possible to recognize aspects of an art object which take their form from the artist's desire to give the work an aesthetic order. Frequently it is difficult to separate this order from the total content of the work. The expressive meaning of a blue form in a painting is achieved by its position on the canvas, by the particular color and shape of the form, and by the interaction between this part of the painting and the other parts that surround it. This meaning may also be determined by the identification that the viewer makes between the blue form and objects in nature. The blue form may be a part of a pattern of color forms, which can reveal itself to those who are aware that such a pattern may exist, and the content of the painting will be intensified or broadened when the viewer can recognize the multiple functions played by the elements in it.

In many art objects the expressive or descriptive aspects of the elements are restricted. In some, these elements are employed solely as parts of an aesthetically satisfying unity. What can stimulate a viewer to respond to the appearance of a calligraphic line? The line is not a symbol. It does not describe or express an experience of anything seen in nature. The observer's response to the line must depend upon the direction,

136. Development of calligraphic strokes.

the rhythms, and the texture resulting from the drawing instrument, and then upon the position of the line on the sheet of paper. Imagine a calligrapher at work, starting with an empty sheet. If the artist begins a stroke, pen filled with ink, intending to make the stroke three times the length of the initial mark, how shall it be completed? Figure 136 suggests possible alternative solutions. It is not necessary here to agree on one of these in preference to the others. It is important to realize that one of them, or one of many possible variations, will be chosen. After that choice has been made, others will be needed before the drawing is complete; more strokes may be added, or other instruments used.

In the process of working, the artist continually makes choices from the infinite range of available possibilities. Once the art object has been started, some choices seem to follow inevitably from previous decisions. Forms and colors in the work suggest other forms, other colors, to a painter; the shapes and surfaces in a piece of sculpture suggest related treatments to the sculptor. The aesthetic order sought by the ceramist, the sculptor, the painter, or the architect can be developed in many ways that are basic to all the visual arts. Young art students are introduced to these methods in the early phases of their training, and it will be useful for those who wish to understand the visual arts to acquaint themselves with a number of the ways employed to organize art objects. However, it should be understood that the skillful plastic organization of a work of art does not in itself ensure the production of a masterpiece, any more than the work of a skilled grammarian necessarily produces a great novel. Often, the person who defies the traditional aesthetic form or who creates new forms of order is the one who produces the extraordinary work of art. A slavish adherence to established principles can result in a dull, academic exercise. Despite this possibility, it is still valuable to understand certain basic organizational principles, so that even those works of art which appear to be a reaction to precedent can be seen in contrast with it.

Unity and Variety

Aesthetic unity is achieved when the parts of an art object fit together in some identifiable order. The order, or organization, of the elements may appear to be simple or it may be highly complex; it can be based upon one or several characteristic qualities in the elements.

Perhaps the simplest method for creating unity within a work of art is by repeated use of similar or identical elements.

In Figure 137 the large rectangle is divided into four similar areas. This is a design in which there are many repeated elements. All the forms are rectangles, and all the rectangles are identical in size and shape. Their color is the same. They are placed so that their long and short axes are parallel. This extensive repetition produces a unified design, but though the similarity between the several elements is immediately recognizable, the design has little interest for most viewers. Yet the composition is undeniably unified. If the observer seeks meaning (and meaning in the visual arts derives from aesthetic order), why does the diagram in Figure 137 seem so dull? Psychologists tell us that the need to understand, to find meaning in the world about us, is coupled with a need for stimulation and involvement. We need to be challenged; we need problems to solve, mountains to cross. We require a sense of participation in our environment.

137. Repetition of forms in a rectangle.

138–141.
Variation in rectangular forms.

138

139

140

141

The artist recognizes the need to involve observers by presenting them with a work that is ordered and seems comprehensible, but at the same time the observers must not be bored. A work of art must provide enough of a challenge to maintain the interest of those who stop to view it. It must have unity, but it must also have within this unity a complexity, a difficulty, to involve the viewers in a search for a meaning that they sense must be there. Both attributes, unity and complexity, or, as it is often called, variety, are essential to any work of art, and the measure of an art object is often the result of the skill of an artist who combines the elements into a unified whole with the imagination that adds variations to and within the basic unity.

In Figure 137 a more pleasing composition would result if some of the elements were unified and others were used to provide variety. The rectangle in Figure 138 is the same as the rectangle in Figure 137. The four forms within the larger one are identical with those in the previous drawing, but the color of two of the areas has been changed. This design is not exceptionally exciting, but even a variation as simple as this adds interest to the original composition.

Figure 139 demonstrates another variation on the original design. Again four small rectangular forms are drawn. Unity is retained by repetition of rectangularity in the forms and by repetition of color, but the rectangles are no longer of identical proportions and size. Their major axis has been shifted, too, adding

still another variation to the design. Figures 140 and 141 demonstrate two other ways of varying the basic scheme. In each one there remains enough similarity in the character of the four separate forms to give a sense of unity, but at the same time each drawing exhibits a variation or a number of variations which add a certain degree of complexity.

Obviously, it is possible to combine a number of these variations in one design. The painting *Composition in White, Black, and Red* by Piet Mondrian (Pl. 23, p. 100) is an excellent example of just this kind of play with similar and dissimilar characteristics. Using a minimum of means, the artist devised a composition in which the space of his canvas is divided into rectangular areas. Careful examination of the painting will show that areas which seem identical, including the width of the lines, have been subtly varied. The long red rectangle at the bottom of the canvas and the area of black at the top effectively contrast with the white rectangular forms separated by the black lines.

The apparent simplicity of this painting is misleading, for it is a painstakingly controlled composition. The precise size, shape, color, and position of the elements on the canvas are those which the artist felt were the optimum choices for the creation of the greatest aesthetic effect. It is the precision of the decisions that makes this painting complex, so that a seemingly simple composition can, in fact, result from complex interrelated and interdependent choices.

142. Compositional analysis of Plate 25 (p. 117), Rubens' *Tiger Hunt.*

The paintings of Josef Albers are superficially even simpler than those by Mondrian. The example of Albers' work in Plate 24 (p. 117), *Study for an Early Diary,* is composed of three square forms aligned on a vertical axis. Each of the forms is painted in a single, relatively flat color. Actually, it is incorrect to describe this painting as having three squares, for only the center form is a square. The other two forms are more accurately characterized as square "doughnut" shapes. Such distinction is important, because the composition is based upon the effects produced by the interaction of color areas enclosed by other areas of color. By surrounding the blue center square with orange and the orange area with pink, Albers produced a brilliant, rather mysterious color experience. The painting seems to radiate light, and the flat forms appear to shift in space, moving toward the observer and then away.

The complexity in this painting depends upon the precise selection of the colors, the arrangement of those colors, and the size of the color areas. Albers restricted the shape of the forms, severely limited the number of the forms, and applied the paint to the surface of the canvas in a simple and direct way. But even means as minimal as these provide the artist with combinations and variations of color and form that are overwhelming in number.

An adequate response to paintings of this type requires a highly discriminating sensitivity to the interaction of color. For those who can recognize the differences between very similar hues and values of color and the way color areas appear to change when related to other areas of color, this form of painting offers the basis for a satisfying aesthetic experience.

Plate 25 (p. 117) is a painting by Peter Paul Rubens, dated in the seventeenth century. Though an initial glance at this painting may give the viewer the feeling that it is very much like a photograph, a closer study will disclose important differences between the mechanical system of photographic representation and the work of this artist. Rubens was extremely careful about the organization of his work. Wherever possible, he repeated curved lines and curved forms to achieve a basic unity. Note the repetition of the curve in the back of the tiger as it continues through the body of the attacked rider. This curve is echoed by the movement of the breastplate of the rider at the right. It is picked up and repeated innumerable times throughout the rest of the painting, as can be seen in a compositional analysis of the painting (Fig. 142). Even the arms of the figure fighting with the lion have been stylized into curved muscular forms.

This composition, in its purposeful organization, is similar to the Mondrian. It differs in that here the basic design has been used as a skeleton for the arrangement of human and animal forms, whereas in Mondrian's work the skeleton and the finished forms are one. In both cases, however, the repetition of qualities in the elements is one of the basic means for the unification of the work.

143. SOL LEWITT.
Fifteen-Part Black-White Composite. 1978.
Wall drawing, pencil. Courtesy the artist.

above: 144. Detail of Figure 143.
below: 145. Close-up detail of Figure 143.

The large wall drawing by Sol LeWitt shown in Figures 143 to 145 provokes some interesting questions. How much unity or how much variety is necessary in a composition to provide sufficient stimulation for an aesthetic experience? LeWitt's drawings are often executed by assistants who work from his written instructions. In the example shown here, pencils were used to draw the thousands of individual straight lines covering the surface of a wall in the Museum of Modern Art in New York City. From a distance the repeated graphite marks give the wall a slightly modulated color. Walking toward the drawing, one reaches a point at which the tonality is revealed as a pattern of lines. Closer inspection proves that the apparently equal spaces between the lines vary slightly, some lines being closer together, some farther apart, as a natural result of slight inaccuracies in measurement and draftsmanship. This is a *humanizing*, almost automatic, variation on an ideal *written* conception. It introduces visual characteristics to the drawing that result from the fact that the lines were formed by persons, not machines. Their eyes and hands were incapable of absolutely accurate control.

Even closer inspection of the lines offers a viewer still another level of perception. The granular track of the pencils changed in width and tonality as the graphite points wore down from their initial sharpness to broader dimensions. Thus the drawing, which from a distance had an almost nonexistent organization, takes on increased levels of complexity as a result of the observer's changing perception. The composition becomes more complex when the observer moves across the room to a position close to its scribed surface.

LeWitt begins the drawing by describing it in terms specific enough to permit his assistants to draw the required marks. They, in turn, introduce random characteristics in the drawing that the artist might have anticipated but could not not predict precisely. Finally, the perceptions of each observer add a final component, transforming the image from one of its visual states to another as a result of changing position in relation to the work.

Artists know that aesthetic satisfaction can be derived from unraveling innovative and demanding compositions; and they devote ingenuity and craft to the invention of provocative combinations of related visual elements that will involve the perception, intelligence, and imagination of the viewer. But compositions such as LeWitt's, like the complex patterns in Oriental rugs, suggest the possibility that the very nature of human perception encourages the discovery of unity and variety even when no preconceived compositional system exists. If the artist presents the viewer with enough units to "play with," and the viewer is sufficiently intrigued with the puzzle, a composition can take form as a result of the creative cooperation of artist and observer.

In LeWitt's drawing the thousands of lines and intersections, with their unplanned variations of space and tonality, provide the material necessary for this process. The drawing is never seen in its entirety. When the viewer is far enough away to have the whole wall surface within the visual field, the individual lines and their relationships cannot be seen. When the viewer is close enough to see these details, only a portion of the surface is available for careful study. At any one time the viewer will *attend* to a limited number of visual events, selectively perceiving some and neglecting others. This selective perception is not consciously controlled; it depends upon unpredictable patterns in observation that satisfy a need for organization. We distinguish in the drawing a unity that is *potentially* there from many other unities potentially existing in it. And, given the complexity of the design that originates this cooperation of artist and observer, the initial composition can be reconstructed repeatedly into many alternative satisfying arrangements.

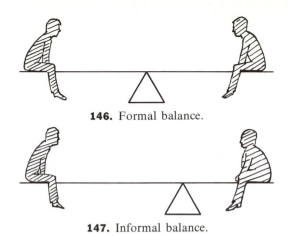

146. Formal balance.

147. Informal balance.

Unity through Contrast

Unity may also be found where seemingly it should be absent—in contrast. If repetition of similar qualities in the plastic elements produces unity, contrast might appear to be an ideal way of creating chaos. Contrast may be defined as a relationship between extremes, an expression of differences. This definition in itself hints at the unity of contrast. The statement that contrast is a *relationship* assumes that there is a connection between the contrasting parts; they are joined as extremes of the same or similar characteristic qualities. Black and white are bound together, as are green and red, empty and full, or up and down. In each instance the presentation of one-half of a polar couple calls forth its opposite number. Each part of the combination seems to need the other to reach completion, a state of equilibrium. The union which results from the combination of two opposite elements demonstrates a resolution of forces. It is a unity that most people can sense immediately. Often it is referred to as a "sense of balance."

It is rarely possible to find obvious examples of precisely balanced compositions. Yet an understanding of the principles of visual balance may be useful in the perception of unity through contrast.

The simplest form of balance is the duplication of forces in operation on both sides of a fulcrum, as in placing two children of equal weight at equal distances from the center of a seesaw. This kind of balance, in which one side is identical to the other, is called "formal" (Fig. 146). It is an extremely limiting method of creating equilibrium. An artist who uses it must be prepared to repeat all elements on each side of the center line. However, it is possible for two children of different weights to balance themselves on their seesaw by adjusting the distance between themselves and the center of the board, so that the heavier one is closer to the fulcrum. A similar adjustment can

148. When forms are identical in shape and color, size affects visual weight.

When forms are identical in shape and size, color affects visual weight.

Shape can affect visual weight, though mass and color may be similar.

be made to achieve balance in art. This kind of balance, in which unequal elements are resolved, is called "informal" (Fig. 147). The artist can bring dissimilar elements together to equal other combinations of dissimilar elements. In the case of the seesaw, weights and distances are combined so that their product is equal, even though the individual parts are different. But the elements need not be restricted to two. As our visual interpretation of balance changes from actual physical weight to other kinds of "weight," such as the "weight" of colors, the "weight" of textures, or even the "weight" of ideas, it is possible to perceive rather complex combinations of elements as equaling other combinations and therefore in balance with them (Figs. 148, 149).

These examples of balance are very simple, but once a composition becomes complex and many different colors and irregular shapes are introduced, it is impossible to arrive at a balanced composition by a mechanical method. Balance in the visual arts is a function of *visual weights*. The apparent weight of an element in a composition may vary as its color is changed, its shape is altered, or its texture or size is varied. Its position on the sheet of paper or the canvas is a critical factor in this system. Elements may vary in weight as they are moved from the bottom to the top or from side to side in a composition (Fig. 150). Even the symbolic significance of an element may influence its effect on the balance of a composition. For instance, a gray rectangular form will have a certain weight in a composition, depending on its size,

149. The symbolic content of a form or group of forms can add visual weight to an area. Because the forms below are grouped to read as a word, their visual weight is affected.

150. Visual weight can be affected by the position of the form in relation to the edges of the space being composed.

151. Visual weight
can be increased by the use
of an added level of meaning.

shape, position, color, and surface variation. When a photograph of about the same tonality is substituted for the rectangle, the visual weight increases, because the photographic image gives an added level of meaning to the form it fills (Fig. 151).

Obviously, the complexity of even the Mondrian painting (Pl. 23, p. 100), composed with apparent simplicity, requires more than a mechanical placement of elements to arrive at a state of equilibrium. The most one can say regarding the attainment of such an end is that the artist arrives at it intuitively and the viewer's intuition must be used in responding to the visual evidence. With so many variables affecting the weight of the plastic elements, no artist can consciously control all the significant factors that must be resolved in the balance of a work of art. Nevertheless, because of the need to achieve a feeling of equilibrium in studying each work, the artist organizes the elements in it toward that end, whether consciously or intuitively.

Another use of contrast for the organization of painting occurs in the work of "optical" artists such as Richard Anuszkiewicz (Pl. 26, p. 118) and Bridget Riley (Fig. 152). Anuszkiewicz was a student of Josef

152. BRIDGET RILEY. *Current.* 1964.
Synthetic polymer paint
on composition board,
4'10⅜" × 4'10⅞" (1.48 × 1.5 m).
Museum of Modern Art, New York
(Philip Johnson Fund).

153. Movement and continuity.

Albers and, like Albers, he concerns himself with problems of color interaction. His paintings are composed of simple geometric forms, usually divided into small areas. By restricting the light-and-dark (value) contrast of his colors and exploiting the juxtaposition of hues with such combinations as red and green, orange and blue, or violet and yellow, Anuszkiewicz produces paintings that seem to shimmer and vibrate.

If the traditional concept of aesthetic balance is applied to the Anuszkiewicz canvas, the composition is seen to be symmetrically organized. In fact, the color areas and the forms in which they are arranged are formally balanced along both the vertical and horizontal axes. Given the degree of symmetry in this painting, an observer might expect to find a stable, somewhat restrained composition. Instead, the work is vibrant and exciting. Substituted for the contrast of forms that might have produced this excitement in an asymmetrical arrangement is a contrast of adjacent color areas.

Similarly, the English artist Bridget Riley presents us with a composition that employs symmetry along a horizontal axis in combination with a repeated linear form that alternates black and white (Fig. 152). Here, too, the dynamic visual impact results from the contrast of adjacent areas of color.

The seemingly shimmering surfaces in both these paintings demonstrate the response of the human eye to agitating patterns. It is correct to say that these two examples are balanced, but this description does not explain how opposing elements have been joined to create a dynamic composition. The unity in both paintings depends, in large part, on the fact that each color form is a part of an interacting matrix. Variety is not introduced by the usual methods but comes from *optical* shifts and movements in the perception of the observer.

The use of color contrast to produce vibration is not, in itself, an innovation. The Impressionists adopted this device, but in Impressionist painting the vibration of areas was employed as a means for the representation of flickering light and shadow in nature (Pls. 7, 8, p. 26). In the later paintings sensory stimulation replaces representation as the essential intention of the works. Paintings like those by Riley and Anuszkiewicz have been grouped into a category identified as "optical," or Op, art. Actually, all paintings are in a sense optical, for they all depend upon the function and the limitations of the human eye for perceptual response. However, Op painting differs from earlier types in that the organization of the works is almost totally dependent upon a pattern of interacting color forms.

The observer, like the artist, seeks a world in balance; both respond to a sense of forces in equilibrium. But unless the observer realizes that visual balance depends upon the relationships between many plastic elements, only the most obvious or familiar visual weights will stimulate a response. Given enough time, however, even an untrained observer can learn to recognize the significance of many of the plastic elements in a balanced composition.

Unity through Movement and Continuity

In Figure 153 the reader is given a prescribed path to follow, which moves from separate element to separate element and ties them all together by virtue of a continuous visual sign. The drawing offers a series of visual orders which moves the observer in a step-by-step awareness from part to part—now up, now to the right, then down, and back again. No matter how complex the path, no matter how devious the route, the observer who can follow it is able to sense a continuity between individual elements, because they are connected by a ribbon of linear movement which is easy to follow.

In order to unify many different elements in a composition, the artist can make use of this sort of linear connection—can establish a more or less continuous linear path which links all the separate elements into a large, understandable unit. This unit may be very simple—a geometric form such as a triangle or a circle—or it may be developed into a highly complex movement of mazelike appearance.

left: **Plate 24.** JOSEF ALBERS.
Study for an Early Diary. 1955.
Oil on canvas, 15″ (38 cm) square.
Sheldon Memorial Art Gallery,
University of Nebraska, Lincoln.

below: **Plate 25.** PETER PAUL RUBENS.
Tiger Hunt. c. 1616. Oil on panel,
3′2″ × 4′3/4″ (.97 × 1.24 m).
Wadsworth Atheneum, Hartford, Conn.
(Ella Gallup Sumner
and Mary Catlin Sumner
Collection). (See Fig. 142.)

Plate 26. RICHARD ANUSZKIEWICZ.
All Things Do Live in Three. 1963.
Acrylic on masonite, $21\frac{7}{8} \times 35\frac{7}{8}''$ (66×91 cm).
Collection Mrs. Robert M. Benjamin, New York.

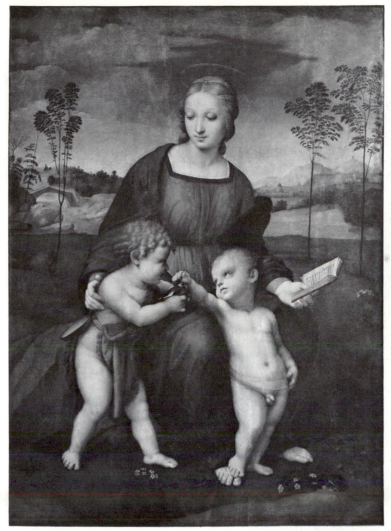

above: **154.** RAPHAEL.
Madonna del Gardellino. 1505.
Oil on panel, 42 × 29½″ (107 × 75 cm).
Uffizi, Florence.

155. Compositional analysis of Figure 154.

In the *Madonna del Gardellino* Raphael adopted such a device (Fig. 154). By it he was able to group the major elements of the painting into a triangular structure (Fig. 155). The three figures, the two infants and the female figure, are contained within the space of the triangle. This simple geometric form is easily recognized and provides the unifying basis for the entire composition. Also, this large triangle sets the pattern for many secondary triangular motifs, which the artist repeated in the position of the children's legs and in the movements in the drapery. The composition is an instance of unity by repetition reinforcing unity by continuity.

Repetition, balance, and movement, or continuity, are often combined as unifying methods in a single work of art. An artist uses whatever seems most appropriate and most effective to support and intensify the content of an image. Decisions on color, form, line, and texture may be made consciously, but often they are part of a sequence of intuitions that occur as the work progresses, each element tested against others already in place until the combinations feel right and no further adjustment is called for.

Henri Matisse' *Pink Nude* (Pl. 27, p. 135), evolved over an extended period of time as the artist, proceeding by trial and error, gradually approached the

156–159. HENRI MATISSE. Four states of *Pink Nude* (Pl. 27, p. 135). 1935. Oil on canvas, 26 × 36½" (66 × 93 cm). Baltimore Museum of Art (Cone Collection).

right: 156. First state, May 3, 1935.

157. Third state, May 29, 1935.

final image. Beginning with a rather traditional representation of the female figure (Fig. 156), Matisse painted and repainted the forms of the model and the setting in which she was posed (Figs. 157–159). As the drawing changed under the artist's repeated revisions, the distribution of color changed. Progressively, the pink area within the drawn form of the figure came to dominate the composition. The rectangular blue-and-white chaise—contrasting against the warm curved central form and the yellow area that once represented flowers—now sits strangely in the background, filled with an energy that threatens to push it

forward. A spatial tension has been established between the yellow patch and the strongly stated frontal position of the left arm, drawn in an enlarged scale and tied to the lower (the most forward) edge of the canvas.

Matisse' realization of the composition was a form of purification. He purged redundant details, clarified and exploited essential contours and forms, using each stage in the sequence as preparation for the stages that followed. The *Pink Nude* now known to us exhibits such a comfortable disposition of linear edges and flat color areas that the viewer may well

158. Fourth state, June 20, 1935.

159. Sixth state, September 15, 1935.

take the painting to be the result of a rapid, spontaneous composition. This effect is a measure of the artist's skill, for only a master could have maintained the freshness of his original vision throughout the many weeks of active decision-making that Matisse committed to the *Pink Nude.*

In painting and sculpture, even in architecture, the many acts required for the completion of a work are often so fused into the complex final form that the individual decisions are no longer separately distinguishable. One decision is canceled or adjusted by others. Even some works that offer the superficial

appearance of simplicity may have emerged from an extensive series of choices and procedures, often pursued over great lengths of time. Each stage of the *Pink Nude* was a trial plan, and every time a color area was changed or an edge redrawn, the alteration affected, to some degree, the appearance of all the color areas previously applied. Thus the artist gradually developed the final form of the work.

Matisse' trial-and-error procedure took place directly on the canvas that was to carry the completed painting. Often an artist will develop a final compositional scheme in a set of preliminary drawings or

above: **160.** WINSLOW HOMER. *Undertow.* 1886. Oil on canvas, $29\frac{3}{4} \times 47\frac{5}{8}''$ (76 × 121 cm).
Sterling and Francine Clark Art Institute, Williamstown, Mass.

161–163.
Three of Homer's studies
for Figure 160.
Sterling and Francine Clark
Art Institute, Williamstown, Mass.

right: 161. Pencil and black chalk
on greenish-gray paper,
$7\frac{1}{8} \times 8\frac{5}{8}''$ (18 × 22 cm).

sketches that allows extensive experimentation with alternative combinations of form and color.

Winslow Homer, the American illustrator and painter, witnessed the rescue of a woman from the sea in 1883 at Atlantic City, New Jersey. That year he began a painting of the subject, which was completed three years later (Fig. 160). The painting is a skillful, dramatic evocation of the original experience. Homer preceded the painting with a series of drawings. There is no accurate record of the order in which these drawings were completed, but Figure 161 appears to be an early attempt to decide on a composition. Two figures support the victim between them. The generally vertical postures of the group contrast with the horizontal and diagonal indications of the surf. At the right the artist has made three vertical lines successively testing the best position for the three figures as they relate to the right edge of the composition. The emphasis on the inner vertical indicates his choice, a choice that appears to have been followed in the final painting, even though the group went through many revisions.

Figure 162 continues the use of a three-figured composition, but the forms are arranged in a basically diagonal grouping with a strong horizontal emphasis. The concept of a tightly intertwined group is introduced, and a striding figure enters at the left of the composition, seeming to derive from the figure on the right in the previous study.

By the time Homer produced the drawing in Figure 163, he had established the final relationships among the figures. Much remained to be worked out.

162. Pencil, 5 × 7⅞″ (13 × 20 cm).

163. Pencil on greenish-gray paper, 3½ × 5¼″ (9 × 13 cm).

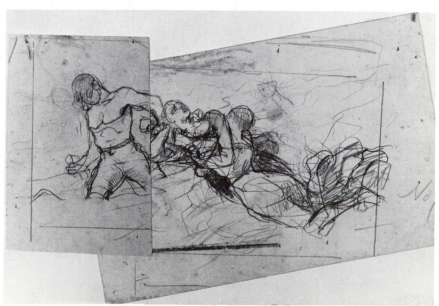

Other drawings exist for this project, and there may have been still others that are now lost. From those reproduced here the reader can see the image develop, gradually moving toward its final form.

Picture-Plane Organization

We can understand painting either as a flat, two-dimensional arrangement of colored forms or as an instrument for presenting illusionistically an equivalent of three-dimensional form and space on a two-dimensional surface. In either case the methods of aesthetic organization contribute to the creation of a unified composition.

If we consider the painting in its actual two-dimensional context, the area to be organized is that bounded by the sides of the canvas. It is a flat, two-dimensional plane of measured length and width. This frontal area is called the "picture plane." When organizing the picture plane, the artist thinks in terms of flat shapes, which may vary in size, shape, color, and pattern. These shapes can be arranged on the surface of the picture plane in an infinite variety of positions. No indication of depth in the painting is considered in picture-plane organization. It is as though the artist worked with a group of cut-paper forms which never overlap.

Pablo Picasso's painting *Still Life with Fishes* (Fig. 92; Pl. 15, p. 79) can be analyzed as a picture-plane composition which utilizes a number of the organizational methods described in this chapter. There is repetition of the shape of the forms. With few exceptions they are triangular sections with straight edges. A number of curved forms are introduced, notably in the railing at the left. These curves are also repeated in the bottom of the drape at the right and in the tail of the lower fish. Triangular forms dominate the composition, but curves in a subordinate grouping help to unify the design. Color, too, is repeated. Black forms and green, yellow, blue, and orange forms are distributed in a complex interrelationship. Sizes of the areas vary greatly, as do the intervals between them, introducing a significant factor of variety within the basically unified composition. A number of edges are disposed so that there is a continuous movement along them. Sometimes this occurs without a break, as in the edge at the top left, which combines black, green, and orange forms in a diagonal that echoes the major diagonal movement of the black form at the right edge of the table. Another movement continues the vertical edge of the right table leg into the form of the curtain. To the left is still another vertical movement along the edge of the table; however, this time it is not continuous but, after a space, is picked up directly above to extend the vertical thrust.

A more extended structural analysis of this painting would show the same methods of organization applied to smaller details. However, an analysis such as the one above comes after the fact of the painting. It is doubtful that Picasso consciously planned all the relationships he organized in this painting; many must have been intuitively felt. Nevertheless, the finished work does take on much of its character from the arrangement of the interrelated plastic elements on the picture plane.

Pictorial Spatial Organization

In contrast to the flattened, picture-plane emphasis of the Picasso, Canaletto's painting *View of Venice, Piazza and Piazzetta San Marco* seems to deny the existence of a picture plane (Fig. 164). It is as though the artist wished to eliminate the front surface of the painting and make the viewer believe that an actual three-dimensional space existed behind the frame. Linear perspective (see pp. 148–151) is used here to represent the deep space, but at the same time the converging diagonal lines of the buildings produce a linear continuity which connects the many separate forms into a few basic movements on the picture plane (Fig. 165). Vertical repetitions are also a unifying factor, as are the repeated curved forms in the arcades and umbrellas. Here, then, is a painting in which the organization of the picture plane seems to be disregarded, and yet that organization does exist.

To assume that Canaletto was primarily concerned with picture-plane composition would be to deny the obvious pictorial emphasis in this painting. The painter produced an illusionary space representing two great city squares in Venice. However, the pictorial intention does not eliminate the need for aesthetic organization in the painting. The illusionary space and the forms filling that space may be organized much as a choreographer or a director would organize the human and constructed forms which fill a stage. If an artist paints as though there were no picture plane, methods of aesthetic organization can be applied to the *pictorial* elements rather than to the *plastic* elements. That is, the painter can arrange buildings, walks, trees, and people, rather than forms, lines, and colors.

Imagine the space in the Canaletto painting without figures in it. If the artist had wished to, he might have placed figures at any spot within the illusionary space of the two squares. All the figures could have been lined up, evenly spaced, along the front of the pictorial space, leaving the rest of the square empty. They could all have been grouped at the left or at the far right. Instead, the painter arranged them in groups of various sizes and then arranged the groups within larger groups. Grouping is another form of

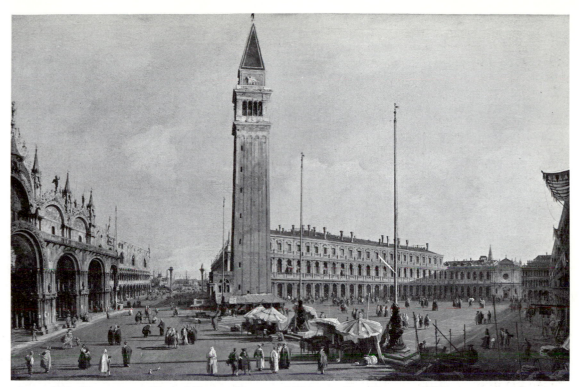

above: 164. CANALETTO. *View of Venice, Piazza and Piazzetta San Marco.* c. 1730.
Oil on canvas, 26 × 40½″ (66 × 103 cm).
Wadsworth Atheneum, Hartford, Conn. (Ella Gallup Sumner and Mary Catlin Sumner Collection).

below: 165. Compositional analysis of Figure 164.

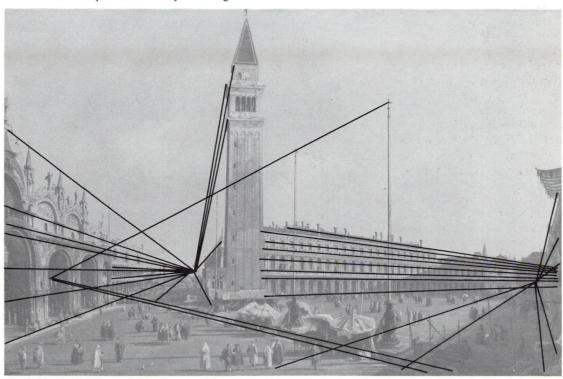

linear continuity and is used rather frequently by painters in organizing a pictorial space.

Note, too, that the space created by the painter varies in depth, receding far back at the left-center but blocked by the mass of the building and the enclosed area of the Piazza at the right. The speed of the movement back seems to shift also, moving quickly at the left and more slowly at the right.

It might be argued that the composition of this painting was an *automatic* result of the arrangement of the buildings and spaces in the actual subject matter—that the artist did no more than record what he saw. Even if this were true, the artist could have placed himself anywhere in the Piazza to draw the forms and space there. His *choice* of observation point would be an important way of arranging the elements of his composition. The fact is that this painting is not the simple result of the work of a painter who set up his easel in the Piazza San Marco and began to paint. It is, rather, the consequence of a careful construction of space based upon a perspective system of drawing, in which the receding, converging diagonals of the forms are organized as the artist wished them.

The detailed rendering of forms, textures, and light in this painting depends on the skill of the artist. No camera, unless fitted with a special lens, could have produced an image comparable to that created by Canaletto in this work. Had the camera or the eyes of a human observer been pointed down to the Piazzetta and the ships moored at the Grand Canal on the left, the deep space to the right would not appear as it does. If the camera had been turned to the right, pointing into the Piazza, the space of the Piazzetta could not have been seen. The painting is actually composed of two separate views, each conforming to traditional perspective rules, but the combined views create spaces that are "incorrectly" drawn by the standards of strict linear perspective.

A "correct" drawing would be based on a linear arrangement which assumes that an observer would remain at a single position before the scene and that the whole scene would be drawn with the draftsman's head and eyes rigidly fixed on a single point on the horizon. Divide the painting along a vertical axis through the bell tower, and two distinct scenes will appear, each based on a different observation point. That they have been united into one painting suggests that the composition is a deliberate organization based upon the artist's wish, rather than the result of an accurate transcription of a scene observed from a single viewpoint.

Aesthetic organization in painting may take place either on the picture plane or in the illusionary space that an artist can suggest behind the flat surface of the painting. Whether the organization is two-dimensional or in the illusion of a third dimension, it unifies the elements employed by the painter into a coherent, interrelated structure. Repetition, continuity, and the balance of visual weights can be made to serve the principle of unity just as they can serve to give variation or complexity.

Two-Dimensional Representation of the Third Dimension

Objects in the real world may be touched; they may be seen from many orientations; often it is possible to see them under different conditions of light. When these objects and the space they occupy are to be represented on the flat plane of a painting or a drawing, the artist finds it impossible to include in the representation all that can be perceived about them. Even the representation of the simplest solids gives rise to problems that suggest the kinds of restrictions placed upon the artist who works in the two-dimensional arts.

What is a cube as perceived by an observer? It is a solid that is square in cross section; it has six sides, each shaped as a square, each in a different plane. Each side is parallel to one other side and at right angles to the four remaining sides. All this information is perceptible to an observer, but how is it possible for a painter to represent it? If emphasis is placed on a form of representation that emphasizes the shape, it will be necessary to begin with a square.

Figure 166 represents the square form. The sides are equal and the angles are 90 degrees. But only one of the six sides is shown.

Figure 167 represents six sides, but the orientation of the sides does not correspond to the viewer's perception of them.

Figure 168 does not seem to answer the requirements of the representation with any more satisfactory solution.

If it is desirable to retain an accurate representation of shape relative to the perception of the cube, the artist must face the obvious limitations that exist in the previous three figures. What happens if a variation in the shape is permitted, granted that when turned at an angle to the perceiver, the square shape of the sides of the cube does not look square? At times the sides may look like single lines or edges.

Even with this change it is still impossible to represent the sixth side. If the sides are represented as forms approximating rhomboids, what then? Figure 169 more closely fits the image most people would accept as a satisfactory representation of a cube, but only three sides are shown, and they present a considerable degree of variation from the perceived orientation of the sides in our initial description. Even the assumption that the cube is transparent, as in Figure

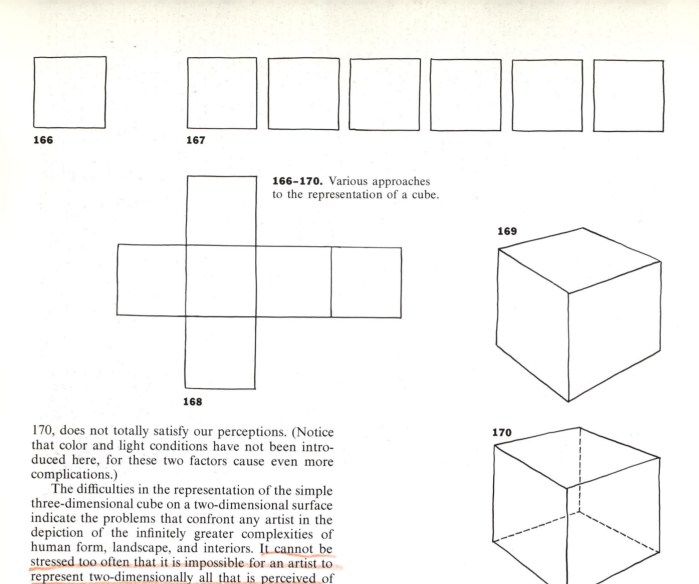

166

167

168

166–170. Various approaches to the representation of a cube.

169

170, does not totally satisfy our perceptions. (Notice that color and light conditions have not been introduced here, for these two factors cause even more complications.)

The difficulties in the representation of the simple three-dimensional cube on a two-dimensional surface indicate the problems that confront any artist in the depiction of the infinitely greater complexities of human form, landscape, and interiors. It cannot be stressed too often that it is impossible for an artist to represent two-dimensionally all that is perceived of an object or a scene in the three-dimensional world.

170

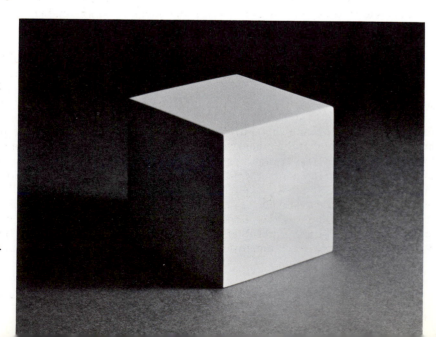

171. Photograph of a cube.

172. Setting of a village street, constructed for a television production.

The question might be asked: "Why does the diagram in Figure 169 seem so satisfying as a representation of a cube?" The answer is not known with certainty, but studies in human perception suggest that the limited amount of information conveyed by the diagram communicates to the observer that there is more to the figure than can be seen. Though only three sides are visible, the observer deduces that there are three other sides which are hidden. A photograph of a cube (Fig. 171) gives information in a manner quite similar to that provided by the line drawing in Figure 169.

Photography

From a photograph showing only two sides of a building we assume that the other two sides are there, too. Sometimes that assumption is proved wrong, and we discover that we have been fooled, as we would be in the case of a false-front production set, which is revealed to be simply a façade (Fig. 172).

Many people today believe that the photographic image is the "real," most truthful, and most accurate way of picturing the three-dimensional world on a two-dimensional surface. This notion is not common to all times and all cultures. In fact, psychologists and anthropologists reported in the past that primitive peoples often could not identify human images in photographs when they first saw them.

Each two-dimensional representational image is the result of a set of decisions. Even though some image makers are not aware of many of the factors that affect the appearance of the equivalents they produce, their images are shaped by the limitations and potentials of their media and, of course, by the attitudes and perceptions they bring to their efforts. In photography, which appears to many to be a relatively automatic method of recording accurately the real appearance of the world, many restrictions are placed upon the person who clicks the shutter. The most obvious are those that depend upon the relative positions of the photographer and the subject. The distance between them affects the amount of the subject included in the viewfinder. It also controls the scale of the image recorded on the film. A tree photographed from a distance of 100 feet (30 meters) will be represented in its totality as a large three-dimensional form, comprising trunk, branches, and

above left: 173.
Photograph of a tree from about 100′ (30 m) away.

above right: 174.
Trunk area of same tree from about 2′ (.6 m).

left: 175.
Leaf of same tree.

leaves as parts of the primary image (Fig. 173). The same tree photographed from a distance of 2 feet (.6 meters) will have its representation in a detailed study of the texture of some small portion of the whole—the trunk or the leaves and branches (Figs. 174, 175). Because one photograph of the tree cannot show it from a 360-degree circumferential point of view, the photographer must decide which side of the tree to represent. Because photography is dependent on light, the photographer is concerned about the intensity, direction, and perhaps the color of the light playing on the subject.

In addition, the camera itself imposes limitations. A great many different cameras are available, many with highly specialized uses, but all of them have the same basic components: a *lens,* or *lens system,* that focuses the light from the subject through a shutter, which controls the amount of light permitted to fall on sensitized *film.* The *lens,* the *shutter,* and the *film* can be altered to make significant changes in the

image produced by any photographer. Even a cursory examination of possible variants will provide the reader with a sense of the changes these components can effect in the image-making process.

The photographs reproduced in Figures 176 through 179 were all taken with the same 35-millimeter camera from the same position. An 8-millimeter fish-eye lens was used in Figure 176. It has a 180-degree angle of view that permits the photographer to

show the field, the surrounding trees, and the columns at the end of the green. To achieve this extraordinary coverage, the lens bends the light rays so that the focused image on the film alters the vertical axis of the trees to follow the curvature of the lens. Foreground and background seem to be stretched apart. A wide-angle lens was used to photograph Figure 177. It includes a field of view that is about twice the normal horizontal distance that the human

176. Photograph through 8-mm fish-eye lens.

177. Photograph through 24-mm lens.

178. Photograph through 50-mm lens.

179. Photograph through 300-mm lens.

eye can see sharply without moving from a fixed position. The image in Figure 178 was made with a 50-millimeter lens and closely approximates the field of view of the fixed observer. When a 300-millimeter lens was used to enlarge the image, the field was severely reduced (Fig. 179).

The camera shutter controls the amount of light that enters the camera. It does this by changing the size of the hole, or *aperture,* that admits light through the lens and by changing the period of time the aperture is kept open. By altering the size of the aperture, the photographer can work under varying light conditions, enlarging the aperture when the light is decreased and reducing it when brilliant lighting conditions require limitation of the amount of light allowed to focus on the film.

The size of the aperture also affects the focus of the camera. As the aperture decreases in size, more of the background and foreground are sharply delineated. An aperture setting of f/2, which indicates that the opening is very wide, will produce a picture in which objects in only a very narrow band parallel to the camera will be reproduced in sharp focus. Objects in front of and behind the band will be blurred (Fig. 180). A setting of f/16, which indicates a much smaller aperture, will produce an image with a much greater depth of field in focus (Fig. 181). Clearly, this control of the focus in a photograph offers the experienced photographer opportunities for expression that can be a valuable communications asset.

The speed of the shutter can be used with the aperture adjustment to control the amount of light

above left: 180.
Photograph with aperture setting of f/2.

left: 181.
Photograph with aperture setting of f/16.

182. Photograph taken with shutter speed of 500, stopping the action of the subject.

that reaches the film, but its most obvious application is in *freezing* motion. A moving object passing before a camera with a slow-moving shutter will register on the film as a blur. If the shutter speed is increased, the blur will be eliminated. Shutter speed can even be sufficient to stop the motion of objects that are blurred to the human eye (Fig. 182).

Camera film varies in its sensitivity to light. Fast film requires less light than slow film to initiate the chemical action that creates an image. With fast film the photographer can use faster shutter speeds and smaller apertures or take photographs at limited light levels. Film varies, too, in its graininess, its ability to produce sharp images. Some films offer the option of hard-edged and clearly defined forms; others permit softened edges and lessened contrasts that approximate the character of a painting.

Metropolitan Opera Bar (Fig. 183) was photographed by Garry Winogrand with the limited amount of light he found in this interior. Winogrand opened his shutter to a setting of f/1.5 and set the speed for 1/30 second. The lack of sharp focus combined with the graininess of the film gives a provocative, romantic quality to this photograph, in which the dramatic indication of depth combines with somewhat ambiguously defined details.

The limits of photographic representation are extended beyond the examples noted above when the photographer employs special lighting equipment. *Swirls and Eddies of a Tennis Stroke,* the photograph by Harold E. Edgerton shown in Figure 184, was made with the use of a stroboscopic light source. The

right: 183. GARRY WINOGRAND.
Metropolitan Opera Bar. 1954.
Photograph.

184. HAROLD E. EDGERTON.
*Swirls and Eddies
of a Tennis Stroke.* 1939.
Stroboscopic photograph.

185. BILL BRANDT.
Nude on a Pebbled Beach.
1953. Photograph.

image produced on the film is a record of movement. The form of the tennis player is obscured, almost eliminated, and in its place the pattern of player and tennis racquet communicates information, but not the kind of data usually found in a snapshot.

Bill Brandt's photograph of a nude reclining on the pebbly surface of a beach (Fig. 185) was taken with an old wooden camera with a wide-angle lens. Using a very small aperture, so that the depth of field was at its maximum, and an ultrasensitive film to compensate for the limited amount of light that came through the aperture, Brandt transformed the nude into a strange sensuous mass that is thrust into the space formed by the floor of pebbles and wall of rock. The camera lens has emphasized the inward direction of the pattern of pebbles, adding a kinetic quality that acts as a counterpoint to the simple, sculptural form of the body.

An artist-photographer knows that there is a great difference between seeing a scene and producing a photographic equivalent for it. Experience suggests the film, lens, and shutter adjustments that will realize the image the photographer is seeking. Often the scene needs preparation before the photograph is taken, so that the picture will develop as intended despite the limitations of the medium. Yale Joel had the assignment of photographing the ceremony that took place in St. Patrick's Cathedral in New York City during the visit of Pope Paul VI in 1965. The interior of the cathedral was dimly lighted, its high vaults, nave, and aisles too dark to permit a shutter speed fast enough to stop the action of the participants in the services. Joel's seemingly simple and direct photograph of the event (Fig. 186) required the distribution in the upper section of the cathedral of fifty large electronic flash units wired to respond to the photographer's signal. Tripping the shutter of the camera released an artificial flood of light that made the picture possible.

Even after the image has been captured on film, the materials and processes of the darkroom can contribute to the fulfillment of the photographer's intention or misrepresent it. Many artist-photographers do their own developing, enlarging, and printing, for they know that the image that was stored in the camera, on the film negative, can be transformed in

186. YALE JOEL.
Pope Paul Entering St. Patrick's Cathedral.
1965. Photograph.

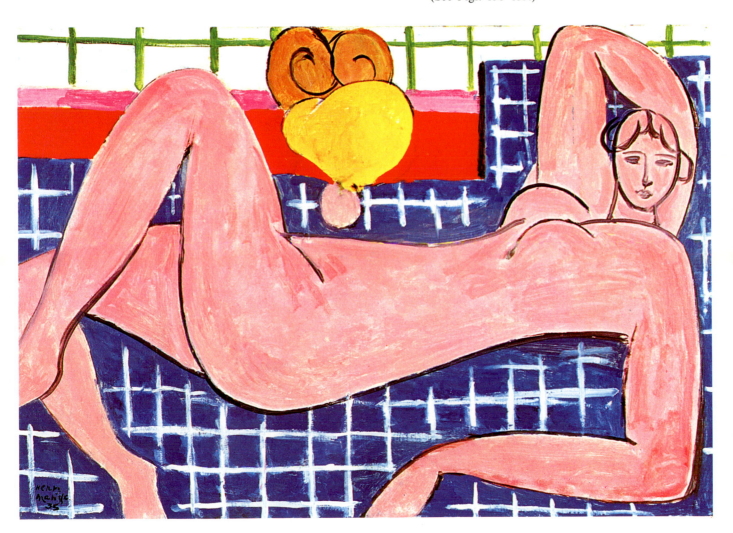

Plate 28. EDGAR DEGAS. *Woman at Her Toilette.* c. 1903. Pastel, 29½ × 28½″ (75 × 72 cm). Art Institute of Chicago (Mr. and Mrs. Martin A. Ryerson Collection).

Plate 30. FRANK STELLA.
De la nada Vida a la nada Muerte. 1965.
Metallic powder in polymer emulsion on canvas,
7′ × 25′5¾″ (2.13 × 7.77 m).
Art Institute of Chicago
(Ada S. Garret
Prize Fund Income).

Plate 29. PIERO DORAZIO. *Construction Eurasia.* 1964. Oil on canvas, 5′8″ × 8′1/2″ (1.73 × 2.45 m). Collection Mrs. John B. Dempsey, Cleveland.

187. Haida motif representing a bear. From Franz Boas, *Primitive Art,* Instituttet for Sammenlignende Kulturforskning, series B, VIII, Oslo, Leipzig, London, and Cambridge, Mass., 1927.

the darkroom before the printed positive is complete. The composition can be changed by enlarging or eliminating portions of the negative image. The choice of developing chemicals, the timing of exposures, and the qualities of photographic printing papers all offer alternatives that must be considered in order to produce the desired print. For a black-and-white print the selection of the paper alone presents many possibilities: in color, from blue-white to sepia tones; in texture, from hard-surfaced and glossy to soft and grainy; in contrast values, from low-keyed ranges of grays to sharp blacks and whites. Only the photographer really knows which choice will best carry out the desired effect.

Clearly, then, the observer of two-dimensional representations of form and space cannot assume that pointing a camera at a scene and snapping the shutter will result in a picture that can be used to judge the accuracy of any other image of the same scene. The photograph is the most commonly seen representation of the three-dimensional world on a two-dimensional surface, but it, too, has limitations. The photographer, of necessity, must represent less than can be perceived, and it is misleading to assume that what is omitted is insignificant. For another artist, using another medium, those aspects of reality that elude the photographer and the photographic equipment may contain the essence of the subject. Freed of the restrictions of the camera image, artists may find it possible to represent their perception of the real world through visual forms that differ radically from those created with the techniques of photography. It is not only what artists see that shapes their images; it

is also what they wish others to see, and this intention is the motivating force behind the many representational systems that have been employed in the two-dimensional visual arts.

Perception of the Third Dimension and Its Two-Dimensional Representation

Many past and present examples of two-dimensional representation of the three-dimensional world bear no relation whatever to photographic representation. There is no evidence to suggest that these examples are solely the result of inadequacy on the part of the practitioners in this field at so-called "primitive" or "decadent" periods of time, for many of them are to be found in cultures that were vital and highly complex. It is probable that these other representational systems satisfied most of the artists who used them and were acceptable to their patrons.

Had the Haida Indian artist used a photographic image of a bear instead of the drawing in Figure 187, the anatomical facts that are an essential part of the bear's appearance could not have been communicated with the same degree of clarity. The Haida motif tells the observer that the animal represented has two ears, two eyes, two nostrils in a single nose, one mouth, and four legs. These paired features are shown complete and in equal sizes, rather than partially and in different sizes, as they might be represented in a photograph.

Similar examples of two-dimensional images based upon clear, unambiguous information that

above: 188. Aerial photograph of a section of Washington, D.C.

below: 189. U.S. Department of Interior map of area shown in Figure 188.

cannot be represented photographically are to be found today in representational drawings such as maps and architectural plans. An aerial photograph of a section of Washington, D.C. (Fig. 188), establishes an image similar in many respects to that delineated in the map in Figure 189. Major traffic arteries and certain of the capital's famed monuments can be identified. The Potomac River, Rock Creek Park, a reservoir, and additional topographic details can be found in the photograph. But consider the information offered by the map that is missing in the photograph: the names of districts, route numbers, mileages to other cities, the location of schools and military installations. To provide this information, it is necessary to add letters, numbers, and symbols. Many facts that could be designated on the map have not been included. Geological, ethnographic, and agricultural data are omitted, for they are unrelated to the map's purpose.

The section and plan of Rouen Cathedral (Figs. 39, 40) communicate intelligence regarding real form and space to the student of Gothic architecture. Construction details, measurable distances, and the relative position of the parts of the buildings are conveyed in a representational mode that has the completeness of the Haida drawing. Even significant historical data are included in the illustration, providing the viewer with material impossible to include in photographic representations.

Two-Dimensional Equivalents for Form

To represent a three-dimensional form on the flat plane of a drawing or painting, the artist must single out some fundamental visual aspect of the form selected and, by means of one or more of the plastic elements, represent that aspect on the working surface in such a way that the beholder can respond with a sense of recognition.

For this purpose the element of line can be used in several ways. Perhaps the most basic method is the drawn line made by moving a marking instrument on the picture surface so that the marks recording its path conform to the general outline or silhouette of the object to be represented. A silhouette can also be created by painting an area of color, the edges of which, in contrast to the background, are perceived as a linear boundary of the form. Both drawn line and linear color edges are utilized to define forms in the thirteenth-century Chinese ink drawing reproduced in Figure 190.

However, very few forms found in nature are as simple as those in the drawing by Mu-Ch'i. Natural forms are most often composed of a number of related masses or planes, each of which has a unique shape, joined to comprise a larger unit. A form as

below: 192. A human figure photographed in silhouette with arms and legs spread.

left: 190. Mu-Ch'i. *Six Persimmons.* 13th century. Ink on paper, 14½ × 11¼″ (37 × 29 cm). Daitoku-ji, Kyoto.

below left: 191. A cube photographed in silhouette from three vantage points.

below: 193. A crouching figure photographed in silhouette.

simple as the cube illustrated in Figure 171 is difficult to represent adequately in silhouette (Fig. 191), for the position and relationship of the six square planes is not clearly indicated by a simple outline. The human body is made up of six major form subsections—the torso, the head, and four limbs. Only when the body is represented standing in a frontal position, with the arms and legs somewhat separated from the torso (Fig. 192) does the silhouette give a viewer a significant amount of clear information. As soon as the figure is bent or turned away from the viewer, the separate forms of arms, legs, head, and torso can no longer be defined with certainty. Lost too is the more detailed information about the positions of the smaller forms—eyes, nose, ears, and mouth in the head; fingers and toes in the limbs; the planes and folds of skin in the torso (Fig. 193).

left: **194.** Douris.
Two Women Putting Away Clothes,
detail of red-figure kylix.
c. 470 B.C. Painted earthenware.
Metropolitan Museum of Art, New York
(Rogers Fund, 1923).

left: **195.** Kitagawa Utamaro.
Bust Study of a Beautiful Girl. Late 18th century.
Color woodblock print, 13 × 8¾″ (33 × 22 cm).
Cleveland Museum of Art
(bequest of Edward L. Whittemore).

above: **196.** Henri Matisse.
Upturned Head (*Head of a Recumbent Figure*).
c. 1906. Transfer lithograph, printed in black,
13¾ × 10¾″ (34 × 26.5 cm).
Museum of Modern Art, New York
(gift of Abby Aldrich Rockefeller).

To define the components that physically exist within the confines of a silhouette, the artist can introduce lines or edges that divide the large external form. These lines can be arranged so that they suggest the relative positions and sizes of the parts. In Figure 194 the Greek vase painter Douris used internal lines to indicate the separation between legs, and by an apparent overlap one leg in each figure is shown in front of the other. In the figure on the left a sequence of overlaps clearly defines the relative positions of the left arm, the bundle of clothing, the two breasts, and finally the right arm, each in its turn partially obscured by the forms represented as closer to the observer. On a smaller scale the fingers and toes of the two figures form overlapping progressions. Both external and internal linear contours with overlaps are to be found in the eighteenth-century woodcut by the Japanese artist Kitagawa Utamaro (Fig. 195) and the head by Henri Matisse (Fig. 196).

Early in the history of art it was recognized that when rectangular solids are placed so that one vertical edge is measurably closer to the viewer than another, the horizontal edges appear to slant up or down as they recede. This illusion is the basis for the method of representation used by early Roman muralists in the architectural painting shown in Figure 197. Note that the angles used to suggest recession of the edges of the building are not equal, nor do they seem to conform to any consistent overall scheme. Later artists did utilize a system that determined the angles to be used in drawing the edges of receding forms, but it was not until the fifteenth century that the method called *linear perspective* was introduced.

An examination of the pastel drawing by Edgar Degas in Plate 28 (p. 136) will reveal a number of methods adopted by the artist to represent the form of the figure. A strongly emphasized outer silhouette is interrupted by lines that break the edge to suggest overlapping forms. This is particularly evident at the lower edge of the front arm as it joins the body. In a progression that gives the sense of forms moving down and back, the arm overlaps the breast, which in turn overlaps the fold of skin above the abdomen. At the top edge of the arm another progression moves from shoulder to head, to cloth, to the bend of the arm, and finally to the elbow. The angular relationship of the edges representing the arms clearly places the left elbow closest to the observer, with the left hand and shoulder receding deeper into the composition. Degas used still another device. He drew the right arm at a smaller scale than the left arm. This difference between two forms that are normally identical in size is perceived as a difference in distance from the viewer.

In addition to line and edge for the representation of form, the artist may use graphic analogues for the play of light on the surfaces of three-dimensional objects. Illumination from a single source of light will fall upon a three-dimensional object in a consistent pattern. Usually those surfaces nearest the light will receive the most illumination, and those surfaces which are turned from the light source will receive proportionately less illumination. The shape of the object has an effect on the pattern of light and dark areas produced in this way. Representing the light on

197. Architectural view from the cubiculum of a villa at Boscoreale, Italy. 1st century B.C. Wall painting. Metropolitan Museum of Art, New York (Rogers Fund, 1903).

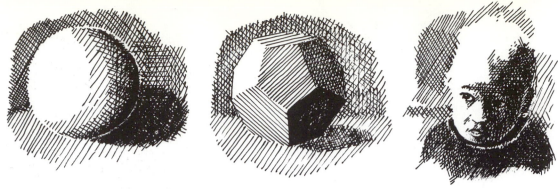

198. Representation of form by dark and light areas illuminated from a single source.

the forms by graduated areas of dark and light colors on the two-dimensional surface of the painting or drawing, the artist can combine this device with that of contour edges and thus contribute further to the illusion of form (Fig. 198).

The portrait in Figure 199 by Albrecht Dürer is an example of the play of light and dark subtly and sensitively used to amplify the representation of forms already delineated by their edges. However, the shading does not in itself accomplish the appear-ance of volume. If all the shading were eliminated, leaving only the outer and inner contours, the large-scale indication of form would remain clear.

In summary, it may be said that the illusion of three-dimensional forms can be created in the two-dimensional arts by a variety of methods, among which the following have been discussed and illus-trated so far:

1. The drawn line or the edge contrast of a color area can serve as an equivalent for the silhouette of the subject.

2. Internal contours can offer information about the smaller subforms within the outline.

3. Both edges and lines can be overlapped to indicate nearer and farther features of the overall form.

4. Oblique lines have the capacity to suggest the recession into depth of planes with parallel edges.

5. Reduction in scale can represent increased distance of the form from the viewer.

6. And, finally, the shading within drawn forms can represent the pattern created when light falls on the surfaces of a three-dimensional object and thus describes the configuration of its total shape.

All these methods, more or less freely conceived, have been adopted at various times throughout the history of art to communicate the artist's perception. Much more subject to rigid rules and controls for the artist is the linear-perspective system of representing three-dimensional form and space. This system, based upon mathematical and optical principles for-mulated for artists during the early Renaissance in

199. ALBRECHT DÜRER.
Portrait of a Young Woman. 1506.
Oil on panel, $11\frac{1}{4} \times 8\frac{1}{2}''$ (29 × 22 cm).
Staatliche Museen, Berlin.

200. *Madonna and Child.*
Tuscan, second half of 13th century,
or Florentine, late 13th century.
Tempera on wood, gold ground;
5'1½" × 3' (1.54 × .91 m).
Metropolitan Museum of Art, New York
(gift of George Blumenthal, 1941).

Italy, remained virtually unchallenged in the art of Western civilizations for almost five centuries as the correct way to simulate the mass, depth, and expanse of the physical world within two-dimensional limits. It will be considered a little later in this chapter. First, however, it may be useful to examine some of the other means of conveying the sense of space in painting and drawing.

Two-Dimensional Equivalents for Space

Some of the devices for representing space on a two-dimensional surface are comparable to those used to produce equivalents of form. Actually, any three-dimensional form in nature occupies a space, and the distance between the front and back of a form is a measurable spatial dimension. One may consider the progression of forms in the Degas pastel drawing seen in Plate 28, but it is also meaningful to take note of the space that is indicated between the left elbow and the bend of the right arm.

In nature, form remains constant, even though the space it occupies may change. That is, a sphere looks and feels the same whether it occupies one place on a table or another. However, space is not just that volume occupied by a form; it can also be the distance between forms. Certain forms can be perceived to be in front of others. They can be found close together or far apart. One form may be above another or below it.

Artists who have wished to represent on a flat surface the spatial relationships between forms in nature have traditionally used one or more of the following methods:

1. Overlapping planes
2. Variation in size
3. Position on the picture plane
4. Linear perspective
5. Aerial perspective
6. Color change

Overlapping Planes Figure 200 displays a typical example of the use of overlap to indicate the arrangement of forms in depth. In this thirteenth-century panel by a Tuscan painter the form of the Child

overlaps a portion of the form of the Madonna. This simple device indicates to the viewer that the Child is placed in front of the mother. Similarly, the Madonna is positioned closer to the viewer than is the back of her throne, and her hand rests clearly in front of her body, all indicated by overlap.

Overlapping often becomes much more complicated than the illustrated example in Figure 200. Several planes can overlap in sequence, or some planes may appear to be transparent, so that the illusion of looking through a forward plane to one behind enhances the viewer's feeling of three-dimensional space (Pl. 29, p. 137).

Variation in Size Variation in the sizes of forms can be employed to indicate the relative importance of persons represented in a composition. This practice is typical of early Egyptian paintings and reliefs. In the wall painting in Figure 201, from the tomb of Neb-amon at Thebes, the three figures represented are all aboard the same boat and are thus essentially the same distance from the viewer. The difference in size between the lord of the burial chamber and his wife represents their relative importance; and a similar difference between the wife and the child has the same cultural symbolism. All the indications of spatial position depend on overlaps.

Though it is possible for size differences to indicate social or religious relationships between similar signs or symbols in a single image, these differences are often meant to express spatial position.

Looking at a work containing objects of various sizes, the observer may assume one of two alternatives: first, that the objects represented are, in fact, of different sizes; or, that the objects are of the same size but are represented differently to correspond to their distances from the observer. This spatial interpretation of the size difference applies not only to objects assumed to be identical in size but also to objects having accepted proportional sizes; that is, a man is smaller than a house, and therefore the representation of a house drawn smaller than a man will suggest

203. DUCCIO. *The Transfiguration of Christ,* from the back predella of the *Maestà Altar.* 1308–11.
Tempera on panel, $18\frac{1}{8} \times 17\frac{3}{8}''$ (46 × 44 cm).
National Gallery, London (reproduced by courtesy of the Trustees).

a much greater space differential than a similar comparison made between two houses (Fig. 202).

Position on the Picture Plane In certain paintings the system of spatial representation is based upon the position of forms relative to the bottom margins of the picture plane. This method is frequently found in the work of medieval Western artists and the artists of China and Japan. Those objects which are near the bottom are closest to the observer; distance increases

as objects are placed correspondingly higher from the bottom of the work. Sometimes this system is combined with changes in size, but it is not unusual to find works in which position and size are not correlated in spatial representation.

Duccio, an Italian fourteenth-century artist, painted a panel of the Transfiguration of Christ (Fig. 203) in which six figures are represented on a rocky mound. The figures are grouped in two rows of three. There can be no doubt that the artist intended

left: **204.** ALBRECHT DÜRER.
Artist Drawing a Portrait of a Man,
from the treatise
Underweysung der Messung . . .
1525. Woodcut.
Metropolitan Museum of Art, New York
(gift of Henry Walters, 1917).

below: **205.** Convergence of parallel
lines toward the vanishing point.

the upper row of figures to appear to be behind the
forms in the lower group, and, in fact, they do seem
thus placed. No overlapping is used here to achieve
this effect, and the size of the figures does nothing to
contribute to the representation of depth, for the
lower group is somewhat smaller than the one above.
It is the position of the forms relative to the lower
edge of the painting which serves to suggest their
respective distances from the observer.

Linear Perspective The following quotation from
the notebooks of Leonardo da Vinci is the great
fifteenth-century artist's description of "the way to
represent a scene correctly":

> Take a piece of glass the size of a half sheet of royal
> folio paper, and fix it well . . . between your eye and
> the object that you wish to portray. Then move away
> until your eye is two-thirds of a braccio [arm length]
> away from the piece of glass, and fasten your head . . .
> in such a way as to prevent any movement of it whatso-
> ever. Then close or cover up one eye, and with a brush
> or a piece of red chalk finely ground mark out on the
> glass what is visible beyond it; afterwards copy it by
> tracing on paper from the glass.[1]

A painter following this procedure would produce
a drawing constructed in *linear perspective.* A careful

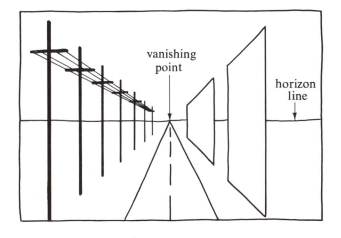

examination of Leonardo's instructions suggests some
inconsistencies between the actual experience of
looking at the world and the requirements placed
upon an artist who is eager to obtain a perspective
image. Most human beings do not go through life
observing the world in the static manner described by
Leonardo. They do not hold their heads immobile,
nor do they keep one eye shut as they look about
them. However, in fifteenth-century Europe linear
perspective seemed to provide, as it still does for

many people today, a means of drawing an image that the artist and the public alike could regard as an accurate representation of the real world on a flat surface. No existing drawing by Leonardo illustrates his method of accurate drawing through the use of an instrument, but the woodcut by Dürer in Figure 204 exhibits a device similar to that described by the Italian master.

An analysis of a picture drawn by the linear-perspective method would reveal certain basic characteristics of all linear-perspective constructions. They are:

1. All parallel lines that exist in nature appear to converge at a "vanishing point" (Fig. 205).

2. A different vanishing point exists for each set of parallels, but all points used to construct objects parallel with the ground exist on the same horizontal line. This line is called the "horizon line" (Fig. 206).

3. Round forms are drawn as though inscribed in the rectangles which have sides tangent to the curves (Fig. 207).

The perspective study by Leonardo da Vinci (Fig. 208) includes a grid that stretches from the

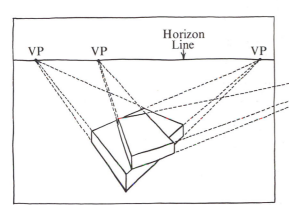

left: 206. Multiple vanishing points and the horizon line.

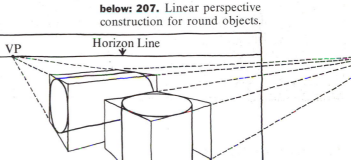

below: 207. Linear perspective construction for round objects.

below: 208. LEONARDO DA VINCI. Perspective study for *The Adoration of the Magi.* 1478–81. Pen and brush. Uffizi, Florence.

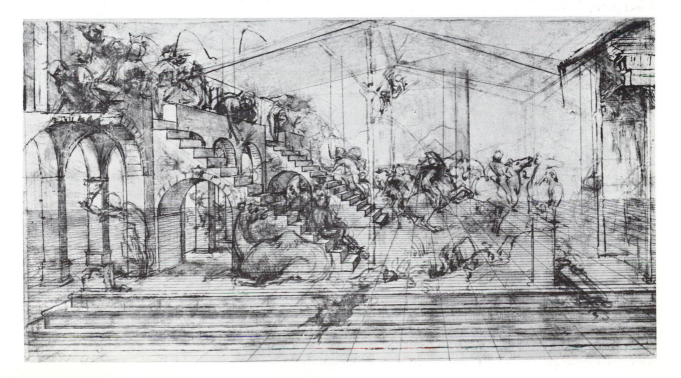

bottom of the picture frame back toward the horizon. One set of grid lines converges at the horizon line. Another set, parallel to the bottom of the drawing, is drawn with the receding lines spaced sequentially closer together as they indicate movement toward the rear of the constructed space. Just as the rectangles of the floor are reduced in size by the perspective pattern, the human and animal forms placed in this space are drawn smaller according to their positions on the grid; their scale is consistent with the scale of the floor divisions on which they rest.

There are certain exceptions to these rules, such as the use of supplemental vanishing points in drawing planes not parallel to the ground plane and the use of a vanishing point to converge the vertical parallels in objects seen from extreme up or down viewpoints; but they should not concern the reader, for they do not alter the basic concept of this description.

As noted in the section on two-dimensional equivalents for form, oblique lines representing parallels moving away from the picture plane have sometimes been employed to suggest volume rather than the convergence within a true linear-perspective system (Fig. 197). Similarly, the diagonal arrangement of forms can be used to indicate spatial differences. To be effective these diagonals do not have to conform to a consistent linear-perspective system. In Figure 209 the receding forms of the crosses and the sides of the towers are drawn with parallel oblique lines. The spatial indications depend primarily upon overlapping forms, but in addition the artist has placed the figures, especially those behind Christ, in a progression toward the back of the main group.

Frank Stella, a contemporary American painter, has taken advantage of the same principle for the suggestion of space, but has employed a new form

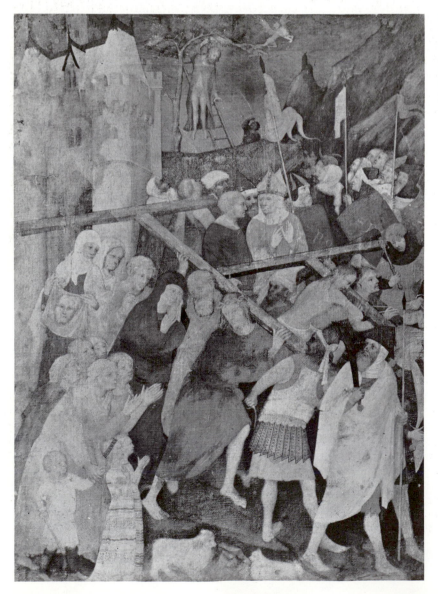

209. JACQUEMART DE HESDIN and others. *Christ Carrying the Cross,* from *Les Grandes Heures du Duc de Berry.* 1409. Illumination on vellum, $14\frac{7}{8} \times 11\frac{1}{8}''$ (38×28 cm). Bibliothèque Nationale, Paris.

210. Diego Velázquez. *Surrender at Breda*. 1635. Oil on canvas, c. 10 × 12′ (3.05 × 3.66 m). Prado, Madrid.

(Pl. 30, pp. 136–137). Stella stretched his canvas in an irregular shape to make it conform to the arrangement of the stripes in his painting. Flat color areas and the defined edges of the shaped canvas emphasize the two-dimensionality of the painting, but the diagonal stripes, in conjunction with the diagonal portion of the shaped canvas, suggest a three-dimensional spatial relationship. The conflict between these two mutually inconsistent effects invests Stella's painting with a psychological tension surprising in a work so simple in concept and execution.

Aerial Perspective Another method of representing space, which often was combined with linear perspective after the sixteenth century, was *aerial perspective*. In this technique the artist approximates the observable atmospheric phenomenon by which distant forms lose the sharp definition of their edges and appear dimmer and less distinct than objects close to the observer. Also, in aerial perspective the artist paints distant forms in lighter, cooler, and less brilliant colors than those in the foreground and softens the contours of these forms so that they appear to blend into the areas adjacent to them. Note in Velázquez' *Surrender at Breda* (Fig. 210) and *The Rape of Proserpine* by Niccolò dell'Abbate (Pl. 12, p. 61) the strong contrast of the dark and light areas in the front plane. Compare this portion of the paintings with the background forms, which are depicted as though seen through a bluish haze.

Color Change The color of a form can differ from the color of another form in several ways. It may be lighter or darker. It may be more or less brilliant. And finally, but perhaps most obviously, one color can be distinct from another in its location on the spectrum. The identity of the colors located along the spectrum is designated by the common words associated with color—red, orange, yellow, green, blue, violet.

As noted above, aerial perspective uses changes in the dark and light quality and changes in the brilliance of color to indicate distance. Some painters have augmented the illusion of aerial perspective by giving distant forms in their paintings a bluish tint, but, in the main, aerial perspective does not utilize the full potential for the indication of space offered by color contrasts and similarities.

The colors on the spectrum are often referred to as members of a "warm" or "cool" group. This division places those colors which are close to the red end of the spectrum in the warm family; those adjacent to the blue end are called cool. Under certain conditions warm colors give the illusion that they are closer to the viewer than are cool colors, and some artists have exploited this quality to increase the illusion of space in their paintings. By painting foreground forms in relatively warmer colors and background forms in relatively cooler colors, the artist can enhance the sense of space. The word "relatively" is important here, for it is possible to have one red that is cooler than another; that is, a red with a bit of blue in it will appear to be cooler than one without a blue cast.

Other spatial indications are made possible by *consistent* use of color variation within some characteristic quality of color—its value, its brilliance, or its spectrum difference. In each instance the artist makes change in color an equivalent for change in spatial distance, and in each instance the success of the method is directly related to the consistency with which it is used. The types of color change capable of creating the illusion of space could include either of the following:

1. Variations in brilliance, the most brilliant colors in the foreground and progressively less brilliant colors receding to the back (Pl. 31, p. 138).
2. Variations on a single spectrum color against a background painted in a different single color. Colors which vary in contrast to the background would come forward in proportion to their contrast. If the background were painted red, forms painted in green, which is the color greatest in contrast to red, would separate from the red most obviously and therefore would appear to be farthest away from it. Red-violet forms in this system would be closer to the red background and therefore not so close to the foreground (Pl. 32, p. 138).

Representation of Time-Space Perceptions

The photographic image is remarkably similar to the linear-perspective image in its rendering of depth. Actually, the camera fulfills the demands made by Leonardo for the production of an accurate image. As a one-eyed instrument that does not move during the time it is "looking" at the scene before it, the still camera does not require the restrictive harness that a human being would need while producing the picture. The sheet of glass on which the scene is drawn is replaced by the flat surface of the photographic film behind the camera lens. The image produced by the camera would seem to be the ultimate form of three-dimensional representation, and yet in the nineteenth century a number of artists found a need to represent some aspects of "reality" which were not communicated by either the photograph or its hand-made equivalent system, linear perspective.

The camera is not moved when it is used to make a still photograph. An artist's linear-perspective rendering is drawn as though the world were perceived through a single, one-eyed view, in which neither the eye nor the head moves during the period of perception. The artist acts like a camera.

In the late nineteenth century, a period which burgeoned with new industry and technology, the idea of change and movement was in the air everywhere. Transportation was developing. Steam locomotion on land and on the sea added to the sense of dynamic change in the world. For scientists such as Darwin and Maxwell, the world and the people who inhabited it were parts of a changing condition. Some of the artists who lived in this period responded to the same forces that affected the scientists. They saw about them a world in flux, a world which could no longer be considered a static series of forms, spaces, and actions. Linear perspective was a product of a world which saw itself as a series of unchanging, separate views, a world which could accept as the most accurate representation of itself the one perceived from the immobile viewpoint of the bound observer described by Leonardo.

Lift your eyes from this page. As you look about the room, do you see it from one unmoving position? The normal process of perception requires that you move your eyes, your head, and quite often your whole body as you perceive the space about you. That space and the forms within it are discovered one part at a time, each movement of the eyes or body giving a different view. And yet a still photograph of that room would show only the view from the stationary position of the camera at the time the photograph was taken (Fig. 211). The picture taken by the camera and the perception of the mind-eye complex may be

similar (though not identical) during each separate fixation of the eye as it looks at the room, but the perception of the room is based upon many fixes, and the perception of a broad landscape or of a narrow table is accomplished in the same way.

How, then, can an artist communicate a full perception of a whole room in a medium that limits the representation to a single flat surface? It can be done by separating the picture area into separate sections and placing a different picture, seen from a single vantage point, in each section (Fig. 212). Or it can be accomplished by combining a number of separate views within the format of a single picture, representing each portion of the room as it was seen from the position required to view it most comfortably. This technique was the method devised by Paul Cézanne (Pl. 33, p. 155), a French painter of the nineteenth century, and then continued in the twentieth century by a group of artists identified as Cubists.

The traditional forms of painting and drawing which were the basis for the arts in the nineteenth century were extensions of the modes established during the Renaissance. Linear perspective was the unquestioned standard for the representation of form

above: 211.
Photograph of a hallway, with camera lens on an axis parallel with the floor.

left: 212.
Photomontage of separate photographs of the same hallway (Fig. 211) taken with the camera lens directed at portions of the walls, floor, and ceiling.

and space in the artist's vocabulary. Even the controversial painters who were contemporaries of Cézanne, Impressionists such as Claude Monet, used a traditional linear-perspective construction in their representation of forms. The controversy aroused by their works concerned their use of color and the methods of paint application they employed, but basically they followed in the Renaissance tradition when they drew forms in space (Pl. 7, p. 26). The construction of the illusion of space that was used by all of these artists was based upon the single horizon line and the fixed point of view.

The photograph of a table and the objects on it in Figure 213 is the equivalent, in its basic structural essentials, of a linear-perspective drawing. The single lens of the camera took in the entire scene without changing position. The four photographs in the following sequence (Fig. 214) were all taken from the same position, but the camera was directed to separate portions of the table, much as a viewer's eyes would turn when looking at portions of the table. By combining segments of the photographs (Fig. 215) and so constructing a composite montage, we can arrive at a representation of the table which differs

above left: 213.
Photograph of a still life,
with the camera lens directed
at the center of the table.

above right: 214.
Photographs of the same
still life (Fig. 213),
with the camera lens directed
at different portions
of the table.

left: 215.
Photomontage of the same
still life (Fig. 213),
made up of the separate
portions shown in Figure 214.

Plate 33. Paul Cézanne.
The Basket of Apples. 1890–94.
Oil on canvas, $25\frac{3}{4} \times 32''$ (65 × 81 cm).
Art Institute of Chicago
(Helen Birch Bartlett Memorial Collection).

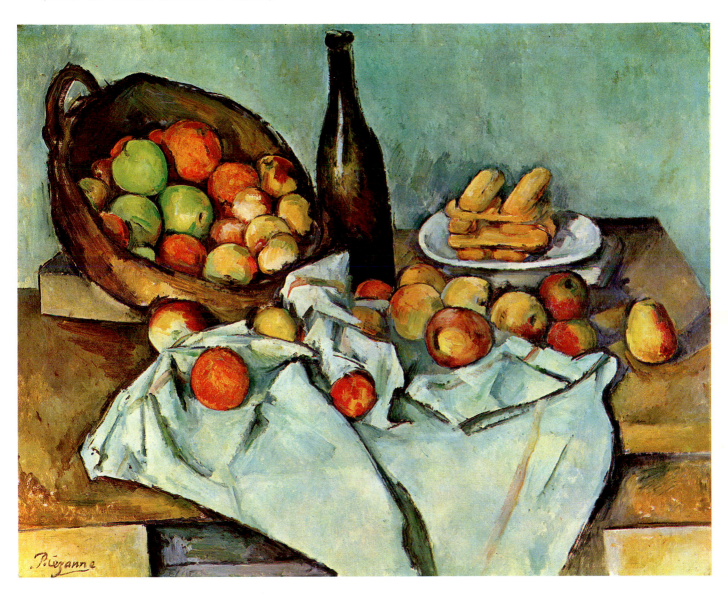

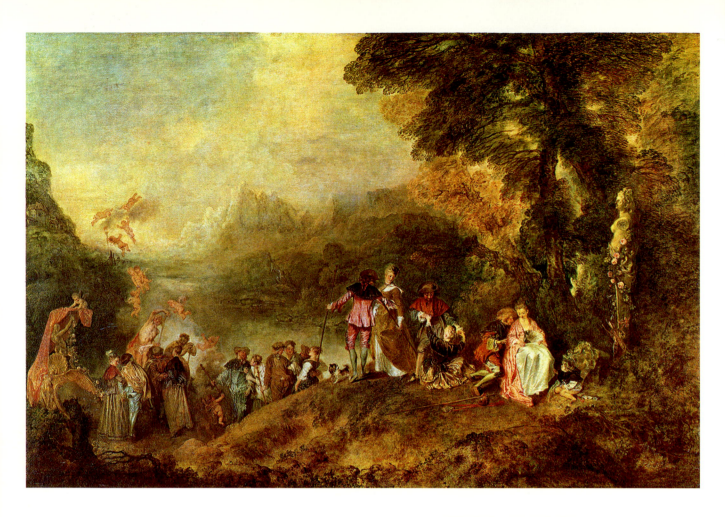

above: **Plate 34.** Jean-Antoine Watteau.
*The Embarkation from the
Island of Cythera.* 1717.
Oil on canvas,
4′3″ × 6′4½″ (1.3 × 1.94 m).
Louvre, Paris.

right: **Plate 35.** Detail of Figure 220,
Monet's *Sunflowers.*

above: **Plate 36.** JEAN-LÉON GÉRÔME.
Gray Eminence (*L'Eminence Grise*). 1874.
Oil on canvas,
25¾ × 38¾″ (65 × 98 cm).
Museum of Fine Arts, Boston
(bequest of Susan Cornelia Warren).

left: Plate 37. Detail of Plate 36.

left: **Plate 38.** Carpet page
from the *Book of Durrow.* A.D. 700.
Illuminated manuscript. Courtesy
Board of Trinity College Library, Dublin.

below: **Plate 39.** JACKSON POLLOCK.
Mural on an Indian Red Ground. 1950.
Oil, enamel, and aluminum paint on canvas
mounted on board; 6 × 8′ (1.83 × 2.44 m).
Teheran Museum of Contemporary Art.

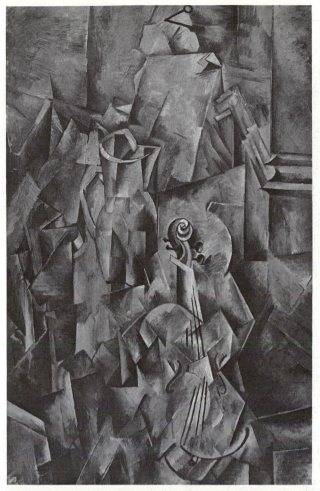

216. GEORGES BRAQUE. *Violin and Pitcher.* 1910.
Oil on canvas, 46⅛ × 28⅝″ (117 × 73 cm).
Kuntsmuseum, Basel (gift of Raoul La Roche).

217. PABLO PICASSO. *"Ma Jolie."* 1911–12.
Oil on canvas, 39⅜ × 25¾″ (100 × 65 cm).
Museum of Modern Art, New York (Lillie P. Bliss bequest).

considerably from a perspective representation such as that in Figure 213.

Which picture gives a more accurate representation of the table? This question cannot be answered, for, as has been noted before, the difference in the pictures is not due to their accuracy but to the kind of information they present. The perspective representation seems to emphasize the forms of the objects, enabling the viewer to "read" the detail in a single, cohesive, isolated moment of time. The composite representation gives the viewer a sense of the dynamics of the experience of vision. It was this kind of representation which became an important aspect of Cézanne's work. In his still-life painting (Pl. 33, p. 155) note the similarities to the composite photograph. The back edge of the table breaks and rises, as does the front edge. The bottle is drawn with a num-

ber of shifts to the left as it rises from the table, giving it a tipped appearance. Similarly, the dish on which the rolls are placed is drawn from one viewpoint for the left contour and from another, higher point for the right. Cézanne's attempts to paint a new kind of formal and spatial representation were part of a searching study that he carried out during the course of his entire painting career. His initial inquiry into nonperspective spatial representation has had a major influence on the art of the twentieth century.

In Paris, during the first decade of this century, Juan Gris, Georges Braque, and Pablo Picasso cooperated to extend the concept of the representation of a nonstatic seeing experience. The style resulting from their studies is called Analytical Cubism (Figs. 12, 216, 217). In their painting of this period one can follow the development of a progressively

218. EADWEARD MUYBRIDGE. *Walking, Hands Engaged in Knitting.* Photographed July 28, 1885; time interval 178 seconds. From *Animal Locomotion,* Philadelphia, 1887. George Eastman House Collection, Rochester, N.Y.

greater complexity of construction, multiple viewpoint combined with multiple viewpoint until the overlapping edges of the separate views became so numerous that objects defy identification.

Movement and change fascinated many people about the turn of the century. In the United States, as early as the 1880s, Eadweard Muybridge experimented with stop-action photographs of human and animal subjects in motion (Fig. 218). A similar interest in the representation of movement gave rise to the system of Futurism, specifically proposed by a group of Italian artists in a "manifesto" published in 1909 and well exemplified by the work of Giacomo Balla (Fig. 219), one of the founding members of the group. These artists conveyed the sense of motion by depict-

ing a sequence of poses caught in stopped action, one after the other, in the course of a movement, or by forms derived from the continuous overlapping of such poses (Fig. 57).

Representation of Color and Light

An awareness of the physical world is not limited to forms and spaces. Descriptions of objects can just as well refer to their color as to their shape or texture. "The figure is pink." One way of making a visual equivalent for that statement is to draw the outline of a nude and paint the enclosed area a single shade of the indicated ground color. This method of color representation is to be found in Plate 27 (p. 135), *Pink*

Nude by Henri Matisse. But is the body always seen as a single color? When shading is employed to represent form, the figure is made lighter in the illuminated areas and darker in the shaded areas. The pink of the body is called its "local color," but that specific color is only one of many different pinks Matisse would have had to use to create the illusion of a nude seen under natural conditions of light. This system of color representation—local color that is shaded—was used throughout the Renaissance (Pl. 17, p. 80) and remains current today.

The use of shaded local color for the representation of color in nature was not completely satisfying to some artists of the seventeenth and eighteenth centuries. The shaded areas they saw in nature did not always seem to be the color produced by adding black to a local color. Nor were the highlighted areas always the color produced by combining white with the local color. It is not unusual to find blue and green tones in the shadows of red clothing or on the heads of the subjects in paintings by Rubens (Pl. 25, p. 117) and Watteau. Watteau's painting *Embarkation from the Island of Cythera* (Pl. 34, p. 156) clearly shows the use of blue in the left and center distance and in the shadowed areas of foliage in the right half of the composition. The artist's utilization of warm colors in the foreground sunny areas and cool colors in the shadows is apparent throughout the painting.

In the nineteenth century, spurred on by the experiments in light and color by such scientists as Rood, Maxwell, and Chevreul, a number of painters began to experiment with new methods of color representation and paint application. These artists recognized that the apparent color of an object is affected to a considerable degree by the color of the light that shines upon it. The morning light is quite blue, as compared with the reddish light of the sunset. (Let doubters take photographs of the same scene, in color, before 8 A.M. and after the sun has begun to set in the evening and then compare them.) The color of the light not only affects the forms in the light but also alters the apparent colors in shadow, usually introducing hues that are the opposite of the color of the light source—for example, bluish shadows and yellowish sunlight. Some painters, including Renoir and Monet, realized that it was impossible to repre-

219. GIACOMO BALLA. *Dynamism of a Dog on a Leash.* 1912.
Oil on canvas, 35⅜ × 43¼″ (90 × 110 cm). Albright-Knox Art Gallery, Buffalo (George F. Goodyear and the Buffalo Fine Arts Academy).

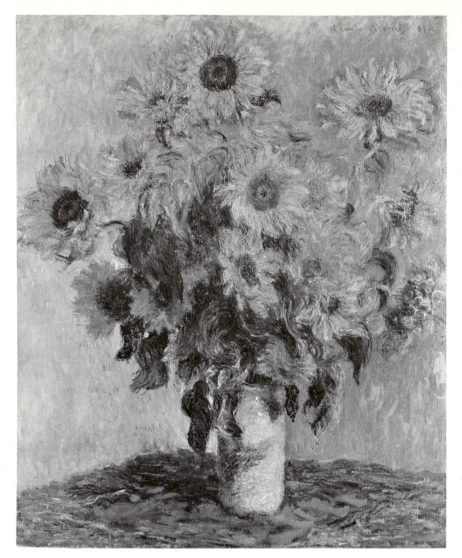

220. CLAUDE MONET. *Sunflowers.*
1881. Oil on canvas,
39¾ × 32″ (100 × 81 cm).
Metropolitan Museum of Art,
New York
(bequest of Mrs. H. O. Havemeyer,
1929, H. O. Havemeyer Collection).

sent the brilliance of the colors of natural forms seen under sunlight by using the traditional methods of painting inherited from the Renaissance (Pl. 1, p. 7; Pls. 7, 8, p. 26; Pl. 35, p. 156). The paints available to these artists were just not bright enough to reproduce the color experience they had when they looked at a field at noon or the façade of a Gothic cathedral shimmering in the evening light.

Led by Monet, a group of artists, who were later given the name Impressionists, introduced a revolutionary method of paint application and color usage. They found that areas of the canvas painted in small strokes of color would appear, from a distance, to be more brilliant than similar areas painted in flat or in gradually modulated tones. They also found that an area of green appeared more intense and even greener when it had within it small numbers of red or orange spots. Blues could be made more brilliant by a similar introduction of orange. In effect, what they did was to create a form of optical vibration, which occurs when contrasting hues of similar value are juxtaposed. The vibrating small spots of color gave the surface of the canvas a shimmering quality, which seemed to make the light and colors represented in the painting more like the original subject.

The Impressionist painters were excited and challenged by the light and color in nature. They saw form and space as secondary aspects of the light that delineated objects, which, for these artists, were not things to be touched but things to be seen. The method of representing this visual world made it almost impossible to represent forms with the detail

and concern for texture that were traditional before the work of Monet and his colleagues. Application of paint in small broken strokes prevented the creation of sharp contours and surface variation, which are typical of the paintings of an artist who wishes to represent objects in a sculptural manner. Compare the detail from a painting by Monet with one by his contemporary Jean-Léon Gérôme. Monet's use of paint (Fig. 220; Pl. 35, p. 156) prevented his representing form with all the concern for detail we see in the work of Gérôme (Pls. 36, 37, p. 157), but Gérôme's method precluded the possibility of representing light and color with the brilliance of Monet's surfaces. Once again, we are faced with the conclusion that it is impossible to depict all aspects of real experience on the same canvas.

Nonrepresentational Painting

For thousands of years the ability of the artist to use eye and hand to represent the human experience has given the image makers a special and important role in many societies. Not all representational images have been intended as illusionistic portrayals of perceived reality; some have been stylized or symbolic. But when it was necessary to record or communicate the history, mythology, or day-to-day life of a people in pictures, the artist was expected to meet the need. With the invention and widespread use of photography and photomechanical reproduction, that role has been severely curtailed, but many painters and printmakers refuse to surrender their representational function to the photographer. They continue to paint and draw images that satisfy them and provide, for a responsive public, equivalents for people, places, and things which differ from or are superior to photographs. But other artists have consciously or unconsciously responded to the pictorial revolution of the camera by relinquishing their traditional roles as reporters and recorders. They have found their challenge and their satisfaction in nonrepresentational visual images.

Some have concentrated on purely compositional inventions, testing the limits of aesthetic response and the ways in which the plastic elements may be combined to fascinate and confound our perceptions and our conceptual expectations. Others have devoted themselves to a search for images that communicate the nonvisual, internal realities so important to us all and so difficult to express. Still others have continued the decorative tradition that is as ancient as any in the visual arts, creating objects that delight our senses without reference to their symbolic content.

The page from the early Irish *Book of Durrow* in Plate 38 (p. 158) is a 1,200-year-old ancestor of nonrepresentational painting. It is crafted with admirable skill, and its intriguing complexity captures our imaginations in the puzzle of the knotted skeins of woven tracery.

Jackson Pollock's *Mural on an Indian Red Ground* (Pl. 39, p. 158) has much in common with the appearance of the page from the Book of Durrow, though they are based on different intentions. Pollock's painting too has its mystery. It is a web, delicate and intricate, that enmeshes the viewer in overlapping, intertwining threads of color—a dense spatial field that stimulates the imagination and offers an opportunity for provocative contemplation.

The quiet intensity of Mark Rothko's painting (Pl. 40, p. 175) contrasts with the active surface of the *Mural,* but it shares with that painting and the manuscript (Pl. 38, p. 158) a suggestion of the third dimension that adds visual complexity to the essentially two-dimensional composition. Without representing a space filled with three-dimensional objects, each of these three works introduces visual cues indicating that some parts of the painting seem to be closer to the observer than others.

In the Rothko canvas the large rectangular forms appear to float against and still be part of the subtly modulated, deep purplish brown of the back plane. The orange area at the bottom seems to force itself forward, held back slightly by the soft edges that are tenuously connected to the surfaces behind. The black form at the top has a spatial position somewhat behind the orange area but clearly in front of the transparent central element. The sense of space in Rothko's painting derives from a real, immediate experience that involves the viewer at the time of contact with the work. The large scale of the canvas (approximately 5 by 8 feet, or 1.5 by 2.4 meters) helps to produce the effect of a vista beyond the wall on which it hangs, opening into the void a warm, silent environment made for reflective study.

Five vibrant squares of billiantly dyed paper conceived and prepared by Ellsworth Kelly (Pl. 41, p. 175) play tricks with us as they defy their obvious simplicity. Our attention shifts from one block to another in an unpredictable rhythm as one field and then another demands our interest. Small differences along the boundaries of the squares become surprisingly important in the absence of major variations of form. The colors shift their spatial positions in an ambiguous way, one plane pushing forward for a moment only to recede in favor of another.

All artists working in two-dimensional media face the problem of the third dimension, for it is impossible to place a dot on a piece of paper without having it assume a spatial position in the mind of a perceptor. Does the dot sit on the white surface, and therefore in front of it? Does the dot indicate a hole in the plane

of white paper, through which a dark depth is seen? Few observers will perceive the dot and the white area at the same spatial distance. Thus, few two-dimensional art forms throughout the history of art lack a hint of the third dimension. In many of them some accommodation has been made between the two-dimensionality of the medium and the illusion of depth. Some artists have emphasized the flat surface with but a limited concern for the effect of a space that moves in or out from the picture plane. Others have attempted to produce a three-dimensional illusion as though the flat surface of the picture did not exist, and the picture frame served as a window through which a viewer saw forms and spaces comparable to those in the real world. Each of these attitudes toward picture-making offers the trained observer a different form of visual communication. There is little profit in establishing one solution to the three-dimensional problem as the ideal standard for judging all others. A photographic system of spatial representation cannot be fruitfully applied to Cubism or to the work of Mark Rothko. On the other hand, the methods of communicating three-dimensionality used by Cézanne, Picasso, Matisse, Pollock, Rothko, Kelly, and others who have forgone the use of perspective systems offer no criteria for judging the work of painters who have substituted illusionistic equivalents for real space. Each approach must be seen as a part of a larger visual content, and the effectiveness of the spatial indication must be measured against the communicative intention of the individual artists concerned.

Part Three

THE LANGUAGE AND VOCABULARY OF THE VISUAL DIALOGUE

Three-Dimensional Forms

Sculpture: The Plastic Elements

When a sculptor begins to work with a mass of clay in the studio, the process that is started may eventually result in a work of art. The inert material is pulled and pushed into shape; pieces are added and removed; sculpture tools, hands, and fingers are used; and gradually the work approaches its final state. The forms are fixed; concavities, convexities, and open spaces all assume positions. Out of the soft, yielding, inanimate portion of earth a sculpture emerges. Shapelessness turns into ordered forms and spaces, chaos into meaning.

Rarely does the sculptor, painter, or writer build a work of art as a child would build a tower of blocks, by placing one block upon the other so that each section sits firmly on the section under it and supports the section above. Instead, motivated by an experience or by the desire to fashion an image or an object of unique character, the artist commences with a limited number of forms arranged in a configuration that approximates the original conception. Then begins a period of trial-and-error during which the ultimate design and organization of the piece gradually grows. Subtleties and complexities of formal and spatial relationships, not previously planned, develop as the sculptor reacts to the process of parturition.

Sometimes the original motive is considerably altered or even transformed in the shaping process. Finally, the work is complete; nothing more can be added or taken away that will increase the artist's satisfaction with the web constructed of interrelated elements.

For some image makers the developmental process takes place in a brief, intense period of time; for others the work is extended, requiring preparatory studies and models; for still others, a very limited group, the process advances without deviation along a predetermined path from a minutely conceptualized idea to total realization. But no matter what differences exist in the procedure of individual artists, the result of their efforts depends upon the utilization of their chosen medium and the basic elements they can manipulate in that medium. Each art form has its own primary compositional units, or plastic elements, and these serve the painter, sculptor, and architect much as the syllable, word, sentence, and paragraph serve the writer.

Sculpture is a three-dimensional art form, and a sculptor can imitate quite precisely the forms of things found in nature. Donatello, who worked in Italy in the fifteenth century, appears to have approached sculpture in just this representational way.

left: **221.** DONATELLO. *St. George.* c. 1417.
Marble, height 6'10¾" (2.1 m).
Museo Nazionale, Florence.

below: **222.** JOHN ROGERS.
"Wounded to the Rear," One More Shot.
American Civil War period. Bronze, height 23½" (60 cm).
Metropolitan Museum of Art, New York
(Rogers Fund, 1917).

223. Rear view of Figure 221. **224.** Right side of Figure 221. **225.** Left side of Figure 221.

So does John Rogers, a nineteenth-century American. However, if we compare Donatello's *St. George* (Fig. 221) with Rogers' statuette entitled *"Wounded to the Rear," One More Shot* (Fig. 222), there are differences which obviously set them apart. Both statues represent human forms clothed in fabric; but if we study the *St. George,* we can find an organization of the folds of cloth on the figure which suggests that the sculptor carved them with a purpose other than the representation of a casually worn garment. When seen from the back, the forms of the cloak in the *St. George* are simplified into a strong diagonal plane (Fig. 223); the folds are indicated with an emphasis that repeats the diagonal. Seen from the front or the side, this statue seems contained in a relatively simple contour edge. Notice the sweeping curve which begins at the statue's left shoulder, continues down the arm to the elbow and through the drape of the cloak, and is then picked up by the diagonal line formed by the edge of the shield and carried down to the base. The figure's right side has a similar contour, which moves in a quieter arc from shoulder to arm to shield (Fig. 224). A study of the statue from its left side (Fig. 225) reveals the form of the cloak used once again to provide a simple, direct contour at the back, contrast-

ing with a more active contour at the front edge, but even this complex movement seems to be unified into a strong diagonal.

Clearly, the arrangement of the forms in the *St. George* is based on a conscious design. The sculptor's main concern was the creation of a religious image, but he also wished to create an aesthetic object.

The statuette by Rogers is also concerned with representation. The forms of the clothing appear to be determined by the artist's desire to imitate cloth arranged and folded in response to the posture of the bodies within the uniforms. One feels that the sculptor wished to isolate a moment in time. The naturalistic detail in figures and drapery serves to involve a viewer with the activity and condition of the subjects. It is possible to admire the careful observation of the artist and his skill at producing an accurate equivalent for a real-life scene, but the intent of the piece is limited by the medium the artist has used. A 23-inch (58-centimeter) bronze statue does not convey the scale and physical quality of the original subject. No degree of skill will convince even the most naïve that bronze has been transformed into flesh, hair, and cloth, and no effort on the part of the sculptor can ever really make us forget that the object produced.

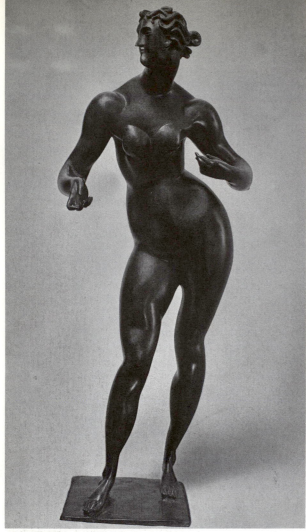

226. ELIE NADELMAN. *Standing Female Nude.* c. 1909.
Bronze, height 21¾″ (55 cm);
at base, 5¾ × 5½″ (14 × 15 cm).
Museum of Modern Art, New York
(Aristide Maillol Fund).

degree, and still maintain the integrity of a representational statue.

Within these limitations, however, there are a great many possible arrangements that the artist may choose to exploit. Like a choreographer who directs dancers to take certain poses, the sculptor may arrange the position of torso, head, limbs, and drapery in a great variety of ways, as well as simplify or selectively emphasize certain forms. The surface of the sculpture may be treated to enrich the appearance of the material, even though this limits its imitative function. Bronze can be colored or polished; marble can be made satin smooth, so that its hard, cold character is emphasized.

The *St. George* communicates to a viewer in several ways. It represents the figure of a young man in the costume of a warrior; it represents a religious symbol; and an observer may respond to the work on the basis of one or both of these equivalencies. But, in addition, the statue exists as a testament to itself. Donatello's sculpture, unlike that of Rogers, has been conceived as an ordered arrangement of planes and surfaces cut into stone. The differences between this sculpture and the original model who posed for it are not deficiencies; they are positive factors contributing to the impressive dignity the statue possesses, an affirmation of its presence as the product of the mind and physical effort of its creator.

Should a sculptor decide that the aesthetic relationships will be the primary concern in a work, that decision removes the necessity for arranging the forms and spaces of the sculpture to approximate the forms and spaces found in natural objects. Concave and convex contours can be used where they will yield the most satisfying aesthetic result. Forms may be angular or rounded, finished to a smooth, light-reflecting surface or left rough, still showing the marks of the tools used to fashion them. If the sculptor feels that two forms should be separated by a space, or that one should be placed above and to the right of another, they can be arranged in that position. Often, a sculptor bases the work on natural objects, using the subject as a point of departure for the statue but altering the natural arrangement of forms and spaces for aesthetic reasons.

The nude by the American sculptor Elie Nadelman (Fig. 226) is an example of just this kind of sculpture. If Nadelman's figure is compared with Donatello's *St. George,* Nadelman's greater concern for the aesthetic relationships is obvious, for he consciously treats the female figure as a group of simplified spherical forms. Each portion of the statue becomes a part of a flowing sequence of curvilinear masses and silhouetted edges. As a result of this rhythmic flow, the image of the nude figure is given an enhanced quality of grace and motion. In addition, the surface

by him is, in fact, a statuette. Rogers appears to have ignored this fact; Donatello did not.

Both Donatello and Rogers were limited in the way they could arrange the material which formed their sculptures. They may not have been fully aware of the limitations upon them, but the need for a relatively naturalistic form of representation restricted the disposition of the shapes, contours, and masses which compose both pieces of sculpture.

The human body has certain general characteristics of form which cannot be changed without suggesting grotesque distortion. There are proportions of head to body, of eye to head; there are positions natural to the torso, to the arms and legs; there are forms which are naturally concave, others which are convex. No sculptor may depart from these relationships and characteristic shapes, to any appreciable

of the bronze has been burnished, creating a sensuous object that can offer tactile and visual pleasure.

Henry Moore, a British sculptor, has used the reclining female figure repeatedly as a motif for his sculpture. Comparing three of his works based on this subject, we can see that, although they differ significantly one from the other, they share a number of characteristics. In each the reclining figure serves as a point of departure for a compositional variation fusing a figurative image to an aesthetic order that is unrelated to any representational intention.

Figure 227, carved in 1929, shares with the Nadelman figure an arrangement and proportion of torso, head, and limbs that approximate those found in the original subject. Both are simplified, but Moore uses angular planes as the basis for his composition, in contrast to the system of curves employed by Nadelman. This planar arrangement enhances the stony quality of the piece by suggesting the resistance of the material to the carving process. Concurrently, it creates a geometric monumentality that turns the female form into a powerful symbol recalling images of ancient goddesses and secret rites.

In *Reclining Figure, Internal-External Forms* (Fig. 228) Moore's concern for the manipulation of the plastic components is even more pronounced, and, as

227. HENRY MOORE. *Reclining Figure.* 1929. Horton stone, length 33″ (84 cm). Leeds City Art Gallery, England.

228. HENRY MOORE. *Reclining Figure, Internal-External Forms.* 1951. Bronze, length 21″ (53 cm). Museum of Fine Arts, Montréal.

a result, the naturalistic representational aspect of the statue is reduced. Moore shaped an enveloping hollow shell reminiscent of some of the forms in the female figure. Within the space of the shell he placed another, more linear mass, which also derives from human forms. The outer shell is pierced by openings permitting the viewer to look into the somewhat mysterious inner recesses which contain the enfolded figure. Open spaces and solid forms are interrelated, each affecting the shape and placement of the other. It is this organization of open and closed form, inner and outer space, which dominates the conception of this work, and not the demands of representation.

The third example of Moore's figurative sculpture is a bronze casting divided into three units placed in a delicate balance, each piece working to support the others and in turn dependent on them for its own stability. The figure, in its parts, becomes a group of bony vertebrae, or perhaps a landscape with stone bridges arching over ravines and craggy bluffs supported on improbable columns (Fig. 229).

This figure is far removed from Donatello's *St. George.* Nevertheless, it has a comparable capacity to affect viewers aesthetically. Donatello's image and the images by Moore and Nadelman were formed with different intentions, though presumably each artist wished to move those who came to see the results of his labors. These sculptures differ as a result of cultural influences, the effects of time, place, and tradition, and as a result of personal preference. But each example carries the potential for aesthetic satisfaction; recognition of both the representational nature of a work and the artist's capacity for plastic invention can lead to a rewarding response.

Form and Mass

The sculptor's intention, the original motivating conception, automatically limits the forms to be used. A personal aesthetic attraction to some forms rather than others may also set limits. Whatever the basis for choice, the process begins with masses shaped in some way. The sculptor may use or produce solid forms of varied sizes and configurations; they may be many or few; they may be clustered into dense, compact groups or separated from one another by open space. The decisions which affect the quality, the number, and the disposition of the forms are basic to the final appearance of the sculpture, and are made as the work progresses.

It is possible to discuss the forms in a single sculptural piece as separate and distinct entities, but the isolation of the element of form is just a convenient device. Actually, the characteristics of forms are also dependent upon the spaces between them and the material used to produce them. Forms made of clay, which is opaque (Fig. 230), are very different from transparent forms produced in plastics (Fig. 248). The form of a doughnut is affected by the shape and size of the space, the hole, in the center. Reflection of light by the surface of certain forms can appear to strengthen or diminish the scale and importance of the actual masses that would be perceived by touching the sculpture with the eyes closed. Yet, with care and an awareness of the simplification involved, it is possible to focus attention on the rounded knoblike forms in Henry Moore's *Reclining Figure* (Fig. 228) and see them as significantly different from the rounded forms in the Nadelman nude (Fig. 226) and

even more different from the forms in Reuben Nakian's terra-cotta study (Fig. 230).

The words "form" and "mass" are often used interchangeably, but there is an important difference between them. Forms can be described in terms of shape and size. A description of mass includes its weight. This distinction means little when forms or masses are produced by color on a flat surface. However, for the artist who works three-dimensionally the weight of a form affects the choice of material and the manner in which that material is connected to the other elements in the composition. Problems of strength, distribution of supporting and counterbalanced weights, and the stability of the entire complex of component masses can become a central concern in the compositional system, which, in addition, will have expressive possibilities and limitations.

The sculptor may create a visual illusion, intending observers to disregard the actual weight and strength of the material in the sculpture, wishing, instead, for a response to the *apparent* effect of gravity on the subject represented. In Aristide Maillol's *The River* (Fig. 231) the figure seems arrested in the act of falling. This appearance of instability, so ap-

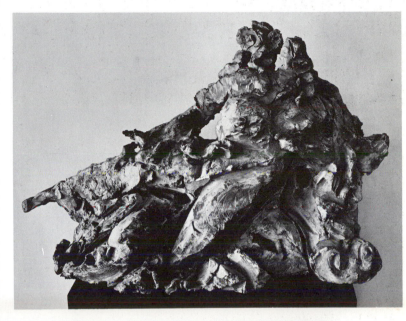

right: 230. REUBEN NAKIAN.
Voyage to Crete. 1949.
Terra cotta, length 26″ (66 cm).
Private collection.

below: 231. ARISTIDE MAILLOL.
The River. 1938–43.
Lead, 4′5¾″ × 7′6″ (1.37 × 2.29 m);
at base, 5′7″ × 2′3¾″ (1.7 × .7 m).
Museum of Modern Art, New York
(Mrs. Simon Guggenheim Fund).

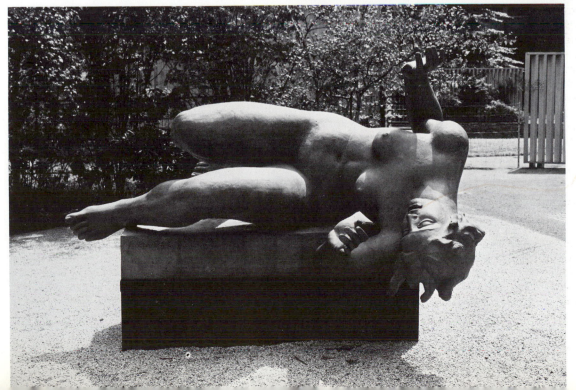

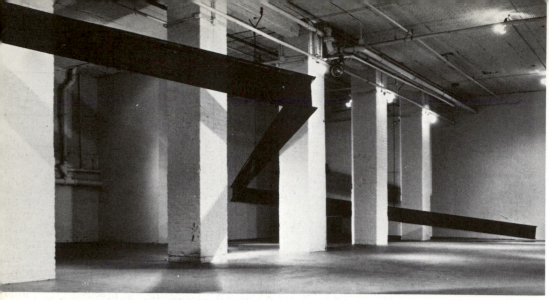

left: 232. CHARLES GINNEVER.
Zeus. 1975.
Mild steel, 3 sections;
length of each section
30′ (9.14 m).
Courtesy Sculpture Now, Inc.,
New York.

below: 233. RICHARD SERRA.
Sight Point. 1972–75.
"Cor-Ten" steel,
height 38′10⅛″ (12 m).
Stedelijk Museum, Amsterdam.

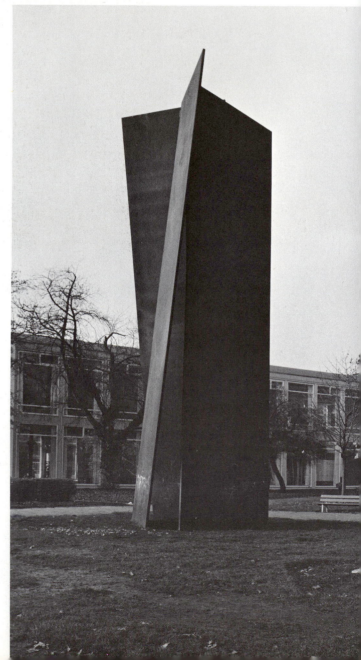

propriate to the subject, is based on our response to the metal image as though it were an actual body pulled by the force of gravity from its rectangular platform. Our experience with our own bodies and our perception of objects in the real world, as they are affected by gravity, causes us to expect such an apparently unstable arrangement of mass to fall or collapse. Actually, the sculpture is a construction of lead engineered so that it is secure on its supporting pedestal. The strength and the weight of the lead are not those of a human body. Maillol's representational and expressive intention depended on the way in which the lead mass contradicts our expectation of the normal state of flesh, bone, and muscle in a similar position. In *The River* the figure does not fall because its lead mass is joined to and counterbalanced by the heavy base. The condition of the mass as visually perceived is in contradiction to the actual conditions of the real physical mass that constitutes the sculpture.

A similar illusionistic device is used in a dramatically different way in Charles Ginnever's piece in Figure 232. Ginnever has welded three 30-foot (9-meter) long steel I-beams into a construction that appears to defy gravity. They float magically, in a space charged with their improbable presence. Note how the lower end of the zigzagging metal seems to remain unsupported above the floor. More careful study of the illustration will reveal thin, almost invisible rods from which the I-beams are suspended. But even when we take their presence into account, the weight of the steel appears unexplainably levitated.

Another use of mass in sculpture appears in a work by Richard Serra. Here the artist does not depend on illusion. Using large metal plates, he exploits their physical characteristics—their size, shape, and weight—to form images based on their structural relationships. The 39-foot (12-meter) high steel plates of *Sight Point* (Fig. 233) create a tense and threaten-

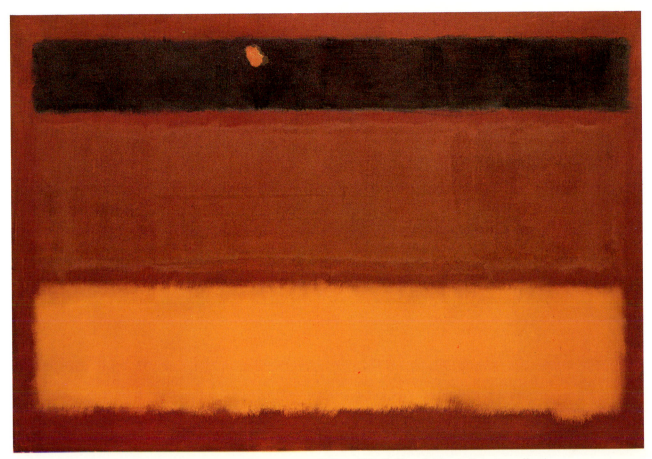

Plate 40. MARK ROTHKO. *Untitled.* 1962. Oil on canvas, 5'4" × 7'8" (1.68 × 2.03 m). Private collection.

Plate 41. ELLSWORTH KELLY. *Blue/Green/Yellow/Orange/Red.* 1977. Dyed pulp laminated to handmade paper, 13½ × 46" (34 × 117 cm). Produced and published by Tyler Graphics Ltd. Copyright 1977 Ellsworth Kelly.

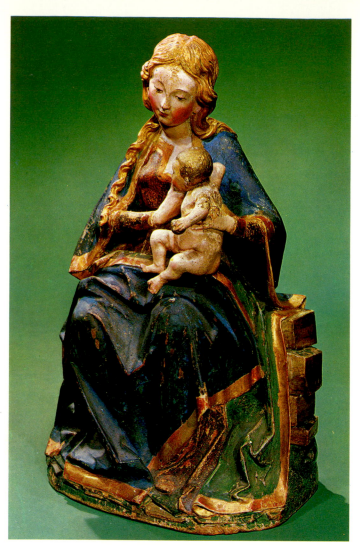

left: **Plate 42.** *Virgin and Child.* c. 1500.
Polychromed wood, height $10\frac{1}{4}''$ (26 cm).
Metropolitan Museum of Art, New York
(bequest of George Blumenthal, 1941).

below: **Plate 43.** DUANE HANSON.
Man on a Bench. 1977.
Polyester and fiberglass, life-size.
Collection Richard and Gloria Anderson,
Overland Park, Kans. (See Fig. 82.)

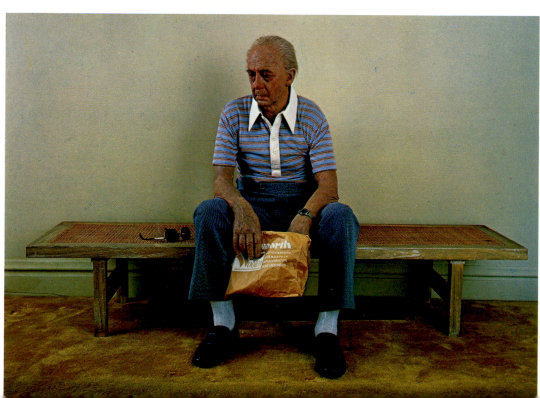

above: 234. Cylinders viewed from the south.

below: 235. Forms in Figure 234 viewed from above.

236. Forms in Figure 234 viewed from the east.

237. Forms in Figure 234 viewed from the southeast.

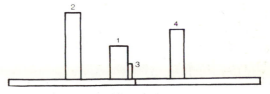

238. Forms in Figure 234 viewed from the east-northeast.

239. Forms in Figure 234 viewed from the southwest.

ing construction that denies its simple and straight-forward form. The tenuous stability of this structure is achieved by leaning the great plates against each other like a section of a house of cards. The same portent of impermanence and inevitable destruction is present here that we find in the tilted pasteboards awaiting a passing breeze. A simple description of the rectangular forms of the piece and their angular positions is insufficient to explain the disturbing power of this work. Not until we describe the weight of the masses and the resistance to the forces of gravity is the expressive content adequately communicated.

Space

Space is an element that is difficult to illustrate unless an actual three-dimensional object is present. The following diagrams may be of some help. Figure 234 represents four thin cylinders standing upright upon a flat, square field. The cylinders vary in height, and the distances between them are irregular. The cylinders are the vertical forms in this arrangement.

Figure 235 represents an overhead view of the arrangement in Figure 234. The cylinder forms are seen as circles. Each one of these circles is at a measurable distance from every other circle and from the edges of the square on which they are placed, and each one forms an angle with any other two (see solid lines). These distances and angles describe the space between the forms. When this group of three-dimensional forms is seen from the side, as in Figure 234, it is possible to sense a spatial relationship between them which results from their varying heights (see shaded area). The arrangement indicated in Figures 236 to

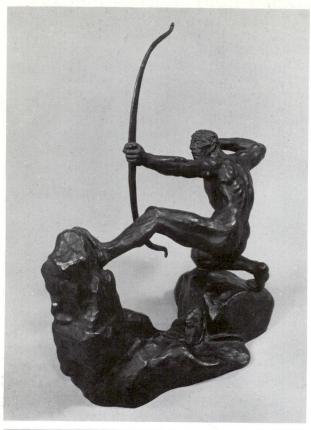

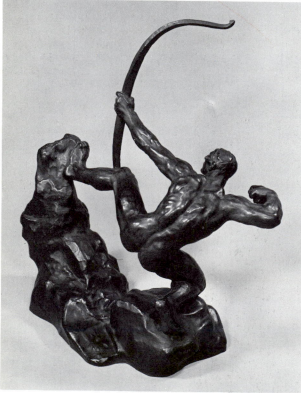

239 gives the viewer a variety of *apparent* form-space relationships as seen from different vantage points. Shifting the position of the forms can result in an infinite range of different spatial relationships.

When the forms used in a three-dimensional composition are more complex than simple cylinders, the variation in shape has a stronger effect on the shape of the space between them. This interaction of form and space can become very complex and highly interrelated. Imagine Emile-Antoine Bourdelle as he was working on the clay model for his bronze sculpture *Hercules* (Figs. 240, 241). The forms of the work are directly controlled by the forms and proportions of the human body, but had he raised the left arm a bit, the size and shape of the space between the body, the left leg, the arm, and the bow would have changed. Similarly, changes in the forms and the positions of the legs and in the forms of the rock would have altered the shape and size of the space bounded by these elements. The decisions Bourdelle made had to include those which affected the open spaces between the forms. In Henry Moore's composition (Fig. 228) the artist has integrated forms and spaces without the restrictions inherent in a representational work. As in the diagrams, the spatial organizations of the Bourdelle and the Moore pieces create different space shapes as a viewer moves about the sculpture.

When discussing sculpture we can consider space in still other ways. If Moore's bronze were covered with a plastic bubble conforming to the external shapes of the piece and then removed from the formed shell, the empty volumes within the plastic case would express the space actually filled by the physical structure that comprises the sculpture. But there is also a *presence,* a form of psychological energy, created by the art object that extends beyond its actual physical dimensions. This vitality can seem to appropriate some limited volume of space about the object, like a light that illuminates a dark void, most intense at the source of energy and gradually losing its effect as the radiation diminishes at the outer perimeter. The amount of space psychologically filled by a work of art differs with the size of the work, with its composition, and, of course, with its impact on a viewer. Quite probably, the space energized by a particular art object will differ for individual viewers, but the effect does exist, and this does become a part of the plastic organization shaped by the sculptor.

above left: 240. EMILE-ANTOINE BOURDELLE. *Hercules (The Archer).* 1908–09. Bronze, 25 × 17″ (66 × 43 cm). Wadsworth Atheneum, Hartford, Conn. (Keney Fund).

left: 241. Rear view of Figure 240.

Texture or Surface

The *texture* or *surface* of the material used by the sculptor can be controlled and made to function as a significant element of composition. The sculptor can create texture by working the material with tools, or by smoothing and polishing it. If the basic substance is soft, the act of pushing and pulling it into a final shape, the caress of the artist's hands, or the slash of a knife will produce tactile surfaces. These must be subjected to a considered judgment before they are allowed to remain as part of the completed work.

The small figure by Medardo Rosso (Fig. 242) is made of wax. Rosso was interested in the play of light over his work. The artist found the soft, reflective surfaces of wax an ideal material for the luminous effects he wished to achieve, and he therefore developed a method of working wax around a plaster core. The surface of the wax figure retains the evidence of the way the material was manipulated with fingers and warm instruments. Hollows and built-up forms suggest surfaces collected from dripping candles as much as they do the image of a figure.

The Japanese-American sculptor Isamu Noguchi carved *Black Sun* from a block of granite (Fig. 243). Great physical effort was required to shape the hard stone from its rough state to the highly resolved forms and surfaces of the completed piece. The rich undu-

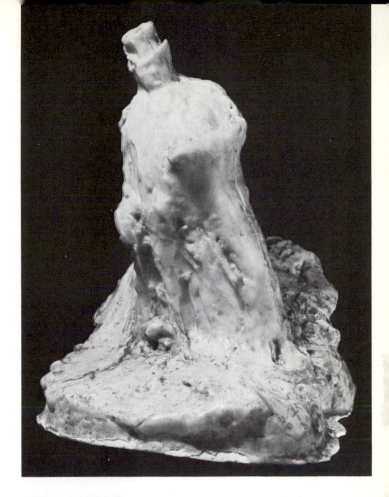

above: **242.** MEDARDO ROSSO.
The Bookmaker. 1894.
Wax over plaster,
$17\frac{1}{2} \times 13 \times 14''$ ($44 \times 33 \times 36$ cm).
Museum of Modern Art, New York
(Lillie P. Bliss bequest).

left: **243.** ISAMU NOGUCHI.
Black Sun. 1960–63.
Black Tamba granite,
diameter 30'' (76 cm).
Courtesy National Trust
for Historic Preservation
(bequest of Nelson A. Rockefeller).

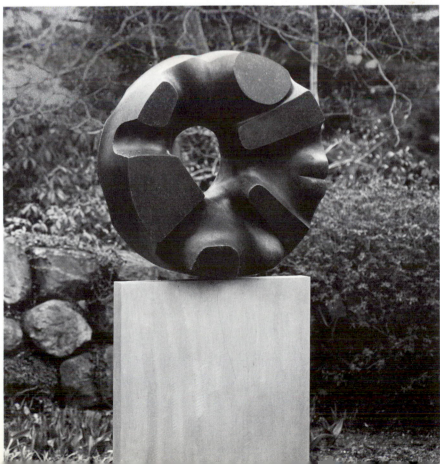

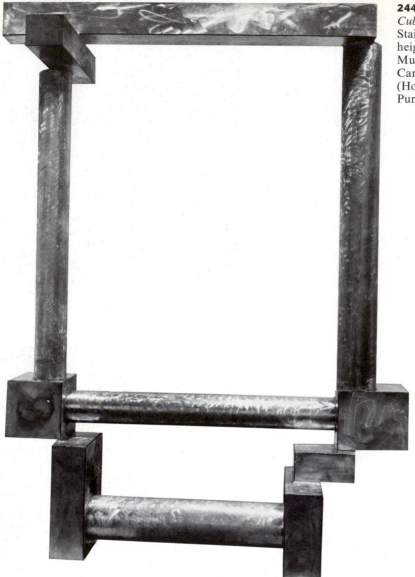

244. DAVID SMITH.
Cubi XXIV. 1964.
Stainless steel,
height 9′5″ (2.87 m).
Museum of Art,
Carnegie Institute, Pittsburgh
(Howard Heinz Endowment
Purchase Fund).

lating skin of the granite was ground and polished
after the sculptor had used cutting tools to arrive at
the essential forms. This final surface treatment
deepened the color of the granite, perfected the con-
tours of the forms, and gave them the appearance
and feel of a firm, cool, sensuous material. The marks
of the chisels were eliminated, and the reflections of
light replaced them to become part of the image.

The dramatic contrast of light and dark reflections
on the surface of Brancusi's *Bird in Space* (Fig. 74)
results from careful polishing and buffing of the
bronze casting. The machinelike perfection of this
surface enhances the sweeping upward curve of the
sculpture with an effortless grace that belies the effort
that produced this effect.

Cubi XXIV (Fig. 244), by David Smith, is con-
structed of welded stainless steel. Had the steel been
polished to a mirror finish, like Brancusi's surfaces,
the light reflected from the surfaces would have em-
phasized the stark geometry of the construction. In-
stead, Smith ground the surfaces with an abrasive
wheel to obtain a calligraphic light pattern that be-
comes a counterpoint to the severity of the geometric
solid forms.

Figure 245, *Accession,* is a construction by Eva
Hesse. A galvanized steel mesh box is densely laced
with plastic tubing so that the interior space is bris-
tling with resilient tendrils in contrast to the severe
geometry of the exterior. Here texture has a strong
expressive function, for the tubes, in hairlike profu-

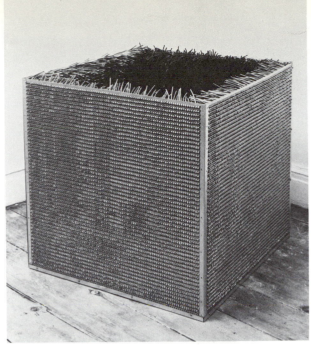

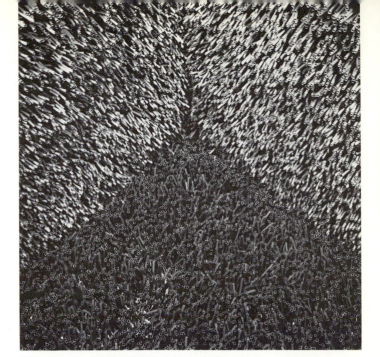

245. EVA HESSE. *Accession.* 1967. Galvanized steel, vinyl extrusion; 36″ (91 cm) square. Detroit Institute of Arts.

246. Detail of Figure 245.

sion, suggest a caged living organism that is both fascinating and threatening (Fig. 246).

Every material employed by a sculptor has the potential for many surface treatments. Each method of shaping and finishing stone, wood, and metal leaves traces on the material, and the artist may decide to retain in the completed work the clear evidence of the process in the marks made by tools and hand. Or, it is possible to alter the surface by procedures that file, grind, polish, or color the basic element. The artist may even wish to cover the sculpture with a surface that hides the quality of the primary material, or combine two or more materials so that their formal and surface differences may be exploited. In every instance the tactile and visual surface characteristics of a sculptural object will affect the response to it, and the artist must consider them a variable factor in producing the image.

Linear Elements

Another basic constituent of sculpture is *line.* As applied to the work of a sculptor, "line" can have a number of meanings and a linear element may be created in several ways. In the study for *Doors of Death* by the Italian sculptor Giacomo Manzù (Fig. 247), the bronze relief panel was originally formed

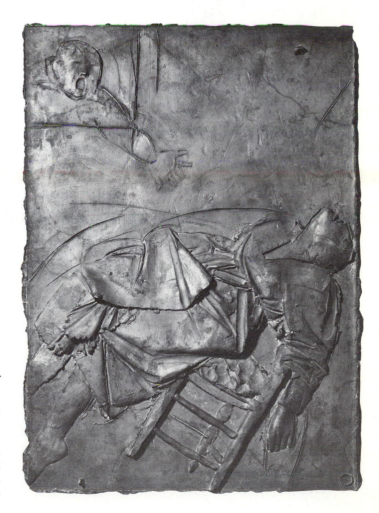

247. GIACOMO MANZÙ. *Death on the Earth,* study for *Doors of Death,* Basilica of St. Peter, Rome. 1963. Bronze, 37 × 23½″ (94 × 60 cm). Courtesy Paul Rosenberg & Co., New York.

from a slab of soft clay or wax. The artist built forms out from the flat surface of the slab, shaping them to catch the light or to cast shadows. In effect, he *drew* his composition by means of controlled projections and depressions. When the modeled elements in a relief have subtle three-dimensional transitions, the light on them produces shaded tonal modulations. When the projections come to a sharply defined edge, they produce a *shadow line* similar to a *drawn line.* These lines are combined with others cut into the background plane with a knife or modeling tool. Manzù's panel is called a "low relief," and, like others of its kind, including images on coins, it uses three-dimensional means to create visual effects similar to those in two-dimensional art forms.

In sculpture, as in painting, it is also possible to consider line as a part of the element of form. The edge of a sculptural form becomes linear when seen against a contrasting background, inside or outside the work. One may speak of the "curved line" produced by the external edge of the thigh in the figure by Elie Nadelman (Fig. 226). It is also appropriate to refer to the way in which the *line* created by the edge of the left sleeve in Donatello's *St. George* is contin-

ued as a diagonal by the edge of the shield in the view of the statue in Figure 221. This linear continuity disappears when the figure is examined from another viewpoint and is replaced by other linear repetitions, contrasts, or silhouettes.

The edges of Plexiglas, a strong, transparent plastic material, take on the appearance of lines floating in space in Sylvia Stone's *Another Place* (Fig. 248). They intersect and assume spatial positions seemingly unaffected by gravity. Because the planes are transparent, it is possible to circle the piece looking through surfaces that interrupt but do not obscure our vision. Lines shift, planes take on and release chromatic changes, as the viewer's point of observation changes and the arrangement of plastic sheets assumes different angular relationships.

The sculptor can also treat thin strands of light-reflecting wire as lines in space, arranged in an extraordinarily controlled pattern, or, like Alexander Calder, the artist can use stiffer wires, bending them into a form of three-dimensional line drawing that rearranges itself in a jiggling rhythm when moved by the touch of a hand or the pressure of a passing draft (Fig. 249).

248. Sylvia Stone. *Another Place.* 1972.
Plexiglas, 6′8″ × 17′ × 28′2″ (2.03 × 5.18 × 8.59 m). Collection Al Held.

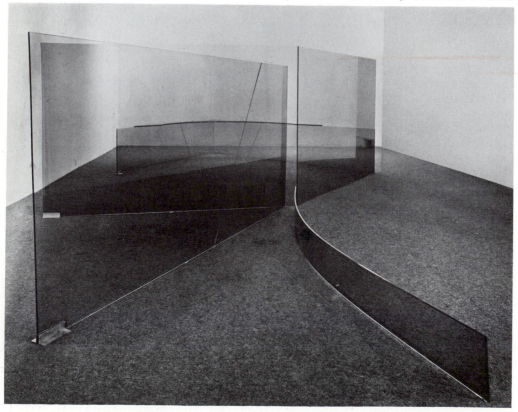

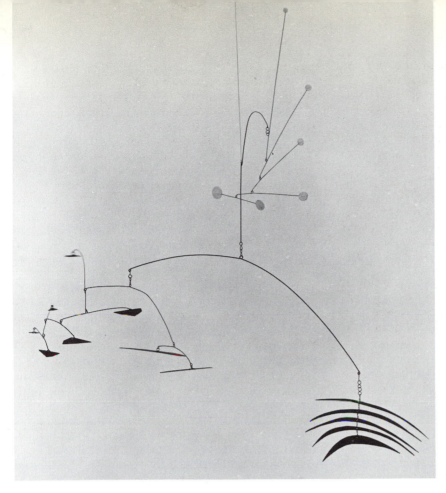

left: 249. Alexander Calder. *Five Red Arcs.* c. 1948. Sheet metal, metal rods, wire; 3′11¼″ × 4′8″ (1.2 × 1.42 m). Solomon R. Guggenheim Museum, New York.

below: 250. Diagram of linear axis in Figure 226, Nadelman's *Standing Female Nude.*

Finally, *line* in sculpture can refer to the implied or imagined major axis of a form. Like a spine supporting the form internally, the linear axis may be sensed as curved or straight. It may appear to tilt at an angle from a horizontal or vertical base. It may move through several forms, uniting them in a continuous flow. Return again to the Nadelman nude (Fig. 226) and note the curved axis that begins at the head, shifts direction through the upper torso, then reverses at the hips to continue through the left leg (Fig. 250). The lower arc of the S curve is echoed by a slightly bent diagonal that unites the thigh and calf of the right leg in a parallel movement.

Color

To some degree there is an interdependence between surface and *color* in sculpture. As noted in the comments on the granite carving by Isamu Noguchi (Fig. 243), the polished surface of a material such as stone has a marked difference in color from a rougher surface of the same material. When working in black granite, a sculptor cannot produce a deep, dark color in the work without polishing the surface to a high finish. Similarly, the surface reflections on Constantin Brancusi's sculpture (Fig. 74), which become a part of the color of his work, are directly dependent upon polishing.

Many sculptural materials have natural colors that become an integral part of a piece produced in that material. A sculptor may choose a certain material primarily to realize particular forms from it and thus may have to accept the color natural to the substance. If the artist acknowledges this limitation, it

may be necessary to accommodate the design to the color available. However, many materials can be made, through appropriate treatment, to yield or vary color effects. The surface of bronze can be given a dark *patina*—that is, heated and treated with chemicals to darken it permanently (Fig. 240). Similarly, stains and waxes can be applied to wood to deepen or alter the natural coloration.

Color in sculpture may be used to simulate the original color of forms in nature. The long historical precedent for representational color includes examples of late Gothic woodcarving such as the *Virgin and Child* (Pl. 42, p. 176). Among more recent examples of sculpture in which color has an essentially representational function is the ultranaturalism of Duane Hanson's figure (Pl. 43, p. 176) and compositions such as those of Luís Jimenez, who uses fiberglass polychromed with epoxy paints (Pl. 44, p. 193) which refer to the original color of his subject and simultaneously remind us of inexpensively produced plastic objects from carnival booths and souvenir shops throughout the country. They combine the contrasting images of a monumental symbol with a cheap, mass-culture cliché.

Color can unify a composition when all the parts are painted identically or when the inherent color of the material remains constant throughout the work. Color can also separate components of a composition so that they are seen as individual units, enhancing the contrasts of form with parallel contrasts of hue and value. George Sugarman's polychromed aluminum construction, *Kite Castle* (Pl. 45, p. 193), makes an interesting contrast with Anthony Caro's *Sun Feast* (Pl. 46, p. 194), which is formed from welded steel units. In the former the color not only defines individual units but also divides some of the segments, differentiating folded planes and the front and back surfaces of the same form. The piece by Caro uses a single color throughout, depending on the light that bathes the work to introduce subtle chromatic variations.

Light and the colors that can be created by lenses, filters, and the fluorescence of gases in shaped glass tubes have provided sculptors with a palette that is limited only by their imagination and technical expertise. A spectacular neon-light sculpture by Michael Hayden has been integrated with the architecture of the Yorkdale Subway Station in Toronto, Canada (Pl. 47, p. 194). Combining color with form and movement, the arched glass tubes fill the ceiling of the station with 140 different colors controlled by a computer that responds to the movement of trains entering and leaving the station. The almost infinite variety of possible chromatic combinations can transform this public space into a surprising and diverting environment for commuters.

Movement: Form, Space, and Time

Walking around a piece of sculpture, observers see the work's forms and spaces in changing relationships. The movement of the viewers introduces a kinetic variation into their experience of the object. The idea of producing actual movement in three-dimensional objects has intrigued artists for centuries. In three-dimensional representations found in Egypt, arms, eyes, mouth, and head were made to move, increasing the lifelike character of the subjects. Other examples are to be seen in the art of the Greeks and Romans. Moving elements are also present in the ritual masks of indigenous tribal cultures throughout the world (Fig. 251).

The development of clockwork mechanisms that activated portions of sculpture invested toys and objects of art, in both the East and the West, with entertaining and sometimes magical qualities. Often, these moving statues were highly sophisticated in form and movement. New York's Metropolitan Museum of Art has in its collection a statuette of Diana mounted on a stag that is automated to rear on its hind legs (Fig. 252). Several animals are placed beneath the leaping stag, including two dogs with heads that move when activated by the same small mechanisms that power the figures above them.

More recent examples of movement in sculpture are works by Alexander Calder, who pioneered the development of *mobiles* (Figs. 249). A mobile is a construction in which portions of the piece are connected by articulated joints. This structural device enables the parts to move, changing their positions relative to the other parts in the composition. Through the use of motors or the action of the wind, mobile elements can be made to flutter, wave, undulate, or spin in small and great arcs. For Calder the joints of his constructions were as important as the forms, for the joints control the kind of movement that will occur when the connected elements are activated. As can be seen from the stroboscopic photograph of a Calder mobile (Fig. 253), the movement produces a pattern in space, and this pattern is directly related to the way the parts connect.

Early in his experiments with an art of movement Calder used electric motors to provide motion in his sculpture. He abandoned them because he felt that the movements generated by motors were too predictable and preferred the unexpected and random motion provided by air currents. In the late 1950s and the 1960s a number of sculptors became interested in the possibilities of motorized constructions. Their work, along with mobiles like those of Calder, are grouped under the general category of *kinetic art.*

The aesthetic and expressive potential in kinetic art is demonstrated in the startling combination of

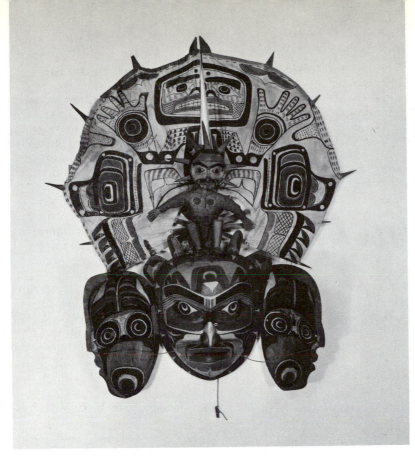

251. Mechanical headdress
representing the sun and several spirits.
Kwakiutl, Alert Bay, British Columbia.
1875–1900. Carved and painted wood
with painted muslin, shown open;
3′10″ × 4′4″ (1.17 × 1.32 m).
Museum of the American Indian, New York
(Heye Foundation).

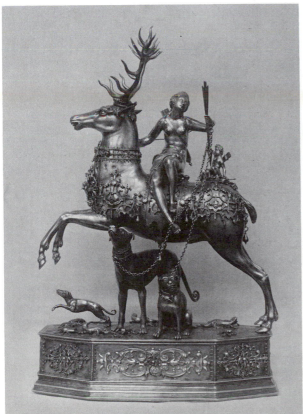

left: 252. JOACHIM FRIESS. *Diana the Huntress.*
Augsburg, early 17th century. Silver, silver-gilt, and jewels;
height 14¾″ (37 cm). Metropolitan Museum of Art, New York
(gift of J. Pierpont Morgan, 1917).

below: 253. Stroboscopic photograph of Alexander Calder's
Hanging Mobile (in motion). Aluminum and steel wire,
width c. 28″ (71 cm). Collection Mrs. Meric Callery, New York.

rubber, wires, cloth, and a mechanical forced-air system called *Octopus* (Fig. 254), devised by Otto Piene. The arms inflate, deflate, and twist as the air is blown into them and then evacuated. They appear to be parts of a giant living organism, and the observer does not know whether to respond to the work in fear or amusement.

Fountains have functioned, for centuries, as a form of kinetic art in which moving water is shaped by controlling orifices and confining containers. Sprays, spouts, bubbling, frothy emissions, torrential flows, and mesmerizing drips are all possible in the design of fountains. Examples of the seemingly inexhaustible range of aquatic compositions would include an intimate trickle of water in the trough of a bamboo pipe in a Japanese garden and the recent monumental work of the sculptor Isamu Noguchi in Detroit, Michigan (Fig. 255). The artist has designed a fountain that combines massive stainless-steel cylinders with light and water to create the central focus of Dodge Plaza in the center of the city.

Time is a major factor in the organization of art objects that incorporate moving elements or systems of changing light patterns. As in the composition by Michael Hayden in the Toronto Subway (Pl. 47, p. 194), visual artists who conceive of their work as a series of shifting events are acting like the composer of a musical score. They think in terms of the relationships that can exist between an arrangement of form and color elements at one moment in time and other arrangements that occur before or after it. The aesthetic content of a temporal composition depends upon the sequential system in which events occur. Some artists plan this sequence carefully, designing or programming mechanical or electronic devices according to a specific scheme. Stages in the series may be arranged to reinforce one another, maintaining a harmonious continuity, or used as contrasting variations; fast movements may precede slow and deliberate ones. Large areas of color will perhaps anticipate or follow fragmented, short-duration explosions of smaller, intense patterns of color spots in an ordered sequence.

A growing number of artists who work with time as a prime element in their compositions have deliberately replaced the conscious selection of variations in a fixed order with mechanisms that allow some degree of randomness to enter the organization of

254. OTTO PIENE with CLIFFORD A. HENDRICKSEN. *Octopus.* 1968–69. Rubber, cloth, wire, electrical components; core 5′ × 4′6″ (1.52 × 1.37 m); length of arms 15′ (4.57 m). Viewers may change the configuration of the arms and inflate or deflate them by changing the air flow from the central core and by pressing electrical foot switches.

255. ISAMU NOGUCHI. Dodge Fountain. 1978. Stainless steel, 24 × 75′ (7.32 × 22.9 m).
Dodge Plaza, Detroit.

events. They do not control the sequence of changes. Instead, they assemble the components capable of producing visual or kinesthetic effects, start the process, then step back to observe the interaction of accidental, unprogrammed phenomena. Having made the initial decisions on the nature and number of the components in the system, however, the artist has some measure of control and responsibility. A considerable degree of knowledge and past experience enters into this decision-making process. The artist may anticipate many of the relationships that potentially exist in the system but cannot conceive of them all. The system presumably will bring forth unexpected effects, initiating unpredictable responses in both the artist and the viewer.

If the number of events occurring simultaneously is large, many of them may not be perceived by the observers. Each person will apprehend only a few of the relationships created by the moving elements, and, most probably, the perceptions of one will not be identical with those of any other. However, even though the series of changes is relatively unplanned, many viewers will find an order in the experience. They will tend to make perceptual, esthetic, intellectual, and emotional connections among the events they perceive, introducing their own personal characteristics into the totality of the experience. Each person, including the artist, will impose an individual order on the experience, both at the time it takes place and when recollecting it.

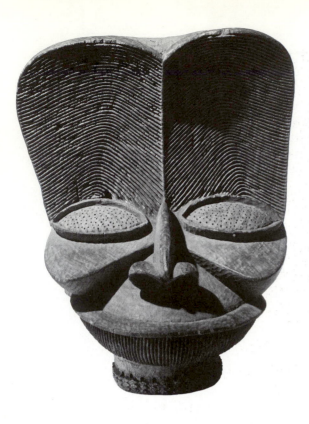

256. Bamileke mask, from Cameroon Grosland. Later 19th century. Wood, height 26½″ (67 cm). Museum Rietberg, Zurich.

In many ways, art forms that depend upon a time sequence of random events reflect the human experience. Each person exists within a more or less structured, ordered time system. For some individuals almost every activity in each day is predetermined. Waking, dressing, eating, going to work, the routine of the job, the return home, and the habitual close of the day are all laid out. Yet, in a highly routinized life, unexpected and unpredictable events occur, frequently causing individuals to seek logical associations between the lives they lead and the unanticipated experience. Even those whose lives seem free and in a continual state of flux find in the chance encounter a certain meaning as it relates to the events that preceded it.

Some artists who are interested in stimulating the senses by sequential systems of events have expanded the original concern with visual phenomena to include experiences for the senses of touch and hearing.

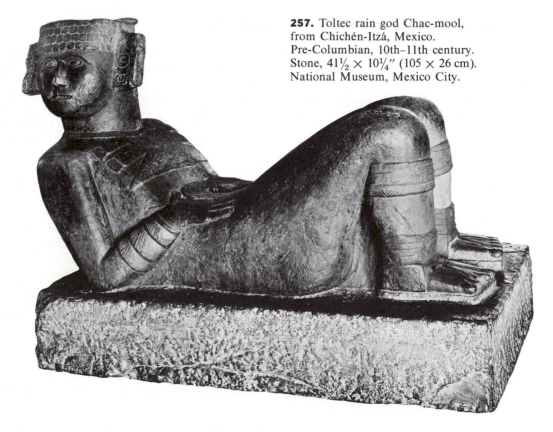

257. Toltec rain god Chac-mool, from Chichén-Itzá, Mexico. Pre-Columbian, 10th–11th century. Stone, 41½ × 10¼″ (105 × 26 cm). National Museum, Mexico City.

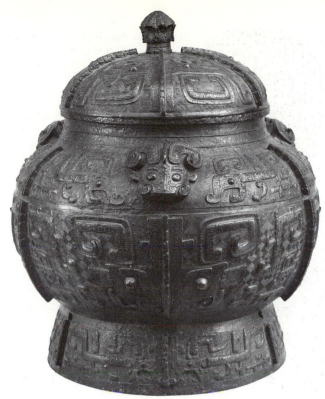

258. Chinese covered food vessel. Chou Dynasty, 1115–1077 B.C.
Bronze, height 21¼" (54 cm). Metropolitan Museum of Art,
New York (gift of J. Pierpont Morgan, 1917).

They have created physical environments that affect those who enter them in surprising and often disquieting ways. Projected images, changing colors and textures, variations in spatial effects are exploited to create an environment for which the visitor has not been previously prepared. Instead of looking at an organization of changing plastic elements, the viewer is within it, a participant rather than an observer.

Many such environmental constructions are carefully designed and programmed; others combine planned events with random effects, chance combinations of moving forms, colors, representational images, and sounds. Human participants may be added to the optical and mechanical inputs; dancers, actors, even unprepared members of the audience can become part of the totality of the involvement.

In the early 1960s events of this kind were called *happenings*. More recently they have been included under the broader category of *performance art* (see Chap. 2). It is difficult to illustrate them with still photographs or drawings and diagrams, because their aesthetic effect depends upon interrelationships that are perceived between sequential or simultaneous events. Each participant responds in a personal way to the sensory stimulation that he or she isolates from the whole experience.

Materials

About the beginning of the twentieth century sculptors trained in the traditions that stemmed from the Renaissance became aware of a body of sculpture that did not conform to the aesthetic canons of European art. Wooden pieces from Africa, stone carvings of the pre-Columbian cultures of South and Central America, the sculpture of the Far East and India gave the twentieth-century artist an expanded vision of the nature of sculpture. The direct way in which many materials were developed in these non-European arts suggested that there was a vitality and expressive quality to be found in each medium available to the sculptor. The wooden masks of the Bamileke of Cameroon Grosland derived their forms in large part from woodworking methods (Fig. 256). The hardness of stone and a limited ability to cut it gave the figures of the Mayans from Chichén-Itzá a monumental simplicity (Fig. 257). The intricate designs on bronzes of the Chou period in China provided new insights into the possibilities of this long-used material (Fig. 258).

Artists and critics were stimulated by this tradition-shattering art to see positive values also in periods of Western sculpture which had long been ne-

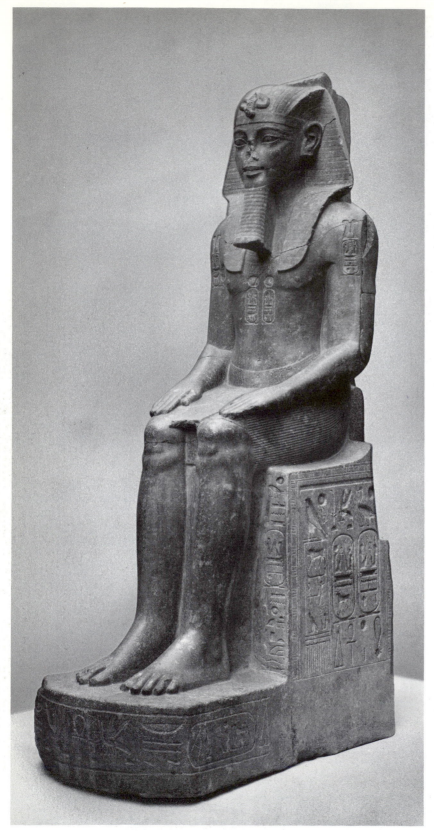

left: 259. Egyptian statue, from Luxor. 19th Dynasty, 14th–13th century B.C. Stone, height 7'5¾" (2.28 m). Metropolitan Museum of Art, New York (contributions from Edward S. Harkness and Rogers Fund, 1921).

below: 260. Statuette of a woman, from the Cyclades Islands. c. 2500 B.C. Marble, height 14¼" (36 cm). Metropolitan Museum of Art, New York (Fletcher Fund, 1934).

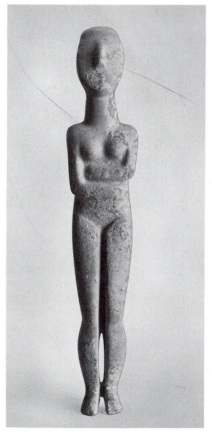

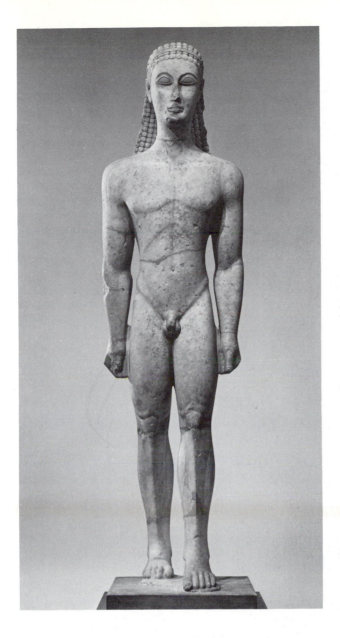

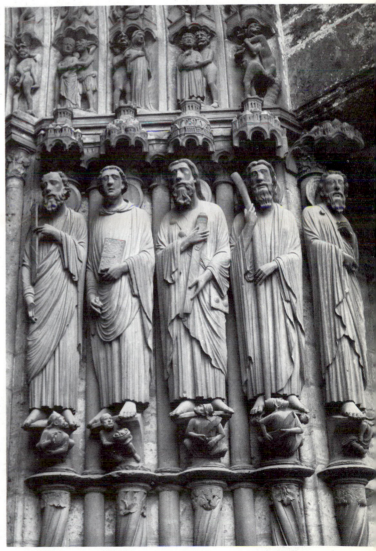

left: 261. Greek statue of a youth of the "Apollo" type. 615–600 B.C. Marble, height 6'1½'' (1.87 m). Metropolitan Museum of Art, New York (Fletcher Fund, 1932).

below: 262. *St. James the Greater, St. James the Lesser, St. Bartholomew, St. Paul, and St. John,* south portal of Chartres Cathedral. Stone, height 7'10'' (2.39 m).

glected because the work of these eras did not fit the criteria inherited from the Renaissance. Egyptian sculpture (Fig. 259), Cycladic statuettes (Fig. 260), Greek sculpture prior to the fifth century B.C. (Fig. 261), and Romanesque and early Gothic sculptures (Fig. 262) took on a new importance in the twentieth century.

Today, much of the aesthetic concern in sculpture is directly related to the materials employed by the artist and the processes used in shaping them. It is not unusual for the material to stimulate the imagination of the artist who is intrigued by its formal and expressive possibilities.

Hans Haake's *Condensation Box* (Fig. 263) may be discussed in terms of the traditional plastic elements, but if we do so, there is little to say about its essential visual appeal. The clear cube that is basic to Haake's construction has measurable dimensions and a surface which can be described by its tactile and visual qualities, but the work's essential character does not emerge from these static features. Sealed within the cube, water is acted upon by the natural forces of vaporization and condensation as the exterior temperature rises or falls. A continuous process takes place, causing beads of moisture to form on the interior surfaces of the planes. As Haake conceived of this piece, he could limit the size of the interior space enclosed by the six sides, he could regulate the water content sealed inside the controlled environment, and he could predict that the water would successively vaporize and condense within that environment; but he could not control the appearance of the globules or runs of water that would form on the surfaces. His knowledge of the material he chose and the process he initiated was as basic to his conception as the organization of plastic elements to another sculptor.

An artist may conceptualize to some extent the way in which a material or process will act under certain conditions, knowing that it cannot be totally under control. Some element of chance will operate as the material acts in accordance with the physical characteristics natural to it. When Robert Morris cut the limp felt fabric comprising the composition in Figure 264, he could assume that, hanging from a

above: 263. HANS HAAKE. *Condensation Box.* 1965–67. Plexiglas and water, 30″ (76 cm) square.

below: 264. ROBERT MORRIS. *Untitled.* 1968. Wool felt, 9′6″ × 12′ (2.89 × 3.66 m). Walker Art Center, Minneapolis (gift of the T. B. Walker Foundation).

above: **Plate 44.** Luís Jimenez, Jr.
Progress I. 1973.
Fiberglass with epoxy coating,
height 8′8″ (2.64 m).
Collection Donald B. Anderson,
Roswell, N.M.

left: **Plate 45.** George Sugarman.
Kite Castle. 1973–74.
Painted steel, height 18′ (5.49 m).
Collection Charles De Pauw, Brussels.

wall, it would form a group of reverse arches with certain twisted configurations, but he could not know exactly what those open and closed areas would finally look like.

The work of Haake and Morris clearly depends upon the conceived potential in the material they selected. This involvement with the anticipated behavior of the substance is similar to the attitude of the sculptor who carves wood and stone. Experienced carvers know that oak is hard, that elm twists, that alabaster is transparent before they even begin to cut into the raw block or log.

To the degree that it forces the composition into certain forms and surfaces, to the extent that certain spatial organizations are limited or facilitated by its very substance, the material must be regarded as a basic element that concerns the artist prior to and during the creation of a work.

These elements—form, space, texture, line, color, movement, and material—are the principal preoccupation as the sculptor works. For a portrait bust which is to approximate the physical forms of a model, the sculptor must think, "How shall I form the clay to construct an equivalent for the physical shape and the nonphysical personality of my sitter?" Working with a large piece of wood, the carver may ask, "What forms, what spaces will best utilize the living pattern of grain? Shall I leave the marks of the chisel, or will polishing the wood to a rich luster enhance its appearance?" Such decisions are part of the creative process. They are made continually during the progress of the work, and in total they are the work.

opposite above: **Plate 46.** ANTHONY CARO. *Sun Feast.* 1969–70. Painted steel, 5′11½ × 13′8″ × 7′2″ (1.87 × 4.17 × 2.18 m). Private collection, Boston.

opposite below: **Plate 47.** MICHAEL HAYDEN. *Arc-en-Ciel.* 1978. Neon sculpture, length 570′ (173.7 m). Yorkdale Subway Station, Toronto.

Sculpture: Representation and Organization

10

Working in three dimensions, a sculptor is able to produce an exact replica of the forms and spaces in natural objects. Yet this imitative potential is rarely satisfying to the artist, for though natural forms share their three-dimensionality with sculpture, the differences between a statue and its subject require a sculptor to develop representational equivalents that often seem far removed from the physical appearance of animals and human beings. The most notable difference is the potential of the human body for movement and the static nature of the sculpture. Even at rest the living move. Each breath animates the body; eyelids flicker, nerves pulsate. And, of course, larger movements are normal—changes in the position of legs, arms, torso, and head. Devoid of movement, the human body seems to lose some of its essential character.

A second difference between sculpture and living subjects, the difference in material, is similarly apparent. Sculpture can be made of a great variety of metals, woods, stones, clay, plastics, and other materials, but there are sharp differences in color and surface texture between these materials and skin, hair, teeth, nails, and clothing.

Finally, living things do not exist in isolation. The sense of reality conveyed by the appearance of the human body depends in part upon the fact that the body is seen in the context of some environment. Life seems to flow around the living. Light changes; the air moves and brings with it wafted sounds and motions associated with human experience. The figure exists in a landscape or within the space of a room filled with the evidence of human presence. On the other hand, the sculptor usually produces a figure that is isolated from an environment. With the exception of certain examples of bas-relief, which have characteristics similar to painting, sculpture tends to isolate representational images from the environment that would normally surround the figure.

Though the sculptor can copy the physical appearance of a human being exactly, the distinctions between the statue and its subject remain obvious. The sculptor, like the painter, can create only an equivalent for the subject. To represent a subject in the natural world, the sculptor must devise a combination of forms and surfaces in space which will suggest, symbolize, or become a surrogate for that particular subject.

265. PRAXITELES. *Hermes and the Infant Dionysus.*
c. 340 B.C. Marble, height c. 7′ (2.13 m).
Museum, Olympia.

right: 266.
Virgin and Child.
French, 13th century.
Oak, height 31½″ (80 cm).
Wadsworth Atheneum,
Hartford, Conn.

below: 267.
Kubera as Brahma.
India, 12th century.
Stone, 22 × 13¾″
(56 × 35 cm).
Metropolitan
Museum of Art,
New York (gift of
Robert Lehman, 1947).

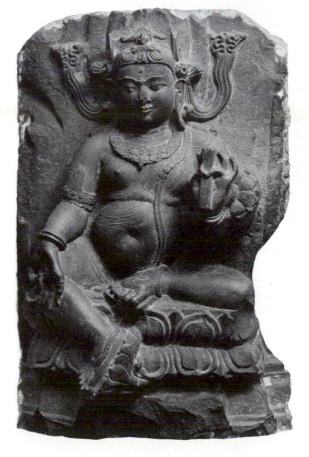

Throughout the long history of sculpture, human
and animal figures have been represented by a great
variety of three-dimensional equivalents. Even if the
discussion is restricted to the human figure, the range
of representational images is remarkable. Compare a
Cycladic statuette carved on an Aegean island about
4,500 years ago (Fig. 260); a figure of Hermes by the
Greek sculptor Praxiteles, made about 340 B.C. (Fig.
265); a thirteenth-century *Virgin and Child* from
France (Fig. 266); a twelfth-century figure from India
(Fig. 267); a Maori figure from New Zealand (Fig.

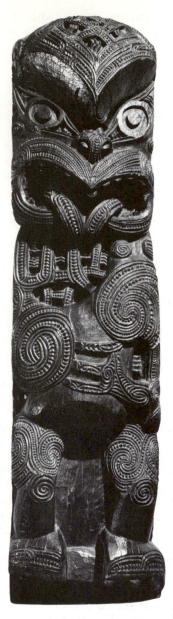

left: 268. Maori figure from New Zealand.
19th century (?).
Wood, height 43⅛″ (110 cm).
Metropolitan Museum of Art, New York
(Michael C. Rockefeller Collection
of Primitive Art,
bequest of Nelson Rockefeller, 1979).

below: 269. Seated figure,
probably Haida.
British Columbian, 19th century (?).
Bone, height 6″ (15 cm).
Whereabouts unknown.

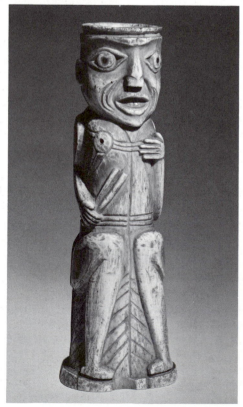

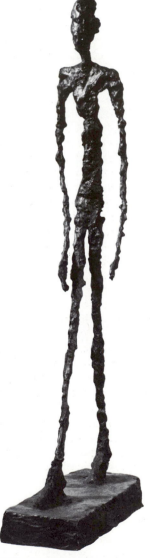

270. ALBERTO GIACOMETTI.
Walking Man. c. 1947–49.
Bronze, height 27″ (69 cm).
Hirshhorn Museum and Sculpture Garden,
Smithsonian Institution,
Washington, D.C.

268); one from the Northwest Coast Indians of British Columbia (Fig. 269); and, finally, two examples by the Italian Alberto Giacometti and the English sculptor Henry Moore (Figs. 270, 228). All these examples represent the human figure for some society or individual. The figure by Praxiteles seems to correspond most closely to the forms of the human figure as it appears in nature, and yet it too must be considered an abstraction from real life, when compared with a living human being.

Actually, a child's doll, made of a single piece of wood representing a torso, to which has been added a crosspiece suggesting arms, a knob for a head, and two additional lengths of wood for legs, is easily recognized as a symbol for the human body. The body is so much a part of each person's experience that even the crudest simulation of parts combined into a figurelike whole will be recognized as a figural image.

The particular combination of forms that satisfies a sculptor's desire to represent a real subject may be strongly influenced by cultural tradition. This is demonstrated by the examples above from Greece, India, France, New Zealand, and British Columbia. Working within these stylistic canons, an artist may be able to indicate differences of sex, movement, and expression. These potentials are certainly utilized in the sculpture of the Greeks. Often, however, the style is more restrictive, and in the figures typical of a cultural group the artist seems to have disregarded some or all of the differences among human beings.

The work of Giacometti and Moore does not conform to any single stylistic pattern imposed upon them by an external group or culture. Each artist has developed a symbolic image of the human form that satisfies his own expressive and aesthetic needs.

Because the image of the figure is so readily grasped, even when a figural piece is markedly different from the forms of the real subject, the contemporary sculptor is free to depart from imitative surfaces and forms. The work may combine representation with a subjective comment about individuals or societies, or it may emphasize the purely organizational aspect of composition and seek to produce an aesthetic object that satisfies or delights its beholders.

Materials and Methods

Sculpture is an ordered arrangement of actual masses that have their existence in a real space.

The plastic elements of sculpture, as discussed in Chapter 9, are form, space, line, material, color, movement, and texture, and the sculptor, like the painter, seeks to organize these elements into a unified composition.

The organization of sculpture begins with the material. Stone, wood, metal, clay, and other substances are transformed through a number of processes into the final forms and spaces which compose the finished work.

The sculptor can shape the material in two separate and distinct ways. One is to join small parts into larger components by pressing bits of wax or clay together, or by fastening metal segments with mechanical or welding techniques. The other is to cut away or carve into a block of stone or wood larger than the finished work, eliminating the extraneous parts of the block and leaving the statue as the residue of this process of reduction. The first method is called *additive sculpture* and the second is called *subtractive sculpture.*

Additive Sculpture

One form of additive sculpture is *modeling*. For modeling, the sculptor uses a pliable material such as wax or clay, which can be shaped into three-dimensional masses. This procedure permits the artist to make quick, spontaneous sketches, as well as prolonged studies. Because the material is soft and easy to manipulate, the artist can shape it by hand or with a great variety of tools. Contemporary additive sculpture also includes pieces composed of small elements of wood, metal, or other material joined to form the complete work.

Antoine Bourdelle's *Hercules* (Fig. 240) is an example of modeling. The final state of the work was cast in bronze, but the original was clay. Clay models are fragile and perishable, so they are usually cast in another, more durable material. Sometimes the clay is baked at high temperature in a kiln, like pottery, to form a finished material called "terra cotta."

To appreciate sculpture it is not necessary to know all the intricacies of the technology for turning an original clay model into a finished metal statue. However, the viewer should realize that the sculptor who works in this method must think from the beginning in terms of the final casting and not of the clay. The earthen forms must be envisioned as bronze surfaces with the patina they will take and the way they will absorb or reflect light. The sculptor may wonder, "Will the forms I have used look suitable in metal? Will they suggest the character, the strength of the material?" These questions are typical of those which would influence the appearance of the finished work. Contemporary artists have replied with a great variety of sculptural forms and surfaces. They have polished some works until the surfaces took on the quality of a mirrorlike skin, reflecting light in flashes or star-bright brilliance (Fig. 283). Other surfaces have been made to suggest the fluid quality of metal

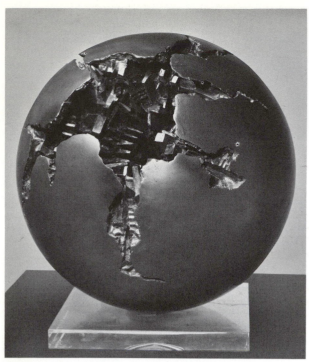

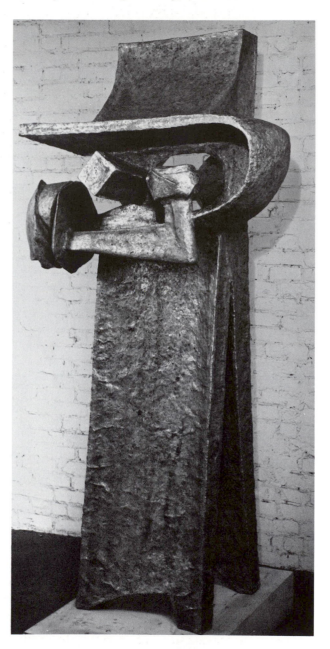

left: **271.** Arnoldo Pomodoro.
Sphere with Perforations. 1966.
Bronze, diameter 23½" (60 cm).
Courtesy Marlborough Gallery, New York.

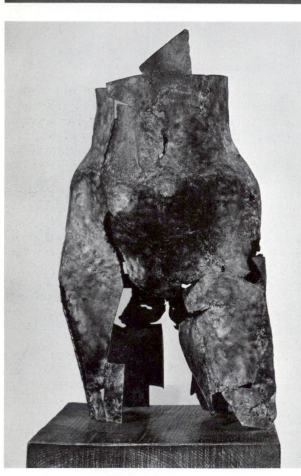

left: **272.** Julio González. *Torso.* c. 1936.
Hammered and welded iron, height 24⅜" (62 cm).
Museum of Modern Art, New York
(gift of Mr. and Mrs. Samuel A. Marx).

above: **273.** Seymour Lipton. *Defender.* 1962.
Nickel silver on Monel Metal,
height 6'9" (2.06 m).
Courtesy Marlborough Gallery, New York.

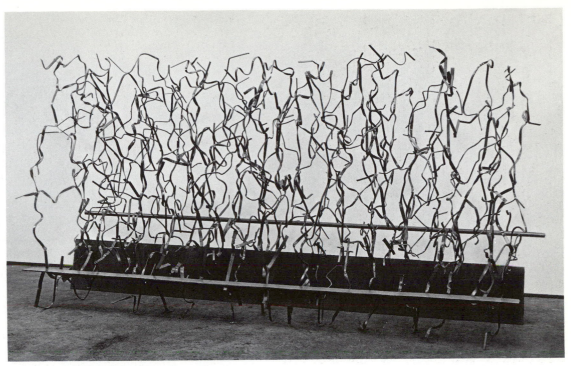

274. BROWER HATCHER. *Aureola.* 1975.
Steel, 5'10" × 12' × 5'3" (1.75 × 3.6 × 1.58 m).
Courtesy André Emmerich Gallery, New York.

hardened into rough, lavalike encrustations (Fig. 270). Still others are engraved and worked after the casting process to contrast the inner color of the metal with the color of the outer surfaces (Fig. 271).

Sculpture cast in metal has all these possibilities, but for the contemporary sculptor it poses important disadvantages. Metal casting is relatively expensive. In the past, when patrons commissioned works, it was not too difficult for artists to find the financial support to have their pieces cast or to do the casting themselves. Much of the work of contemporary sculptors, however, is done before a buyer is found. Frequently they must take on the financial burden of the casting procedure. As a result, many modern sculptors have been frustrated in their desire to create permanent metal sculpture. One solution to the problem was the introduction into the studio of the techniques and procedures of the industrial metalworker. By forming a sculpture of small pieces of metal and welding them into larger, more complex structures, the artist could work directly in steel, brass, or even precious metals and produce a durable, permanent sculpture.

Cost was not the only reason for the introduction of *direct-metal sculpture.* Many artists were drawn to this process because it had appealing aesthetic and expressive values. One of the first to work in this medium was Julio González, who came from a family of ironworkers in Barcelona, Spain. Trained as a painter, González turned to wrought-iron sculpture only in his maturity, in the late 1920s and the 1930s. His *Torso* (Fig. 272) makes use of flat sheets of iron hammered into curved forms, then welded together. The completed construction combines the image of a female torso with the surface, edges, and beaten forms of the ironworker's craft.

González was followed by many sculptors who worked directly in welded metal with stylistic potentials as varied as earlier sculptural procedures. Seymour Lipton beat metal sheets in the manner of González *Torso.* The curved planes in the *Defender* (Fig. 273) are made of Monel Metal surfaced with nickel silver. It presents a dramatic contrast to the wildly agitated linear construction by Brower Hatcher (Fig. 274), who welds twisted steel strips into aggressive screens that recall the skeins of color in the paintings of Jackson Pollock (Pl. 39, p. 158). These agitated linear compositions are very different from the warped planes and simple geometry of Anthony Caro's *Sun Feast* (Pl. 46, p. 194).

Sculptural constructions combining several units are found in wood as well as in metal. However, the shape and the limited diameter of tree trunks and

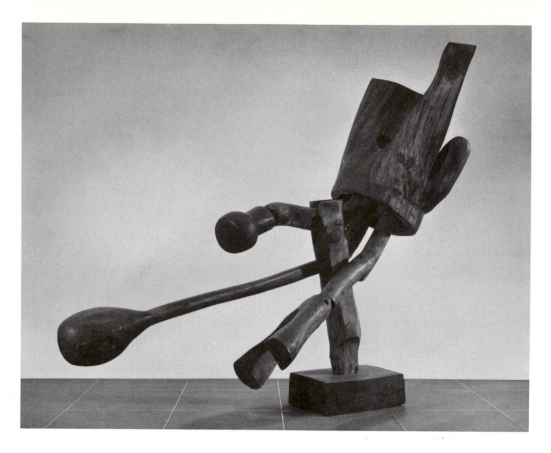

above: 275. JOHN ANDERSON. *Big Sam's Bodyguard.* 1962.
Ash wood, 6'10½" × 6'9½" (2.1 × 2.07 m).
Whitney Museum of American Art, New York.

left: 276. GABRIEL KOHN. *Bird Keys.* 1962.
Wood, 39 × 40" (99 × 102 cm).
Courtesy Marlborough Gallery, New York.

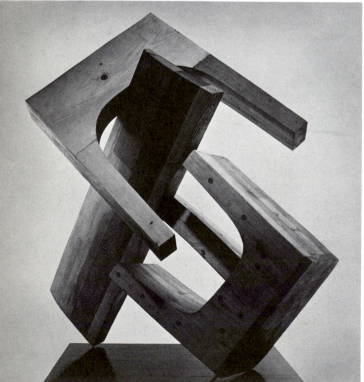

branches tend to restrict wood sculpture to relatively small-scale pieces of compact design, unless a number of smaller segments can be joined into a composite structure. John Anderson does this with *Big Sam's Bodyguard* (Fig. 275). Similarly, when a sculpture is composed of wood planks or sheets, these too must be joined to provide the desired volumes and masses, as in Figure 276.

Subtractive Sculpture

As the word "modeling" is associated with additive sculpture, "carving" is the most familiar term for subtractive sculpture. The process of reducing a block of wood or stone to the forms the carver wishes to retain requires no small physical effort. Cutting into wood, or into the even harder stone, is laborious and time-consuming, and for this reason carved pieces often lack the quality of spontaneity to be found in

many examples of modeled or direct-metal sculpture. An artist who expects to devote extended periods of time to the completion of a work does not begin to carve on a whim or a capricious fancy. Modeling is an ideal method for the production of the quick sketch, and many sculptors try out their work in stone or wood with studies in clay. Carving, however, tends to be a serious business, and the attitude of the carver usually finds its way into the finished work.

Materials suitable for carving differ in many ways. Their hardness varies, as well as their initial size. They may have a neutral physical structure that does not affect the cutting action of the sculptor's tools; or they may have a structure, such as the pronounced grain of certain woods, that draws the chisel along predetermined paths.

A sculptor may produce the original model for a carving in a flexible material such as clay, wax, or plaster. This original can then be transferred to the block by a complex measuring process called "point-ing." The sculpture is completed with the removal of excess material by the artist or by a skilled craftsman. Many contemporary carvers prefer to work "di-rectly," developing the composition in response to the material and the carving process. Like Michelangelo, they can imagine the existence of a form within the block, waiting to be released. Though the initial concept in the mind of the artist may be responsible for the choice of a particular log or marble mass, that concept may be adjusted if the discovered structure of the material suggests an alternative image more compelling than the original.

Raoul Hague is an American sculptor known for his massive wood carvings. *Sawkill Walnut* (Fig. 277) is one of his typical pieces, and it exemplifies his involvement with the material he uses. Many of Hague's carvings are named after the wood he used for them. In *Sawkill Walnut* the forms seem to result from the growth process itself. Note how the grain becomes an integral part of the composition, flowing with the forms, reinforcing their directional movement, and at the same time enriching the surface. Even the wedged cracks in the wood seem to become essential to the composition, adding a textural variation to a flattened plane.

The hardness of stone and the textural possibilities inherent in the carving process are suggested by the *Head of Christ* in Figure 278, the work of another

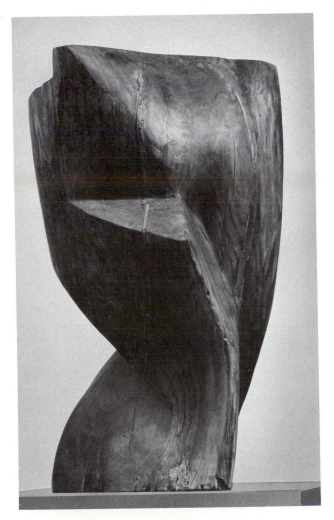

left: 277. RAOUL HAGUE. *Sawkill Walnut*. 1955. Walnut, height 42″ (107 cm). Whitney Museum of American Art, New York (gift of the Friends of the Whitney Museum).

below: 278. WILLIAM ZORACH. *Head of Christ*. 1940. Peridotite, height 14¾″ (37 cm). Museum of Modern Art, New York (Abby Aldrich Rockefeller Fund).

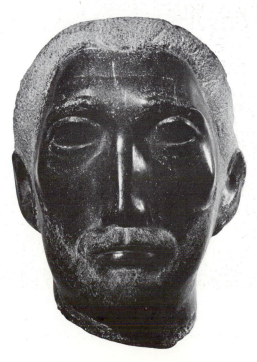

American sculptor, William Zorach. The material here is peridotite, a very hard rock. It has been polished to a smooth, satiny finish on the surfaces that represent skin, but the marks of the sculptor's tools are retained on the forms of the hair and beard. Over all there is a sense of the resistant stone, which gave way reluctantly to the hammer and the chisel.

Organization

Sculptors face the same problems as painters in organizing their work to create an aesthetic unity with enough variation to offer contrasts and complexities that will challenge and surprise the viewer. Here again, the aesthetic organization of the work cannot truly be isolated from its expressive or representational aspects. Ideally, aesthetic organization, expression, and representation are all interrelated, but sculptors, like painters, can use repetition, continuity, and *contrast* as aesthetic choices in the creative process. Important in sculpture, however, is the fact that a statue is a three-dimensional object. Except in the case of relief sculpture, the organization is not restricted to one surface or face. The sculptor must relate the back to the front and both front and back to the sides. Indeed, it becomes difficult to describe many pieces as though they had four distinct surfaces, for the artist has formed them into groups of elements which appear to have a continuing relationship through a 360-degree circle. A form or plane or linear movement may begin at one point, and a viewer might need to move all the way around the piece of sculpture in order to trace the entire shape or path of that element.

The sculptor's material can have a strong unifying effect on a composition. The material can provide a unity of color and surface texture. However, once the shaping of that material begins, the sculptor must

left: **279.** JACQUES LIPCHITZ. *Man with Mandolin.* 1917. Stone, height 29¾" (76 cm). Yale University Art Gallery, New Haven, Conn. (gift of Société Anonyme).

right: **280.** Side view of Figure 279.

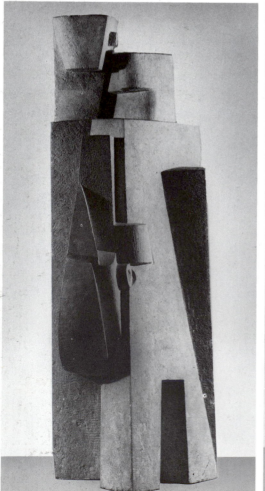

organize forms, carved or modeled surfaces, and linear movements so that they are integrated. Repetition of the size or shape of forms and spaces and continuity of edges and planes are frequently used to this end. The sculptor may repeat surface treatment, that is, rough or smooth textures. Without duplicating shapes or forms exactly, it is possible to give them a similar character. They could be angular and cubelike or softly rounded and sensuous.

By use of inscribed line, hard linear edges of forms, the linear edge of the silhouette of the work, and slender linear elements, the sculptor can produce a unity based on a continuous movement.

In *Man with Mandolin* (Figs. 279, 280) Jacques Lipchitz employed repeated rectangular and triangular forms to unify the work. When seen from the front, the repeated vertical edges of some of the forms establish the primary emphasis in the composition. This vertical movement is contrasted against a number of diagonals created by form edges. Note how the diagonal on the left ties together a series of small elements as it moves along on the left side of the lower central group and then continues upward along the right side of the upper forms of the head. Cylindrical forms also are used on this face of the sculpture, as a subordinate and contrasting part of the composition, but the curves move away from the viewer, so that their characteristic arcs do not interrupt the vertical and diagonal emphasis. The face of the large plane on the right is placed at an angle so that it directs the viewer around toward the right side, where the sculptor has carved forms which echo those on the front face of the piece. Diagonals and verticals dominate the composition again, but the curved forms are somewhat more insistent. A study of the rear view and the left side of this carving would reward the spectator with the discovery of further unifying relationships similar to those noted here. The problem for Lipchitz was to tie each view of his composition to the view that was exposed before. The composition of the side had to appear inevitable, once the front of the piece had been seen. Yet the skillful sculptor arranges the forms so that, while they may seem to be an inevitable extension of the views already seen, they are, at the same time, surprising variations of the other faces of the structure.

A composition based upon strong planar movements is to be found in the *Deposition from the Cross,* by Michelangelo (Figs. 281, 282). Here the figure of Christ twists so that the left arm, the head, and the

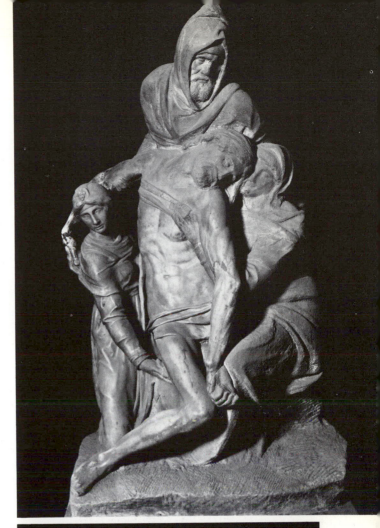

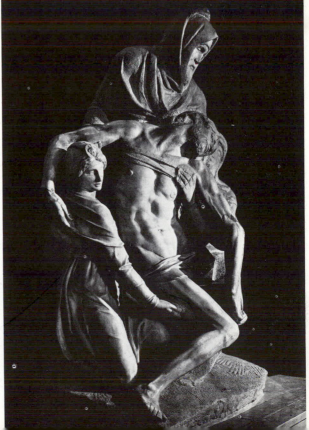

above right: 281. MICHELANGELO.
Deposition from the Cross. Left unfinished, 1555.
Marble, height 7′5″ (2.26 m). Cathedral, Florence.

right: 282. Side view of Figure 281.

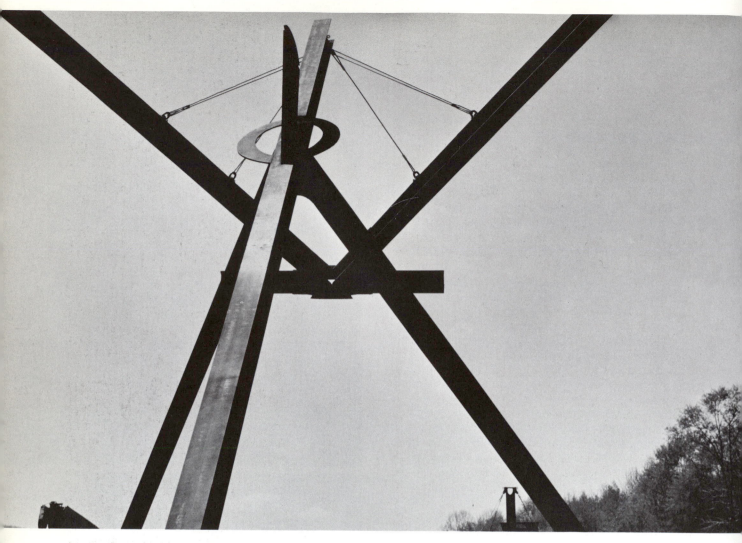

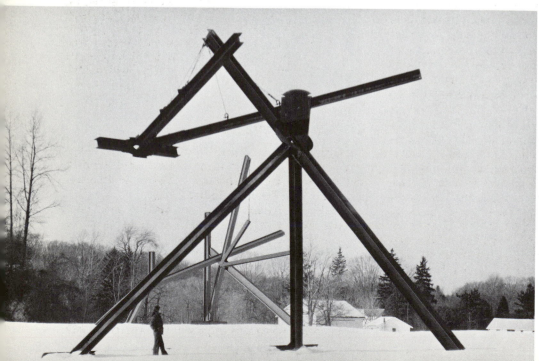

above: 283. MARK DI SUVERO.
Mon Père, Mon Père. 1974–76.
Steel, 35′ × 40′ × 40′4″
(10.67 × 12.2 × 12.3 m).
Courtesy Richard Bellamy,
New York.

left: 284. Another view
of Figure 283.

knee form the forward edge of a plane that moves back from this line and around toward the left. It is intersected by another plane created by the female figure at the left, which continues this movement back behind the central axis of the group. To the right the forms of the other female figure interlock with those in the foreground and move back, this time in a secondary direction toward the right. Another planar movement runs upward from the juncture of the knee and the hand in a slow curve to form an arc with the hooded head of the figure behind Christ, which leans forward over the dead body.

Linear movements are carried along the edges of the forms and through the axis of the fallen figure and those which support it. A slow arc is repeated over and over again: in the body of Christ, in the position of his left arm, in the right arm of the female figure to the left, in the hood of the rear figure, and in the arch of the body of the female figure at the right. The whole group could easily be enclosed by a form shaped like a tall cone with slightly curving sides.

In some contemporary examples of sculpture, particularly those made directly in metal, the organization of space is emphasized over the organization of forms. Mark di Suvero's monumentally scaled constructions of steel I-beams speak of the forces that are harnessed to support the massive weight of the thrusting diagonal members. The I-beams are not in themselves particularly interesting forms. It is their positions relative to one another that creates their visual energy. Seen from different viewpoints, the spaces trapped between the opposing struts and the suspended V change dynamically, transforming the construction in unexpected ways (Figs. 283, 284).

Most sculpture can be fully understood only when the observer moves around the entire piece and views the relationships and movements uniting all the parts. There are exceptions to this rule. Some compositions are based upon a series of contrasting forms arranged vertically one above the other. *Torso of a Young Man* (Fig. 285), by Constantin Brancusi, is a brass figure set on a base of wood and marble designed by the artist to create a symmetrical organization of the whole along a major vertical axis. The forms of the figure and the base contrast with one another, as do the textures of the materials used in the individual sections. It is the juxtaposition of one form, one texture, against another that produces the full aesthetic effect of this piece. Extremely important in its organization are the surfaces worked on the sculpture's forms. They offer to the viewer the sensuous pleasure of touching the warm, living firmness of wood; the granular, yet smooth surface of marble; and the cold perfection of polished metal. It is an esthetic satisfaction which can be sensed even though the piece is seen and not touched.

285. CONSTANTIN BRANCUSI. *Torso of a Young Man.* 1924. Brass, height 18″ (46 cm), on original base of marble and wood. Hirshhorn Museum and Sculpture Garden, Smithsonian Institution, Washington, D.C.

Kinetic Sculpture

The artist who is concerned with movement in sculpture is always working with separate elements joined so that some form of articulation is possible. In a real sense this is additive sculpture.

Sculptural compositions with moving parts offer the artist two organizational possibilities as a basis for the conception and construction of the work. One approach is to consider motion a way of creating changes in the spatial relationships between the forms in the sculpture. Articulated parts will move toward

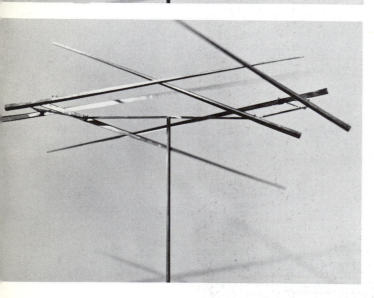

right: **286.** GEORGE RICKEY.
Six Lines in a T. 1965–66.
Stainless steel,
6′8″ × 11′ (2.03 × 3.35 m).
Storm King Art Center,
Mountainville, N.Y.

below: **287.**
Another view of Figure 286.

bottom: **288.**
Another view of Figure 286.

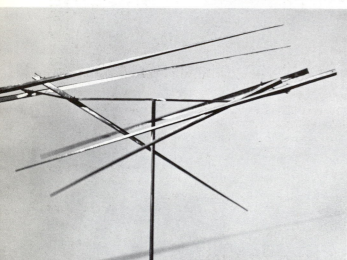

or away from one another. Distances and angles of separation will vary. At any one moment the parts will have a definite ordered relationship, but this may change so that another moment in time will find the parts distributed in a different composition. Having determined the shape of the forms in the sculpture and having designed the joints to permit movement, the artist can predict the general character of the form-space relationships possible in the piece; but it is impossible to accurately predict the composition at every single moment in time.

Another approach to kinetics in sculpture is based on the quality of the movement rather than on the arrangement of the parts. These two approaches are not mutually exclusive; they tend to overlap and affect each other. Artists who choose motion as a major characteristic of their sculpture use articulated forms in a spatial interrelationship, but they may wish to emphasize the character of the movement rather than the position of the parts. Joints and moving elements can be designed to jiggle, to wave, to bounce, or to soar. The sculptor is less concerned with where the parts of the construction are placed and more concerned with the dancelike way in which they move within their prescribed orbits. To quote George Rickey, the creator of the work reproduced in Figures 286 through 288 and a leading artist in this field:

> The artist finds waiting for him, as subject, not the trees, not the flowers, not the landscape, but the *waving* of the branches and the *trembling* of stems, the piling up or scudding of clouds, the rising and setting and waxing and waning of heavenly bodies, the creeping of spilled water on the floor, the repertory of the sea—from ripple and wavelet to tide and torrent.[1]

The examples and illustrations of kinetic sculpture represented in the preceding chapter (Figs. 252–254) are works whose articulated elements receive power and move when driven by motors or by the action of gravity or wind. Rickey has suggested a number of other possibilities. They include the attraction of magnetic fields on metal elements; jets of water to suspend forms or perhaps to move paddles; plastic, cloth, or rubber membranes susceptible to shaping or distortion by changing forces; color and motion variations produced by polarized light; differences in tactile stimuli that are felt by the observer; and even the participation of people as an integral moving element in large architectural environments. Such inventions occupied a number of artists in the early 1960s and have since found rather frequent application in the design of sculptural objects.

As one such innovation, Jean Dupuy, Ralph Martel, and Harris Hymans built a freestanding box with a glass panel in one side (Fig. 289). The observer, looking through the panel, sees a cloud of red dust moving in time to the rhythms of an enclosed tape recorder that plays an amplified recording of heartbeats. The dust is lithol rubine, a brilliant red pigment of low specific gravity, which is activated by a tightly stretched rubber membrane in the bottom of the open space. At the top of the opening an intense light is focused through a lens to illuminate the moving pigment. The effect is one of a mysterious, almost animated, cloud that pulses like a living thing, a presence of amorphous form. Another interesting example is a kinetic spatial construction designed and built by Rockne Krebs in collaboration with the Hewlett-Packard Corporation (Fig. 290). Colored

above: 289. Jean Dupuy, artist; Ralph Martel and Harris Hymans, engineers. *Heart Beats Dust.* 1968. Wood, glass, rubber, lithol rubine, tape recorder, coaxial speaker, tungsten-halogen lamp; 22″ (56 cm) cube.

below: 290. Rockne Krebs. *Day Passage.* 1971. Argon and helium-neon lasers, optical system and mirrors; 100′ (30.48 m) corridor. Executed in collaboration with the Hewlett-Packard Corporation for the Art and Technology exhibition, Los Angeles County Museum of Art, May 10–August 29, 1979.

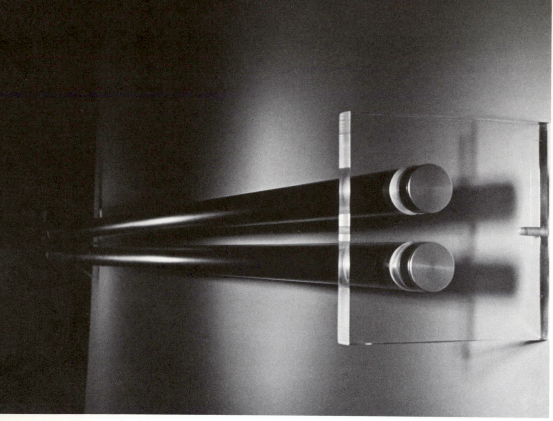

291. JOHN GOODYEAR. *Hot and Cold Bars.* 1968. Aluminum, plastic, and electric circuitry;
$5\frac{3}{4}'' \times 5\frac{3}{4}'' \times 6'$ (.15 × .15 × 1.82 m).
Collection J. Kelly Kaufman Family, Muskegon, Mich.

beams of laser light were directed at mirrors. The rays and their reflections crisscrossed, forming three-dimensional webs through a mysteriously foggy space that increased their visibility. The energy of the light was transformed into a tangible structure that shifted according to a programmed schedule.

In contrast to the previous examples, the *Hot and Cold Bars* of John Goodyear has no visual moving elements (Fig. 291). Instead, the "viewer" is invited to touch the two bars attached to a wall. The bars appear the same, but one has been heated and the other chilled electronically. The response to this tactile surprise is the basis for the aesthetic response.

Clearly, one cannot approach John Goodyear's construction expecting to react as one does to the sculpture of Henry Moore or George Rickey. Art objects so different in conception may be arbitrarily placed in a category of things called "sculpture," but they are, in fact, as different from one another as a book of poetry from a textbook on atomic physics. An observer must confront these objects, and others equally different, on their own terms, responding to the stimuli presented by the artists, and must seek what each offers without demanding that it conform to a preconceived set of limitations defining the nature of sculpture.

Architecture: Form, Function, and Expression

11

Architecture is a three-dimensional art that serves both practical and aesthetic needs. Spaces that protect life, providing shelter and security, as well as monumental constructions raised to gods, governments, and individuals have been found throughout history on every continent. Imagination, ingenuity, and craft, supported by labor and the wealth of nations, have provided us with an almost limitless number of structures that offer extraordinary aesthetic riches, even when they no longer meet current functional requirements.

The appreciation of architecture has much in common with the appreciation of sculpture, for both share the plastic elements of form, space, texture, material, line, and color. Both are concerned with the organization of forms in space. In fact, many examples of architecture can even be regarded as monumental pieces of sculpture. If a division is to be made between these two art forms, we may best define it by recognizing two aspects of architecture which do not typically find a parallel in sculpture.

First, architecture is a *functional art*. A building is erected to fulfill some practical purpose. It may be argued that sculpture also functions for a purpose, but the purpose of the sculptor's art is restricted to symbolic communication and the evocation of an aesthetic response. Architects may wish to include these two principles in their work, but they must also be concerned with the problems of providing a sheltered space for some specific human function.

Second, architecture is a *structural art*. The architect or the builder must devise a system capable of supporting itself against the forces of gravity and supporting the weights and stresses necessary to meet the functional intentions of the design. Materials must be chosen and joined in ways that will utilize their strengths and compensate for their weaknesses.

Some sculptors make the structural systems of their pieces an essential characteristic of the images they produce. Michael Singer has done this in the work illustrated in Figure 292, which uses bamboo elements tied with jute to form an enigmatic, ritualistic construction.

Figure 293 is a photograph of a fishing station constructed in Kisangani, Zaire (formerly called Stanleyville, Congo). The complex of poles driven into the river bottom is joined by connecting horizontal members that serve both to strengthen the fragile construction and to provide narrow perches for the fishermen suspended above the moving water. Fish

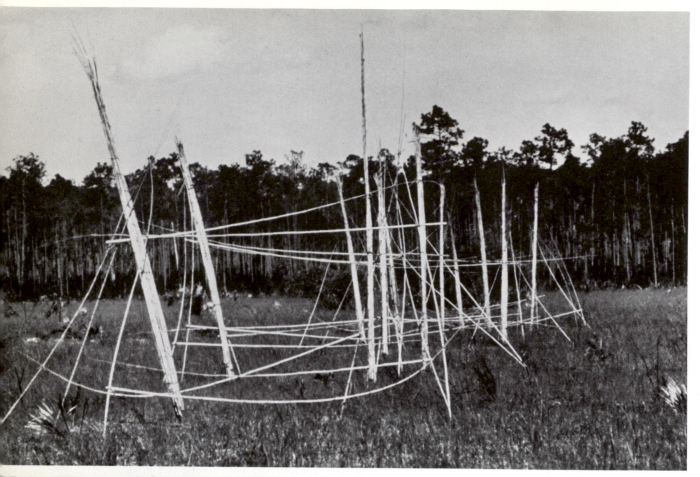

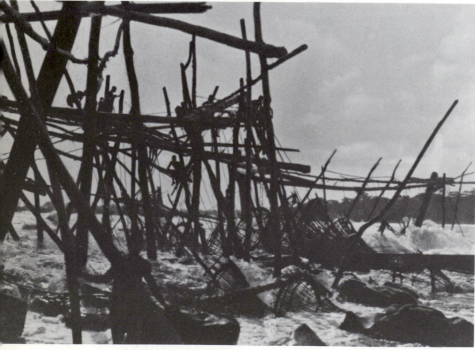

above: **292.** MICHAEL SINGER.
Glades Ritual Series. 1975.
Phragmites, jute, bamboo; installation
in Everglades National Park, Fla.
Courtesy Sperone Westwater Fischer,
New York.

left: **293.** Fishing station
in Kisangani, Zaire.

traps are strung beneath the wooden framework, tied to it by slender cords. This intricate but tenuous bridging serves the food-gathering needs of the Kisangani natives. The labor used to construct it is rewarded with each new catch of fish. This is architecture in its most essential form. The forest of poles and their connectors divides the sky and the river into fascinatingly varied spaces, but the visual impact is incidental to the fishermen's needs, rather than a predetermined aesthetic intention.

Although there is a visual similarity between the fishing station and Michael Singer's contemporary construction, the parallels are only superficial. There is a functional logic to the complex arrangement and scale of the poles of the fishing platform. It must withstand the pressure of the river; it must support the weight of the fishermen; and it must keep the traps from being washed downstream. An aesthetic response to the spatial configuration of the visual elements without a sense of their utility is possible, but there is much more to see and know that can offer increased or extended satisfaction. It is our perception of the reality of function in the Kisangani construction that enriches its content, and it is our need to provide an imagined use for Singer's construction that creates its content.

The Functions of Architecture

Vitruvius, who wrote his *Ten Books on Architecture* in the first century B.C., stated that the fundamental principles of architectural design were convenience, beauty, and strength. In our own time, the word "function" has often been substituted for "convenience," and to this requirement has been added the idea that beauty and strength (that is, aesthetic order and the structural use of materials) are inseparably united. In some instances, architects and critics of their art have insisted that all three are part of one unity. "Form follows function" is a phrase often used in architectural criticism, and it is interesting that the belief in an interdependent relationship between aesthetic value and usefulness had its champions in the United States as early as the middle of the nineteenth century. The American naval architect John Griffiths, in 1853, published a book on the theory and practice of shipbuilding, in which he said: "With regard to beauty in ships, we have said that it consisted in fitness for the purpose and proportion to effect the object designed."[1]

Louis Sullivan, an American architect who worked at the end of the nineteenth century, was one of the leaders in the development of this idea in the design of buildings. In an essay discussing the problems inherent in the design of tall office buildings, Sullivan stated:

It is my belief that it is of the very essence of every problem that it contains and suggests its own solution. This I believe to be natural law. Let us examine, then, carefully the elements, let us search out this contained suggestion, this essence of the problem.

The practical conditions are, broadly speaking, these:

Wanted—1st, a story below-ground, containing boilers, engines of various sorts, etc.—in short, the plant for power, heating, lighting, etc. 2nd, a ground floor, so called, devoted to stores, banks, or other establishments requiring large area, ample spacing, ample light, and great freedom of access. 3rd, a second story readily accessible by stairways—this space usually in large subdivisions, with corresponding liberality in structural spacing and expanse of glass and breadth of external openings. 4th, above this an indefinite number of offices piled tier upon tier, one tier just like another tier, one office just like all other offices—an office being similar to a cell in a honey-comb, merely a compartment, nothing more. 5th, and last, at the top of this pile is placed a space or story that, as related to the life and usefulness of the structure, is purely physiological in its nature—namely the attic. In this the circulatory system completes itself and makes its grand turn, ascending and descending. The space is filled with tanks, pipes, valves, sheaves, and mechanical etcetera that supplement and complement the force-originating plant hidden below-ground in the cellar. Finally, or at the beginning rather, there must be on the ground floor a main aperture or entrance common to all the occupants or patrons of the building.[2]

How different are the functions of a commercial building rising out of the streets of Chicago or New York in the twentieth century from the functions of a building dedicated to an ancient god, sited on a plateau overlooking the Mediterranean over two thousand years ago! Geography, history, economics, politics, religion—all these can have their effect on the function of any single building in the architectural continuum. But essentially there are three major functions that must concern the architect: the *operational* function, the *environmental* function, and the *expressive*, or *symbolic*, function. Often one of these areas dominates the other two in the development of a particular stylistic period. Ideally they would all make important contributions to the resolution of any architectural design.

The Operational Function

Who is to use the building? How many people will occupy it? What will they be doing when they are within it? These are questions which would apply to the operational function of a building. In the extensive study of architecture entitled *Forms and Functions of Twentieth Century Architecture,* edited by T. F. Hamlin, the table of contents lists forty-two building

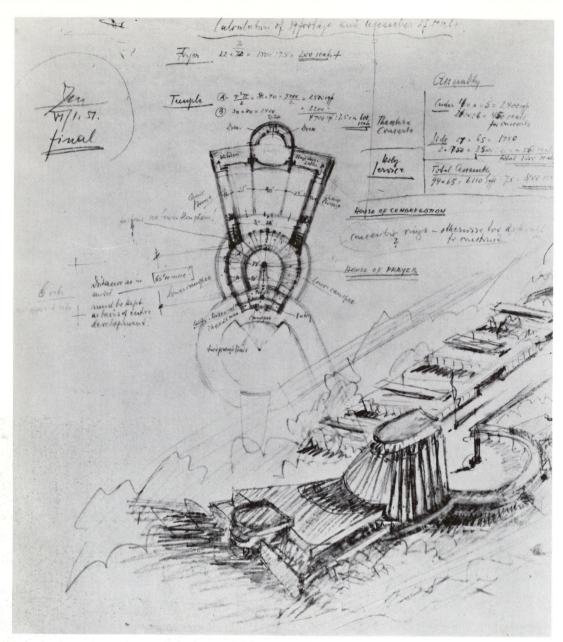

294. ERIC MENDELSOHN. Sheet of project drawings for Temple Emanu-El and its Community Center, Dallas. 1951. Collection Mrs. Eric Mendelsohn, San Francisco.

types. Under the headings "Buildings for Residence," "Buildings for Popular Gatherings," "Buildings for Education," "Government Buildings," "Commerce and Industry," "Buildings for Transportation," and "Buildings for Social Welfare and Recreation," the contributors discuss the problems relating to the design of each of these categories. Our society has grown so complex, its needs served by so many specialized groups and highly sophisticated organiza-

tions, that it is no longer possible to restrict the forms of architecture to a few limited types.

When we study Eric Mendelsohn's sketch for the design of a temple and community center (Fig. 294) the architect's multiple concerns are evident. Mendelsohn's written and pictorial notes establish the general configuration of the building, its plan, its position on the site, the shape and size of the spaces required to meet the clients' needs. Even at this pre-

liminary state of planning, architects must consider the patterns of movement of the occupants as they use the building. They must place related activities in adjacent spaces. Floor, wall, and ceiling finishes must meet aesthetic, acoustical and maintenance requirements. Plumbing, ventilation, and lighting must be planned. The structural problems must be solved. Stairways, elevators, and storage areas must be located and detailed. Imaginative accommodation of all these functional elements is often tempered by building codes regulating the density of occupancy and the use of specific materials and methods of construction. Finally, it must be noted that the architect is usually faced with the problems of budget. The cost of construction and the anticipated burden of maintenance can affect both aesthetic and structural options in a planner's scheme.

With the growing scarcity and escalating cost of energy throughout the world, architects have had to rethink many of their design concepts. Functional priorities are being shuffled, with a greater value assigned to the efficient use and conservation of power and materials.

The orientation of a building to exploit the natural effects of sunlight and prevailing winds, the careful use of insulation, and the placement and size of windows to control temperature and ventilation have been important considerations for many builders in the past, especially in locations with severe climatic conditions. With the predictable continuation of the strain on our energy resources, the design of buildings everywhere will reflect the need to cooperate with nature, and the use of nonexpendable solar and wind power will increase.

We no longer automatically assume that the replacement of older buildings and communities is desirable. The restoration and alternative utilization of buildings once abandoned, particularly in our cities, has stimulated inventive designs that adapt these structures to current aesthetic and functional standards. An example is the seventy-five-year-old, five-story New York City tenement illustrated in Figure 295. Typical of thousands of aging buildings, this apartment house was an unprofitable and unsatisfactory living space. As the result of a cooperative effort on the part of a tenant group, the building was recycled. The solar-collector system that was installed on the roof meets 85 percent of the building's hot-water requirements. Almost all of the electrical power required by the occupants is produced by a 2-kilowatt wind generator mounted adjacent to the panels. These new systems, as well as increased insulation and a redesign of the interior spaces, have revitalized the decaying building, transforming what could have been an urban liability into a valuable economic and social asset.

The Environmental Function

The architect must think of a building not just as an efficient machine designed to facilitate the activity of its tenants but also as an environment in which human beings will spend a portion of their day. This statement is not so self-evident as it may seem. Human beings have often been considered cogs in some huge mechanism. Often, their physical needs have been satisfied, but little concern has been given to emotional or aesthetic needs. Today, however, there is a growing awareness of the connection between environment and human efficiency. Office buildings and huge assembly plants, as well as other structures designed for commercial, industrial, and public purposes, house great populations for a substantial portion of their lives. The atmosphere in which these people work cannot fail to affect them, and, of course, whatever may be said for the buildings that shelter our public and economic complex is equally, or even more significantly, pertinent to the design of our residential architecture.

295. Rehabilitated apartment building with solar hot-water heating panels on the roof. East 11th Street, New York.

Light, color, the size of rooms, the kinds of materials used—all can have a pronounced effect on the physical and psychological response to the architectural environment. The architect begins with the human being—individual size, need for personal identity, response to sound and movement in a restricted sphere of activity.

In their book *Body, Memory, and Architecture,* Kent C. Bloomer and Charles W. Moore write of their belief that there has been a "general assumption, seldom debated, that architecture is a highly specialized system with a set of prescribed technical goals, rather than a sensual social art responsive to real human desires and feelings . . . that the human body, which is our most fundamental three-dimensional possession, has not itself been a central concern in the understanding of architectural form."[3]

After discussing some models of perception, the function of touch in defining experience, and the implication of the image people develop of their own bodies, Bloomer and Moore continue:

Architecture, the making of places . . . is . . . a matter of extending the inner landscape of human beings into the world in ways that are comprehensible, experiential and inhabitable

What is missing from our dwellings today are the potential transactions between body, imagination, and environment. It is absurdly easy to build, and appallingly easy to build badly. Comfort is confused with the absence of sensation. The norm has become rooms maintained at a constant temperature without verticality or outlook or sunshine or breeze or discernable source of heat or center or, alas, meaning. These homogeneous environments require little of us, and they give us little in return besides the shelter of a cubical cocoon. . . .

To at least some extent every real place can be remembered, partly because it is unique, but partly because it has affected our bodies and generated enough associations to hold it in our personal worlds.[4]

The creation of an architectural environment is directly dependent upon the aesthetic aspect of the interior spatial design of a building. As in other art forms, the architect is concerned with the creation of an aesthetic organization through the use of form, texture, and color in a spatial order. These plastic elements are related to and are, in part, created by the structure of the building itself, which is, in turn, related to and dependent upon the building's operational function.

Many types of buildings are used by the public at large (stores, offices, apartment houses, schools, and residences), and it is possible for many within the nonspecialist public to draw pertinent conclusions about the ingenuity employed to accommodate the needs of the occupants.

No building exists in isolation. Whether erected in a city or on a rural site, a new construction affects and is affected by the environment that surrounds it. Operational and environmental functions within any building are invariably tied to conditions existing outside its walls. Road and transportation systems, the availability of adequate energy resources, waste disposal services, air and water quality are essential concerns for architectural planners as they consider the location, scale, and functional characteristics of their buildings.

The environmental function of an architectural design is, once again, that aspect of a building which most affects the people it serves. Occupants may find it difficult to isolate all of the elements within and without a building which generate a state of pleasure or well-being, but they know when that state exists. The appreciation of architectural design comes inevitably from an intuitive response to the combination of architectural and environmental elements acting upon the observer. Differences of personality and physiology among occupants of a building color the reactions to a planned environment, so that no single, consistent response is possible. Each person who seeks to understand a building will have an individual subjective response to it. But there are many common physical and emotional needs that can be satisfied by intelligent, imaginative, and sensitive planning. When architects succeed in satisfying these needs, the results can be widely appreciated.

The Expressive, or Symbolic, Function

Architecture has limits.

When we touch the invisible walls of its limits then we know more about what is contained in them. A painter can paint square wheels on a cannon to express the futility of war. A sculptor can carve the same square wheels. But an architect must use round wheels. Though painting and sculpture play a beautiful role in the realm of architecture as architecture plays a beautiful role in the realms of painting and sculpture, one does not have the same discipline as the other.

One may say that architecture is the thoughtful making of spaces. It is, note, the filling of areas prescribed by the client. It is the creating of spaces that evoke a feeling of appropriate use.[5]

These are the words of Louis Kahn, who designed the research facility for the Salk Institute of Biological Studies (Figs. 334, 335). Like many other architects, Kahn recognized the need to consider a building as a symbol for the activity housed within it. By its appearance, a school, a church, an office building, and a

296. HENRY BACON. Lincoln Memorial, Washington, D.C. 1914–22.

seat of government must be distinguishable to those who use as well as pass by and through it.

The symbolic function of architecture depends in part upon the response of the public to the forms erected by the builder, as the agent of the architect, who satisfies the client's need. A portion of this response will most certainly be conditioned by buildings of the past, which have had historical significance in some aspect of the culture of the contemporary society. One need only look at the hundreds of government buildings in the United States and abroad which have been influenced by the forms of Greek and Roman architecture to realize that the columned temple has been identified with public buildings. The Lincoln Memorial in Washington, D.C., is one of many examples of an architectural design modeled on Greek antecedents (Fig. 296).

Completed in 1922, and certainly one of the buildings of great significance to many Americans, this monument derives much of its expressive content from the Classical style chosen by the designers. The colonnade surrounding the great statue of Lincoln in the interior announces that the visitor is within a space of importance. The scale of the building and the white marble surfaces of its walls and columns add to the grandeur and the emotional impact. It does not debase this response to suggest that some significant portion of it is owing to the stylistic connection between the building and other, more ancient examples of monumental architecture.

If the Lincoln Memorial is compared with the Jefferson Westward Expansion Memorial (Fig. 297), in St. Louis, Missouri, which was designed by Eero Saarinen, the difference in conception is startlingly

297. EERO SAARINEN. Jefferson Westward Expansion Memorial, St. Louis. 1966.

298. Municipal offices.

299. Residence.

300. Library.

301. Church.

298–301. Various buildings of "colonial" type.

evident. The Lincoln monument is tied to the past, with all its associated meaning; the great catenary arch of the Jefferson Memorial has no stylistic precedent. Age-old, the idea of an arch as the entrance or a gateway to an important space is indeed present, but the stark simplicity of the form devised by Saarinen could have been conceived only in the twentieth century. The grand scale, the gleaming surface of stainless steel, and the soaring form of the structure create an expression of the vision of Thomas Jefferson, the opening of the West, and the achievements of the early pioneers who traveled through St. Louis to reach the new frontiers beyond the Mississippi.

Expression in architecture is not confined to monuments. Each human activity can suggest the environment, the forms, and the spaces appropriate to the function performed within a building. The architect may select and combine those materials and struc-

tural systems which serve as both the container and the symbol of the activity for which the building is intended. A building may indicate wealth, power, modernity, tradition, ambition, or repose. It may suggest withdrawal from society or stand as an invitation to visit and share the hospitality of the owners. It can stand apart from the land, an object suggesting the scientific technology that has resulted from the application of the human mind and the industry of the contemporary society (Fig. 314), or it can remain close to the earth, rising from the soil and rocks, a part of nature, associating the human species with all other forms of life, like the great rambling Arizona home and studio of Frank Lloyd Wright (Fig. 326).

Expression in contemporary architecture cannot evade the traditions of the society that sponsors it and whose needs it must satisfy. Architectural critics often condemn eclectic or imitative architecture because it does not find its expressive forms in the present-day world; when a building is given a superficial, imitative skin that camouflages an internal design with an anachronistic shell, the inconsistency between the nature of the building and its appearance can be bizarre and even ridiculous. To clothe a municipal office building, a residence, a library, and a church (Figs. 298–301) in the same architectural forms sacrifices expressive design to stylistic consistency. However, many of the personal and social activities common to people of the past still exist in a somewhat similar form today, and in these areas of our culture eclectic designs may serve in much the same way as their antecedents. The typical eighteenth- or early nineteenth-century house is still able to meet the needs of many twentieth-century families with but few alterations in design. For many people, the so-called "colonial" house expresses security, the warmth of family life, and a continuity of earlier cultural values which, in total, provide a satisfying aesthetic environment. A person from New England may leave home, a contemporary version of a 200-year-old design, and travel to an office in a steel-and-glass tower without feeling that there is an inconsistency between these totally different environments. This same person, at the end of the working day, before returning to the hearth of the "colonial" home, may stop at a newly decorated restaurant and dine in a "Victorian" environment, surrounded by newly made versions of nineteenth-century stained-glass lamps and "old" oak paneling. A visit to California would permit this twentieth-century New Englander to visit Disneyland, with its storybook villages intentionally scaled at three-quarters normal size to enhance the quality of intimacy and nostalgia they create (Fig. 302).

To some contemporary critics this form of architectural eclecticism indicates a lack of artistic integ-

302. Sleeping Beauty Castle, Disneyland, Anaheim, Calif. © Walt Disney Productions.

rity. They believe that each cultural period produces its best architecture when the social needs, functions, and technologies of the time and the place are fused into the expressive forms of the buildings. They believe that each building speaks best when it speaks of its own time in its own idiom.

The Boston City Hall (Figs. 303, 304) represents the efforts of the designers to resolve the difficult problems of housing the varied departments and

functions of a major metropolitan government in a single building that must also symbolize the political center of the community. The design (Figs. 305–307) was the winning entry in an architectural competition that presented the participants with a predetermined site and plan for traffic circulation. The City Hall was to be one of a number of buildings in a large administrative center in a redeveloped area of central, downtown Boston. The building would measure 100 to 130 feet (30 to 39 meters) high and approximately 275 feet (82.5 meters) square. To be included in the plan was a substantial amount of office space for the mayor, the staff, and other city officials; large ceremonial meeting halls; a municipal library; and public office space accessible to transient visitors. Each of the space allocations identified as a part of the requirements for the design had different functional, environmental, and expressive characteristics, corresponding to the needs of the occupants.

Many architects have solved problems of this kind by designing a large envelope that encloses several varied functions of a public building, giving an external appearance of unity to an internal complexity. Such a solution is the basis for the design of the

above: **303.** KALLMAN, MCKINNELL & KNOWLES. West façade and south side, Boston City Hall. 1968.

left: **304.** South lobby, Boston City Hall.

305. Plan of third floor,
Boston City Hall:
(1) south lobby; (2) open courtyard;
(3) mayor's stair; (4) offices.

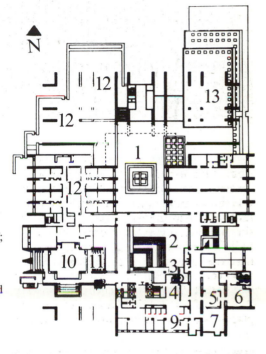

306. Plan of fifth floor,
Boston City Hall:
(1) open court;
(2) south lobby;
(3) mayor's stair;
(4) reception of mayor's
department;
(5) reception of mayor's
office;
(6) mayor's conference
room;
(7) mayor's private office;
(8) mayor's dressing room
and bath;
(9) offices of mayor's staff;
(10) council chamber;
(11) council chamber
galleries and access;
(12) councilors' offices and
conference rooms;
(13) exhibition hall;
(14) reference library.

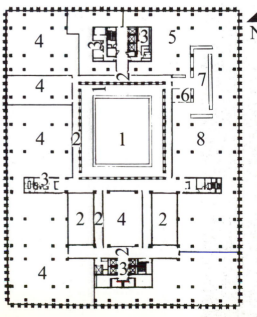

307. Plan of eighth floor,
Boston City Hall:
(1) open court and terrace;
(2) public corridors, empty space;
(3) service;
(4) offices and conference rooms;
(5) Building Department;
(6) Cashier;
(7) public service counters;
(8) Building Department
Administration.

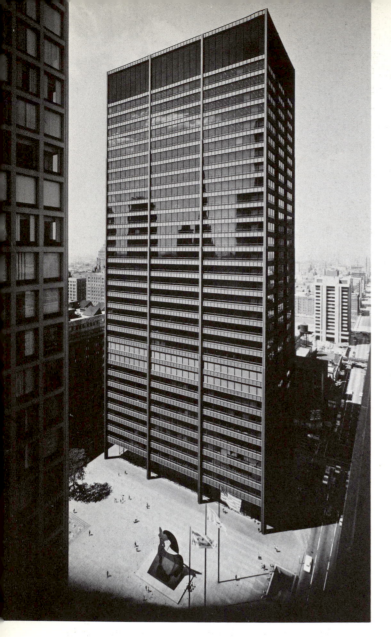

Chicago Civic Center (Fig. 308, 309). The 31 floors of this building are designed so that each one is anonymous and flexible, suitable for a number of possible functions. The Civic Center houses 140 courtrooms and their associated offices. Included also are hearing rooms and the public spaces necessary to accommodate the inquiries and activities of approximately 12,000 people who use the building each day.

The approach of the architects to the design of the Boston City Hall was in direct contrast to that taken in Chicago. The Boston plan has an external face indicative of the internal complexity. Beginning with a sloping site, the architects specified a brick platform to connect the lower portion of the building with the great plaza that surrounds it.

The first two floors contain offices and counters, located for the convenience of the citizen who needs to obtain licenses or registrations and permits. On the first floor a concourse is open to those who wish to walk through on their way to one of the other buildings in the complex. There is an appearance of openness and accessibility. Large public inner courts and stairways announce the public and symbolic character of these impressive spaces. The citizen is aware of being in an important building, but a building that is a part of the city, not isolated from it. On the fifth floor (Fig. 306) the mayor's offices and chambers, the council chamber and associated offices, and the reference library are placed in close proximity, emphasizing their functional and symbolic relationships. These three areas are expressed externally by massive geometric elements that punctuate the façades on the east, south, and west, supported by gigantic concrete pillars that raise the building over the plaza. The third floor (Fig. 305) provides offices for services related to the fiscal operation of the city, which are easily reached by the public from below and by the mayor and members of the council from above. Finally, the top four stories are designed as utility office

above: 308.
C. F. Murphy Associates;
Skidmore, Owings & Merrill;
and Loebl, Schlossman
& Bennett.
Chicago Civic Center. 1964.

right: 309.
Plan of 24th floor,
Chicago Civic Center.

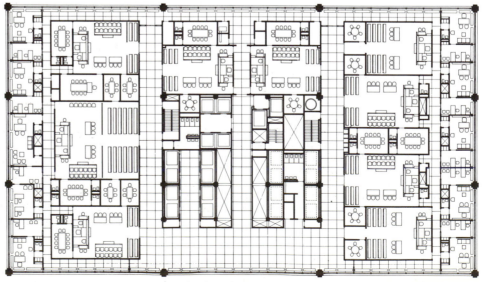

310. Venturi and Rauch. Model for Football Hall of Fame, New Brunswick, N.J. 1966.

space, a form of beehive that serves the entire complex and, from the exterior, presents a powerful horizontal band, like a Classical frieze, that binds the vigorous energies of the voids and solids into a coherent visual statement.

The architect Ludwig Miës van der Rohe saw the design of buildings as the organization of sensitively related structural elements to create flexible anonymous spaces suitable for many different purposes. His motto "less is more" is a way of saying that an architect must isolate the essential character of a design problem and then attempt to express it in a carefully controlled, highly refined integration of form, space, structure, and material. Though not designed by Miës van der Rohe, the Chicago Civic Center exemplifies an architectural aesthetic that reflects his design principles. One of the most influential architects of the twentieth century, Miës said:

> Teaching forced me to clarify my architectural ideas. The work made it possible to test their validity. Teaching and working have convinced me, above all, of the need for clarity in thought and action. Without clarity, there can be no understanding. And without understanding, there can be no direction—only confusion.[6]

In his book *Complexity and Contradiction in Architecture,* another architect-teacher, Robert Venturi, champions a concept of architecture that argues against the aesthetic position of Miës van der Rohe:

> I like complexity and contradiction in architecture. I do not like the coherence or arbitrariness of incompetent architecture nor the precious intricacies of picturesqueness and expressionism. Instead, I speak of a complex and contradictory architecture based upon the richness and ambiguity of modern experience, including that experience which is inherent in art. Everywhere, except in architecture complexity and contradiction have been acknowledged. . . .

Architects can no longer afford to be intimidated by the puritanical moral language of orthodox Modern architecture. I like elements which are hybrid rather than "pure," compromising rather than "clean," distorted rather than "straightforward," ambiguous rather than "articulated," perverse as well as impersonal, boring as well as "interesting," conventional rather than "designed," accommodating rather than excluding, redundant rather than simple, vestigial as well as innovating, inconsistent and equivocal rather than direct and clear. I am for messy vitality over obvious unity.[7]

Venturi made it quite clear in his short, intense book that he does not recommend an anarchic architecture but, rather, architecture organized on many different levels at once. He wants architecture to look to the past for solutions to problems that have been solved before, without slavishly imitating past styles. He wants it to reflect the complexity of the activities and services of which it is a part. He wants the design of architectural units to recognize that a building can play many visual roles rather than one. It may be seen as a wall when one is standing beside it, a gateway when one moves through it. It can serve a sculptural function when viewed as a part of an urban skyline, and certainly it will provide the spaces needed to fulfill the requirements of those within it. A building is an economic unit, a space, a series of forms, a home, or a place of business, a part of a community. All these things are part of the nature of a building, and each one may demand a different design solution. Venturi asks that the designer recognize and deal with these often contradictory requirements in each building, accepting the complexity instead of a simpler solution that seems aesthetic but meets only one aspect of the overall need.

Venturi and his associate, John Rauch, expressed this interest in the union of disparate elements in their proposal for a Football Hall of Fame which employs an electronic billboard as a façade (Fig. 310).

left: 311. The Towne House, relocated from Charlton, Mass., to Old Sturbridge Village, Mass. 1787.

313. Plan, Towne House

312. Dining room, Towne House

This symbolic connection with weekend television would announce to the visitors who park their cars in the surrounding lot that they had arrived at a place devoted to fun and sports information. Behind the media event a simple enclosed rectangular space would house the exhibits, separate units that could be flexibly arranged to meet changing display needs.

The Visual Organization of Architecture

The operational, environmental, and expressive functions of a building may affect the architect's choice and arrangement of elements to be used, but the elements are rarely, if ever, organized solely on the basis of those intentions. There is a visual order, similar to that underlying the composition of sculpture, that helps to shape the appearance of a building, and its aesthetic content is, in part, dependent on this organization.

A building may be conceived and perceived from either outside or inside. It is in its external configurations that a building seems most like a large sculptural composition, and aesthetic satisfaction can result in response to the size, shape, and use of materials on the exterior. On the other hand, the interior volumes within that exterior shell have concerned architects throughout history; in certain periods this concern has taken precedence over the aesthetic relationships of the external elements. The appreciation of architecture must therefore include an awareness of interior space as well.

This kind of total appreciation is more difficult in architecture than in the other visual arts. As in the case of sculpture, there is the problem of the partial view, of being able to see only a portion of the work at one time. In architecture the problem is amplified. A piece of sculpture may be seen completely from the outside, whereas full knowledge of a building re-

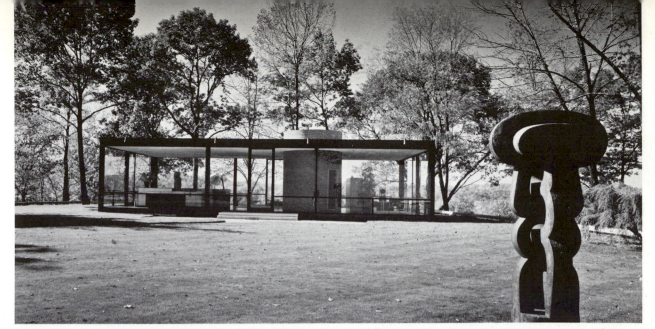

314. Philip Johnson. Glass House, New Canaan, Conn. 1949.

quires the experience one has within the enclosed space as well as outside it. The size of the architectural design often complicates the process that leads to its appreciation. To understand a building that covers a large area and is constructed on more than one level means that the observer must relate spaces and forms isolated by the barriers of walls and stairways. It requires the ability to see aesthetic relationships between visual experiences separated by minutes and possibly by hours.

A simple colonial house seen from without has the form of a modified cube (Fig. 311). An observer who looks at this building from the street has no accurate idea of the layout of the interior rooms. For this person the building exists as a solid form pierced by window and door openings. Once inside, it is no longer possible to react to the exterior, sculptural appearance of the building; the house becomes a volume of space created by the placement of walls, floors, and ceiling (Fig. 312). The visitor, glancing around the entrance hall, can sense the size and proportions of this space. Doors on either side of the hallway permit entry into other spaces, each one somewhat different from the others in size and proportion. Windows join the interior and exterior world.

The connected spaces between the exterior and interior walls that surround them fill the house, cutting it into many different volumes. Each one can be seen and understood only when the viewer stands within it or studies a plan that graphically represents the spatial organization of the building (Fig. 313).

In the colonial house there is a certain similarity between the forms of the exterior and the spaces of the interior. Usually both aspects of the building are rectangular, and the size of the exterior gives some suggestion of the interior dimensions. One building that seems to integrate form and space to the point where they become almost indistinguishable is the Glass House designed by Philip Johnson as his residence (Figs. 314, 315). The glass walls do not isolate exterior from interior space. Instead, they hint at the rectangular form of the building as the reflections in the glass delay the viewer's perception of the interior. The flat plane of the roof and the supporting columns also work to define the form, but it is the interior

315. Interior, Glass House.

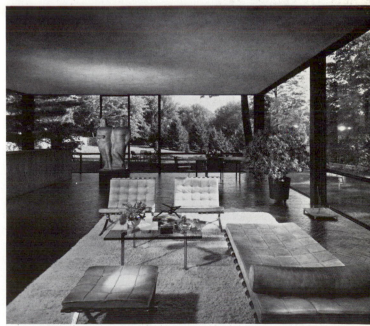

316. Philip Johnson. Guest house, New Canaan, Conn. 1953.

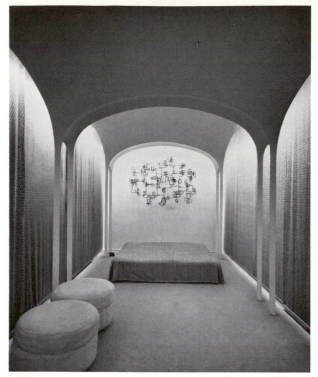

317. Interior, guest house.

volume which dominates the conception of this structure. Though it too is the work of Johnson, the adjacent guest house (Figs. 316, 317) offers a marked contrast to the transparent cubic form of the main building. It is opaque. The relatively small openings which pierce its sides only heighten the sense of the opacity of its exterior mass. The interior of the guest house gives further evidence of the architect's desire to isolate form and space in this design. Within the blocklike exterior shape Johnson constructed a series of canopied vaults, creating a rounded space within the cube, a surprise to the visitor who anticipates an interior which reflects the exterior forms.

Space in architecture is created and defined by the shape, the position and materials of the forms employed by the architect. Opaque planes set at right angles to one another to form a box will produce a cubelike interior space. The effect of this space will be directly related to the volume enclosed by the opaque planes. A small spatial volume with low ceilings will affect the occupant in a manner entirely different from a larger space of similar proportions. If the

planes are of glass, the enclosed space will differ from the apparent space felt by an observer, and the architect's design may control these spaces.

Quite obviously, the contours of the forms used by the architect will define the space. Even the flat, two-dimensional photograph of the interior of Eero Saarinen's Trans World Flight Center at Kennedy International Airport in New York (Fig. 318) conveys the sense of an enclosed space which flows through the building, shaped by the fluid forms of concrete into a dynamic series of connected curved volumes.

318. Eero Saarinen. Interior, Trans World Flight Center, Kennedy Airport. 1962.

Plate 48. JOHANN MICHAEL FISCHER. Interior, Abbey Church, Ottobeuren, Germany. 1736–66.

below left: Plate 49. MINORU TAKEYAMA. 2-ban-kahn, Tokyo. 1970.
below right: Plate 50. 2-ban-kahn (Pl. 49), newly painted. 1977.

above: 319. Painted tepee.
Plains Indian (probably Cheyenne).

above right: 320. Louis I. Kahn.
Interior, Presidential Square,
Dacca, Bangladesh.

right: 321. Ludwig Miës van der Rohe.
Seagram Building, New York. 1956–58.

Mass

Many forms developed by architects derive from the materials and the structural system selected. The simple conical form of the tepees of the American Plains Indian is created by stacked poles covered by skins or fabric (Fig. 319). Buildings constructed from stone or brick depend upon the methods of stacking and bridging used to raise the walls and support the floors and roof. The forms that emerge from these construction systems tend to emphasize vertical and horizontal planes and right angles. When arches, vaults, and domes are used, they add curves and spherical shapes to the vocabulary of form used by the architect (Fig. 320).

The tall steel-and-glass office buildings of contemporary cities owe much of their appearance to the nature of their construction. For instance, the severe rectangularity of Miës van der Rohe's Seagram Building (Fig. 321), in New York City, results from the architect's use of relatively short steel beams connected into a vertical and horizontal web, or cage.

pleasing examples include many eclectic buildings in imitation of earlier historical styles of architecture. St. Patrick's Cathedral in New York City (Fig. 323) is a relatively modern building constructed from 1850 to 1879 on a metal frame. The architect wished to create the impression that the building was constructed entirely of stone, like the Gothic churches of the fourteenth century. The forms of St. Patrick's Cathedral were designed with little or no concern for their structural function, and even though stone was employed on the exterior surfaces, some of the interior vaults have plaster surfaces in imitation of stone. In this instance, both form and space, as conceived by the architect, were unrelated to material and structure. Instead, they were selected to give an architectural illusion that would satisfy the aesthetic taste of those who saw and used this building.

above: 322. EERO SAARINEN. Trans World Flight Center, Kennedy Airport, New York. 1962. (See Fig. 318.)

right: 323. JAMES RENWICK. St. Patrick's Cathedral, New York. 1850–79.

The buildings seen behind and beside the Seagram Building are constructed in a similar manner, and though they are variously sheathed in stone, brick, or concrete, they display the same boxlike forms.

Contrast these buildings with the TWA terminal (Fig. 322). The exterior forms of this building repeat the flowing movement of those within it (Fig. 318). They result from the use of reinforced concrete, which was poured into wooden forms much as batter is poured into a muffin tin. The fluid concrete filled the forms and, when rigid, produced a group of soaring shells which remained when the supporting forms were removed.

These very different examples all demonstrate the prime influence of material and structure on form in architecture.

It is also possible to shape building materials into forms which deny either their inherent characteristics or the structural system of the building. Aesthetically

324. HENRY HOBSON RICHARDSON. Crane Memorial Library, Quincy, Mass. 1883.

Surface and Pattern

Texture is as significant in architecture as it is in sculpture. Stone, brick, and wood—the age-old primary materials of architecture—can form patterns in the way walls and partitions are erected; or, by their very nature, the building materials can provide opportunities for textural design. For the Crane Memorial Library (Fig. 324) in Quincy, Massachusetts, Henry Hobson Richardson specified roughly cut stone for the major wall surfaces and arranged the rectangular blocks in parallel courses at the base of the building. Above the base, blocks of varying sizes have been organized with an apparent spontaneity that contrasts with the regularity of the lower section. The rough, chipped surfaces of the stones provide a textural unity over the entire façade, giving the building a fortresslike strength and monumentality. Carved stone moldings accentuate the door and window openings and help to refine the essentially powerful conception. The wooden shingle roof, a large area of finer surface variations, creates a textural counterpoint to the stonework, echoing but subordinate to it. At the peak of the roof the line of tiles makes a strong horizontal termination to the façade and helps to pull the asymmetrical elements into a cohesive but dynamic whole. Even here, however, the vertical pattern of the tiles agitates the basic horizontality to offer a crisp, final recapitulation of the tactile theme fundamental to the building.

For the office building illustrated in Figure 325, the highly reflective surface of black glass was used

325. NORMAN FOSTER. Willis Faber Office, Ipswich, England. 1975.

326. FRANK LLOYD WRIGHT. Taliesin West, Phoenix, Ariz. Begun 1938.

by the English architect Norman Foster. The transparency of the glass wall is eliminated for those outside but retained for the occupants. Mirrored images continuously alter the undulating panels, adding the vitality of street life to what might otherwise have been a dark and forbidding urban structure. The reflecting wall weds the city to the building by acting as a large motion-picture screen providing an endless picture show of city life for the citizens of Ipswich.

An architect may prefer certain materials because they integrate the building design with its site. An example of this approach to the aesthetics of architecture is the impressive complex of buildings designed by Frank Lloyd Wright at Taliesin West, near Phoenix, Arizona (Fig. 326). Constructed of local stone and wood, the forms of these buildings seem almost to grow out of the desert that surrounds them, and the plants beside the buildings seem as natural there as they do in the untended landscape.

Contrast this intimacy of texture and form with the severe separation of building and land in the Savoye House (Fig. 327), whose architect, Le Corbusier, used flat concrete, glass, and steel to isolate his work from its natural surroundings. The Savoye House could be placed in many different sites without losing its essential character, for it seems to be designed as a separate and distinct unit, indifferent to the appearance of the surrounding landscape. The architectural approaches of Frank Lloyd Wright and Le Corbusier reflect two major aesthetic attitudes in

327. LE CORBUSIER. Savoye House, Poissy-sur-Seine, France. 1929–30.

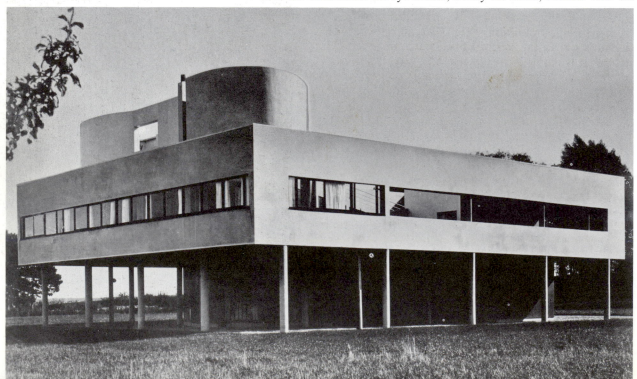

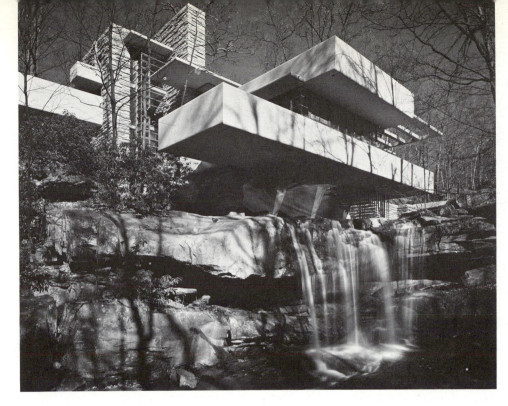

twentieth-century building, and in each instance the textures of the materials used in construction are important to the total effect of the finished form.

Line

Line is a secondary element in architecture, as it is in sculpture. Line exists for the architect in the silhouette of forms (Fig. 328)—in the edge created by a change of plane or at the juncture of two or more planes. It is also possible to consider the axis of a form or a spatial volume as having a linear quality, so that the Seagram Building (Fig. 321) can be described as having a strong vertical line, meaning a vertical axis that is emphasized. One might also refer to the vertical lines created by the forms of the metal elements, which produce the regular patterns on the surface of the same building.

In addition, many architectural features, both external and internal, provide linear effects. Any long thin form in a building can be read as a linear element. As light-reflecting and shadow-casting features, such details offer a changing pattern of lines and edges and divide interior walls or external façades into geometric segments, the ultimate effect dependent upon the time of day, the season, or the quality of artificial illumination.

In his design for the Palazzo Rucellai (Fig. 329) in Florence, Italy, the Renaissance architect Leon Battista Alberti kept the walls flat and articulated them with a minimum of sculptural detail below the cor-

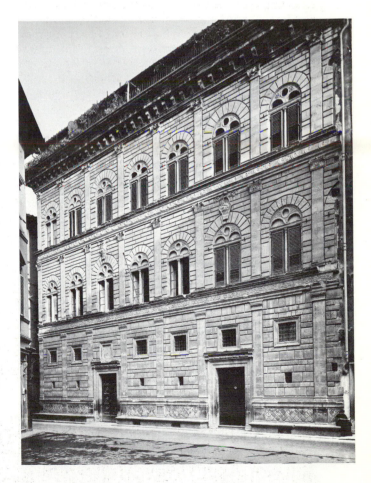

nice at the roof line. Separations between the individual stone blocks and pilaster strips are precise, regular, and relatively shallow. They cast shadows that rule the façade like the carefully placed lines with which a draftsman divides a drawing.

Cast shadows also produce the strong repeated linear motif in the Columbia Broadcasting System Building (Fig. 330), the work of Eero Saarinen. The unbroken verticals of the narrowly spaced columns are formed of triangular granite-covered sections separated by darkly tinted glass. As one walks past the building, the angular forms of the façade visually shift; their spacing appears to vary, opening and closing, adding a rhythmic complexity to the severely simple composition.

330. Eero Saarinen & Associates. Columbia Broadcasting System Building, New York, 1962–64.

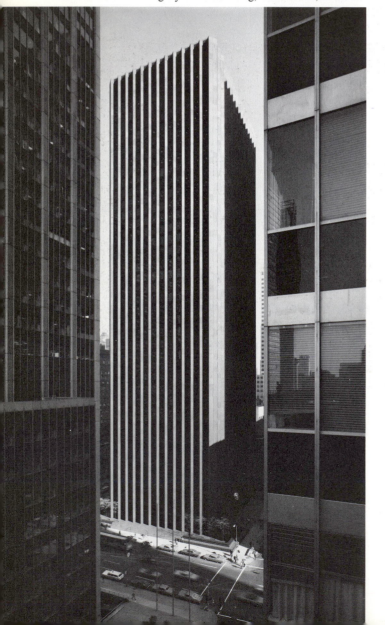

Color

Throughout history, interior and exterior surfaces of buildings have received polychrome decoration. The three-dimensional parts of a façade like that at San Miniato al Monte in Florence (Fig. 331) can be delineated and enriched by a combination of materials in different colors. At times, colors seem to have been chosen in an effort to contradict the structural integrity of the building they decorate, to dematerialize the masonry with an aggressively active pattern. Also, the decorative effect of mosaic and painted design has often been combined with symbolic content to make architectural environments. The interior of the Benedictine abbey church at Ottobeuren (Pl. 48, p. 227), in Germany, is an ambience of spatial fluidity and fantasy of form. Its structural, sculptural, and painted components fuse in a pulsating relationship, whose impact is theatrical and of overwhelming proportions.

The Japanese architect Minoru Takeyama has used color in an aggressive and light-hearted manner on the exterior of 2-ban-kahn, a commercial building located in the heart of Tokyo (Pl. 49, p. 228). This unique shell houses fourteen bars, several restaurants, and a game room. Takeyama's original decorative scheme was applied to his building in 1970. Treated like a giant three-dimensional poster, the design included mirrored glass panels that reflected the city movement and the changing light of both street and sky, making a kaleidoscopic counterpoint to the brilliantly painted walls. Festive as a fair building, 2-ban-kahn candidly proclaimed its recreational purpose. In 1977 it was redesigned and repainted. The new scheme, with its strongly linear elements, creates a new organizational relationship between the several three-dimensional masses that constitute the building complex (Pl. 50, p. 228).

With new developments in the treatment of metals to give them permanent, integral color, with the advances made in plastics and their increased use in construction, and with the deeper understanding of the psychological function of color, it is certain that this factor will have still greater importance in the architecture of the future.

Light

Even more than in sculpture, light has joined color as a functional and expressive principle in architecture. With the invention and utilization of electricity for illumination, the architect had an opportunity to reconsider many of the limitations on the design of public and private buildings.

Dependence upon natural light to make interior spaces usable required designs that employed the window as a wall-piercing device. This necessity had

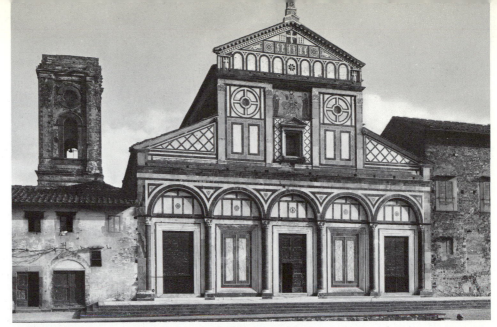

above: **331.** San Miniato al Monte, Florence. Completed c. 1062.
below: **332.** ANTONIO DA SANGALLO and MICHELANGELO.
Courtyard, Palazzo Farnese, Rome. 1530–89.

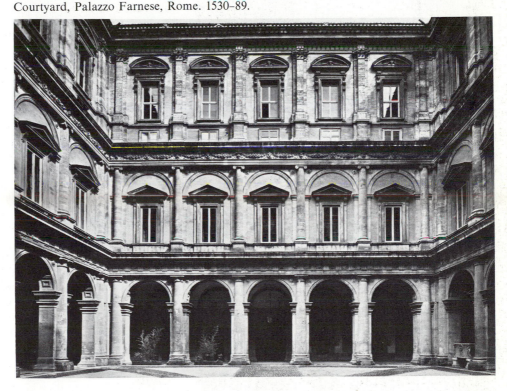

its positive values, for the window could be treated in many aesthetically satisfying ways. It could be shaped into openings that left rhythmic accents on the surface of the wall (Fig. 329) and decorated with moldings that added detailed sculptural variations or color notations to interior and exterior areas (Fig. 332). And, of course, as in the Gothic cathedrals, window areas could be glazed with colored glass to enrich the light within the great inner spaces of the buildings, simultaneously introducing pictorial and decorative images that added expressive meaning to the function of the church (Pl. 51, p. 261).

The limited artificial light that was available before the use of electricity tended to restrict the size of interiors for all but the wealthiest, free-spending clients, who could afford the substantial cost of copious

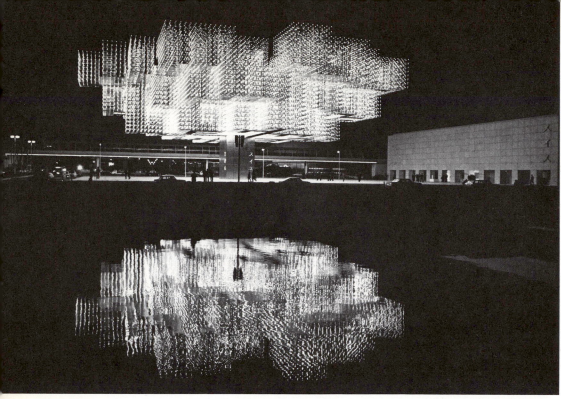

333. Willi Walter. Swiss Pavilion, Expo 70. Osaka, Japan.

illumination. In time, oil and, later, gas lighting fixtures began to affect the design of domestic and public buildings, but the availability of inexpensive electric light made possible a new era in design.

When looking at the window-walled office buildings and apartment houses now common to all urban centers, one can regard the use of the window in these structures as identical in function and necessity to the use of the window in buildings a century older. It is true that the window allows light to pass through the wall, but it is equally true that interior walls and partitions in these modern buildings often restrict the daylight from illuminating all but the perimeter space. Light cannot enter from above, as in older, single-storied structures, and the length and width of the typical office building necessitates interior central areas on each floor that must be lighted throughout the day by artificial illumination. We have become so accustomed to electric light that, even when after sunset we see from the exterior the lighted windows of our buildings, we rarely think of the way in which it has permitted the architect to plan the interior spaces (Fig. 321). Not until a failure of our electrical system occurs are we dramatically made aware of the interdependence of modern architectural design and lighting systems.

The pleasure felt by many during the Christmas season, when colored lights brighten the night, is a simple demonstration of the aesthetic potential of light. A more dramatic use of light for decorative effect was presented in the Swiss Pavilion at Expo 70 in Osaka, Japan (Fig. 333). An aluminum "tree" of 35,000 lights was constructed with the points of light energy massed to give the appearance of an architectural form. More sculpture than architecture, this "tree" suggests the possibilities of utilizing light to define form and space in architecture without the traditional materials of enclosure. The transparent cubes that appear to exist in space take their shape from the position of the lights in clusters. Whereas the light in the late-afternoon photograph of the Seagram Building (Fig. 321) is contained by the fabric of the walls, the very walls of the Pavilion are created by the light, with the dark areas in the construction functioning as "windows."

Service Systems

Contemporary architecture cannot be designed or understood without some consideration of several other systems that, like lighting, are basic to the planning of complex buildings. Heating and air-conditioning systems require space for the installation of large pieces of equipment. The duct work necessary to carry cooled air, the vents to provide and exhaust heat at critical locations, are all a part of the total design. Water and waste plumbing must be placed to coincide with the organization of walls and partitions. Elevators and escalators consume large amounts of space, and they, too, must be located in conformance

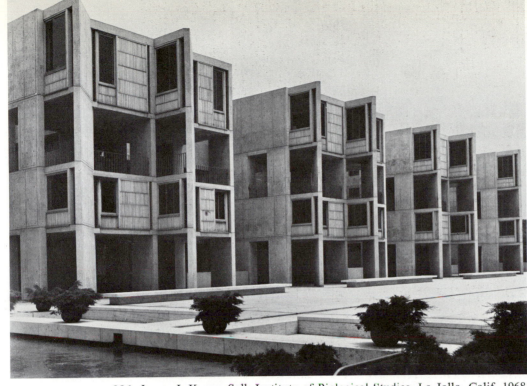

334. LOUIS I. KAHN. Salk Institute of Biological Studies, La Jolla, Calif. 1968.

with the traffic patterns that are assumed for a specific building. The plan of the twenty-fourth story of the Chicago Civic Center building in Figure 309 will show that almost a quarter of the floor space there is devoted to elevators, stairwells, and the service bays that carry the heating and cooling duct work. The three large rectangular areas at the top of the building (Fig. 308) mask the spaces for the mechanical and cooling equipment. Other service areas are hidden behind opaque screens on the ninth and tenth floors.

Some highly specialized buildings may require the installation of facilities for many services related to their function, and the cost of preparing for these services may exceed all the other costs of erecting the structure.

Buildings designed by Louis Kahn for the Salk Institute of Biological Studies (Figs. 334, 335) are composed of a stack of three laboratory floors separated by two service floors. The service floors are placed to permit easy access to the electrical, plumbing, and air-moving systems that can be directed to the laboratories above or below. The planners for the Salk Institute wished to provide an extraordinary degree of flexibility for the scientists and technicians who might need to increase, decrease, or change the arrangement of their experimental equipment as their research progresses.

A similar desire for open, flexible space was an integral part of the plan that resulted in the startling design for the Georges Pompidou National Center

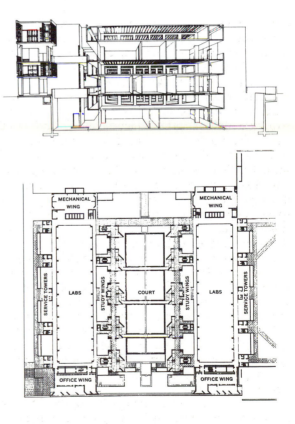

335. Section of the south building and plan, Salk Institute.

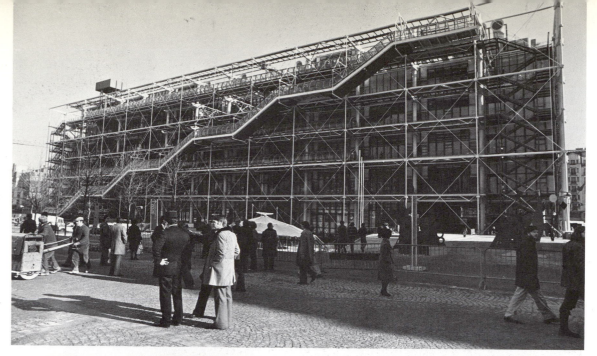

above: 336. RENZO PIANO and RICHARD ROGERS.
Georges Pompidou National Center
for Art and Culture ("Beaubourg"), Paris. 1977.

left: 337. Georges Pompidou Center,
service façade.

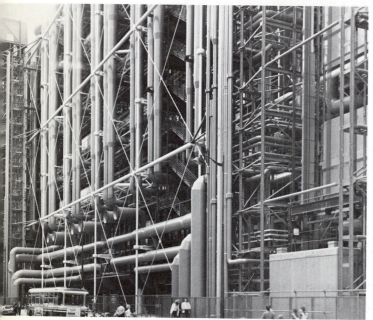

units on the roof are connected to rows of brightly painted tubular ducts on the service façade. The main façade is dominated by glass tubes that contain escalators and by connecting horizontal galleries. When filled with people being carried to the upper floors, these transparent pipes provide a spectacular kinetic show for pedestrians in the plaza west of the Center. The whole system is supported on a giant steel framework, assembled like an Erector set, with the glass-enclosed space of the exhibition floors set behind the screen of trusses.

In seeking to appreciate architecture, we may recall Louis Sullivan's phrase, "every problem contains and suggests its own solution," but we should note that he did not say that the solution to a problem was in itself sufficient to provide aesthetic satisfaction. Sullivan implied that the design was to be *suggested* by the need—not *form is created by function,* but *form follows function.*

A building that functions successfully has an order deriving from the logic of its solution to practical problems, but architects rarely find total satisfaction in this exclusively pragmatic approach to design. Though they may speak of "functional architecture," we frequently find that their work has a visual order based on the same principles of unity and variety, repetition and contrast that are to be found in the other visual arts. The Pazzi Chapel in Florence, by

for Art and Culture in Paris (Figs. 336, 337). This building houses the National Museum of Modern Art; a public library serving three to four thousand visitors daily; a center of industrial design; and multipurpose halls for theater, music, and cinema. Required services are complex; they include facilities for moving large numbers of people.

The architects Renzo Piano and Richard Rogers solved their problems by placing the service elements on the exterior of the building and exposing them as major visual components on opposite sides of the rectangular structure. Air-conditioning and heating

the Italian architect Brunelleschi, reveals this kind of order (Fig. 338). The dominant element on the front of the chapel is a screenlike façade, which introduces the characteristic design elements used repeatedly throughout the building. Six columns are set in two groups of three. The same rhythm is repeated on the flat upper portions of the façade, but here the columns are replaced by relief forms of the columns called pilasters. The pilasters are doubled and are smaller than the supports beneath them. Areas between the pilasters are filled with rectangular panels. An arch connects the two sections of the screen, which flank the entrance, focusing attention on the front doors just beyond the porch. Horizontal and vertical elements, curved arch forms, and decorative details based on historic styles unify the interior and exterior of the building.

Repeated pilasters adorn the outer walls of the chapel, echoing the division of space established on the front screen. This same rhythmic scheme is found inside the building on both the long walls. Tall, narrow windows topped with arches are placed between the pilasters, and they, too, are found repeated as decorative moldings within (Fig. 339).

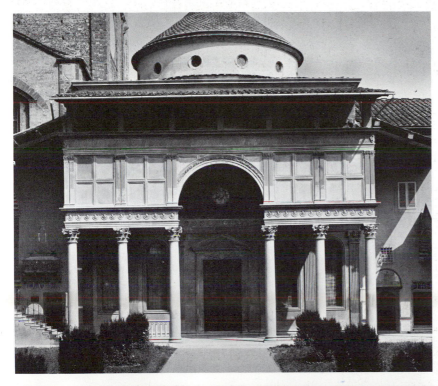

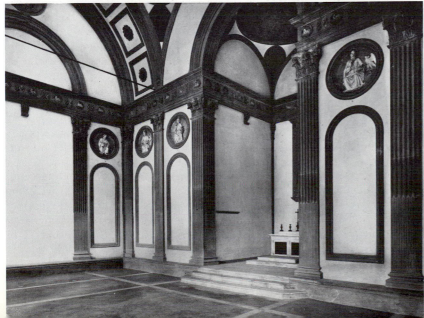

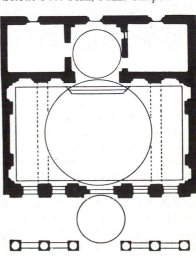

left: 338. FILIPPO BRUNELLESCHI. Pazzi Chapel, Florence. 1429–43.

below left: 339. Interior, Pazzi Chapel.

below: 340. Plan, Pazzi Chapel.

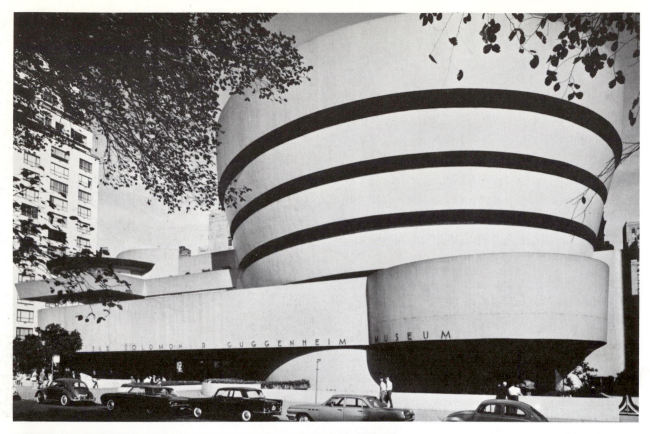

above: **341.** FRANK LLOYD WRIGHT.
Solomon R. Guggenheim Museum,
New York. 1959.

left: **342.** Ramp and reflecting pool,
Solomon R. Guggenheim Museum.

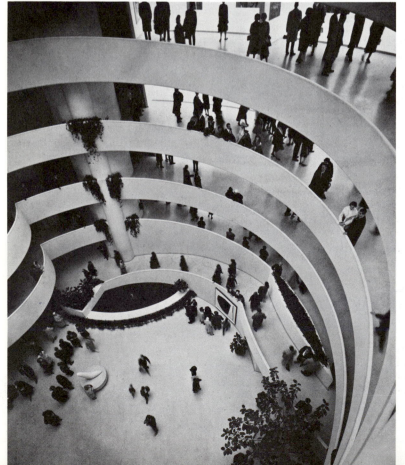

343. Stairwell,
Solomon R. Guggenheim Museum.

The interior space is covered by a large ribbed dome, which rises from supporting arched elements, echoing the curves in the porch. Each flat wall surface is tied to the general decorative scheme in a consistent repetitive use of vertical, horizontal, and curved motifs. Even the domed space of the main body of the chapel finds its introduction in a smaller dome over the entrance of the porch and its echo over the alcove that houses the altar.

The plan of this building shows an essentially symmetrical composition, but it does not suggest the variety of spaces created within the basically simple scheme (Fig. 340). The sheltered, shadowy space of the porch leads the viewer into an inner volume that rises upward into the central dome, which is illuminated by a group of circular windows between the ribs which support it.

A more detailed analysis would find additional repetitive elements that tie the parts of this structure into a single unified composition. Here, then, is an example of a classic method of aesthetic organization—repetition—used in architecture as a means of producing an elegant series of planes and spaces.

Repetition has also served as the primary compositional device in the Solomon R. Guggenheim Museum (Fig. 341). Here, the architect, Frank Lloyd Wright, took the curve as the basic design motif.

The museum exhibition area is a great open, spiral ramp, which descends six stories from a ribbed, translucent dome to the ground level. This spiral is housed in the southern portion of the museum. From the outside, the inner structure is mirrored in the inverted truncated-cone form of this main section of the building. To the north a smaller cylindrical mass houses the administrative offices and library. The two curved sections are tied together with a massive horizontal band, which contrasts against the curves while also functioning to relate the building to the ground plane and to provide the dramatic emphasis for the entrance. A secondary repeat of the horizontal occurs above the lower band, in a form of cornice, which creates a sharp angular contrast above the rounded corner of the building at the northwest.

A visitor enters the museum under the horizontal mass. The low ceiling height of the shadowed entrance dramatizes the great volume of space and light that expands out and up from the entry. Nowhere is one permitted to forget the unity of this extraordinary composition. Throughout the building, curved forms are repeated: on the exterior, in the design of windows, screens, walls, and planting areas, and, of course, in the two masses comprising the main features of the façade; in the interior, in the shape of the lavatories, the elevators, and even the pattern of the terrazzo flooring, which echoes the motif.

Contrasts to the dominant shape are to be found in the spiral itself. Instead of permitting the rising curve to continue unbroken from floor to dome, Wright interrupted the corkscrewlike movement with a section on each story that bulges out in a reversal of the main arc (Fig. 342). Another important contrast begins with the design of the main stairwell, which abuts the ramp. In this area it is the triangle that unites all elements of the design (Fig. 343). Like the repeated curves in the gallery, the triangular repeats are everywhere, even in the exterior shape of the stairwell pylon, which intersects the coil of the spiral on the east side of the building. Stairwell and main gallery are joined compositionally by the introduction of the triangular shape in recessed lighting fixtures, which dot the ceiling of the ramp, and finally in the supporting ribs of the dome which crowns the building (Fig. 344).

Like the painter or sculptor, both Brunelleschi and Wright sought to order their compositions by using repetition, continuity, and contrast; but, unlike

344. Interior dome,
Solomon R. Guggenheim Museum (Fig. 341).

their counterparts in the other visual arts, the architects had to consider more than the aesthetic organization of their designs when faced with the problem of creating these two structures. Before Brunelleschi's building was a complex composition of curves and horizontal and vertical elements, it had to be considered a *chapel*—a structure that would stand erect, a shelter in which a group of people expected to worship their God. Before Wright's design could exist in space, it had to be constructed with sufficient strength to support the dome and the weight of the hundreds of people who come to see the exhibitions.

There is a natural order of events in the design of a building. Beginning with the architect's analysis and conception of the functional problems to be resolved, the process moves to a period of testing. Various options of structure, materials, cost, and visual form are joined in alternative combinations. Often, one of the choices provides the key to the selection of the others. A unique steel structure may dictate the basic shape of the façades; an expressive visual form may initiate a search for a structural system capable of providing the requisite formal relationships. The ideal integration of function, structure, and visual organization is achieved only rarely, but when it is, the resulting work of art is capable of inspiring rewarding responses in many generations of men and women whether they use the building or react to it as transient visitors.

Structural Systems of Architecture

12

Intimately connected with the form, function, and expression of any structure are the methods of construction and the materials used to build it. In creating the space needed by clients, the architect can never ignore the basic problems of how to raise walls and what will support a roof. Practical, structural considerations are part of the total complex to be resolved in the architect's design. Sometimes the structural problems of the builder do not seem to concern the designer or the person who looks at the completed work. A viewer who delights in the appearance of a large equestrian statue need not know that inside it there is a complex skeletal structure. Just so, the person enclosed by the geometry of a classic Renaissance church (Fig. 345), the bombastic drama of a Baroque building (Fig. 346), or the soaring arches of a contemporary ferroconcrete reception hall (Fig. 347) may have a rich and satisfying aesthetic response without knowing how the building has risen. Nevertheless, there can be a connection between the knowledge of the way a structure has been erected and the satisfaction a viewer can feel when confronted by the building. Understanding how the architect fights the forces of gravity that tend to keep the walls of a building from rising and the roof from

remaining suspended above the earth can excite the mind and alert the senses. No one who has crossed a great suspension bridge can think of neglecting the part played by each thin strand of wire in the overall form, function, and aesthetic impact of the structure (Fig. 348). The following section provides a short description of the major structural systems and a discussion of their significance in the design of various styles of architecture.

A structural material must resist certain forces which test its strength. It may be required to support weights that operate to crush it, exerting what is known as the "force of compression" (Fig. 349). Or perhaps it will be pulled and stretched like a rubber band, by the "strain of tension forces" (Fig. 350). Both these forces—compression and tension—may be applied to a single element in a structural system, or, possibly, they may operate separately. The problem in building has always been to find materials that can resist these forces and to develop structural systems in which the materials can serve to best advantage.

For protection from the elements builders have used their ingenuity to take materials from nature and form them to suit social and physical needs. The range of materials includes the snow blocks of the

above: **345.** FILIPPO BRUNELLESCHI. San Lorenzo, Florence. 1423.

below: **346.** GIACOMO VIGNOLA. Interior, Il Gesù, Rome. Begun 1568.

northern Eskimo, the great stone blocks of the Egyptians, the animal skins and thin wooden frames of the American Plains Indian, and the living rock of India, from which monolithic temples were carved like sculpture. For the most part the early history of building is tied to the materials that were readily available to the peoples of a particular area, and characteristic architectural styles resulted from demands imposed by these materials. Only in the most primitive societies do we find people living within the hollow of a single tree or within an open cave or beneath a rock shelf. As soon as people have more sophisticated living quarters, they must cope with the problem of combining a number of separate pieces of a material into a larger unit. With wood, each piece must be attached to another piece. The pieces must be woven, tied, joined, nailed—somehow they must be united to form upright walls and, perhaps, a roof to protect the inhabitants from the weather.

Building in stone or brick requires the solution of similar problems. The examples in India of temples

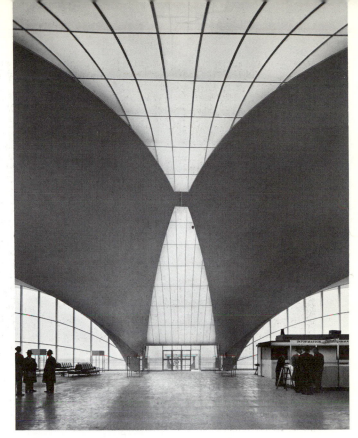

347. George Francis Hellmuth, Joseph William Leinweber, and Minoru Yamasaki. Airport Reception Building, St. Louis. 1953–55.

348. O. H. Ammann and Cass Gilbert. George Washington Bridge, New York. 1927–31.

349. Forces of compression.

350. Forces of tension.

carved completely out of stone cliffs (Fig. 351), which become forms of giant hollow sculpture, constitute an incredible monument to human perseverance and ingenuity, but they are rare exceptions in the use of stone for architecture. Stone construction, perhaps to an even greater degree than construction in wood, requires the union of relatively small elements into much larger structural complexes.

Post and Lintel

One of the simplest and most universally used systems of construction is the *post and lintel* or wall and lintel. Examples of this method are to be found in Egyptian temples dating back to 2700 B.C., in Greek temples of the sixth and fifth centuries B.C., and in buildings of the Roman Empire and the European Renaissance. The half-timbered medieval houses and the one-room cabins of the early Colonial settlers are found in this group, too. The Japanese, the Chinese, and the peoples of India and of the Yucatán peninsula learned to raise their buildings by this structural method. The system is nothing more complicated than the erection of two vertical elements, posts or walls, which are bridged by a horizontal element, the lintel. The repetition of these structural units in different ways has permitted the development of many architectural styles (Figs. 352–355).

A glance at the façade of a Greek temple will show the characteristic form of the post and lintel (Fig. 356). In the Parthenon, built during the fifth century B.C., a row of columns is placed at the perimeter of the building. Stone lintels span the spaces between the columns to create a horizontal band called the *entablature,* a major design element in the

above: 351.
Kailasanatha Temple,
Ellora, India. c. 750.

right: 352.
Hall of Amenhotep III,
Temple of Karnak, Luxor, Egypt.
c. 1400 B.C.

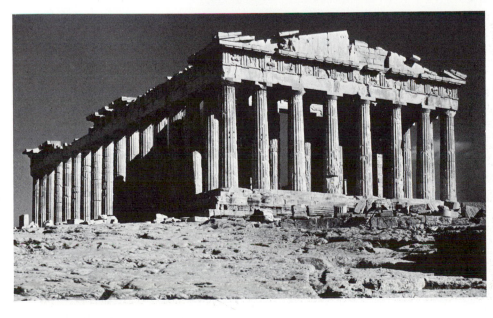

356. ICTINUS and CALLICRATES. The Parthenon, Athens. 447–432 B.C.

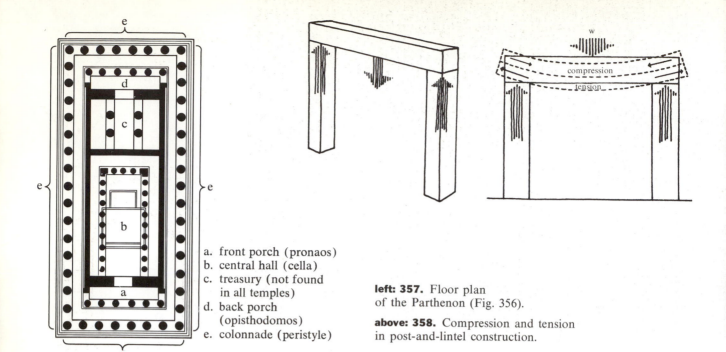

a. front porch (pronaos)
b. central hall (cella)
c. treasury (not found in all temples)
d. back porch (opisthodomos)
e. colonnade (peristyle)

left: 357. Floor plan of the Parthenon (Fig. 356).

above: 358. Compression and tension in post-and-lintel construction.

typical Greek temple. A second row of columns on the east and west ends of this building also support lintels. Stone walls within the line of columns act with smaller interior columns to support additional bridging elements to complete the structural system.

Though simple, post-and-lintel and wall-and-lintel construction can be employed to create highly refined architectural designs, but the need for vertical sup-

ports to carry overhead loads limits the usable space in this system of building.

A floor plan of the Parthenon (Fig. 357) shows that much of the interior space is occupied by the columns or walls which support the roof. This abundance of supports is required because the stone lintels could not be very long in relation to their width and thickness. Stone, which is very strong in compression,

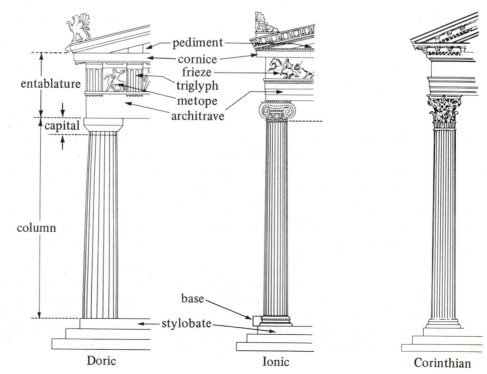

359. Doric, Ionic, and Corinthian orders.

pediment
cornice
frieze
triglyph
metope
architrave

entablature

capital

column

base

stylobate

Doric Ionic Corinthian

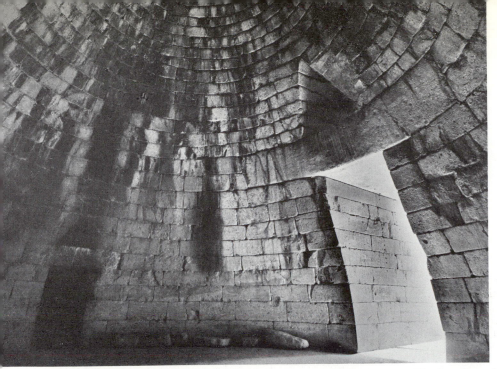

left: 360. Interior, "Treasury of Atreus," Mycenae, Greece. c. 15th century B.C. Stone, height 44'6" (13.56 m).

voussoir

361. The function of the voussoirs in arch construction.

is inefficient as a material for lintels, because it is not elastic and tends to give way under tension.

Figure 358 indicates the way in which posts and a lintel work. Note that the weight (w) carried by the lintel is countered by an equal and opposite force exerted by the posts. This action of forces tends to bend the lintel in a bowlike manner (represented by the dotted lines). The upper portion of the lintel is forced into compression as the material yields to assume the bowed shape; the lower portion is placed under tensile stress as the material tends to assume the bowed shape.

The bearing surface at the top of posts or columns supports the weight of the lintels above. Increasing the size of this surface distributes the weight and reduces the compression forces on each square inch of the contact area. The enlarged upper portion of the column has been given a variety of decorative treatments by architects and designers. Three of these *capitals* are shown in Figure 359. Originating in ancient Greece, the styles illustrated here are known as Doric, Ionic, and Corinthian. Each was part of a total architectural design system that determined the proportions of the building and its parts. Later adapted by the Romans, the three styles, and variants upon them, have remained a part of the architectural vocabulary for two thousand years.

Wood is a more satisfactory material than stone in this method of construction, but it remained for the development of a material that was strong in both compression and tension before wide spaces could be bridged without using many vertical supports. This occurred with the introduction of steel, but it was not until the end of the nineteenth century that its use influenced architectural style.

Arch and Vault

Because stone is permanent and fireproof, as well as impressive, builders adopted the material wherever it was available. The earliest attempts at building with stone were probably no more than rows of rocks heaped one upon another, with a small space left open within the pile. A covering for the open space was created by laying flat stones about it so that the upper stones projected slightly beyond the lower ones, gradually converging from all sides until they joined at the top of the structure. This is *corbeled construction* (Fig. 360), which goes back to the early history of architecture, but not until the principle of the arch was developed did stone construction reach its zenith. There are essential differences in the systems. Corbeled stone elements are laid parallel to the ground, layer on layer. Each course of stone projects out into the opening between the walls a bit farther than the one beneath. The weight of the upper courses pressing down on the stones beneath them permits a builder gradually to close the gap over an opening. The projections produce a characteristic sawtooth form in the closure. In the arch the stone parts, called *voussoirs,* are placed radially, with their axes directed toward a central focus. The wedge-shaped voussoirs direct the weight of the arch and the stone above it out at an angle, rather than down, so that the resulting force tends to spread the sides of the arch and flatten the form (Fig. 361).

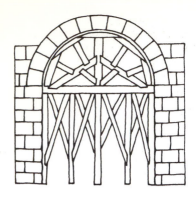

left: 362.
Centering
in arch construction.

right: 363.
Barrel vault.

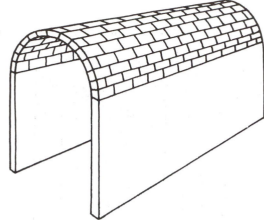

364. Basilica of Constantine, Rome.
Begun under Maxentius A.D. c. 306–12;
completed by Constantine.

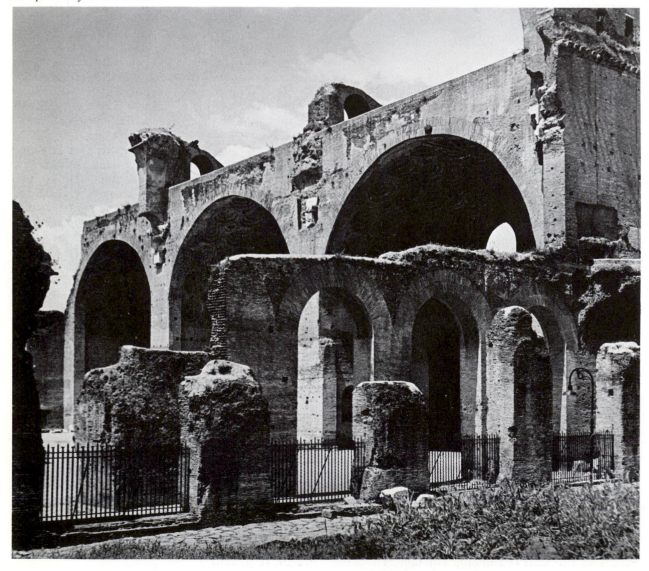

365. Intersecting barrel vaults.

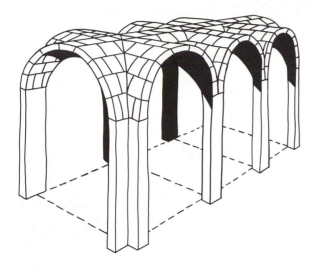

366. Open cross vaulting.

The arch is a more sophisticated form of stone construction than corbeling, for it requires that the faces of the stone be dressed accurately, so that each voussoir is at the proper angle to its neighbor to form the semicircular structure. Incorrect cutting of these sides would cause the separate components of the arch to slip, making a structural weakness that would result in its collapse. There is also the necessity of building a temporary support until all the voussoirs are in place, for an arch cannot stand until that is done; it is dependent upon their interaction for its strength. To hold them in position during the process of construction, it is usual to build a semicircular wooden form called "centering" (Fig. 362). When the voussoirs have been fitted, the centering is removed and the arch stands unaided.

The basic concept of the arch was used to provide buildings with continuous stone roofs. Setting one arch behind another produced a structure which resembled a tunnel (Fig. 363). This was the *barrel vault*. It provided early builders with stone roofs which could span impressively wide spaces and which could, of course, be continued in length for extended distances (Fig. 364).

The forces working on the barrel vault act just as those on the arch do, but they exist over its entire length and require similar counterforces to resist the tendency to collapse. As in the case of the arch, centering is required to support all parts of the vault until they are in position. This is a limiting factor in the construction of vaulted roofs, for centering is expensive and time-consuming. Another restriction imposed by the barrel vault is the limited amount of light admitted to a building in this manner. Builders were hesitant to pierce the sides of vaulted buildings for fear that the opening would endanger the strength of the vault. Any openings introduced were, of necessity, small. Only the arched ends of the structure were free for the entry of light. These problems of illumination and centering were partially resolved in the development of the groin vault.

As early as the third century, builders in Rome experimented with variations on vault construction. They found that if two barrel vaults were built at right angles to each other over a square area, all the thrust of the two intersecting vaults would be concentrated at the corners, permitting openings at each side of the square. Even though it was essential to provide an enormous amount of buttressing at these points, this new system freed the architects from the necessity for continuous, heavy walls. They could divide any building into squares, or *bays,* and cover each square with its own vault (Fig. 365). These *groin vaults* were relatively free of the stresses from the other similar vaults in the building, so that upon the completion of each vault, the wooden framework employed in its construction could be removed and used elsewhere.

The design of Roman vaulting was highly refined. The early builders recognized that not all parts of the groin vault required the same strength. Most of the vault's load is carried by the arches at the outside faces and at the crossing. If these portions are built of heavy stone, the areas between them can be filled in with relatively light material. An additional advantage is that the major supports can be removed, once the heavy ribs, or arches, are in place. Since these elements remained freestanding, only the space between them, the web, required additional centering, and this can be supplied by material of much lighter weight (Fig. 366).

367. Round arch.
Height = 1/2 diameter of the circle.

368. Round arches
on unequal sides of a rectangle
produce unequal heights.

Stone vaulting remained at this stage of development until the end of the eleventh century. Previously, the design of a groin vault had been based upon the geometry of the circle. A round arch is a segment or arc of a circle, and the height of the arch cannot be more than half of its width (Fig. 367).

To construct a groin vault in which all the arches rose to the same height, the builder had to use arches of identical width and so produce square bays. On the other hand, if a bay of rectangular plan with unequal sides was desired, the builder could not readily use round arches, for the vault would rise to different heights on the long and short sides of the bay (Fig. 368). Several methods of covering a rectangular bay with round arches were developed by Romanesque builders in the eleventh and twelfth centuries, but none of these was completely successful. Four hundred years later, during the Renaissance, groin vaults were constructed with a combination of round and elliptical arches, employing a more sophisticated geometry than was used by the earlier builders.

An imaginative, efficient solution to this problem was achieved by constructing arches in the form of two arcs rising upward to a pointed joint at their intersection. By changing the radius of the arc segments and the angle of their intersection, it was possible to vary the width of the arc while maintaining a single height (Fig. 369). Not only did the pointed arch permit the use of rectangular and irregularly shaped bays, but it also directed the thrust of the arch in a more nearly vertical direction, requiring less buttressing to counter the outward thrust of the normal arch forces (Fig. 370).

Further refinements were added to the ribbed vault and the pointed arch. Instead of being carried on the exterior walls of the cathedrals, the thrust of the vaults was diverted by means of connecting arches to large vertical piles of masonry beyond the sides of the building. These devices were called *flying*

above: **369.**
Pointed arches
permit uniform height,
although sides are unequal.

right: **370.**
Pointed arches
direct the thrust downward.

buttresses (Fig. 371). They reduced the forces playing on the walls of the buildings and allowed the builders to achieve heights beyond their early dreams. It also permitted the side walls to be opened for the introduction of large glass windows.

The combination of these structural systems—the ribbed vault, the pointed arch, and the flying buttress—produced what is now called the "Gothic system" of construction (Figs. 371–373).

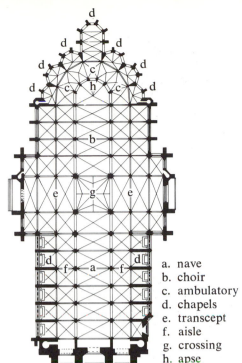

a. nave
b. choir
c. ambulatory
d. chapels
e. transcept
f. aisle
g. crossing
h. apse

above and right: 371.
Plan and section of a
typical Gothic cathedral.

a. nave arcade
b. triforium
c. clerestory
d. vault
e. aisle
f. buttress
g. flying buttress
h. wooden roof

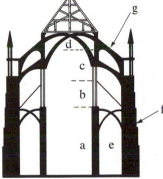

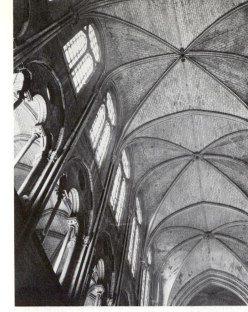

372. Ribbed vaults in the ceiling
of Notre-Dame Cathedral, Paris.
13th century.

373. Right flank,
Notre-Dame Cathedral, Paris.
13th century.

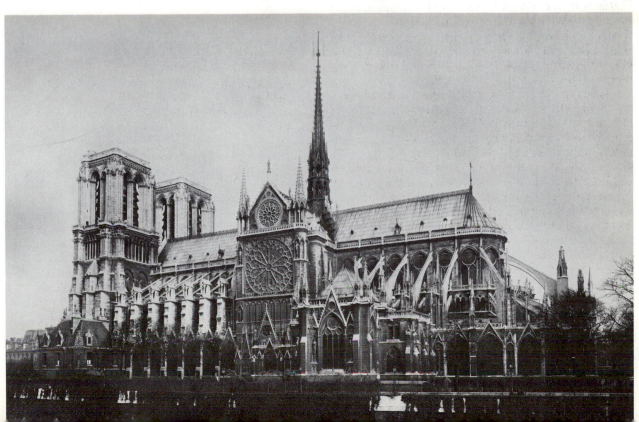

374. Expanding forces of a dome.

375. Area of a dome on a square plan, showing corners to be bridged.

square building

exposed corners

round edge of the circle to the straight edges of the walls (Fig. 375). One way of solving this problem is to fill in the corners with triangular wedges that sit under the edge of the dome. These wedges are known as *squinches* (Fig. 376). They help make a transition from the rectangle to the circle by producing at the corners angles that are less acute than the usual 90 degrees and therefore easier to bridge.

A more elegant solution was developed in the Near East. It consists of erecting four arches above the sides of the building, each arch springing from the two corners of the wall on which it sits. The space between two adjacent arches is filled with stone to produce a curved triangular form with a point where it meets the corner of the square. The two rising edges of the triangle are formed by the sides of the arches and the upper edge curves below the base of the surmounting dome, forming one quarter of its support (Fig. 377). This device is called a *pendentive,* and it became an important structural feature in Byzantine architecture (Fig. 378).

Dome

The dome was developed by the Romans after it had been invented in the Middle East. Essentially a hemispherical vault, the dome is subject to the same forces that work upon the arch and the vault, but the thrust of the dome is exerted around its rim for 360 degrees (Fig. 374). It, too, must be buttressed so that its thrust is contained by heavy walls or by other, smaller, half-domes pressing back in on it.

Because the plan of a dome is a circle, the dome most easily covers a cylindrical building. To use a dome as the roof of a building with a square plan, the builder must cover the corners and somehow join the

Truss

A triangle is a geometric form which cannot be forced out of shape, once the sides are joined. This stability permits a designer to join pieces of wood, iron, or steel into triangular structures, or *trusses,* which can be used to span large spaces. Individual members in the truss design may be under compressive or tensile forces, and frequently their cross section is altered to suit the demands of their function. Many different kinds of trusses have been designed by combining triangles of different angles and dimensions (Fig. 379). The design of a truss frequently becomes the basis for interior or exterior architectural forms.

376. Squinch construction, St.-Hilaire, Poitiers. 11th century.

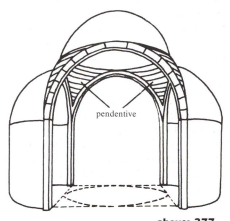

above: 377.
Construction of pendentives.

right: 378.
Interior, Hagia Sophia, Istanbul.
6th century.

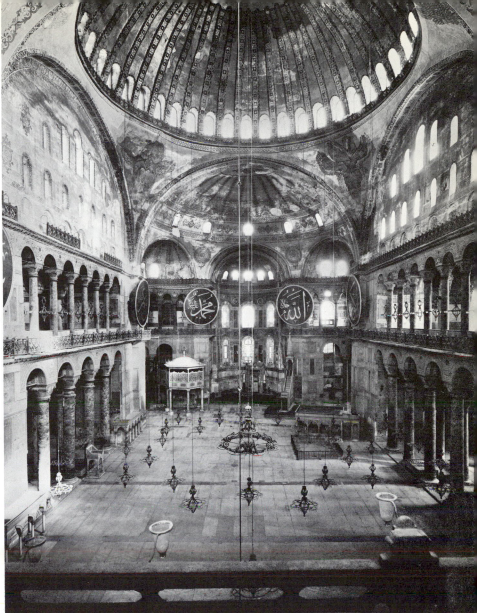

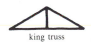
king truss

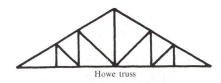
Howe truss

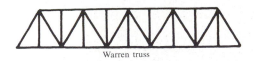
Warren truss

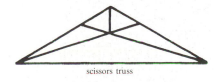
scissors truss

379. Examples of trusses.

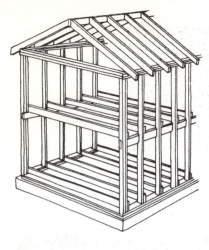

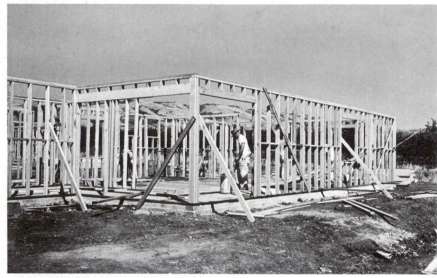

left: **380.** Basic house framing using lightweight wooden elements.

below: **381.** Typical contemporary wood framing during construction.

Balloon Frame

With the beginning of the nineteenth century a new chapter opened in the development of architecture. Out of the Industrial Revolution, which was born in England and spread throughout Europe and the United States, new building methods slowly developed, based on the use of iron and then steel and the concept of standardized mass-production techniques. The changes that occurred did not happen overnight, but by the end of the century it was plain from the appearance of many contemporary public and private structures that the revolution in architectural design was as significant as the social and economic changes preceding it. Building in wood had previously been based on the post-and-lintel system used in the earliest forms of construction. Heavy wood timbers were assembled with complicated joints and wooden pegs to produce a basic framework upon which the rest of the house depended for its strength (Fig. 354). The work was slow and tedious, requiring highly skilled joinery. Nails were used sparingly, for they were hand-wrought out of metal and therefore expensive.

With the improvement of sawmill machinery and the invention of machines which could manufacture quantities of inexpensive wire nails, a novel method of wood construction was made possible. About the middle of the nineteenth century a system was developed for nailing together pieces of wood only 2 inches (5 centimeters) wide, instead of the heavy timbers which had been used before. Substituting many thin, easily handled pieces of wood for a single massive timber and nailing them together, rather than cutting into the wood to form joints, produced a structure that was strong and easy to raise. This is the method most commonly adopted for the construction of wooden buildings and interior partitions today (Figs. 380, 381). Though this technique became universal, it was considered daring, even dangerous, at the time of its introduction. Old-time builders refused to believe that anything so frail in appearance would have the strength necessary for substantial walls and roofs. They called it *balloon* construction, a derisive term that has remained.

Although the method was used, in the main, to construct houses that were similar in exterior appearance to those built before its introduction, it exemplifies the influence of technology on building.

Iron and Steel Construction

Prior to the Industrial Revolution, ferrous metals were employed only sparingly in the construction of buildings. Though iron was known to the Greeks and the Romans, and even to earlier peoples, they did not use it in architecture. For durable products they preferred nonrusting bronze, which was cast and wrought in very limited quantities to serve primarily decorative purposes. Renaissance architects were

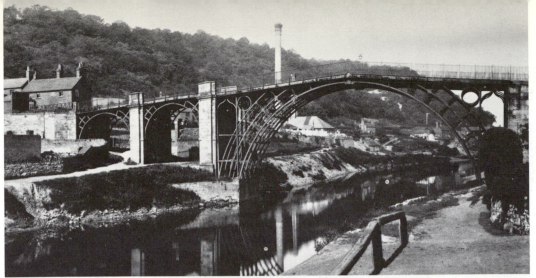

equally reluctant to utilize iron as a structural substance. With the emergence of iron technology, this metal became the symbol of the nineteenth century. Used originally in railroad tracks, it was quickly introduced into the building trades. Cast iron actually predates the nineteenth century; for example, there is a cast-iron bridge in northern England that was erected in 1779 (Fig. 382).

Cast iron was adopted for architectural columns by those who realized that its great strength and relative ease of production made the material admirable for building. Many of the new buildings astounded the public with their light-filled interiors, designed with vast areas of glass and daring open arches and trusses of a cobweblike strength that seemed to deny the force of gravity. One of the most innovative examples of cast-iron construction was the Bibliothèque Nationale in Paris, designed by Henri Labrouste and built between 1858 and 1868 (Fig. 383). Throughout this building, and particularly in the reading room, the potentials of cast iron were exploited in a new and marvelous way.

left: 384. H. H. RICHARDSON. Marshall Field Wholesale Store, Chicago. 1885–87.

below: 385. Steel-frame construction of multistoried building. Steel frame is self-supporting and carries the weight of masonry and glass exterior walls, floors, and interior partitions.

Steel Frame

Until the late nineteenth century a building stood erect because its walls formed part of the necessary structural system. The major exception to this rule is the Gothic cathedral, whose vaults and flying buttresses produced a system in which the wall was not a primary structural element. In the post-and-lintel system and the vaulted constructions of the Romans and the Renaissance, the walls supported the roof or the floor of the next highest story. In multistoried buildings all the weight of the upper floors was finally carried by the lower walls. Windows were essentially holes cut through this operative construction, with the weight above them supported on lintels or arches.

The Marshall Field Wholesale Store, built in Chicago in 1885–87, designed by H. H. Richardson, was one of the last important multistoried masonry buildings erected in this country (Fig. 384). The weight of the interior floors and the roof of the building was carried, for the most part, on cast-iron columns and wrought-iron beams, but the outer walls were self-supporting masonry construction.

At the end of the nineteenth century the introduction of steel as a building material permitted the development of a structural system which freed the exterior walls from their load-bearing function. A skeleton steel-and-iron framework was erected prior to the construction of walls, floors, or interior partitions. This skeleton supported the walls. The strength and relatively light weight of the metal frame reduced the cost of multistoried office buildings and permitted an increase in the number of stories which could be erected on a single site (Fig. 385).

William Le Baron Jenney was one of the early innovators of the steel-frame building. His Home Insurance Company Building, constructed in Chicago

below: 386. WILLIAM LE BARON JENNEY. Home Insurance Company Building, Chicago. 1883–85.

between 1883 and 1885, was the first major example of a structure that did not depend upon its outer walls for support (Fig. 386).

The façade of Jenney's building appears much lighter in weight than the Marshall Field Store, but it still seems quite heavy when compared to buildings such as New York's Lever House (Fig. 387), which is constructed on the same structural principles.

The aesthetic need for a masonry wall remained an important factor in the design of steel-frame buildings for many years, even though the practical need no longer existed. The appearance of masonry on the exterior of a large building seemed to provide a sense of strength and stability that was expected in a major building. Only gradually did the function of the external wall find expression in the thin glass and metal skins so common now.

An interesting variant of the steel-cage construction system is to be found in the Alcoa Building designed by Skidmore, Owings & Merrill and erected in San Francisco (Fig. 388). The building combines

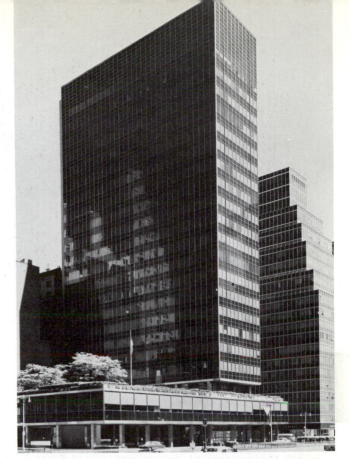

right: **387.** SKIDMORE, OWINGS & MERRILL. Lever House, New York. 1952.

below: **388.** SKIDMORE, OWINGS & MERRILL. Alcoa Building, San Francisco. 1967.

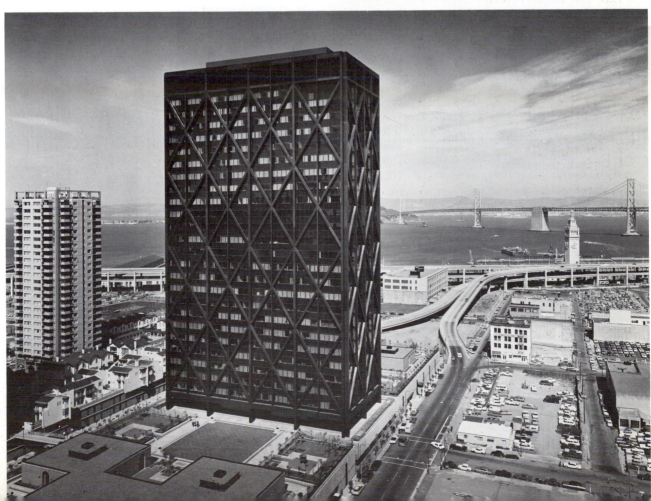

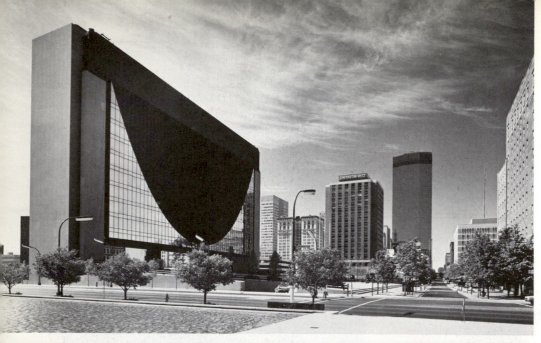

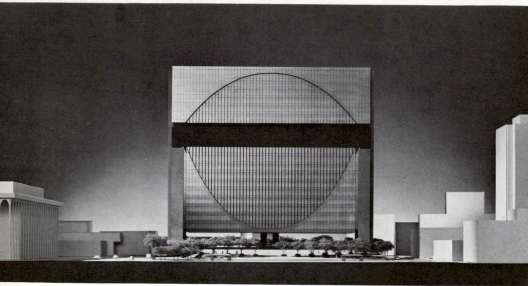

389. Gunnar Birkerts and Associates. Federal Reserve Bank Building, Minneapolis. 1968–73.

390. Scale model of Federal Reserve Bank Building, showing proposed second stage of building.

an internal steel frame with an aluminum-clad external steel trussing system that helps to support the floors but acts primarily as diagonal bracing to provide structural security in case of earthquake. In a sense this design returns to the use of the wall as a structural element. The powerful visual impact of the massive steel frame imparts a sense of strength to an inner, light-weight core in a city where the concern for protection against earthquake has restricted the construction of tall buildings.

A unique steel construction system has been employed in the Federal Reserve Bank Building in Minneapolis, Minnesota (Fig. 389). The dominant structural elements are two steel catenary members that hang from massive towers at the ends of the build-ings. Like a suspension bridge, this building carries the floors on the catenaries, each floor supported in part by hanging vertical tension members and in part by light-weight vertical steel columns resting on the inverted arches. The design has two advantages in addition to the startling visual effect produced by the dramatic elevation of the central part of the building between its two great terminal supports: floors are suspended between the outer walls without the necessity of inner columns; and the building can be expanded vertically by the addition of an arch that will support six more floors transferring the loads to the end towers already standing (Fig. 390). Here, too, is an example of a structural design utilizing external walls as working elements in the construction.

left: **Plate 51.** Interior,
Cathedral of St.-Denis, Paris. 1144.

below: **Plate 52.** VINCENT VAN GOGH.
Crows over a Wheatfield. 1890.
Oil on canvas, 20 × 39½″ (51 × 101 cm).
National Museum Vincent van Gogh, Amsterdam.

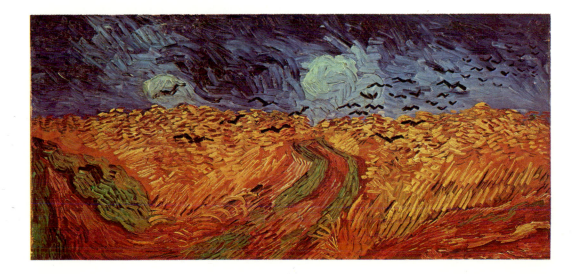

above: Plate 53. WASSILY KANDINSKY.
Panel (4). 1914.
Oil on canvas, 5'4" × 2'7½" (1.63 × .8 m).
Museum of Modern Art, New York
(Mrs. Simon R. Guggenheim Fund).

right: Plate 54. AD REINHARDT.
Abstract Painting, Blue. 1952.
Oil and acrylic on canvas, 6'3" × 2'4" (1.91 × .71 m).
Museum of Art, Carnegie Institute, Pittsburgh.

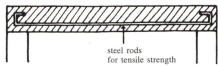
391. Reinforced concrete beam (below) and slab (right).

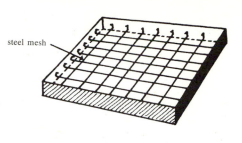
steel mesh

steel rods
for tensile strength

In contemporary architecture the wall has been given a new meaning. Though it may still function structurally to support a roof or floors, there are instances in which the wall is nonstructural, when it functions to protect the interior areas from the weather or perhaps when it becomes a means of achieving visual or aural privacy. Specific wall materials may satisfy any of these three separate functions; glass, plastic, thin sheets of metal, even cloth, may serve best in any one instance. Materials may, but need not, have multiple functions. This flexibility offers alternatives that were not possible before, and it increases the architect's opportunity to suit design to functional and expressive purpose.

Ferroconcrete Construction

Concrete is a mixture of small stones or gravel bound in a cement mortar. As it is mixed, this material has a heavy, fluid consistency. To be used in building, concrete is poured into molds which shape its final appearance. When the concrete has dried and the molds are removed, it keeps its shape and has structural properties similar to those of stone. This homogeneous material was known and used during the time of the Roman Empire. Forgotten until the end of the eighteenth century, concrete was rediscovered and employed for the first time in modern history in the construction of lighthouses.

Like stone, concrete is strong in compression but weak as a tensile material. By the end of the nineteenth century a building method had been developed in which metal rods were embedded in the concrete, combining the tensile strength of the rods with the compressive strength of the concrete. This combination is called *ferroconcrete,* or *reinforced concrete* (Fig. 391). It is an extremely strong and versatile material.

Architects and engineers quickly adopted ferroconcrete and have learned to make use of its ability to take on the shape of whatever forms were constructed to mold it (Fig. 392). This freedom of design has been expressed in dramatic, thin, concrete shells and used in advanced structures. Vast spaces have been cov-

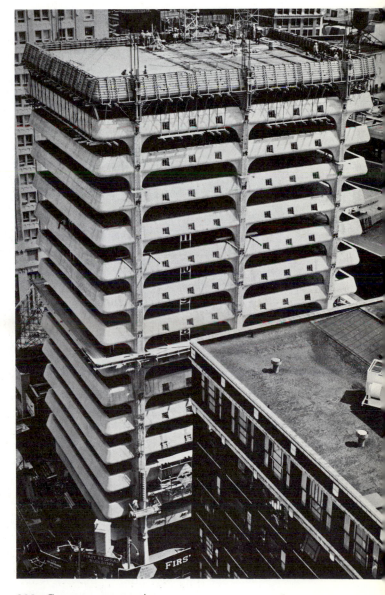
392. Concrete construction with forms still in position and vertical steel reinforcements still showing in upper story.

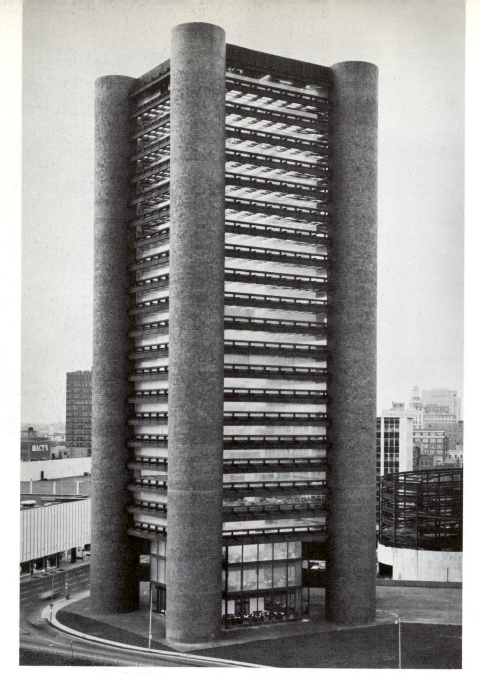

393. KEVIN ROCHE,
JOHN DINKELOO AND ASSOCIATES.
Knights of Columbus
Office Building, New Haven,
Conn. 1969.

ered by domes and complex geometric surfaces with shells less than 1 inch (2.5 centimeters) in thickness. This development in building has the potential for an entirely new landscape for city and suburb.

Steel and concrete construction methods are combined in the Knights of Columbus Office Building in New Haven, Connecticut, designed by the firm of Kevin Roche, John Dinkeloo and Associates (Fig. 393). Four round towers constructed of concrete, like giant smoke stacks, are placed at the four corners of the building. These towers are sheathed in a dark brown tile, and they make a powerful silhouette against the sky. They house service areas, stairways, and ducting systems. Massive steel girders span the spaces between the towers, forming the major elements in the walls and supporting the floors with the help of diagonal girders that tie the walls to an inner elevator core. The structural system is the basis for an extremely clear and dramatic composition that has the logic and strength of a medieval fortress.

The concrete core of the West Coast Transmission Company Building (Fig. 394) in Vancouver, B.C., was built with the same construction technique as the towers in the Knights of Columbus Office Building.

The method, called "slip forming," uses a sliding hollow form designed to elevate slowly during the period in which the concrete is poured. In this building the rate of elevation was 6 inches (15 centimeters) per hour. As the poured concrete hardens, the form rises, creating a continuous vertical space that is filled with concrete. Motorized hydraulic jacks lift the form until the full height of the tower is reached. The core of this seamless, continuous, monolithic tower houses elevators, washrooms, lobbies, utilities, service rooms, heating, and air conditioning. At the top, two crossed arches roof the tower. Over these arches and the four perimeter core walls, six sets of continuous cables are draped so that they hang down and support the floors, which are suspended by their outer edges from the cables. Additional steel framing ties each floor to the central core, and the whole building is finally wrapped with a mirrored glass wall supported by the individual floors (Fig. 395).

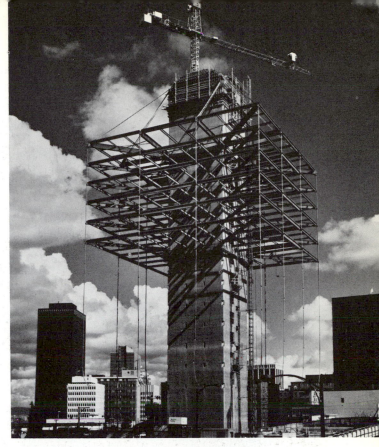

right: 394. ROHNE AND IREDALE. West Coast Transmission Company Building, Vancouver, B.C. 1969. In construction.

below: 395. Completed West Coast Transmission Company Building.

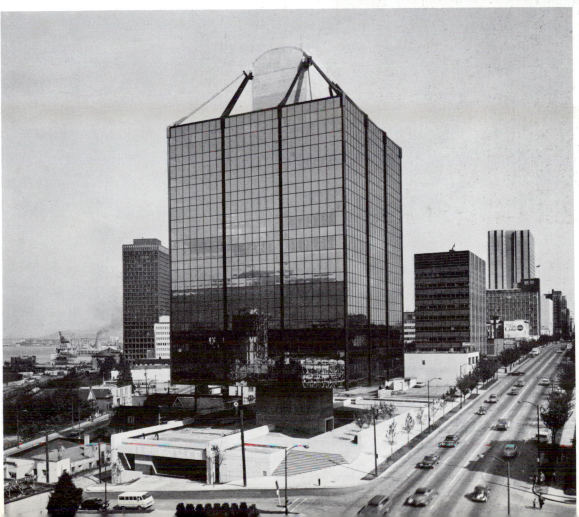

above: **396.** PIER LUIGI NERVI.
Palazzetto dello Sport, Rome. 1957.

below: **397** Interior,
Palazzetto dello Sport.

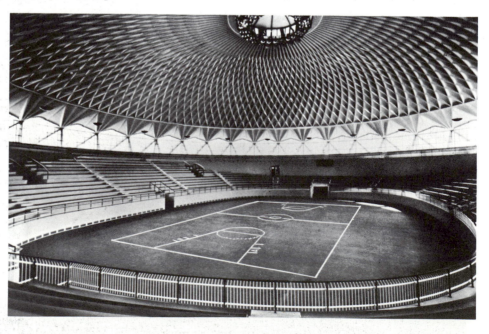

Among the most remarkable and aesthetically satisfying examples of construction in ferroconcrete are the buildings of the Italian architect Pier Luigi Nervi. In 1957 Nervi designed an enclosed stadium for the 1960 Olympic games held in Rome (Figs. 396, 397). It is a concrete shell supported on Y-shaped columns, one of three major buildings designed by Nervi for the athletic events of the games. This building, like all Nervi's work, is an example of the aesthetic potential inherent in the technological developments of recent years.

Nervi said: "It is obvious that engineering and the mental make up produced by engineering do not suffice to create architecture. But it is just as obvious that without the realizing techniques of engineering any architectural conception is as non-existent as an unwritten poem in the mind of the poet."[1]

Kisho Kurokawa's prefabricated apartment building in Tokyo is as dependent on advanced engineering as is Nervi's stadium. One hundred and forty concrete boxes, each with its own built-in bathroom and sound system, are cantilevered from two concrete cores that provide the central services (Fig. 398). These modules were constructed off site and trucked to their present location to be erected like a giant set of children's blocks. Expressive as this building is of a highly technological society, there is an amusing detail in its design that gives evidence of the cultural origins of the designer. Each of the circular windows includes an attached fan which may be opened or closed to provide light control and privacy.

Lightweight Structural Systems

The introduction of lightweight structural metals and plastics has encouraged the development of several unique construction systems that demonstrate the direct relationship between structure and design. Some of these are adaptations of technology developed in aircraft industries. Most often seen are the many house trailers used throughout the world. Some often seem to be imitations of buildings constructed in traditional materials, but trailers such as the Airstream (Fig. 399) are built by a thin-skinned *mono-*

above: 398. KISHO KUROKAWA. Nakagin Capsule Tower, Tokyo. 1972.

left: 399. Airstream trailer.

400. Futuro II house.
Fiberglass;
diameter 26′ (7.92 m),
height 12′ (3.66 m).

coque construction method. The outside shell serves both covering and structural functions. This form of construction is used in airplanes, and it is the basis of the natural structural system found in an eggshell.

Another variant of the monocoque building principle is found in the Futuro House (Fig. 400). Originally designed in Finland, this elliptical pod looks like something constructed for a science-fiction motion picture. It is actually a fiberglass shell insulated with polyurethane foam, 26 feet (7.9 meters) in diameter, with an internal ceiling height of 11 feet (3.6

meters) at the center. Available with complete heating, bathroom, and kitchen facilities, it is offered as a virtually maintenance-free housing unit that can be delivered to almost any site, including those reachable only by helicopter.

The extraordinary form of this building will demand from many observers the same reorientation as was required of earlier skeptical and tradition-bound individuals who found it difficult to accept the direct visual expression of a steel-frame building. It could be hard to imagine a building so unfamiliar as this

401. DAVIS, BRODY & ASSOCIATES.
United States Pavilion,
Expo 70, Osaka, Japan.
1970.

402. R. BUCKMINSTER FULLER. United States Pavilion, Expo 67, Montreal. 1967.

placed in the backyard or next door on a neighbor's building site. However, attitudes do change, and the need for low-cost housing may make the efficient use of new material imperative. Forms once considered bizarre may become more acceptable as their functions are better understood and the pressure to satisfy human needs affects aesthetic responses.

World's fairs often offer designers the opportunity to experiment with novel structural systems. Because most of the buildings are temporary and the atmosphere of a fair is innovative and lighthearted, the architects tend to seek original and relatively inexpensive solutions in pavilion design. The United States Pavilion at Expo 70 (Fig. 401), in Osaka, Japan, fulfilled the need to provide a large, attractive, covered space at a limited cost. A shallow bowl was created by moving earth into perimeter embankments. A translucent airtight bag of gigantic proportions covered this bowl and was inflated by a system of blowers to keep the interior air pressure slightly higher than outside the bag. Inflatable structures of

similar design but somewhat reduced size have been used as warehouses, bowling alleys, and banks.

The United States Pavilion at the Montreal World's Fair in 1967 was a sensational exploitation of R. Buckminster Fuller's *geodesic* principles (Fig. 402). A three-quarter sphere 250 feet (75 meters) in diameter, the pavilion interior was an airy, light-filled space that awed and delighted visitors. After dark the transparent skin that covered the light metal structural elements allowed the interior illumination to brighten the night. The building was an ideal demonstration of a technological achievement that had an aesthetic and expressive character consistent with the function of a temporary exhibition pavilion.

Fuller is a designer who for many years has experimented with new structural principles. His domes are based upon his own system of mathematics, which he calls "energetic-synergetic geometry." Essentially, these structures are trusses based upon the combination of tetrahedrons, a figure constructed of four triangles. By joining tetrahedrons into more

complex groups and extending them to form segments of spheres, Fuller and his associates have produced a large number of designs which combine extremely light weight with a seemingly infinite ability to cover huge volumes. These domes are constructed of small modular elements, which are joined together. The resulting web can then be covered with any of a number of materials to make the enclosed space weatherproof. Plastics, cloth, aluminum, and sheet steel have been used as skins for Fuller domes. Domes based on this structural system have been made of cardboard, waterproofed with plastic, and used by the United States Marines as temporary structures. A geodesic dome has been calculated which could span 2 miles (3.2 kilometers).

Buckminster Fuller believes that structure and design are intimately wedded. He would extend this idea far beyond its application in architecture to include all aspects of human life. As he states in his book *Education Automation*:

My experience is now world-around. During one third of a century of experimental work, I have been operating on the philosophic premise that all thoughts and all experiences can be translated much further than just into words and abstract thought patterns. I saw that they can be translated into patterns which may be realized in various *physical* projections—by which we can alter the physical environment itself and thereby induce other men to subconsciously alter their ecological patterning.[2]

Part Four
EXPRESSION AND RESPONSE

The Expressive Image

13

Much of representational art consists of images corresponding to the physical appearance of the human form. These two-dimensional and three-dimensional objects are products of social and ethnic groups interested in generalized or idealized equivalents for human or animal qualities, rather than unique portraits. Some works in this category treat the subject as an abstract surrogate for the human body, with little or no indication of changes that occur in the position of head, limbs, or torso as a result of normal physical activity.

Figures 403 through 405 are pieces of sculpture produced in ancient Egypt over a period of 2,000 years. For this great span of time the stylistic conventions of representation remained remarkably consistent in Egyptian art. With the exception of a short period during the reign of the Pharaoh Akhenaton, 1375 to 1358 B.C., when Egyptian art showed the personal preference of the monarch for a freer, more naturalistic style, the sculpture of Egypt was stiff and static, lacking any suggestion of mobility in the subject. In statues of standing figures the head, shoulders, and hips are placed in parallel lines, the left leg is positioned before the right, hands are most often at the sides (though there are some exceptions), and the

eyes stare directly forward. The finished statue still retains the sense of the block of stone from which it was carved.

This description could apply to the two-figure group *King Mycerinus and His Queen* (Fig. 403), which dates from about 2525 B.C. It is also relevant for the great figures from the court of Ramses II in Luxor (Fig. 404), which were hewn from stone about 1250 B.C. Carved five or six hundred years later, in the Twenty-fifth Dynasty, the statue of the Pharaoh Taharqa, from Gebel Barkal, retains the early conventions of representation (Fig. 405).

When one considers the qualities that can be associated with a human figure, the body movements, and the indication of personal feelings or emotion, it is obvious that the conventional treatment of this subject in much of Egyptian sculpture indicates a disregard for aspects that other artists, at another time, in another place, might have considered to be more important.

Explanations for the consistent style of ancient Egyptian art often refer to the static society and to the emphasis on the eternal life after death that was a major factor in the religion of Egypt. This cultural climate would tend to reduce the possibility of stylis-

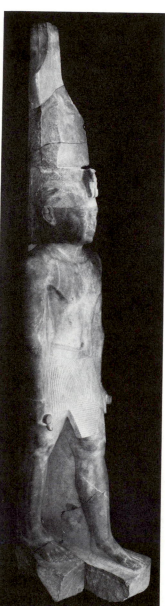

left: **404.** *Ramses II.*
19th Dynasty, c. 1250 B.C.
Stone. Temple of Amon, Luxor.

below: **405.** *Taharqa,*
from Gebel Barkal, Nubia.
25th Dynasty, 7th century B.C.
Stone, height 12′5″ (3.78 m).
Khartoum Museum.

403. *King Mycerinus* (*Menkure*)
and His Queen.
4th Dynasty, c. 2525 B.C.
Painted slate, height 4′8″ (1.42 m).
Museum of Fine Arts, Boston.

tic changes in the art. Once adequate visual symbols had been developed for religious and social purposes, those emblems would prevail as long as the culture continued without major changes.

Across the Mediterranean from Egypt, the Greeks developed an art form starting with many of the static conventions of Egyptian sculpture, but within a period of five hundred years it evolved into an art concerned with movement and the expression of emotion. Compare the *Apollo* from Sounion (Fig. 406), dated about 600 B.C., with the central figure in *The Laocoön Group* (Fig. 407), which was completed in the first century B.C. The archaic *Apollo* has much

below left: 406. *Apollo,* from Sounion. c. 600 B.C. Marble, height 11′ (3.35 m). National Museum, Athens.

below: 407. AGESANDER, ATHENODORUS, and POLYDORUS. *The Laocoön Group.* Roman copy of a Greek original. c. 50 B.C. Marble, height 7′11¼″ (2.42 m). Vatican Museums, Rome.

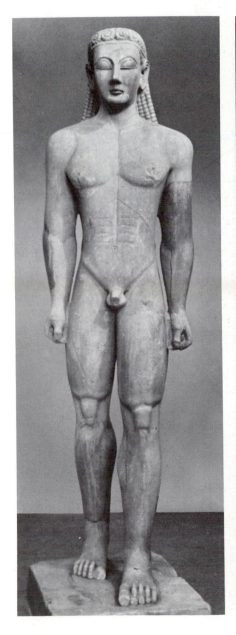

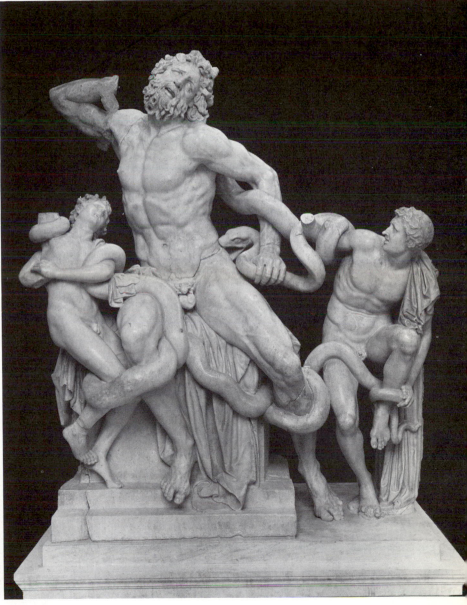

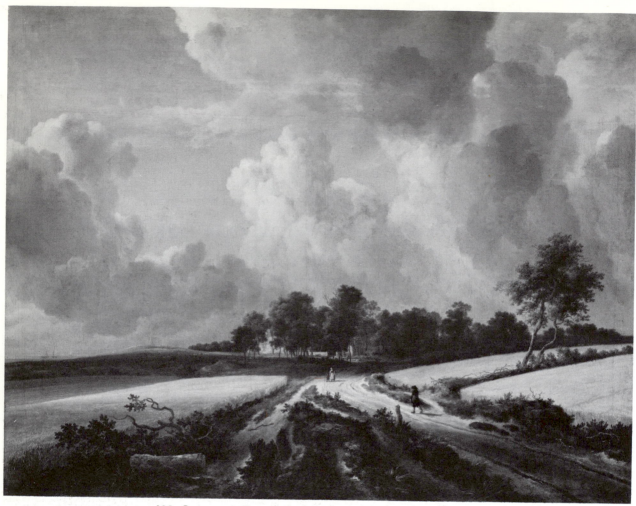

408. Jacob van Ruisdael. *Wheatfields.* c. 1660. Oil on canvas, 3'3⅜" × 4'3¼" (1 × 1.3 m). Metropolitan Museum of Art, New York (bequest of Benjamin Altman, 1913).

in common with the Egyptian figures illustrated here. It is rigid, immobile, the head, body, arms, and legs all oriented along a single axis that runs from front to back. This frontal alignment is to be found in most of the figures produced in Greece at this time. The central figure of *The Laocoön Group* is in sharp contrast to that of *Apollo*. It breaks from the frontal plane and twists the upper portion of the torso away from the direction of the legs. The head is bent back in an attempt to indicate action. This same concern for movement seems to account for the manner in which the feet touch the ground plane, not flat and solidly placed, but bent at the toes as though frozen in movement. The face is contorted in a grimace of pain; even the muscles of the figure are shown in the strain of an emotional experience. Surely for the sculptor who created this work the concept of hu-

manity and nature differ significantly from that of the artist who created the *Apollo,* working five hundred years earlier.

The changes which occurred in Greek art during the period between the sixth and first centuries B.C. reflected parallel cultural changes. Greece went from an aristocratic society, with its wealth and power concentrated in the possession of landowners who had deep roots in the past, citizens who desired the continuation of the ideals and values of their ancestors, to a materialistic society whose wealth was derived from trade. Greece of the second and first centuries B.C. was a country in which the old aristocracy gave way to a new one. Instead of maintaining the *status quo,* this new group broke down many of the old attitudes and values. Emphasis was placed on the present, on the transitory rather than the traditional.

The art of this period presents a new social order and a new concept of human experience.

Early Greek art, like the art of Egypt, was an art of abstraction, though the images were based upon forms perceived in nature. The sculptors did not concern themselves with the representation of expression, but we cannot say that their work is devoid of expression. Looking at these idealized figures today, we can find them powerful, moving images. They can affect the emotions of the observer, though they do not represent emotions.

When we speak of *expressive* art, it is necessary to understand that the term can have several meanings. An expressive image in the visual arts may involve one or more of the following conditions: (1) a response to the representation of an emotional or atmospheric quality in the *subject* of the work; (2) a response to a visual equivalent for the artist's state of mind, a reaction to a subject or an experience; (3) a response, on the part of the viewer, that is elicited by the plastic organization of the work without reference to representational subject matter.

At the outset, it should be noted that the third part of the definition may apply to the other two parts. That is, viewers may have a subjective response to the faithful representation of a beautiful landscape, such as that by Jacob van Ruisdael (Fig. 408). They may also respond to an artist's expressive representation of a landscape, such as the painting by Van Gogh (Pl. 52, p. 261), in which the rhythmic strokes of paint and the complementary use of color animate the cornfield with the energy of the artist's passion.

A viewer's response to the expressive image need not be tied to a representational form of art. In certain paintings and sculptural constructions the image that communicates strongly to an observer may not represent a specific physical object. The paintings of Mark Rothko (Pl. 40, p. 175) are evocative combinations of form and color which may suggest or create an environment or atmosphere that a sensitive viewer can feel as an expressive image. In Louise Bourgeois' sculpture *One and Others* (Fig. 409) the wooden forms are not figural, but their cramped placement on the space of their base has an implication of crowding which can produce the uncomfortable feeling of a claustrophobic society pressed together in a suffocating world.

409. LOUISE BOURGEOIS. *One and Others.* 1955. Wood, height 18¼″ (46 cm). Whitney Museum of American Art, New York.

The Expressive Image in Representational Art

As the shutter of a camera moves in a fraction of a second, it makes permanent a moment in time. The trapped images of human faces and bodies can be caught in externalized gestures that signify emotional states and attitudes, often too fleeting to be caught by the casual observer. Because it has this capacity to stop the movement of life, the camera is an effective medium for the representation of human beings as they react to experience. In the hands of a sensitive, skilled photographer such as Walker Evans, the camera can record the subtle differences in facial expression that register fatigue, boredom, or contemplative repose (Fig. 410). Intense feelings that contort the face and body are to be found reproduced in journalistic photography, where the camera has often replaced the typewriter as the most expressive instrument of communication (Fig. 411).

Painters working within representational conventions that approximate the photographic image have been able to suggest the moods of their subjects by placing the figure in an expressive pose and portraying the features of the face so as to typify the attitude of the inner being. The examples of Bronzino and Ingres (Figs. 75–77), discussed in Chapter 4, are relevant here too. The portraits by these artists are more than representations of the physical apearance of the men they have portrayed. With intuitive sensitivity to human personality, Bronzino and Ingres have been able to invest their sitters with an inner dimension that artists satisfied with a superficial likeness might have neglected.

Because the human expression of emotions is often indicated in a passing moment, it is difficult to represent the intensity of strong feelings in the static forms of sculpture and painting without producing melodramatic, theatrical images. *The Laocoön Group* (Fig. 407), with its display of tensed muscles and agonized grimaces, is intended to communicate terror and fear in the bodies and faces of the three figures struggling with an attacking serpent. Though to its past admirers it was an effective expression of these emotions, contemporary viewers who have seen photographic records of violence find it difficult to respond to the expressive conventions in this sculpture. There is a conflict here between the careful, studied treatment of the surfaces of the marble and the overwrought, mercurial emotions illustrated.

Many intense emotions find visual expression in actions, rather than in fixed poses. Even a smile is a process, rather than a rigid position of a mouth. In their concern for the representation of attitudes and feelings, many artists have recognized the dichotomy between the movement natural to life and the stasis common to sculpture and painting.

left: 410. WALKER EVANS.
Subway Portrait. c. 1941. Photograph.

above: 411. DENNIS CONNOR. *Antiwar Protest at the University of Wisconsin.* 1969. Photograph.

The problem of representing *living* form was a continuing fascination for the French sculptor Auguste Rodin. When he described his approach to expressive representation, Rodin said: "I obey nature in everything. . . . My only ambition is to be servilely faithful to her." When a friend objected, saying that the sculptor's work was not to be compared to a cast taken directly from the model, Rodin agreed, insisting that his work was more accurate than the cast. For the great French sculptor the static cast could not capture the vitality of a live figure. "The cast only reproduces the exterior; I reproduce, besides that, the spirit which is also a part of nature."[1]

Rodin's statement describes the intuitive adjustment of the forms and surfaces of his sculpture to achieve an equivalent for animated form. Duplication of form alone could not satisfy the needs of expression. Rodin is perhaps best known for such monumental figurative work as *The Burghers of Calais* (Fig. 412), but it is in his small improvised sketches that his theories are most clearly demonstrated. The sculptor's figure of the dancer Nijinsky, only 6¾ inches (17 centimeters) high, presents an image of psychological intensity and coiled, controlled energy (Fig. 413). The surface glistens with highlights that seem to shift and flicker throughout the form, refusing to be stilled; the head juts forward as the arms, all tension, are drawn back; the whole figure, tenuously balanced on one leg, suggests a transition from one position in space to another.

Rodin was not the first artist to depart from imitative proportions and surfaces for expressive pur-

left: **412.** AUGUSTE RODIN. *The Burghers of Calais.* 1884–86. Bronze, 7'1" × 8'2⅛" × 6'6" (2.16 × 2.49 × 1.9 m). Hirshhorn Museum and Sculpture Garden, Smithsonian Institution, Washington, D.C.

right: **413.** AUGUSTE RODIN. *Nijinsky.* 1912. Bronze, height 6¾" (17 cm). Private collection.

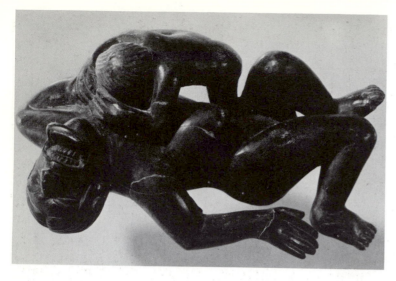

left: **414.** SKAOWS-KE'AY.
Bear Mother. c. 1883.
Argillite, length 5½″ (14 cm).
Smithsonian Institution, Washington, D.C.

below: **415.** *The Temptation of Christ,*
detail of a carved capital.
12th century. Stone.
Autun Cathedral, France.

poses. Precedents are to be found throughout the history of art. One of the most famous examples of Haida Indian art is a small carving known as *Bear Mother* (Fig. 414). It is based upon the legend of a human mother who was wedded to a bear. Her child was half-bear, half-human. The nursing child is shown as a fierce creature, and the mother's pain as she is devoured by her offspring is expressed in her face and the contorted posture of her body.

The relief sculpture reproduced in Figure 415 was carved in the twelfth century on a capital inside the cathedral at Autun, France. The scene it narrates is the New Testament story of the Temptation of Christ. The representational conventions in this work are quite different from those revealed by the previous examples. The posture of Christ is fixed and stylized, as are the folds of the robe draped about the figure. The anonymous artist wished to indicate something other than physical appearance in the figure of the Devil. He did not use the more naturalistic proportions that appear in the Christ figure; instead, he modified the proportions to intensify the communication of a frightful expression. He distorted the representational method of forming the figure so as to express the *significance* of the Devil. As compared with the central figure in *The Laocoön Group*, the Devil in the Autun capital deviates from the conventions of direct representation for the purpose of greater expression. The forms corresponding to the mouth, the eyes, and the nose are similar to those used in the head of Christ, but they have been enlarged and shaped in a manner that abandons the conventions, and so are more expressive. Whenever a cultural period develops standard modes in styles of representation, artists are usually expected to work within those styles. When they depart from them to

any significant degree, this departure can be used to indicate an expression of emotion within the subject or within the artist who produced the work.

Another kind of departure from a representational convention is to be found in the late paintings of El Greco. A study of his *Purification of the Temple* (Fig. 416), painted between 1596 and 1600, will reveal that the treatment of a number of the representational features in the painting do not conform to the conventions common at the turn of the seventeenth century. When this painting is compared with an earlier work by El Greco on the same subject (Fig. 417), significant contrasts in the approach to representation are evident. The more youthful treatment of

above: 416. EL GRECO. *The Purification of the Temple.* 1596–1600. Oil on canvas, 16½ × 20⅝″ (27 × 42 cm). Frick Collection, New York (copyright).

below: 417. EL GRECO. *Christ Driving the Money Changers from the Temple.* 1571–76. Oil on canvas, 3′10″ × 4′11″ (1.17 × 1.5 m). Minneapolis Institute of Arts (William Hood Dunwoody Fund, 1924).

the representation of form and space corresponds, in the main, to that of late Italian Renaissance painting. That is, proportions of the figures in the painting are similar to those usually associated with the human body; shading from light to dark has been used to indicate three-dimensional form, with the source of light appearing to come from the upper right; linear perspective has been used to indicate spatial relationships; and the pattern of light-and-dark shadows and highlights seems directly related to the desire of the artist to represent human and architectural forms in a detailed and consistent manner.

Though the mode of representation in Figure 416 conforms, in general, to that of the earlier work, the figures here are noticeably attenuated. The forms are defined by shading, but the source of light is not clearly indicated. The light-and-shadow pattern on the central figure of Christ is painted as though the source were at the right, yet there are unexplained shadows on the right side of the kneeling figure at the lower right. Other inconsistencies of lighting can be noted in the figure group at the upper right and the central group at the left. The illusion of three-dimensional space in this painting is one of compressed volume. Figures seem forced together. Even the bit of landscape through the central arch has lost the deep spatial effect that is present in the earlier work.

The effect of the painting in Figure 417 is that of a tableau, a staged scene, in which the emotional expression depends upon the poses of the actors within the picture frame; but in the later work the light-and-dark pattern of flickering forms, the agitation of the contours defining the forms, and the attenuation of the forms themselves accentuate the drama and reinforce the communication of emotion.

Artists of the twentieth century have had no single set of conventions for the representation of form and space. Unlike the artists of ancient Greece, the medieval sculptors working on French cathedrals, or El Greco in the late sixteenth century, artists of the present have no single style to use as the standard form of representation. Enriched by the availability of examples and reproductions from the entire history of art, aware of the great variety of representational approaches used throughout the world, each twentieth-century artist can choose from among them the style best suited to personal expressive requirements. If none is adequate, a new style may be invented, restricted only by the imagination and skill of the inventor.

The two drawings (Figs. 18, 19) by Picasso discussed in Chapter 2 demonstrate one artist's ability to choose and utilize two distinctly different approaches to the problem of representation. The contrast is obvious; the choice of representational conventions—from the almost Renaissance approach of the nude figure to the Cubist system of analysis in the *Guernica* study—was apparently made to suit the artist's need. Obvious, also, is the contrasting use of the drawing line in each work—the smooth, flowing movement of the line in the figure and the seemingly crude, scribbled, apparently uncontrolled use of the pencil in the head. As in the two examples by El Greco, the elements of the Picasso drawings have been controlled for expressive purposes.

Compare the *Kneeling Woman* by Wilhelm Lehmbruck with Gaston Lachaise's *Standing Woman* (Figs. 418, 419). Neither of these works pretends to be an accurate replica of the forms of a female figure. The work of Lachaise is composed of bulging, massive, spherical forms, which seem to burst with strength and vitality. The bronze glows as though under stress, appearing to be drawn taut under the effort of restraining the burgeoning energy within. This figure becomes a symbol of woman as the generative source of life, fertility, and power.

Lehmbruck elongates the forms of his figure from those which would be considered an accurately proportioned representation of a young woman. This attenuation and the restrained modeling of the forms produce a quiet image. The stone surface has a slightly flowing quality and a surface that is warm and free from active highlights. This figure is all that Lachaise's is not, and it, too, becomes more than the portrait of an individual. The *Kneeling Woman* suggests grace, introspection, a sense of passive withdrawal from life.

To be sure, the stance of each figure is an important part of the image it projects, one aggressive and active, the other passive and reposed, but equally obvious is the arbitrary treatment of the forms and surfaces used by each sculptor, and this organization of elements speaks as clearly as does the representational statement.

Expressionism

The word *expressionism* is used loosely by historians and critics of the visual arts to describe examples of painting, sculpture, and occasionally architecture which appear to have been shaped by the artist's desire to communicate a strong personal response to a subject or a state of mind. In this sense of the word the late work of El Greco, the paintings of Van Gogh, and the sculpture of Rodin, Lehmbruck, and Lachaise could be considered "expressionistic."

However, *Expressionism* in stricter usage refers to the work of a number of twentieth-century artists who considered the communication of emotion to be a primary essential in all works of art. They combined this aesthetic with a consciously primitive approach to the use of their media, seeking spontaneity and a

above: 418. Wilhelm Lehmbruck. *Kneeling Woman*. 1911.
Cast stone; height 5'9½" (1.77 m),
at base 4'8" × 2'3" (1.42 × .69 m).
Museum of Modern Art, New York
(Abby Aldrich Rockefeller Fund).

right: 419. Gaston Lachaise. *Standing Woman*. 1932.
Bronze; height 7'4" (2.24 m),
at base 3'5⅛" × 1'7⅛" (1.04 × .48 m).
Museum of Modern Art, New York
(Mrs. Simon Guggenheim Fund).

420. FERDINAND HODLER.
The Chosen Vessel. 1893–94.
Oil on canvas,
7'1⅜" × 9'7½" (2.17 × 2.93 m).
Kuntsmuseum, Bern
(Gottfried Keller-Stiftung).

feeling of urgency in the images they produced. The early stages of Expressionism occurred at the end of the nineteenth century, appearing at several centers of artistic activity in Europe. By 1910 or 1911 the movement was well on its way as a major philosophical and stylistic force.

Among the early theorists of Expressionist concepts was the Swiss painter Ferdinand Hodler. He believed that the mission of the artist was to give expression to the "eternal elements" of nature. Like Rodin, he spoke of the inner beauty that motivates the artist to create images expressive of the artist's experience: "For the painter, an emotion is one of the basic stimuli that cause him to create."[2]

Hodler's paintings (Fig. 420) seem closer to the flattened decorative qualities of the work of Paul Gauguin (Fig. 9) than they do to the artists who were to follow him. Even so, it is possible to find in his art a simplification of forms, an emphasis on strong, rhythmic linear repetitions, and the use of arbitrary areas of color that later were utilized in a freer, more direct manner by such Expressionists as Ernst Ludwig Kirchner (Fig. 117; Pl. 11, p. 44).

Another important forerunner of Expressionism was the Norwegian painter Edvard Munch. In 1889 Munch traveled from Oslo to Paris, where he saw the work of Toulouse-Lautrec, Van Gogh, and Gauguin, who were then considered members of the avant-garde. The experience was crucial in Munch's development. He began to produce paintings and prints

421. EDVARD MUNCH. *The Cry.* 1893.
Oil on cardboard, 32¾ × 26⅛" (84 × 66 cm).
Oslo Kommunes Kunstsamlinger.

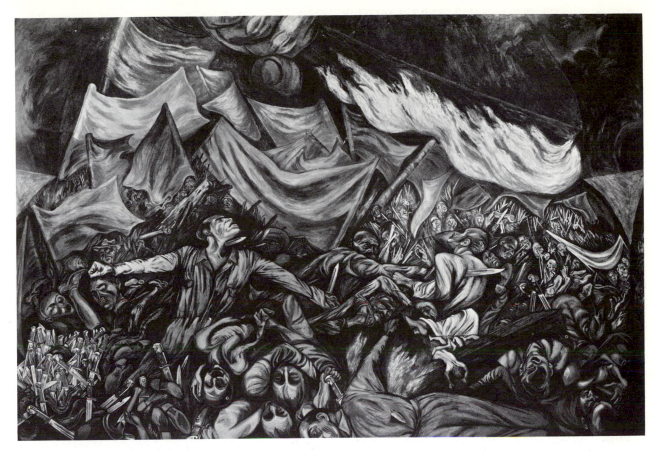

422. JOSÉ CLEMENTE OROZCO. *Civil War.* 1936–39. Fresco. Government Palace, Guadalajara.

that applied the influences of the new art to his own work, using flat areas of color and linear arabesques. Munch sought to represent his response to a world he considered frightening and anguished. Often, he tried to find visual images for nonvisual emotional experiences. *The Cry* (Fig. 421) is typical of this period. In it the foreground figure becomes a part of a sweeping, undulating rhythm, and flattened forms contrast against an indication of deep space. The gesture suggested in the skull-like face is echoed in the forms about it. There is a free calligraphic application of paint denoting a spontaneous reaction to inner forces felt by the artist.

Munch's paintings, including *The Cry*, were shown in Germany in an exhibition that made a significant impact on many of the artists who later became part of the Expressionist movement. Expressionism continued as an important force in European art until the end of World War I. After the war, the close ties between many of the artists were broken, and the movement came to an end, though individual painters and sculptors continued to produce important work, influencing younger artists throughout Europe and the Western Hemisphere. It was especially evident in Mexico, where muralists such as José Clemente Orozco were commissioned to celebrate the revolutionary ideals of the struggle of the Mexican people against economic inequities (Fig. 422).

During the 1950s in the United States, and later throughout the world, Expressionism found a new nonrepresentational form. Led by Jackson Pollock, Willem de Kooning, and Hans Hofmann (Pl. 39, p. 158; Pl. 3, p. 8; Pl. 32, p. 138), many painters reaffirmed the philosophy of the earlier Expressionists with paintings motivated by intense subjective experiences. By applying color in a spontaneous, vigorous fashion to large canvases, the artists sought to realize visual equivalents for their experience of the process of painting. The Abstract Expressionist movement has few direct adherents today, but, like Expressionism, it continues to influence the work of many contemporary artists.

above: **423.** JEAN (HANS) ARP.
Automatic Drawing. 1916.
Brush and ink on gray paper,
16¾ × 21¼″ (43 × 54 cm).
Museum of Modern Art, New York.

left: **424.** RENÉ MAGRITTE.
The Liberator. 1947.
Oil on canvas, 39 × 31″ (99 × 79 cm).
Los Angeles County Museum of Art
(gift of William N. Copley).

Representation and Expression of the "Inner World"

In the twentieth century even unsophisticated commentators on the nature of human action and response assume that "understanding" is not always so simple as it appears. It has become usual to explain our actions by referring to the unconscious and subconscious aspects of our behavior. Psychology and psychiatry have taught us to consider whole areas of unseen, and in some cases unknowable, experience as a real and important part of our lives.

With the introduction of the idea of the unconscious into the realm of human experience, artists found a new source of subject matter. This source was themselves. They attempted to examine and represent those areas of experience and personality which

were kept behind the gates of their conscious lives. These artists have been grouped, generally, into the category of Surrealism. Their first attempts to touch their inner experience followed the paths of current psychological techniques. Paint or ink was blotted without an attempt to determine the final appearance of the forms. Bits of torn paper were allowed to drop onto a surface, producing chance combinations or groups. The artists hoped that these blots and bits of torn paper would suggest images that were locked in the recesses of their minds (Fig. 423).

As Surrealism was developed, it changed its methods. Such artists as René Magritte (Fig. 424) and Salvador Dali (Fig. 425) attempted to represent the world of their dreams through a technique of painting that approached the precision and clarity of a photograph. This approach was, technically, at the extreme pole from the spontaneous, uncontrolled images that resulted from the chance methods of the first Surrealist experimentalists. Nevertheless, these artists insisted that the images in their paintings were spontaneous and directly related to the unconscious experience of their inner world.

Salvador Dali describes his method of painting as follows:

I would awake at sunrise, and without washing or dressing sit down before the easel which stood right beside my bed. Thus the first image I saw on awakening was the painting I had begun, as it was the last I saw in the evening when I retired. And I tried to go to sleep while looking at it fixedly, as though by endeavoring to link it to my sleep I could succeed in not separating myself from it.

Sometimes I would awake in the middle of the night and turn on the light to see my painting again for a moment. At times again between slumbers I would observe it in the solitary gray light of the waxing moon. Thus I spent the whole day seated before my easel, my eyes staring fixedly, trying to "see," like a medium (very much so indeed) the images that would spring up in my imagination. Often I saw these images exactly situated in the painting. Then, at the point commanded by them I would paint, paint with the hot taste in my mouth that panting hunting dogs must have at the moment they fasten their teeth into the game killed that very instant by a well aimed shot.[3]

425. SALVADOR DALI. *Apparition of a Face on the Seashore.* 1938. Oil on canvas, 3'7½" × 4'9" (1.1 × 1.45 m). Wadsworth Atheneum, Hartford, Conn.

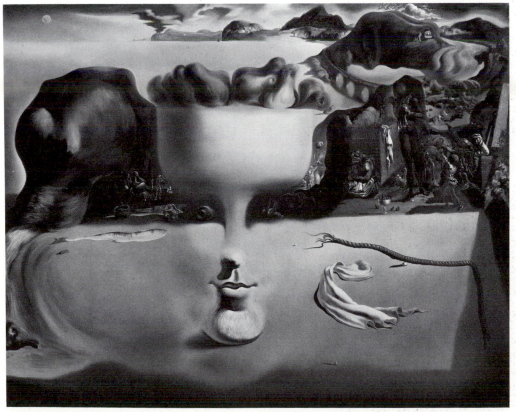

Dali's paintings and the works of others following this general approach have certain typical stylistic qualities. They usually provide a meticulously drawn, ambiguous scene in which the realism suggested by the technique is in conflict with a representation of forms or events outside the viewer's experience. In some cases fantastic worlds are created, filled with frightening monsters or strange architectural structures. In other instances the artist will present a superficially conventional scene with some small detail that cannot be explained logically or that suggests a series of connected images extending beyond the limits of the canvas.

René Magritte's painting *The Liberator* (Fig. 424) is impossible to explain solely on the basis of the information provided by the artist. Even the title adds a perplexing uncertainty to the artist's intention. A figure sits on a rock in a landscape. These essential descriptive terms are in themselves unexceptional. But the figure is presented without a head or upper torso! In their place is an enigmatic chart containing symbols of commonplace articles. The figure holds a jeweled object in his right hand, an object that combines the appearance of a portrait of a woman and a candelabrum. The suitcase beside the seated chimera and the cane in his left hand suggest that the figure is a traveler. Going where? On what odyssey? Behind the figure, on the horizon, a stylized architectural structure, a celestial mansion filled with clouds, compounds the mystery.

Reasonable connections must be made between unreasonably combined elements in the painting if the meaning of the work is to emerge. But without Magritte to provide an explanation, the viewer must construct a meaning mentally by joining the visual inconsistencies into another set of relationships in order to resolve the puzzle. The painting acts then to draw forth, from the viewer, images that might otherwise have lain dormant.

The Expressive Image in Nonrepresentational Art

Somewhat apart from the movement of Surrealism but developing along more or less parallel lines, the paintings and drawings of the Swiss artist Paul Klee bridge the gap between representational and non-representational images. When Klee died in 1940, he left behind him an extraordinary body of work, in which was traced the artist's extended involvement with the problems of pure visual expression. Klee was a member of the Expressionist group *Der Blaue Reiter* (The Blue Rider), and later taught at the Bauhaus, an experimental institute for instruction in the arts, which was established first in Weimar and then moved to Dessau, Germany. It was Klee who said in

1919 that art did not exist to reproduce the visible but to render visible what lay beyond the visual world. His work is a combination of a highly intellectual concern for plastic organization and an intuitive search for expressive images (Fig. 426). Klee's researches (and one may truly refer to his paintings in this way) resulted in some paintings that appear to be formal exercises, others that are imaginary landscapes and cityscapes, and still others that contain enigmatic calligraphy and childlike figurative symbols. Paul Klee's paintings were always highly personal, and yet they opened doors for many artists who followed him in searching for visual, nonliterary images to work with.

In 1911 a Russian Expressionist painter and theorist, Wassily Kandinsky, who later was to be a colleague of Klee at the Bauhaus, published a book in which he attempted to define his new concepts of art. In *On the Spiritual in Art* Kandinsky developed his belief in an art based on an inner conviction. He felt that art should be derived from actual experience but also that it should develop out of the personal, subjective reality of the individual artist, without any attempt to represent, pictorially, the appearance of the outer world. To do this he suggested the use of a "language of form and color." He ascribed expressive values to particular colors and forms and asserted that it was essential for the artist to paint with a primary concern for these values, because they represented the artist's subjective, "spiritual" response to experience.

In *Point and Line to Plane,* published in 1926, Kandinsky continued his development of the idea of a visual language. He attempted to establish particular meanings for colors and forms and their combinations (Pl. 53, p. 262).

Kandinsky realized that his analysis of the expressive qualities of the elements of art could only scratch the surface of the problem. He and other artists who have attempted to relate pure color, form, line, and texture to the expression of visual meaning have not come to any general agreement concerning the specific meanings of particular elements or the meanings of their possible combinations. To assume that one variety of line or a single color will express love, or hate, or happiness is simplifying the problem unrealistically, but it is possible to suggest certain general, and perhaps obvious, kinds of meaning that may be achieved by a selective use of line, form, and color.

For example, short, staccato lines will suggest more agitation than lines that have a flowing continuity. The line itself may be rough or smooth. It may be oriented on the diagonal or curve, placed with a vertical emphasis or a horizontal emphasis (Fig. 427).

Color can be selected to contrast sharply in value or hue, or color combinations can be harmonious and

quietly unified, suggesting many obvious expressive possibilities.

Even when the forms in a composition are restricted to identical squares and those squares are arranged in horizontal and vertical lines, variation in color can produce significant differences in the expressive content of the designs. The two examples shown here illustrate color changes in value. Figure 428 shows variations of value in contrast, and the quality produced is one of agitation, excitement, conflict. Figure 429 is composed of squares of closely related values, and the effect is quite different. Words

above: **426.** PAUL KLEE. *Swan Pond.* 1937.
Gouache and watercolor, 19½ × 16¾″ (50 × 43 cm).
Vassar College Art Gallery, Poughkeepsie, N.Y.
(gift of Mrs. John D. Rockefeller III).

left: 427. Variations of quality in line.

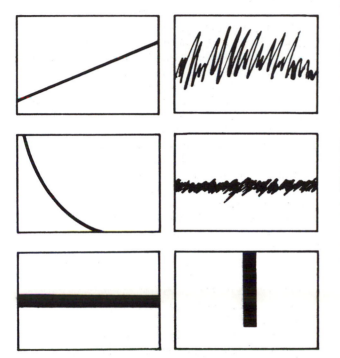

428. Contrasting values.

429. Closely related values.

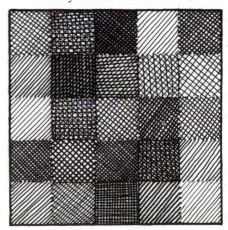

above: **430.** WILLIAM BAZIOTES. *The Beach.* 1955.
Oil on canvas, 3 × 4′ (.91 × 1.22 m).
Whitney Museum of American Art, New York.

right: **431.** JEAN DUBUFFET. *Beard of Uncertain Returns,*
from the *Beards* series. 1959.
Oil on canvas, 45¾ × 35⅛″ (116 × 89 cm).
Museum of Modern Art, New York
(Mrs. Samuel A. Lewisohn Fund).

such as "still," "quiet," "mysterious" might very well apply to this effect.

In the past, an artist who worked within the representational conventions of the period had limited opportunities to explore the expressive potential of drawing, color, and form. The painter and the sculptor conceived of subject matter and executed images within the constraints of tradition and the taste it influenced. Today, with an expanded conception of the nature of art and an increased acceptance of nontraditional imagery, an artist may choose a visual language from among many alternatives. The expressive use of each plastic element may be tested; unexpected combinations of elements may evolve into innovative compositions. What line quality will best express anger? What combination of hues evokes a feeling of gaiety? What type of space is required in a mural to convey a condemnation of aggression?

Such questions have been answered by contemporary artists who have found their own solutions to the creation of expressive visual symbols.

While many options for expressive imagery are available to an artist, it would be misleading to suggest that choices are usually made in a conscious, studied manner. Often, a compositional or stylistic decision is a response to an intuition, a feeling that a certain color or form is "right." Artists may not know the source of their inspiration. A work of art that has been seen before and stored in memory can influence an artist's imagery even after the original work has been forgotten. A critic—or even the artist—may be capable of analyzing the reason for decisions once the work has been completed, but during the creative process, for many artists conscious decisions are interwoven with intuitions as the work proceeds.

Many present-day artists have forsaken a rational, conscious attitude toward art and instead depend upon spontaneous, intuitive responses to the emotional stimuli they feel. Their visual symbols develop in the very process of painting. Their methods and attitudes have much in common with those of the early Surrealists who experimented with automatic writing and accidental collages, and they have a familial connection with the work of Klee.

William Baziotes was a painter who belonged to this group (Fig. 430). He discussed his work in the following way:

> There is no particular system I follow when I begin a painting. Each painting has its own way of evolving. One may start with a few color areas on the canvas; another with a myriad of lines; and perhaps another with a profusion of colors. Each beginning suggests something. Once I sense the suggestion, I begin to paint intuitively. The suggestion then becomes a phantom that must be caught and made real. As I work, or when the painting is finished, the subject reveals itself.[4]

Artists such as Baziotes combine a language of pure form and color in the tradition of Kandinsky with the automatic intuitive development of expressive images in the manner of the Surrealists. They do not represent emotion; they try to produce a visual equivalent for the emotional experience itself.

The phantom to which Baziotes refers in his statement may take the form of a nonrepresentational, chimerical image, which becomes a threatening or beneficent presence that a viewer may sense in the work of art. The painting *Beard of Uncertain Returns* (Fig. 431), by Jean Dubuffet, may be understood to represent the head of a bearded man, and yet it is more than that. The highly textured surface of the single large form dominates the center of the canvas. Here is a portrait of *something*, a nightmarish presence that is far more than an area of textured canvas. The central form becomes an image, rather than a part of an aesthetic organization. It seems to have a life of its own, rather than a function as a color or textural area in a compositional scheme.

A similar nonrepresentational image appears in the bronze by Jacques Lipchitz called *Figure* (Fig. 432). This massive series of forms has elements of a figurative image in it, but its expressive content seems to derive from its scale (over 7 feet, or 2 meters, high),

432. JACQUES LIPCHITZ. *Figure.* 1926–30 (cast 1937). Bronze, 7'1¼" × 3'2⅝" (2.17 × .98 m). Museum of Modern Art, New York (Van Gogh Purchase Fund).

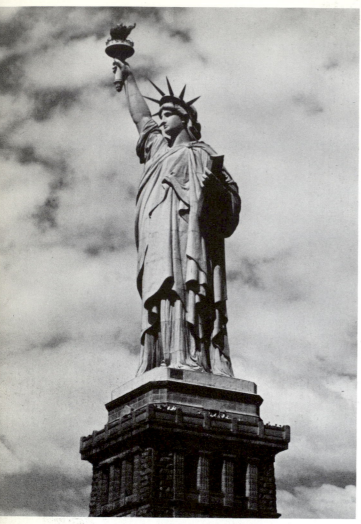

433. FREDERIC-AUGUSTE BARTHOLDI.
Statue of Liberty (*Liberty Enlightening the World*).
1874–75. Copper and iron,
height of figure 151′ (46 m).

unknown men and women, formed into a mosaic that provides viewers with an image of past events.

Frequently, the image in nonrepresentational subjects is an evocative atmosphere, rather than a disquieting specter. The paintings of Josef Albers can be described as compositions based upon overlapping squares of color (Pl. 24, p. 117), but when a group of them is seen together, each seems to suggest a quite different attitude. In fact, Albers' titles often have reference to highly personal experience.

In some instances contemporary painters have increased the scale of their works so that they cover wall-size areas. These large canvases seem to create a personal world of form and color that functions as an environment. They offer a viewer a universe set apart from nature, charged with the emotion that initially stimulated the artist.

An American painter, Ad Reinhardt, produced a number of works based upon simple, flat rectangular forms of very closely related colors (Pl. 54, p. 262). Large in scale, they appear at first to be painted in one color, but as the eyes of the observer accommodate to the subtleties of the contrasts, areas of the painting seem to appear and then fade, to be replaced by still other ghostly forms that enter and then leave the viewer's awareness. This quiet, intense perceptual experience induces in many observers a mood of contemplation and introspection.

Among the mature paintings by Jackson Pollock are several large oils which become expressive environments. His *Mural* (Pl. 39, p. 158) was executed with the unstretched canvas laid flat on the floor. Pollock stood over it, using brushes, punctured cans, and sticks, which dripped paint, to produce the skeins of colored lines that cover the surface. The result is a complex screenlike web surrounding the viewer with a shimmering barrier through which there seem to be visible lights and forms of unknown origin.

The artist described his involvement in this painting process as follows:

> When I am *in* my painting, I'm not aware of what I am doing. It is only after a sort of "get acquainted" period that I see what I have been about. I have no fears about making changes, destroying the image etc., because the painting has a life of its own. I try to let it come through. It is only when I lose contact with the painting that the result is a mess. Otherwise there is pure harmony, an easy give and take, and the painting comes out well.[5]

The scale of Pollock's painting is an important element that affects those who stand before them. Many artists use size for expressive effect. One does not feel the same about a tiny illumination in a manuscript as about a mural that covers a great wall. But in sculpture, perhaps because the three-dimensional

the simplicity of its forms, and a robotlike arrangement of the circular elements in the upper portion of the composition.

Kurt Schwitters, a German artist who died in 1948, produced collages which combine image and composition in a style quite different from that of Dubuffet. Schwitters organized bits of printed matter, commonplace scraps of paper, and cloth into meticulously arranged compositions (Fig. 96). The materials incorporated into these collages often carry with them some of the meaning associated with their original use. A part of a calendar, a ticket stub, the handwritten corner of a note—these become more than textural and color shapes combined to form a pleasant design. They are the residue of the lives of

above: **434.** TONY SMITH. *Die.* 1962.
Steel, 6′ (1.83 m) cube.
Collection Sam Wagstaff, Jr., New York.

right: **435.** CLAES OLDENBURG. *Giant Soft Fan.* 1966–67.
Construction of vinyl filled with foam rubber;
wood, metal, and plastic tubing;
10′ × 4′9⅞″ × 5′1⅞″ (3.04 × 1.47 × 1.57 m).
Museum of Modern Art, New York
(Gift of Sidney and Harriet Janis).

work exists as an actual mass in space, scale seems to have an even greater importance than it does in the two-dimensional media. A sculptural work that towers over the observer has an importance deriving from its height. The Statue of Liberty in the harbor of New York City (Fig. 433) is not a figure of great aesthetic value; it takes its significance from the values it symbolizes, but its monumental proportions also have their effect. Reduced to the stature of a woman, it would lose its impressive appearance and become far less than it now is.

An even more obvious example of the influence of scale on the expressive content of an object can be found in the massive 6-foot (2-meter) cube constructed by Tony Smith (Fig. 434). A 2-inch (5-centimeter) version of this geometric solid would have the interest of a child's building block. Enlarged to its present proportions, it becomes a powerful enigmatic object. If it were given the dimensions of an Egyptian pyramid, it would be awe-inspiring.

A variation on the enlargement of a commonplace object is Claes Oldenburg's *Giant Soft Fan* (Fig. 435),

which combines outsize scale with a change in the material characteristics and the rigid forms associated with the original subject. The organic folds and bulges of the fan, swollen and padded in its exaggerated proportions, give it a sensuousness that requires a conceptual reorientation in the spectator.

To review, the expressive image may be a representation of the attitude of a subject in a work of art; it may be the expression of the artist's reaction to a subject, indicated by an alteration or distortion of an accepted *normal* representational convention; or, finally, in a nonrepresentational work the image may be an evocative symbol or atmosphere which, created by color, form, and the other plastic elements, evokes an emotion in the viewer. The expressive image is in part shaped by the subjective makeup of the observer, and because this is so, no universal response is possible to any single expressive statement. Though many people may agree on the meaning of an artist's expressive intention, so much of the response depends on the variable qualities in each artist and in each individual who looks at the result of the artist's work, that some images are inevitably ambiguous and "meaningless" to some persons. It is enough to say that, for each viewer, certain works of art will express some of the feelings and subjective attitudes which are an important part of the sense of life we all feel. When those expressions are transferred from artist to image to perceiver, the bond that is created provides opportunities for extraordinary satisfaction.

The Visual Dialogue

I would venture to affirm that a man cannot attain excellence if he satisfies the ignorant and not those of his own craft, and if he be not "singular" or "distant," or whatever you like to call him.[1]

What I want to show in my work is the idea which hides itself behind so-called reality. I am seeking for the bridge which leads from the visible to the invisible. . . .

One of my problems is to find the ego, which has only one form, and is immortal—to find it in animals and men, in the heaven and in the hell which together form the world in which we live.[2]

The first of the two quotations above is attributed to Michelangelo, working in Italy during the sixteenth century. It is the expression of an artist who felt that he was important in his society, which had slowly made the transition from the medieval world, where individuality was severely limited. The second quotation is the statement of the twentieth-century German Expressionist painter Max Beckmann, completely immersed in his own personal search for those things and values which were meaningful to him. Though not in the same way, or to the same degree, both Michelangelo and Beckmann turned from those about them to look inward for the basis of their art,

and this attitude is representative of the great majority of contemporary artists.

For the artist today, and for many others, there is no single meaningful, all-encompassing concept of human nature, social order, or ethical and moral absolutes. Instead, there is the recognition of a world fragmented into many separate, though often related, cells, divided by language, custom, religion, economic development, and geographical location. For any single individual in this conglomerate group, the significance of the events which occur from day to day, the nature and meaning of past events, and the expectation of what is yet to happen can differ so widely that it is not strange to think of one artist in one studio in one small part of the world focusing on only a small part of this immense fabric, attempting to express a singular involvement with it.

Today's artist is faced with a situation unique in the history of art. Never before have visual images been so commonplace. Newspapers, magazines, television, motion pictures, amateur and professional photographs are everywhere. The most inexperienced art student has had more contact with representational images and reproductions of art objects than did the professional artist working only fifty years earlier. Each year the history of art grows larger, and

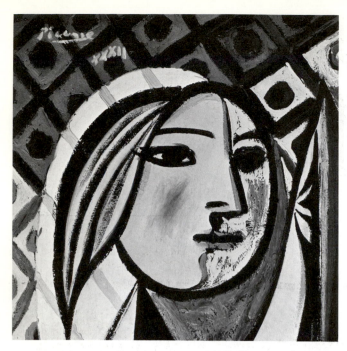

above: 436. Detail of Plate 2 (p. 7), Picasso's *Girl Before a Mirror*.

below: 437. Advertisement for Croton Watch Co., Inc. 1962.

women are going crazy...
about the greatest fashion watch of the decade!

access to the art of the past becomes easier. Museums and galleries in our cities have made possible a first-hand knowledge of major works of art from the very beginning of history to the present, and what the museums have been unable to do for their visitors has been done in classrooms with the help of thousands of color slides. Before the paint is dry on the artist's canvas, reproductions and explications appear in the art journals.

This aesthetic bounty has increased the interest in the visual arts, but at the same time it has driven the contemporary artist to a search for new forms of visual communication.

As the exposure of paintings, sculpture, and architecture has grown, the need for new forms of communication has grown with it. The characteristics of a painting style which seem to express a sincere and direct sensitivity to human experience at one time in history may become the basis for a stylistic cliché at another. Picasso used the Cubist treatment of a head in his paintings of the 1930s as a vital expressive device (Fig. 436). By showing composite views of the head, it was possible for him to intensify the emotional content of his figure symbols. This device has become relatively common and even appears in advertising—drained of emotional impact, a clever stylistic treatment (Fig. 437).

Forms, symbols, and symbolic structures whose meaning is eroded by repeated use cannot serve artists seeking to express ideas and values of importance to them. The artists must find those combinations of the visual vocabulary which provide clear and potent means for communication. The cliché must be avoided, not for the sake of empty novelty and pretentious ambiguity, as many critics charge, but for exactly the opposite reason—to be explicit and meaningful. Contemporary artists are extensions of preceding artistic traditions, but they also try to extend those traditions when earlier forms of image making are inadequate for effective expression.

Many of the expressive forms of art have been conceived as a result of the demand for resolution of practical problems. This is particularly true in architecture, where the structural and operational considerations are crucial to the design, but there are frequently many possible solutions; a roof may be covered by a round vault, a pointed groin vault, or a flat plane. The choice of a structural method depends upon the supply of materials, cost, and the skill of the available craftsmen, but it also depends upon the aesthetic response of the designers. Certain forms and spaces satisfy them more than others, apart from structural or operational necessity.

In painting and sculpture the need and the desire to represent important objects and experiences in the real world do not limit the style chosen.

438. FRANCISCO GOYA. *Tampoco* (*Nor These*), from *Disasters of War*. c. 1820. Intaglio, 5⅜ × 7½″ (14 × 19 cm).
Metropolitan Museum of Art, New York (Schiff Fund, 1922).

Certain painters and sculptors working at the present time feel that their function is to comment on the social and moral condition of their world, using visual images that can be understood by a mass audience. For the most part, artists committed to this belief in the sociological function of art use the traditional forms of visual communication, the forms which have had the greatest exposure and so are most familiar to the public.

In our own age the photograph dominates all other visual media in the dissemination of information. Several times in this book it has been stressed that the photograph gives only a part of the information that can be communicated about experience, but the widespread ability of peoples throughout the world to interpret photographic images and relate them to the real world makes the camera a potent instrument. Usually the photograph communicates a single, ephemeral experience. As it is used in newspapers and magazines, it becomes a journalistic tool. On

occasion a photograph can represent an image of permanent value as an expression of life and the human condition, but the vast number of mass-reproduced photographs are seen and then relegated to the trash heap. Once they have served their purpose for the short-term audience, they are superseded on the next day by another set of consumable visual images.

Like the photographer, the painter, the printmaker, and the sculptor are faced with concerns of relevance in dealing with social and political conditions. Socially conscious works can have an immediate and expressive impact, but often the power of their message declines as the character of life changes. Some exceptional examples seem to possess values untouched by time. The etchings by the Spanish painter Francisco Goya were a damning commentary on the bestiality of war when they were drawn about 1820, as a result of the Napoleonic invasion of Spain (Fig. 438). Today, perhaps because the images of rape, murder, and torture still cry out,

these etchings continue to move a large audience. On the other hand, when one looks at the work in Figure 439, by the American Ben Shahn, there is little comprehension of the message contained in this single composition from a series devoted to the trial and execution of Sacco and Vanzetti, which took place in the 1920s. At the time, the series of protests painted by Shahn was considered a powerful indictment of what many believed to be a grave miscarriage of justice. Today, without the aid of a written historical account of the event, what does this painting express to the viewer who is unfamiliar with the story?

439. BEN SHAHN. *The Passion of Sacco and Vanzetti.* 1931–32. Tempera on canvas, 7'1½" × 4' (2.14 × 1.22 m). Whitney Museum of American Art, New York (gift of Edith and Milton Lowenthal).

It is not possible simultaneously to extend the form of language and to appeal to a mass audience. With new forms of communication come difficulties of understanding, the problem of a confusion of symbolic meanings. New language forms may give artists an opportunity to intensify the content of their messages, but at the same time they limit the audience. A choice must be made between an expressive vocabulary and a large public. In times of crisis the choice has often been for the latter. Today, however, with photography serving as an active and efficient visual art for the communication of ideas to a mass public, the painter and the sculptor seem destined to concern themselves with the development of visual forms of expression which have limited audiences but, at the same time, extend the area of expression.

Why does the artist wish to paint, to carve stone, to organize steel and stone into architecture? Many would answer, "because it pleases and satisfies me as nothing else does." In manipulating the materials of their craft, artists can find pleasure akin to that found by children in games and play. The sensual and kinesthetic release expressed in the scribble of a young child discovering the lines made by crayons and the almost animal delight of squeezing clay between the fingers are still to be found in the mature men and women who are artists, craftsmen, and designers. Of course, there is more. There is the act of discovery. There is the gratification of identifying, in the work under way, the concrete expression of a new reality that has been sensed—half formed—within the mind; and there is satisfaction in establishing order—in being able to control the material and organize the forms and colors to achieve the ends that inspired the undertaking. It is at this level that the artist needs to find that combination of the plastic vocabulary which will express what no other combination can.

Finally, the work of art functions for the artist as a form of communication. After the last brush stroke has been placed and the last mark of the chisel has been ground from the surface of the stone, the uniquely personal statement is offered to those who are capable of and interested in reading the message.

Art seems to have a real value for the artist, but why should anyone else be concerned with it? The answer, of course, is obvious: no one *should necessarily* be concerned, but many people *are*.

For some, the involvement they feel comes from an awareness that certain products of the artist have given them pleasure, and they seek more. It is, perhaps, impossible to establish the basis for this feeling. It seems to have been present in men and women from their earliest days on earth. The ornamentation of simple tools, implements, and weapons testifies to its importance in almost every culture (Fig. 440).

440. Eskimo pipe from Gambell, St. Lawrence Island, Alaska. Collected 1914. Ivory incised in black and red, length 8¼″ (21 cm). Peabody Museum, Harvard University, Cambridge, Mass.

At one time, when art alone fulfilled the function of visually recording and representing the physical world, accurate representation was the aspect of greatest significance to many viewers. Though this function has largely been assumed by photography, there are still many persons who find pleasure in seeing a painting that is essentially representational. Much of the satisfaction offered by such work, as distinguished from the photograph, is similar to that found in the work of the craftsman, the identification of skilled labor, the sense of participation in resolving the technical problems posed by the work. When such a work gives the viewer a sense of reality surpassing that of the photograph, the pleasure to be realized is like that of discovering some new bit of information or insight about a world one already knows.

The paintings of the American Andrew Wyeth have found wide public and critical acclaim. They

441. ANDREW WYETH. *The Wood Stove.* 1962. Drybrush, 13¾ × 26¾″ (35 × 68 cm). William A. Farnsworth Library and Art Museum, Rockland, Me.

combine photographic representation with an extraordinary skill in the application of paint, and, in addition, they often project or evoke an intimate awareness of a sensitivity to everyday experience beyond the perception of most people (Fig. 441).

The revelatory aspect of art and the satisfaction it can provide are not reserved to such readily recognized forms. An art form that is evocative, that seems to point to certain aspects of reality without rendering them in such a familiar guise, also has in it the potential for discovery. It permits an emphatic, subjective response. The reality it offers need not be pleasant in itself; the pleasure is derived from finding the meaning, whatever it may be. There is also the pleasurable sensation of being transported into a world apart, a world which has order and reason to a degree that one cannot often find in the complexity of day-to-day living, or which offers some respite from the realities of the immediate experience and permits the luxury of a temporary existence in an environment created by the artist.

Finally, there are the direct sensory pleasures to be had from the response to color or the touch of a smooth piece of marble, or perhaps the exhilaration that is felt when one stands in the center of a great architectural space.

There are, then, many effects of art on those who do not produce the works: satisfaction of the senses, stimulation of the imagination, isolation of consciousness in a world of clarity or reverie. All these offer the observer an opportunity for experience that might otherwise have been missed, experience which adds to the riches of life in a way that cannot be duplicated by other means.

The public cannot, however, place the total responsibility for its response upon the artist. It is not enough to say that the artist *must* produce an object which makes the public respond, for the appreciation of art results from an *active* participation on the part of an observer. The work of art and the person who stands before it take part in a *dialogue,* in which each contributes a portion of the whole experience.

This dialogue has its counterpart in the studio, for the creation of the work of art frequently results from a process in which the artist acts upon the work and is in turn acted upon by it. The artist begins the process. In painting, a red mark placed upon the canvas will be followed by other marks. The initial impulse to make the marks may arise from a desire to represent a subject, to express a feeling, to fashion an object, or any combination of the three, but once the marks are there, outside the painter, they become a part of a process which continues until the painting is complete. Each spot of color on a canvas has at least some minutely accidental qualities in it. No matter how precise the technique, an artist cannot control every possible variable in each stroke of the brush, and for painters who work in a broad and vigorous manner the factor of accident may be very large indeed. The painter learns, as do the practitioners of the other visual arts, to take advantage of the unexpected or unplanned effects that appear in the work in progress, to permit a dialogue to take place between the artist and the art object.

A continuing interaction can take place as the work progresses, but though the appearance of some portions may be traceable to accidental or unconscious factors in its creation, it is the artist who has the ultimate responsibility for the final result, the decision to retain or eliminate part or all of the work.

It is true that an artist who believes that a dialogue is taking place with an inanimate object is in reality acting introspectively, but this does not alter the fact that communication does *appear* to take place between two *active* participants. The production of a work is a dynamic activity, in which the artist acts and then responds to each act as the process continues to the next step in the sequence that eventually brings forth the completed work.

As noted, the interaction, or the dialogue, that occurs between artist and art object has a parallel in the relationship between the viewer and the art object. The work of art exists as a completed physical entity when it is presented to view, but it becomes an object of aesthetic value only when it causes a response in the observer, and the nature of that response is dependent upon an active participation in the aesthetic experience. The work of art has a statement to make, but it is the observers of the work who shape that statement into a personal communication by committing themselves to the experience. The work can speak to those who are passively involved, but it speaks most eloquently and satisfyingly when it becomes a part of a visual dialogue.

Bibliography
and Notes

The bibliography, topically arranged, is a selection of the sources the author has found responsive to the questions and issues he raised in the course of his own development in art. Far from exhaustive, these few published statements are recommended to the reader as an introduction to the rich store of ideas and commentary that the challenge of art has motivated artists and thinkers of every persuasion to formulate. The notes to the text, which follow the bibliography, cite certain specific sources that have contributed to the book's content. These are arranged by chapter.

Bibliography

Architecture

Banham, Reyner. *Age of the Masters: A Personal View of Modern Architecture.* N.Y.: Harper & Row, 1975.

Blake, Peter, *Form Follows Fiasco: Why Modern Architecture Hasn't Worked.* Boston: Little, Brown, 1977.

Bloomer, Kent C., and Charles W. Moore. *Body, Memory and Architecture.* New Haven: Yale University Press, 1977.

Cook, John W. *Conversations with Architects.* N.Y.: Praeger, 1973.

Cowan, Henry J. *The Master Builders: A History of Structural and Environmental Design from Ancient Egypt to the 19th Century.* N.Y.: Wiley, 1977.

Cranage, David H. S. *Cathedrals and How They Were Built.* Cambridge: Cambridge University Press, 1948.

Fletcher, Banister. *A History of Architecture on the Comparative Method,* 18th ed. N.Y.: Scribner, 1975.

Giedion, Siegfried. *Architecture and the Phenomena of Transition.* Cambridge, Mass.: Harvard University Press, 1971.

————. *The Beginnings of Architecture.* Princeton: Princeton University Press, 1964.

————. *Space, Time and Architecture.* Cambridge, Mass.: Harvard University Press, 1963.

Gropius, Walter. *Scope of Total Architecture.* N.Y.: Collier, 1962.

Hamlin, Talbot F. *Architecture through the Ages.* N.Y.: Putnam, 1940–53.

————. *Forms and Functions of Twentieth Century Architecture.* N.Y.: Columbia University Press, 1952.

Haney, Robert, and David Ballantine. *Woodstock Handmade Houses.* N.Y.: Random House, 1974.

Heyer, Paul. *Architects on Architecture: New Directions in America.* N.Y.: Walker, 1966.

Hitchcock, Henry Russell, Albert Fein, Winston Weisman, and Vincent Scully. *The Rise of an American Architecture* (ed. with intro. by Edgar Kaufmann, Jr.). N.Y.: Praeger, 1970.

Huxtable, Ada L. *Will They Ever Finish Bruckner Boulevard?.* N.Y.: Macmillan, 1970.

Jacobs, Jane. *The Death and Life of Great American Cities*. N.Y.: Random House, 1961.
——. *Economy of Cities*. N.Y.: Random House, 1969.
Jencks, Charles. *Achitecture 2000: Prediction and Methods*. N.Y.: Praeger, 1971.
——. *The Language of Post Modern Architecture*. N.Y.: Rizzoli, 1977.
——. *Meaning in Architecture*. N.Y.: Braziller, 1970.
Lowe, Jeanne R. *Cities in a Race with Time: Progress and Poverty in America's Renewing Cities*. N.Y.: Random House, 1967.
Lowry, Bates. *Renaissance Architecture*. N.Y.: Braziller, 1962.
MacDonald, William L. *The Architecture of the Roman Empire*. New Haven: Yale University Press, 1965.
McHarg, Ian L. *Design with Nature*. Garden City, N.Y.: Doubleday/Natural History Press, 1971.
Millon, Henry A. *Baroque and Rococo Architecture*. N.Y.: Braziller, 1961.
——, and Alfred Frazer. *Key Monuments of the History of Architecture*, N.Y.: Abrams, n.d.
Moholy-Nagy, Sibyl. *Matrix of Man: An Illustrated History of Urban Environment*. N.Y.: Praeger, 1968.
——. *Native Genius in Anonymous Architecture*. N.Y.: Horizon Press, 1957.
Moore, Charles. *The Place of Houses*. N.Y.: Holt, Rinehart and Winston, 1974.
Muschenheim, William. *Elements of the Art of Architecture*. N.Y.: Viking, 1964.
Neutra, Richard. *Survival Through Design*. N.Y.: Oxford University Press, 1954.
Panofsky, Erwin. *Gothic Architecture and Scholasticism*. Cleveland: Meridan Books, World, 1957.
Pevsner, Nikolaus. *An Outline of European Architecture*. Baltimore: Penguin, 1957.
Rasmussen, Steen Eiler. *Experiencing Architecture*. Cambridge, Mass.: M.I.T. Press, 1962.
——. *Towns and Buildings*. Cambridge, Mass.: M.I.T. Press, 1969.
Richards, J. M. *An Introduction to Modern Architecture*. Baltimore: Penguin, 1940.
Rudofsky, Bernard. *The Prodigious Builders: Notes Toward a Natural History of Architecture*. N.Y.: Harcourt Brace Jovanovich, 1977.
——. *Streets for People: A Primer for Americans*. Garden City, N.Y.: Doubleday, 1969.
Safdie, Moshe. *Beyond Habitat*. Cambridge, Mass.: M.I.T. Press, 1970.
Scully, Vincent J., Jr. *Earth, the Temple and the Gods: Greek Sacred Architecture*. New Haven: Yale University Press, 1962.
Smith, C. R. *Supermannerism: New Attitudes in Post Modern Architecture*. N.Y.: Dutton, 1977.
Sullivan, Louis H. *Kindergarten Chats and Other Writings*. N.Y.: Wittenborn, 1947.
Venturi, Robert. *Complexity and Contradiction in Architecture*. N.Y.: Museum of Modern Art, 1967.
——, Denise Scott Brown, and Steven Izenour. *Learning from Las Vegas*. Cambridge, Mass.: M.I.T. Press, 1977.
Wampler, Jan. *All Their Own: People and the Houses They Build*. Cambridge, Mass.: Shenkman, 1977.
Ware, Dora, and Betty Beatty. *A Short Dictionary of Architecture*. N.Y.: Philosophical Library, 1945.
Wright, Frank Lloyd. *The Future of Architecture*. N.Y.: Horizon, 1953.

Color

Albers, Josef. *Interaction of Color*. New Haven: Yale University Press, 1963.
Birren, F. *Color and Human Response*. N.Y.: Van Nostrand Reinhold, 1978.
——. *The Story of Color*. Westport, Conn.: Crimson Press, 1941.
Clulow, Frederick W. *Colour: Its Principles and Their Application*. London: Fountain, 1972.
Hickethier, Alfred. *Color Mixing by Numbers*. N.Y.: Van Nostrand Reinhold, 1969.
Itten, Johannes. *The Art of Color*. N.Y.: Reinhold, 1961.
Libby, William C. *Color and the Structural Sense*. Englewood Cliffs, N.J.: Prentice-Hall, 1974.
Marx, Ellen. *The Contrast of Colors*. N.Y.: Van Nostrand Reinhold, 1973.
Munsell, Albert Henry. *A Color Notation*. Baltimore: Munsell Color Co., 1946.
Ostwald, Wilhelm. *Color Science*. London: Winsor & Newton, 1931–33.
Seitz, William C. *The Responsive Eye*. N.Y.: Museum of Modern Art, 1965.
Wright, W. D. *The Measurement of Color*. London: Hilger & Watts, 1958.

Communication

Haber, Ralph N. *Information-Processing Approaches to Visual Perception*. N.Y.: Holt, Rinehart and Winston, 1969.
Hall, E. T. *The Silent Language*. Garden City, N.Y.: Doubleday, 1959.
McLuhan, Marshall, and Edmund Carpenter. *Explorations in Communication*. Boston: Beacon, 1960.
Ogden, C. K., and I. A. Richards. *The Meaning of Meaning*. N.Y.: Harcourt, 1930.
Ruesch, Jurgen. *Nonverbal Communication: Notes on the Visual Perception of Human Relations*. Berkeley: University of California Press, 1956.
Schramm, Wilber L. *Men, Messages and Media: A Look at Human Communication*. N.Y.: Harper & Row, 1973.
Ulman, Stephen. *Words and Their Use*. N.Y.: Philosophical Library, 1951.
Urban, Wilbur Marshal. *Language and Reality*. N.Y.: Macmillan, 1939.
Whorf, Benjamin Lee. *Language, Thought and Reality*. N.Y.: Technology Press/Wiley, 1956.

Drawing

Anderson, Donald M. *The Art of Written Forms: The Theory and Practice of Calligraphy*. N.Y.: Holt, Rinehart and Winston, 1969.
Bertram, A. *1000 Years of Drawing*. N.Y.: Dutton, 1966.
Blake, Vernon. *The Art and Craft of Drawing*. London: Oxford University Press, 1927.
Chaet, Bernard. *The Art of Drawing*, 2nd ed. N.Y.: Holt, Rinehart and Winston, 1978.
de Tolnay, Charles. *History and Technique of Old Master Drawings*. N.Y.: Bittner, 1943.
Hutter, Heribert. *Drawing: History and Technique*. N.Y.: McGraw-Hill, 1968.
Kaupelis, R. *Learning to Draw*. N.Y.: Watson-Guptil, 1968.
Lindemann, Gottfried. *Prints and Drawings: A Pictorial History* (tr. by Gerald Onn). N.Y.: Praeger, 1970.

Marks, Claude. *From the Sketchbooks of Great Artists.* N.Y.: Crowell, 1972.

Mendelowitz, Daniel M. *A Guide to Drawing.* N.Y.: Holt, Rinehart and Winston, 1976.

Moskowitz, Ira. *Great Drawings of All Time.* N.Y.: Shorewood, 1962.

Rawson, P.S. *Drawing.* London: Oxford University Press, 1969.

Rose, Bernice. *Drawing Now.* N.Y.: Museum of Modern Art, 1976.

Rosenberg, Jakob. *Great Draftsmen from Pisanello to Picasso.* Cambridge, Mass.: Harvard University Press, 1959.

Slive, S., ed. *Drawings of Rembrandt.* N.Y.: Dover, 1965.

Waldman, Diane. *Twentieth-Century American Drawing: Three Avant-Garde Generations.* N.Y.: Solomon R. Guggenheim Museum, 1976.

History of Art

Arnason, H. Harvard. *History of Modern Art: Painting, Sculpture, and Architecture,* 2nd ed. N.Y.: Abrams, 1977.

Ashton, Doré. *The New York School: A Cultural Reckoning.* N.Y.: Viking, 1973.

Bascom, William. *African Art in Cultural Perspective.* N.Y.: Norton, 1973.

Brown, Milton W. *American Painting from the Armory Show to the Depression.* N.Y.: Harper & Row, 1973.

Clark, Kenneth M. *The Romantic Rebellion: Romantic Versus Classic Art.* N.Y.: Harper & Row, 1973.

Cuttler, Charles D. *Northern Painting: From Pucelle to Bruegel.* N.Y.: Holt, Rinehart and Winston, 1968.

Davis, Douglas M. *Art and the Future: A History-Prophecy of the Collaboration Between Science, Technology and Art.* N.Y.: Praeger, 1973.

de la Croix, Horst, and Richard G. Tansey. *Gardner's Art Through the Ages,* 7th ed. N.Y.: Harcourt, 1980.

Fagg, William. *Tribes and Forms of African Art.* N.Y.: Tudor, 1965.

Feder, Norman. *Two Hundred Years of North American Indian Art.* N.Y.: Praeger, 1971.

Ferebee, Ann. *A History of Design from the Victorian Era to the Present.* N.Y.: Van Nostrand Reinhold, 1970.

Fine, Elsa H. *Women and Art: A History of Women Painters and Sculptors from the Renaissance to the 20th Century.* Montclair, N.J.: Allanheld & Schram, 1978.

Fleming, William. *Arts & Ideas,* 6th ed. N.Y.: Holt, Rinehart and Winston, 1979.

Focillon, Henri. *The Art of the West in the Middle Ages,* 2nd ed. (ed. by Jean Bony; trans. by Donald King). N.Y.: Phaidon, 1969.

Gombrich, E. H. *The Story of Art,* 11th ed. N.Y.: Phaidon, 1966.

Gottlieb, Carla. *Beyond Modern Art.* N.Y.: Dutton, 1976.

Greer, Germaine. *The Obstacle Race.* N.Y.: Farrar, Straus & Giroux, 1979.

Hamilton, George Heard. *The 19th and 20th Centuries: Painting, Sculpture, and Architecture.* N.Y.: Abrams, 1970.

Hartt, Frederick. *Art: A History of Painting, Sculpture, Architecture.* N.Y.: Abrams, 1976.

———. *History of Italian Renaissance Art: Painting, Sculpture and Architecture.* N.Y.: Abrams, 1969.

Hauser, Arnold. *The Social History of Art.* 4 vols. N.Y.: Vintage, 1957.

Hess, Thomas B., and Elizabeth C. Baker. *Art and Sexual Politics.* N.Y.: Collier, 1973.

Kramer, Hilton. *The Age of the Avant-Garde: An Art Chronicle of 1956–1972.* N.Y.: Farrar, Straus & Giroux, 1973.

Janson, H. W. *History of Art,* rev. ed. N.Y.: Abrams, 1969.

Lange, Kurt, and Max Hirmer. *Egypt: Architecture, Sculpture and Painting in 3000 Years,* 4th ed. N.Y.: Phaidon, 1968.

Leavitt, Ruth, ed. *Artist and the Computer.* N.Y.: Harmony Books, 1976.

Lee, Sherman. *A History of Far Eastern Art.* N.Y.: Abrams, 1964.

Lippard, Lucy R. *Pop Art.* N.Y.: Praeger, 1966.

———. *Six Years: The Dematerialization of the Art Object from 1966 to 1972.* N.Y.: Praeger, 1973.

Lucie-Smith, Edward. *Late Modern: The Visual Arts Since 1945,* 2nd ed. N.Y.: Praeger, 1976.

Martindale, Andrew. *The Rise of the Artist in the Middle Ages and Early Renaissance.* N.Y.: McGraw-Hill, 1972.

Mendelowitz, Daniel M. *A History of American Art,* 2nd ed. N.Y.: Holt, Rinehart and Winston, 1970.

Meyer, Ursula. *Conceptual Art.* N.Y.: Dutton, 1972.

Müller, Grégoire. *The New Avant-Garde: Issues for the Art of the Seventies.* N.Y.: Praeger, 1972.

Morey, Charles R. *Early Christian Art.* Princeton: Princeton University Press, 1942.

———. *Medieval Art.* N.Y.: Norton, 1942.

Murray, Peter, and Linda Murray. *The Art of the Renaissance.* N.Y.: Praeger, 1963.

Myers, Bernard. *Art and Civilization,* 2nd ed. N.Y.: McGraw-Hill, 1967.

Nochlin, Linda. *Impressionism and Post-Impressionism.* Englewood Cliffs, N.J.: Prentice-Hall, 1961.

Prown, Jules D. *American Painting: From Its Beginnings to the Armory Show.* 2 vols. Cleveland: World, 1969.

Rewald, John. *The History of Impressionism,* rev. ed. N.Y.: Museum of Modern Art, 1961.

———. *Post-Impressionism, from Van Gogh to Gauguin.* N.Y.: Museum of Modern Art, n.d.

Rice, David T. *The Byzantine Era.* N.Y.: Praeger, 1963.

———. *Islamic Art.* N.Y.: Praeger, 1965.

Richter, Gisela M. A. *A Handbook of Greek Art,* 5th ed. London: Phaidon, 1967.

Robb, David M., and J. J. Garrison. *Art in the Western World.* N.Y.: Harper, 1963.

Rosenblum, Robert. *Cubism and Twentieth-Century Art.* N.Y.: Abrams, 1976.

Schapiro, Meyer. *Modern Art: 19th and 20th Centuries.* N.Y.: Braziller, 1978.

Smart, Alastair. *The Renaissance and Mannerism in Italy.* N.Y.: Harcourt Brace Jovanovich, 1971.

Spencer, Harold. *The Image Maker: Man and His Art.* N.Y.: Scribner, 1975.

Tufts, Eleanor. *Our Hidden Heritage: Five Centuries of Women Artists.* N.Y.: Paddington Press, 1974.

Willett, Frank. *African Art.* N.Y.: Praeger, 1971.

Wittkower, Rudolf. *Art and Architecture in Italy 1600–1750.* Baltimore: Penguin, 1958.

Zakon, Ronnie L. *The Artist and the Studio in the Eighteenth and Nineteenth Centuries.* Cleveland: Cleveland Museum of Art, 1978.

Zarnecki, Georges. *Art of the Medieval World: Architecture, Sculpture, Painting, the Sacred Arts.* Englewood Cliffs, N.J.: Prentice-Hall, 1975.

Artists' Materials and Techniques

Chaet, Bernard. *An Artist's Notebook.* N.Y.: Holt, Rinehart and Winston, 1979.

Doerner, Max. *The Materials of the Artist and Their Use in Painting, with Notes on the Techniques of the Old Masters.* N.Y.: Harcourt, 1949.

Egbert, Virginia W. *The Medieval Artist at Work.* Princeton: Princeton University Press, 1967.

Massey, Robert. *Formulas for Painters.* N.Y.: Watson-Guptil, 1967.

Psychology of Art and Perception

Ames, A., C. A. Proctor, and Blanche Amos. "Vision and the Technique of Art," *Proceedings of the American Academy of Arts and Sciences,* Vol. 58, No. 1, February 1923.

Arnheim, Rudolph. *Art and Visual Perception.* Berkeley: University of California Press, 1974.

————. *Visual Thinking.* Berkeley: University of California Press, 1969.

Berlyne, D. E. *Aesthetics and Psychobiology.* N.Y.: Appleton-Century-Crofts, 1971.

————. *Studies in the New Experimental Aesthetics.* N.Y.: Wiley, 1974.

Brandt, Herman F. *The Psychology of Seeing.* N.Y.: Philosophical Library, 1945.

Buswell, Guy Thomas. *How People Look at Pictures: A Study of the Psychology of Perception.* Chicago: University of Chicago Press, 1935.

Cohen, Leslie B., ed. *Infant Perception: From Sensation to Cognition.* N.Y.: Academic Press, 1975.

Eng, Helga. *The Psychology of Children's Drawings.* London: Routledge, 1954.

Gibson, James J. *The Perception of the Visual World.* Westport, Conn.: Greenwood Press, 1974.

Gombrich, Ernst H. J. *Art and Illusion.* N.Y.: Pantheon, 1960.

————. *The Sense of Order.* Ithaca, N.Y.: Cornell University Press, 1979.

————, Julian Hochberg, and Max Black. *Art, Perception and Reality.* Baltimore: Johns Hopkins University Press, 1972.

Gregory, R. L. *Eye and Brain: The Psychology of Seeing,* 2nd ed. N.Y.: McGraw-Hill, 1973.

————. *The Intelligent Eye.* N.Y.: McGraw-Hill, 1970.

————, and E. H. Gombrich. *Illusion in Nature and Art.* N.Y.: Scribner, 1974.

Kennedy, John M. *A Psychology of Picture Perception.* San Francisco: Jossey-Bass, 1974.

Lowenfeld, Viktor. *The Nature of Creative Activity.* N.Y.: Harcourt, 1939.

Ogden, R. *The Psychology of Art.* N.Y.: Macmillan, 1939.

Peckham, Morse. *Man's Rage for Chaos: Biology, Behavior and the Arts.* N.Y.: Schocken, 1967.

Pirenne, Maurice H. L. *Optics, Painting and Photography.* Cambridge: Cambridge University Press, 1970.

Schaefer-Simmern, Henry. *The Unfolding of Artistic Activity.* Berkeley: University of California Press, 1948.

Vernon, M. D. *A Further Study of Visual Perception.* London: Cambridge University Press, 1952.

Young, J. Z. *Doubt and Certainty in Science.* London: Oxford University Press, 1951.

Philosophy of Art and Criticism

Berndtson, Arthur. *Art, Expression and Beauty.* N.Y.: Holt, Rinehart and Winston, 1969.

Bosanquet, B. *A History of Aesthetics.* N.Y.: Meridan, 1957.

Burnham, Jack. *Great Western Salt Works: Essays on the Meaning of Post Formalist Art.* N.Y.: Baziller, 1974.

————, Charles Harper, and Judith B. Burnham. *The Structure of Art.* N.Y.: Braziller, 1971.

Carritt, E. F. *Philosophies of Beauty.* N.Y. Oxford University Press, 1931.

Cassirer, Ernest. *An Essay on Man.* Garden City, N.Y.: Doubleday, 1956.

Chandler, Albert R. *Beauty and Human Nature.* N.Y.: Appleton, 1934.

Dewey, John. *Art as Experience.* N.Y.: Putnam, 1934.

Fiedler, Conrad. *On Judging Works of Art.* Berkeley: University of California Press, 1949.

Gablick, Suzi. *Progress in Art.* London: Thames and Hudson, 1976.

Greenberg, Clement. *Art and Culture.* Boston: Beacon, 1961.

Langer, Susanne K. *Problems of Art.* N.Y.: Scribner, 1957.

Munro, Thomas. *The Arts and Their Inter Relations.* N.Y.: Liberal Arts Press, 1949.

Osborne, Harold. *Aesthetic and Criticism.* N.Y.: Philosophical Library, 1955.

Pepper, Stephen C. *The Basis of Criticism in the Arts.* Cambridge, Mass.: Harvard University Press, 1941.

Read, Herbert. *The Meaning of Art.* Baltimore: Penguin, 1964.

Rosenberg, Harold. *Art on the Edge: Creators and Situations.* N.Y.: Macmillan, 1975.

————. *The De-definition of Art.* N.Y.: Collier, 1973.

Prints and Printmaking

Baro, Gene. *30 Years of American Printmaking.* Brooklyn, N.Y.: Brooklyn Museum/Universe Books, 1976.

Castleman, Riva. *Contemporary Prints.* N.Y.: Viking, 1973.

Eichenberg, Fritz. *The Art of the Print: Masterpieces, History, Techniques.* N.Y.: Abrams, 1976.

Hargrave, Catherine. *A History of Playing Cards.* N.Y.: Dover, 1966.

Heller, Jules. *Printmaking Today,* 2nd ed. N.Y.: Holt Rinehart and Winston, 1972.

Hind, Arthur M. *A History of Engraving and Etching from the 15th Century to the Year 1914.* N.Y.: Dover, 1963.

————. *An Introduction to the History of Woodcut.* London: Constable, 1935.

Ivins, William, Jr. *How Prints Look.* Boston: Beacon, 1943.

————. *Prints and Visual Communication.* Cambridge, Mass.: Harvard University Press, 1953.

Lindemann, Gottfried. *Prints and Drawings: A Pictorial History* (tr. by Gerald Onn). N.Y.: Praeger, 1970.

Man, Felix H. *150 Years of Artists' Lithographs.* London: Heinemann, 1953.

Mayor, A. Hyatt, Richard V. West, and Donald Karshan. *Language of the Print.* Brunswick, Me.: Bowdoin College Museum of Art, 1968.

Mueller, E. G. *The Art of the Print.* Dubuque, Iowa: Brown, 1969.

Peterdi, Gabor. *Printmaking.* N.Y.: Macmillan, 1961.

Sachs, P. J. *Modern Prints and Drawings.* N.Y.: Knopf, 1954.

Saff, Donald, and Deli Sacilotto. *Printmaking: History and Process.* N.Y.: Holt, Rinehart and Winston, 1978.

Sotriffer, Kristian. *Printmaking: History and Technique.* N.Y.: McGraw-Hill, 1968.

Stephenson, Jessie Bane. *From Old Stencils to Silk Screening.* N.Y.: Scribner, 1953.

Wechsler, Herman J. *Great Prints and Printmakers.* N.Y.: Abrams, 1967.

Weekley, Montague. *Thomas Bewick.* London: Oxford University Press, 1953.

Whitford, Frank. *Japanese Prints and Western Painters.* N.Y.: Macmillan, 1977.

Sculpture

Armstrong, Tom, et al. *200 Years of American Sculpture.* N.Y.: Godine/Whitney Museum of American Art, 1976.

Battcock, Gregory, ed. *Minimal Art: A Critical Anthology.* N.Y.: McGraw-Hill, 1966.

Burnham, Jack. *Beyond Modern Sculpture.* N.Y.: Braziller, 1968.

Carpenter, Rhys. *Greek Sculpture.* Chicago: University of Chicago Press, 1960.

Elsen, Albert E. *Origins of Modern Sculpture.* N.Y.: Braziller, 1974.

Giedeon-Welcker, Carola. *Contemporary Sculpture.* N.Y.: Wittenborn, 1955.

Kirby, Michael. *Happenings.* N.Y.: Dutton, 1965.

Krauss, Rosalind. *Passages in Modern Sculpture.* N.Y.: Viking, 1977.

Licht, Fred S. *Sculpture: The Nineteenth and Twentieth Centuries.* N.Y.: New York Graphic Society, 1967.

Mailard, Robert, ed. *New Dictionary of Modern Sculpture.* N.Y.: Tudor, 1971.

Molesworth, H. D. *European Sculpture: From Romanesque to Neoclassic.* N.Y.: Praeger, 1965.

Munsterberg, Hugo. *Sculpture of the Orient.* N.Y.: Dover, 1972.

Panofsky, Erwin. *Tomb Sculpture.* N.Y.: Abrams, 1969.

Ramsden, E. H. *Twentieth-Century Sculpture.* London: Pleiades, 1949.

Read, Herbert. *The Art of Sculpture.* N.Y.: Pantheon, 1956.
————. *A Concise History of Modern Sculpture.* N.Y.: Praeger, 1965.

Richter, Gisela M. A. *Sculpture and Sculptors of the Greeks,* rev. ed. New Haven: Yale University Press, 1950.

Ritchie, Andrew C. *Sculpture of the Twentieth Century.* N.Y.: Museum of Modern Art, 1953.

Struppeck, Jules. *The Creation of Sculpture,* N.Y.: Holt, Rinehart and Winston, 1952.

Tucker, William. *Early Modern Sculpture.* N.Y.: Oxford University Press, 1974.

Valentiner, W. R. *Origins of Modern Sculpture.* N.Y.: Wittenborn, 1946.

Wittkower, Rudolph. *Sculpture: Processes and Principles.* London: Allen Lane, 1977.

Statements by Artists

Americans 1963. N.Y.: Museum of Modern Art, 1963.

Auden, W. H. *Van Gogh: A Self-Portrait.* Greenwich, Conn.: New York Graphic Society, 1961.

Bearden, Romare, and Carl Holty. *The Painter's Mind.* N.Y.: Crown, 1969.

Butler, Reg. *Creative Development.* N.Y.: Horizon, 1963.

Cellini, Benvenuto. *Autobiography of Benvenuto Cellini.* Garden City, N.Y.: Doubleday, 1960.

Chipp, Herschel B. *Theories of Modern Art.* Berkeley: University of California Press, 1971.

Dali, Salvador. *The Secret Life of Salvador Dali.* N.Y.: Dial, 1960.

Fifteen Americans. N.Y.: Museum of Modern Art, 1952.

Flam, Jack D. *Matisse on Art.* N.Y.: Phaidon/Praeger, 1973.

Friedenthal, Richard, ed. *Letters of the Great Artists* (tr., with certain exceptions, by Daphne Wood Ward). N.Y.: Random House, 1963.

Goldwater, Robert, and Marco Treves. *Artists on Art.* N.Y.: Pantheon, 1945.

Gray, Cleve, ed. *John Marin on John Marin.* N.Y.: Holt, Rinehart and Winston, 1970.
————. *David Smith on David Smith.* N.Y.: Holt, Rinehart and Winston, 1968.

Henri, Robert. *The Art Spirit.* Philadelphia: Lippincott, 1923.

Herbert, Robert L. *Modern Artists on Art.* Englewood Cliffs, N.J.: Prentice-Hall, 1964.

Holt, Elizabeth G. *A Documentary History of Art.* 2 vols. Garden City, N.Y.: Doubleday, 1957.

James, Philip, ed. *Henry Moore on Sculpture.* London: Macdonald, 1966.

Kandinsky, Wassily. *On the Spiritual in Art.* N.Y.: Solomon R. Guggenheim Foundation, 1946.

Kelder, Diane, ed. *Stuart Davis.* N.Y.: Praeger, 1971.

Klee, Paul. *Paul Klee on Modern Art.* London: Faber & Faber, 1949.

Meisel, Victor H. *Voices of German Expressionism.* Englewood Cliffs, N.J.: Prentice-Hall, 1970.

Mondrian, Piet. *Plastic Art and Pure Plastic Art.* N.Y.: Wittenborn, 1947.

Morris, Robert. *Robert Morris.* Washington, D.C.: Corcoran Gallery, 1969.

Nemser, Cindy. *Art Talk: Conversations with 12 Women Artists.* N.Y.: Scribner, 1975.

The New Decade: 22 European Painters and Sculptors. N.Y.: Museum of Modern Art, 1955.

Porter, Fairfield. *Art in Its Own Terms.* N.Y.: Taplinger, 1979.

Protter, Eric. *Painters on Painting.* N.Y.: Grosset & Dunlap, 1963.

Richter, Sean Paul, ed. *The Notebooks of Leonardo da Vinci.* 2 vols. N.Y.: Dover, 1970.

Shahn, Ben. *The Shape of Content.* N.Y.: Vintage, 1960.

Williams, Hiram. *Notes for a Young Painter.* Englewood Cliffs, N.J.: Prentice-Hall, 1964.

Notes

Chapter 1

1. Albert R. Chandler, *Beauty and Human Nature,* Appleton-Century-Crofts, New York, 1934, pp. 9, 10.
2. J. Z. Young, *Doubt and Certainty in Science,* Oxford University Press, London, 1951, p. 62.

Chapter 2

1. Clive Bell, "Art," 1913, in *A Modern Book of Esthetics,* ed. by Melvin M. Rader, Holt, Rinehart and Winston, New York, 1935, pp. 247, 252.
2. Robert Henri, *The Art Spirit,* J. B. Lippincott, Philadelphia, 1923, p. 159.
3. Quoted in David L. Shirey, "Impossible Art—What It Is," *Art in America,* May–June 1969, p. 34.
4. Quoted in Elizabeth G. Holt, *A Documentary History of Art,* Doubleday, Garden City, N.Y., 1957, Vol. I, p. 230.

Chapter 3

1. Wilbur Marshall Urban, *Language and Reality,* Macmillan, New York, 1939, p. 21.

Chapter 8

1. *The Notebooks of Leonardo da Vinci,* ed. and trans. by Edward MacCurdy, Reynal & Hitchcock, New York, 1939, pp. 877, 878.

Chapter 10

1. Gyorgy Kepes, ed., *The Nature and Art of Motion,* Vision + Value series, George Braziller, New York, 1965.

Chapter 11

1. John W. Griffiths, *Treatise on Marine and Naval Architecture,* 3d ed., Appleton, New York, 1853, p. 384.
2. Louis H. Sullivan, "The Tall Office Building Artistically Considered," *Kindergarten Chats and Other Writings,* George Wittenborn, New York, 1947, p. 203.
3. Kent C. Bloomer and Charles W. Moore, *Body, Memory and Architecture,* Yale University Press, New Haven, Conn., 1977, p. ix.

4. *Ibid.,* p. 105.
5. Louis I. Kahn, "Structure and Form," Voices of America Forum Lectures, 1960, in Vincent Scully, Jr., *Louis I. Kahn,* George Braziller, New York, 1962, p. 118.
6. A. James Speyer, *Miës van der Rohe* (catalogue), The Art Institute of Chicago, 1968, p. 9.
7. Robert Venturi, *Complexity and Contradiction in Architecture,* Museum of Modern Art, New York, 1967, p. 22.

Chapter 12

1. Pier Luigi Nervi, "Nervi's View on Architecture, Education and Structure," *Architectural Record,* December 1958, p. 118.
2. R. Buckminster Fuller, *Education Automation,* Southern Illinois University Press, Carbondale, Ill., 1962, p. 8.

Chapter 13

1. Auguste Rodin, *On Art and Artists,* Philosophical Library, New York, 1957, p. 46.
2. Ferdinand Hodler, "The Mission of the Artist," in Eric Protter, ed., *Painters on Painting,* The University Library, Grosset & Dunlap, New York, 1963, p. 158.
3. Salvador Dali, *The Secret Life of Salvador Dali,* Dial Press, New York, 1960, p. 221.
4. *Fifteen Americans,* ed. by Dorothy Miller, Museum of Modern Art, New York, 1952, p. 12.
5. Jackson Pollock, "My Painting," *Possibilities,* Winter 1947–48, in Eric Protter, ed., *Painters on Painting,* Gosset & Dunlap, New York, 1963, p. 249.

Chapter 14

1. *Artists on Art,* ed. by Robert Goldwater and Marco Treves, Pantheon Books, New York, 1945, p. 67.
2. *Ibid.,* p. 447.

Glossary

Italicized terms within the definitions are themselves defined in the glossary.

Abstract Expressionism A style of painting and sculpture important as an aesthetic force from 1950 to 1960. Characterized, generally, by large scale and evidence of spontaneous invention, suggesting the creative experience sought by the artist involved in the process of forming the image. Sometimes referred to as Action Painting; also the New York School.

abstraction In art, a translation into a *graphic* medium of a real life object or experience. Usually implies the isolation, emphasis, or exaggeration of some limited aspect of the artist's perception of reality. Not to be confused with *nonrepresentational* or "nonobjective" art, terms often, and incorrectly, used as synonyms for "abstract."

academy The cultural and artistic establishment, formerly an elected group with teaching (academic) and standard-maintaining responsibilities. From the French Académie des Beaux-Arts, the term has often been applied to conservative and traditional forms.

acrylic, or **acrylic resin** A clear plastic used as a *vehicle* in paints and as a *casting* material in sculpture.

additive sculpture Three-dimensional works of art made from a process of combining small pieces of material. Also objects gradually built up from plaster or clay into *forms,* and those made of wood and metal fragments joined by adhesives or mechanical means. See *modeling.*

aerial perspective A method of *representing* spatial depth in two-dimensional art. Color-forms representing objects in the foreground are painted with greater contrasts in *hue* and *value* than color-forms representing distant objects. In addition, forms intended to be seen as distant are painted with imprecise *edges* instead of the sharply delineated edges used in the representation of objects intended to be perceived as close to the observer.

altarpiece A painting, sculptural group, or *bas relief* prepared for and placed above and behind an altar.

analogous colors *Hues* adjacent to one another on the color wheel, usually centered about a *primary* or a *secondary* hue.

Analytical Cubism A style of painting developed by Picasso and Braque (c. 1909–12), with compositions based upon still-life and figurative *subjects* observed or analyzed from a great many separate points of view instead of from the single viewpoint used in *linear perspective* representations. Fragmented sequences of *lines* or shaded planes, derived from the contours of the *forms* of the subject, are the basis for both the *picture-plane* organization and the expression of the real objects observed by the painter. Its compositional orientation is toward the frame, or shape, of the canvas rather than toward geometries built up *illusionistically* inside the composition.

apse A semicircular extension at the eastern end of a Christian church built on an elongated rectangular, or *basilican,* plan.

aquatint A form of *intaglio* printmaking in which the artist uses *rosin* dust to *resist* the biting action of the *mordant* so

that tonal areas can be produced when the plate has been printed.

arabesque From Arabic Islamic design patterns, a stylized decorative or carved motif, based on organic, floral sources, whose lines flow in curved, intricate movements.

arcade 1. A row of columns supporting a series of connected arches. 2. A roofed passageway.

arch Any of a number of freestanding curved structural devices spanning a space.

architrave (ark′-i-trayv) The lowest portion of an *entablature*. That part of the bridging element in a *post-and-lintel* system that sits directly above the *capital* of a *column*.

armature An internal metal or wooden support for clay, plaster, or wax being modeled into sculpture.

art A product of human effort in which materials are skillfully ordered to communicate a human experience.

Art Nouveau (ahr noo-voh′) Literally "new art" in French, a *decorative* style dominant in Europe and America in the 1890s. Characteristic are flat patterns of slender and writhing tendril forms abstracted from a naturalistic conception of vegetable growth. Though most notable in architecture and the decorative arts, the long, sensuously curving line appeared also in much significant painting and sculpture of the period. Art Nouveau remains influential in the visual arts of the 1970s.

assemblage A work of art composed of fragments of objects or materials originally intended for other purposes.

avant-garde (a-vahn-gard′) A French term meaning "advanced guard," used to designate innovators and their experimental art.

axis 1. A centrally placed imaginary line indicating the major directional emphasis in one *plane* of a three-dimensional object. 2. In two-dimensional art, an imaginary line indicating the major directional compositional emphasis on the *picture plane;* or the illusion of an important directional emphasis between objects in the represented *subject* matter.

balance The distribution of *visual weights* in a work of art achieving an interrelated, interdependent state of equilibrium.

balloon frame A building construction system developed in the 19th century, and still in use, that employs lumber of relatively small cross sections nailed together to form a cagelike frame for the support of floors, roof, siding, windows, and doors. Balloon framing replaced the use of heavy, joined timbers as the basic structural system for the construction of small buildings.

Baroque A period and style in European art generally corresponding to the 17th century. In the Baroque, often the arts of painting, sculpture, and architecture were united in a theatrical way to fool the eye with soaring spatial illusions, exuberant, full-blown *forms,* and curvilinear designs, all intended to surround the spectator with color, movement, and light to encourage emotional involvement.

barrel vault A method of covering rectangular architectural space by erecting in masonry a continuous round *arch* extending the full length of the supporting walls. Also called "tunnel vault."

basilica A rectangular plan building, with an *apse* at one or both ends, originating in Roman secular architecture and found later in Gothic and Renaissance architecture.

bas (bah) **relief** See *relief sculpture.*

bay In architecture, a section of the interior or exterior of a building marked off by major vertical elements.

binder The constituent of paint that causes pigment particles to adhere to one another and to the *support.* See *vehicle.*

block print A form of *graphic art* in which an image is transferred to paper or cloth from the surface of a flat wooden or linoleum block that has been carved so that the printing surfaces stand in relief above the nonprinting areas.

brilliance A measure of the reflectivity of a *color.*

burin (byoor-in) A tool employed by engravers to cut lines into a plate.

burr A rough edge of metal thrown up by the cutting process in *drypoint* that holds ink and forms the soft, feathery lines typical of this printmaking medium.

buttress A support, usually exterior, for a *wall, arch,* or *vault* that opposes the lateral forces of these structural elements. See *flying buttress.*

calligraphy The art of beautiful writing. More broadly, any controlled, flowing, continuous use of *line* in painting, drawing, or sculpture.

camera obscura A boxlike device for projecting an image of an object or a scene through a small orifice onto a surface so that it can be traced.

campanile (kam-pah-neel′eh) A bell tower, usually next to but separate from a church building.

capital The upper portion of a *column,* often carved or decorated.

caricature A representation of a person or object that exaggerates one or more of the subject's prominent characteristics to create a satirical or expressive image.

cartoon 1. A full-scale preparatory drawing for a *mural* or tapestry. 2. A simplified humorous drawing.

carving 1. A method of shaping wood or stone sculpture utilizing edged tools that are forced against the material by the pressure of the hand or the blow of a mallet. 2. A piece of sculpture produced by the carving process.

casting 1. A process using plaster, clay, wax, or metal that, in a liquid form, is poured into a mold. When the liquid has solidified, the mold is removed, leaving a replica of the original work of art from which the mold was taken. 2. The molded replica made by the casting process. Also called a "cast." See *cire-perdue.*

catenary The geometric curve taken by a hanging cable of uniform weight and density when supported only at its two ends.

centering A temporary wooden scaffolding or support used to erect an *arch* or *vault.*

ceramics 1. Objects made of clay that have been baked into a permanent form. Often, they are decorated with *glazes,* then returned to the *kilns* for additional firing to fuse the glazes to the clay body. 2. The art and technology of producing ceramic objects.

chiaroscuro (kee-ar′oh-skoor′oh) Literally, "light-dark." In painting and drawing the use of dark and light *value* areas to represent the effects of light and shadow in nature.

chroma See *saturation.*

cire-perdue (seer-pair-dew′) A method of casting metal sculpture requiring a wax version of the original model. The wax form is encased in a heat-resistant molding material. Baking the mold causes the wax to melt and run out, leaving a cavity in its place. The cavity is filled with molten metal which solidifies to become the sculpture when the mold has been broken open.

Classical 1. The art of ancient Greece and Rome and subsequent sylistic imitations of Western antiquity. 2. With a

lower case "c," the term indicates a style of art that is idealized, regular, and rational, based on a carefully controlled and orderly arrangement of *elements*. 3. Also with a small "c," classic can mean established excellence, whatever the period, style, or form. See *Neoclassicism*.

clerestory A row of windows in the upper part of a wall. Also, in church architecture, the upper portion of the interor walls pierced by windows for the admission of light.

collage (kohl-lahzh´) A two-dimensional work of art containing pieces of paper, cloth, or other materials. A form of *assemblage*.

colonnade A series of regularly spaced columns.

color A perceived quality in direct light or in objects reflecting light that varies with: 1. the wave length of the light energy; 2. the *brilliance* of the light source; 3. the degree to which objects reflect or absorb the light energy falling on them. In paint, the light-reflecting and absorbing characteristic, which is a function of the pigment giving the paint its primary visual identity.

color solid One of a number of theoretical three-dimensional models of the variable characteristics of *color, hue, saturation,* and *value.*

column A cylindrical post or support which often has three distinct parts: a base, a shaft, and a *capital.*

complementary colors Two contrasting *hues* that are found opposite each other on a color wheel. Also two hues that neutralize each other when combined, i.e., red and green.

composition In the arts, an ordered relationship between significant parts or *elements.*

compression In architecture, a force that presses material together with a crushing action.

conceptual art An art object or event that in its total or essential *form* is conceived in the mind of the artist before it is fabricated. For some conceptual artists the conception of the work of art obviates the necessity to produce it.

conceptual representation A form of pictorial representation based upon the image of the *subject* in the mind of the artist.

concrete A mixture of gravel or rubble, sand, cement, and water that forms a *plastic mass* easily shaped into architectural and structural *forms.* When solidified it is a homogeneous, strong building material. Originally developed and perfected for monumental forms by the Romans.

conté crayon A form of hard chalk used for drawings.

content The *subject* matter of a work of art, plus all the intellectual, symbolic, emotional, narrative, thematic, and spiritual values, as opposed to considerations addressed purely to *form* and technique. See *subject* and *symbol.*

contour A linear representation of the edge of a *form* or group of forms. Also the edge between juxtaposed areas of color in a painting or drawing. In sculpture, the edge of a form seen against a contrasting background.

contrast The comparative relationship between two or more relatively opposed *elements* or forces.

cool color A *color* generally in the blue, violet, or green section of the *spectrum.*

corbel A block of masonry that projects from a wall to support a beam. Also a method of bridging a space using courses of stone or brick that partially project over the course beneath them to form a stepped diagonal form slanting toward the center of the opening as the courses rise.

Corinthian One of the *Classical* styles of temple architecture characterized by slender channeled *columns* topped by highly carved, ornate *capitals* that use decorative forms derived from the acanthus leaf.

cornice The projecting *molding* at the top of the *entablature* in *Classical* architecture. Also any projecting molding.

cross-hatching A system of *lines* drawn in close parallel order, crossed at an angle by another similar system. Used in drawing and printmaking to provide the effect of changes in tonality in works drawn with lines of uniform *value.*

crossing The intersection of the *nave* and *transept* in a *cruciform* church.

cruciform Arranged or shaped like a cross.

Cubism One of the original "abstract" styles of the early 20th century, Cubism was developed in Paris by Picasso and Braque, from Paul Cézanne's late-19th-century achievements in representational systems. Seeking to express the totality of an object and in respect for the two-dimensionality of the picture surface, the Cubists represented several views of their *subject* in the same *composition* and, in lieu of modeling in the round, superimposed one view over another in a dynamic spatial perception. *Analytical Cubism* (1909–12) emphasized the analysis of form, rigorously excluding the sensual elements of texture and color. From this emerged *Synthetic Cubism* (1912–14), a more decorative style utilizing flat, overlapping planes, the full spectral palette, tactile surfaces, and stylized patterns.

decoration An embellishment or ornamentation of a surface or a space with aesthetically pleasing elements. 1. Linear *calligraphic* ornament or a pattern of *colors* and *forms* applied to an existing surface or three dimensional object. 2. The selection of objects to be used in a room, or rooms, to produce a pleasureable environment (interior decoration).

decorative art A visual art that emphasises the control and exploitation of the sensory qualities of objects rather than their symbolic or expressive content. The term applied to that class of aesthetically pleasing objects made to satisfy practical needs.

design An arrangement of *elements* to satisfy an intention. A *composition* or organization. Also used as a verb, the act of organizing or arranging elements to meet a practical or aesthetic need.

direct-metal sculpture Sculpture formed by welding or otherwise joining sections of metal into three-dimensional constructions.

direct painting A technique that requires the artist to apply each stroke of color directly to the canvas *support* rather than use successive layers of opaque and transparent paint to produce coloristic effects.

direct-plaster sculpture Sculpture in which the *forms* are built up by successive applications of wet plaster.

dome A roof or *vault* generally hemispheric in shape.

Doric The oldest of the *Classical* styles of temple architecture, characterized by simple, sturdy *columns* that rise without a base to an unornamented, cushionlike *capital.*

drybrush A method of painting or drawing that produces tonal areas. The ends of the bristles of a stiff brush are dipped in paint or ink and lightly drawn across a *support* leaving a pattern of fine parallel lines.

drypoint An *intaglio* printmaking method that utilizes the *burr* thrown up when lines are cut into a metal plate to give the printed image a softened, atmospheric character.

Duco paint Originally an industrial paint made with a lacquer *vehicle.* Duco has been used by some artists for easel and mural paintings.

earthworks Large-scale sculptural projects involving the excavation or movement of earth for the purpose of shaping a site into an esthetically satisfying *form.*

eclectic Choosing from earlier styles and combining them as opposed to originating new compositional or expressive *forms.*

ecology The interrelationship of organisms and their environment.

element 1. One of several components selected or formed in combination with others to create a visual system or *composition.* 2. The plastic elements are *color, form, line* and *texture.* 3. A physical unit that is a part of a structural or visual system.

elevation In architectural plans a drawing of one of the exterior sides of a building.

encaustic A form of paint in which the *vehicle* is wax.

engraving 1. A form of *intaglio* printmaking in which grooves cut into a metal plate with a *burin* are filled with a viscous ink and the plate pressed against absorbent paper after its surface has been wiped clean. Also the finished print that results from this process. 2. Any form of decoration resulting from the use of *incised line.*

entablature The portion of a building between the *capitals* of the *columns* and the roof. In *Classical* architecture the entablature includes the *architrave, frieze,* and *cornice.*

environment The physical, social, aesthetic, and cultural conditions and processes that exist in a defined location. Also, an art form in which such conditions have been created and ordered.

esthetic response A pleasurable reaction to the perception of an object or event which an individual would wish to repeat or sustain.

esthetics The study of the nature of beauty and the response to it.

etching A form of *intaglio* printmaking requiring a metal plate coated with an acid-resistant wax which is scratched to expose the metal to the bite of the acid. Lines eaten into the plate by the acid are subsequently filled with ink and transferred to paper after the surface of the plate has been cleaned of excess ink. Also, the finished *print* that results from this process.

Expressionism A form of art developed at the end of the 19th and the beginning of the 20th century that emphasized the expression of the artist's subjective or emotional response to experience through the use of *color,* the direct, vigorous exploitation of media, and the formation of evocative and symbolic representational imagery.

façade The exterior, usually front, wall surfaces of a building.

Fauvism (fohv'ism) A style of painting introduced in Paris in the early 20th century, which used areas of brilliant contrasting color for structural and expressive purposes. Henri Matisse was the leading Fauve.

ferroconcrete A building material composed of *concrete* with rods or webs of steel imbedded in it.

figure-ground A phrase referring to a visually ambiguous relationship between two or more *color forms* on one surface. Their spatial positions may appear to alternate, one then the other closer to the observer.

fine art Traditionally the nonapplied arts; in the visual arts, painting, drawing, printmaking, sculpture, and, in some estimates, architecture.

flying buttress A *masonry* strut or segment of an *arch* that carries the thrust of a *vault* to a *buttress* positioned away from the main portion of the building. An important structural element in the architecture of Gothic cathedrals.

focus A point of convergence; also a center of attention.

foreshortening The representation of *forms* on a two-dimensional surface which creates the illusion that the subject is projecting into, or out of, the frontal *plane* of the composition.

form 1. *Composition* or organization, as in, "The form of the work is complex." 2. A three-dimensional solid. 3. An area on a two-dimensional surface. 4. The *illusionistic* representation of a three-dimensional form on a two-dimensional surface. 5. A mold into which concrete is poured. 6. A verb meaning to shape or order as in, "She formed the clay into a pot."

formal balance A symmetrical arrangement of the *visual weights* in a work of art.

formalism Adherence to a rigid set of rules or conventions in the conception and completion of a work of art.

fresco A painting *medium* frequently employed for *murals* requiring the artist to paint on a freshly laid, damp lime-plaster wall with pigments mixed in lime water. When the plaster has dried the paint is an integral and permanent part of the wall surface. A medium favored during the *Renaissance* in Italy.

frieze The central portion of the *entablature* between the *architrave* and the *cornice.* Also any horizontal *decorative* or sculptural band.

function The work that can properly be done by a unique mechanism or individual.

Futurism A style of painting originating in Italy during the first decade of the 20th century, which endeavored to represent a dynamic, modern, machine-powered world of moving subject matter.

geodesic A form of geometry that is the basis for structures using short sections of lightweight material formed into interlocking polygons.

gesso A mixture of chalk and glue used as a *ground* for *tempera* and other paints. Gesso has also served as surface for wooden *polychromed* sculpture.

glaze 1. A transparent film of paint. 2. In *ceramics,* a pigmented or transparent liquid applied to a clay object that hardens and becomes glasslike when baked at high temperatures.

Gothic A style in European art and architecture that prevailed from the 12th to the 15th century. The highest achievements of Gothic architecture are the great cathedrals of Europe, with their *basilican* plans, *ribbed groin vaults,* and *flying buttresses.*

gouache (goo-ahsh') A generic word for any opaque water-soluble paint.

graphics Any form of drawn, painted, or printed *image.*

graphic arts A term that includes the visual arts of drawing, printmaking, typographic design, advertising design, and the technology of printing.

graphite A manufactured soft, dense, granular material that can be formed into sticks of gray or black color for use in "lead" pencils.

groin vault A structural device constructed in the form of two intersecting *barrel vaults.*

ground The prime or preparatory surface applied to the cloth, wooden, or metal *supports* used by artists for painting. Also, the general area of the *picture plane* on and against which *forms* are composed.

ground line A stylized indication of the horizontal base or ground on which figures and elements of landscape are placed in some paintings, drawings, and reliefs.

happening An event conceived and performed by artists utilizing light, sound, and human and mechanical movements.

hatching A series of closely spaced parallel *lines* serving in a drawing or print to indicate a toned or shaded area.

horizon line The division between the earth and the sky as seen by an observer. Also, in *linear perspective* the indicated eye level to which all points of convergence have been directed.

hue The quality of color that differentiates one *spectrum* color from another; a function of the wavelength of light.

icon An *image* or *representation,* usually of a religious personage. Often refers to a revered stylized image.

iconography 1. The visual imagery selected to represent and convey the meaning and content of a work of art. 2. The study and knowledge of the various forms of meaning to be found in pictorial *representations* in the visual arts.

idealization The *representation* of objects, individuals, and events according to a stylized, perfected, preconceived model.

illumination A decorative illustration or design, used preeminently in the Middle Ages, to enhance *calligraphic* manuscripts or printed texts.

illusionistic Descriptive works of art that seek to represent the natural world in a manner that causes an observer to believe the actual subject is seen rather than an artist's equivalent for it.

image A *representation* of an object, an individual, or an event. An image may also be an evocation of a state of being in *representational* or *nonrepresentational* art.

impasto The three-dimensional surface of thickly applied paint.

Impressionism A style of painting developed in France during the second half of the 19th century and characterized by a concern for the fleeting effects of light as it played on forms in nature. Monet, Renoir, Pissarro, and their group employed discrete juxtaposed brush strokes of color to form a vibrating surface on the canvas, enhancing the representation of the natural luminosity of their subject matter.

incise To cut into a surface with a sharp instrument.

informal balance An asymmetrical arrangement of *visual weights* intended to form an equalized or stable *pattern.*

intaglio (in-tahl'yoh) A type of carving that cuts into a flat surface to shape forms lower than the level of the original plane. In printmaking a technique which requires that the lines and areas to be inked and transferred to paper be recessed beneath the surface of the printing plate.

intensity See *saturation.*

Ionic One of the Greek *Classical* styles of temple architecture, distinguished by slender, fluted *columns* and *capitals* decorated with volutes and scrolls.

keystone The topmost stone or *voussoir* in an *arch;* the last stone to be placed in an arch.

kiln An oven capable of controlled high temperatures in which clay objects are baked.

kinetic art Art that incorporates articulated components moved by the action of air, gravity, or mechanical power. Kinetic art may also use changing light patterns controlled by electric or electronic switching.

kylix (kigh'lix) A two-handled shallow wine cup made by the ancient Greeks.

lacquer A clear, transparent, resinous material used to coat metal and wood to give it a hard, shiny protective surface. Also used as a *vehicle* to form a quick-drying, brilliant paint.

lift-ground A method of producing broad lines and areas in prints made by the process of *etching* and *aquatint.* The artist paints directly on the surface of an etching plate or on the *rosin* covering of a prepared aquatint plate with a syrup of sugar and water. When the drawing is dry the entire plate is covered with an acid-resistant *ground.* The plate is immersed in water; the water melts the syrup and causes the ground covering the sugar painting to lift away, leaving the plate exposed under the lifted portions. The plate is then etched and printed.

line 1. A mark left by a moving point. 2. An implied axis through a form or group of forms. 3. A contour edge or the edge between juxtaposed forms. 4. A form so long in one dimension that the other dimension appears as a negligible characteristic.

linear perspective A system of spatial representation on a two-dimensional surface based on the optical *illusion* that parallel lines, as observed in nature, appear to converge at points on a line related to the height of the observer's eyes from the ground.

lintel A structural member that spans an opening between *columns* or *walls.*

lithography A printmaking medium based upon the antipathy of grease and water. With a grease crayon or waxy liquid, an image is drawn on a slab of grained limestone or on a grained aluminum plate. The drawing is treated chemically so that each grain of the plate touched by the drawing medium can accept a greasy ink and each untouched grain can accept water and repel the ink. When the plate has been wetted and charged with ink, an image in ink is retained which essentially replicates the drawing. The printmaker then covers the plate with a sheet of paper and runs them through a press, which offsets the image onto the sheet, thus producing the print.

local color The identifying color of an object when it is perceived without shadows under a standard light source.

lost-wax casting See *cire-perdue.*

Mannerism A style and period in the history of European art generally corresponding to the 16th century, notable for its deliberate reaction against the calm and balance of the High *Renaissance* (c. 1500–25). Mannerist artists often exaggerated earlier styles to enhance the emotional content of their work.

maquette A sketch or miniature model made by a sculptor in preparation for a larger work.

masonry Stone or brickwork.

mass A distinct body of material, *form,* or group of forms. The physical bulk, weight, and density of a three-dimensional object occupying space.

mat, or matte 1. A nonreflective or dull surface or applied finish. 2. In printing, a papier-mâché mold or matrix used to cast type. 3. A paper or cardboard frame surrounding and protecting a drawing, print, or photograph.

medium 1. The technique, methodology, or technology used by an artist as the means for the production of a work of art. 2. The material used to dilute paint; i.e., turpentine is the medium for oil paint, water the medium for *watercolor.*

mezzotint An *intaglio* printmaking technique that employs a manually produced, densely pitted surface on the plate

to form tonal areas. Deeply pitted sections print black, sections that are smoothed by burnishing print lighter because the depth of the pits has been reduced.

Minimal Art Usually refers to metal or wooden sculptural constructions employing linear and planar components in seemingly simple, geometric compositions. By extension, any *nonrepresentational* art form using severely restricted *forms* and *colors*.

mobile sculpture Sculptural constructions using articulated components activated by motors or the force of the wind.

model 1. A person or object used as a subject by an artist. 2. A scaled miniature representation of a proposed or existing sculpture or building.

modeling 1. Arranging bits of clay, wax, or other pliable material into three-dimensional forms. A form of *additive sculpture*. 2. The effect of light falling on a three-dimensional object so that its forms are defined and dramatized by highlights and shadows. 3. Painting areas of varying tonalities to represent the effect of light falling on a three-dimensional object.

module A standardized two- or three-dimensional unit that is intended for use in multiple groupings.

molding A three-dimensional strip or edge used to define or decorate an architectural surface or frame a picture.

monochromatic colors *Colors* formed by altering the *values* of a basic *hue*.

monochrome A work executed entirely in a single *color* or in the *value* variations of a single *hue*.

monocoque A form of construction that uses a continuous curved shell as both an external covering and a major part of the structural system.

monotype A painting or drawing technique employing a smooth metal, glass, or stone plate on which the artist forms an *image* which is then transferred to a sheet of paper pressed against the plate.

montage (mohn-tahzh′) 1. A composition formed of pictures or portions of pictures previously photographed, painted, or drawn. 2. In motion pictures the sequence in which separate bits of film are combined to result in the continuous narrative or expressive cinematic statement.

monumental 1. Having the quality of a symbol or memorial to a significant person, event, or idea. 2. A work of art grand, noble, timeless, and essentially simple in composition and execution, whatever its size.

mordant The acid used to bite or etch metal, as in *intaglio* printmaking.

mosaic An art medium that requires the use of small pieces of colored glass or stone (*tesserae*) fixed to or imbedded in a background material.

motif See *subject*.

mural A painting on a wall, usually large in size. See *fresco*.

naturalism In the visual arts the attempt to create accurate equivalents for the perception of objects and experiences in the natural world.

nave The central section of a church located in the *basilican* plan between the main entrance and the *crossing* or the *apse;* typically flanked by aisles.

Neoclassicism A style in the visual arts of the late 18th and early 19th centuries that began as a radical movement in opposition to the *Baroque* and *Roccoco* art of the French court. Classic Roman paintings, sculpture and architecture were used as models. The Neoclassicists identified with Republican political ideals that eventually resulted in the French Revolution. Later, Neoclassicism became an *academic* reactionary style supported by the political and social establishment. *Realism* and *Impressionism* were, in part, reactions against neoclassicism.

neutral A *color* not readily associated with any *hue;* also a color that has been formed by mixing complementary hues. Neutralized hues are low-*saturation* colors still retaining their spectral identities though lacking the *brilliance* of the pure hue.

niello (nee-el′o) Black pigment (an alloy of sulphur mixed with lead, silver, gold, or copper) forced into the lines of a pattern engraved decoratively on the surface of metal objects for the purpose of enhancing the contrast between the design and its background. A work made by this technique.

nonrepresentational Works of visual art not based on physical subject matter.

odalisque (oh′da-lisk) A French word meaning a harem slave or concubine; more broadly, descriptive of any reclining female figure used as the subject of painting or sculpture.

oeuvre (uhv) French for "work"; the whole of an artist's production, or lifework.

ogee (oh′jee) An S-shaped curve; also a molding with an S-shaped cross section.

Op, or **optical, Art** A form of two-dimensional art that uses juxtaposed areas of contrasting color to generate optical vibrations and ambiguous or undulating spatial relationships.

order 1. The organization or arrangement of the *plastic elements* in a work of art. 2. *Classical* architectural styles such as *Doric, Ionic,* and *Corinthian,* distinguishable by the proportions and decorative treatment given their *columns, capitals,* and *entablature*.

palette 1. A tray or shaped planar surface on which a painter mixes *colors*. 2. The characteristic range and combination of colors typically used by a painter or a school of painting.

papiers collés (pahp-yay′ col-lay′) A form of two-dimensional art composed of pasted pieces of cut colored paper.

papier-mâché (pahp-yay′ mah-shay′) A material made of paper strips of paper pulp combined with paste that can be molded or built up into three-dimensional objects.

papyrus A plant found in Egypt and Mediterranean lands; also the matted paperlike material made from the split stems of the plant used as a *support* for some ancient manuscripts.

parchment The treated skin of a lamb or goat processed to produce a smooth, flexible surface for manuscript writing and illumination.

pastel 1. A combination of dry pigment and *binder* forming a colored chalk stick; also a work of art resulting from the use of pastels. 2. A light-*valued* chalky color.

patina (pa-teen′a) The surface of metal sculpture that results from natural oxidation or the careful application of heat, chemicals, and polishing agents.

pattern 1. An arrangement or grouping of objects, *forms,* or ideas so that the parts appear to have an ordered relationship. 2. A preparatory design or matrix used to shape the final work.

pediment In *Classical* architecture the triangular portion of the *entablature,* formed by the ends of the sloping roof and the *cornice*.

pendentive In architecture a concave structural element used to support a circular *dome* above a square space formed by walls of equal measure. Essentially a curved

triangular plane (a triangular section of a hemisphere) that has one point placed at a corner of the square base and an opposite edge supporting and contiguous with one-fourth of the circular rim of the *dome.*

photomontage (foh'toh mohn-tahzh') A *montage* using only photographs.

picture plane An imaginary vertical plane assumed to be at the front surface of a painting.

pier A mass of *masonry* rising vertically to support an *arch, vault,* or other roofing member; also a *buttress.*

pigment A dry powder that provides the coloring agent for paint, crayons, chalk, or ink.

pilaster A decorative architectural *element* that looks like a vertical section of a *column* projecting from a *wall.*

plan 1. The scaled symbolic equivalent, such as a *line* drawing, for the arrangement and appearance of the parts of a building as they are placed in a horizontal plane. 2. Any description—verbal, written, or pictorial—providing the essentials of a *composition* or of an informing concept.

plane A surface that is defined and measurable in two dimensions.

planographic printing See *lithography.*

plastic 1. Descriptive of a material capable of being shaped or manipulated. A sculptural or three-dimensional quality in a work of art—roundness, apparent solidity. 2. The plastic elements are the basic components of works of art, *color, line, form,* and *texture,* capable of being shaped and arranged to result in the completed work. 3. The plastic arts are the visual arts. 4. Any of a number of synthetic materials with differing physical and manipulative characteristics.

Pointillism A late-19th-century *Postimpressionist* style of painting developed by the Frenchman Georges Seurat. Paint was applied systematically in small dots or areas of *color* producing a vibrant surface. Some Pointillist paintings seem a refinement of the representational intention and method of the *Impressionists;* other paintings are carefully constructed *compositions* in which abstract *elements* are given purposeful relationships.

pointing A mechanical method of making three-dimensional measurements of a clay or plaster model and of transferring them to a stone block so that a sculptor can carve a replica or enlargement of the original.

polychrome Referring to works of art, particularly sculpture and *ceramic* objects, finished with a painted or glazed surface employing many colors.

Pop Art A style of painting and sculpture that uses popular, mass-media symbols as subject matter, treating them seriously or satirically.

post and lintel A structural system that uses two uprights or posts supporting a member, the *lintel,* that spans the space between them.

poster A form of *graphic art* combining a decoration or an illustration with type or lettering for the purpose of making a public announcement.

Postimpressionism A term applied to *avant-garde* styles of painting that developed from 1885 to 1900 in reaction against *Impressionism* or as an extension of Impressionism. From this period came the concerns for the significance of *form,* myth, *symbol,* expressiveness, and the psychological intensity that have been the constant preoccupations of modern art.

Pre-Columbian The art produced in North and South America prior to the beginning of the 16th century.

primary Basic and essential. When applied to *color,* designating those *hues* that can be mixed to derive all the other hues in the *spectrum.* The primary hues in paint are red, yellow, and blue; in light they are red, green, and blue.

primitive 1. Descriptive of the art produced by untrained, naïve artists. 2. The native arts of Africa, the Americas, and the Pacific islands. 3. An anachronistic adjective for European painting of the 13th, 14th, and 15th centuries.

print A multiple impression made from a master plate produced by an artist and printed by or under the supervision of the artist.

proof The trial *prints* produced by the various printmaking processes before the artist approves the issuance of an edition. Distinguished from proofs are the impressions that are the prints comprising the edition.

proportion The relationship of one part to another and of each part to a whole, measurable in *mass,* linear dimensions, weight, and *color.*

pylon The major entrance to an Egyptian temple formed by paired truncated pyramids.

quoin (koin) 1. Blocks of stone placed at the corners of masonry buildings. 2. In printing, wedge-shaped devices used to lock type into the frames or chases of the press.

Realism A mid-19th century style of painting and sculpture based upon the belief that the *subject* matter of art and the methods of *representation* would be true to life without *stylization* or *idealization. Impressionism* emerged from the desire to achieve in art an absolute fidelity to the perception of physical reality.

reinforced concrete See *ferroconcrete.*

relief sculpture A type of sculpture in which three-dimensional forms project forward or behind a defined plane. The degree of projection can vary, with some forms in high relief and totally disengaged from the rear plane, and low or *bas-relief* forms projecting only slightly from the surface.

Renaissance Literally, rebirth. The period in Europe that began in the 14th century and continued into the 16th century in Italy. It was characterized by a new interest in individuality and the desire for knowledge about all aspects of nature. Historical, scientific, and social studies of humanity were undertaken enthusiastically. The visual art of this period reflected these new values. Painters and sculptors pursued problems of the accurate representation of *form, space* and light, with an emphasis on figurative *compositions* in believable natural environments. Architecture of the period drew on the styles of classic Greece and Rome using columned temples and public buildings, *arched, vaulted* and *domed* structural systems as models. The movement spread throughout Europe and its effects are still to be found in the intellectual and artistic attitudes we hold today.

representation The methods or techniques for producing equivalents for perceptions of the real world.

reproduction A mechanically processed and manufactured copy of an original two- or three-dimensional object.

resist The acid-resistant coating that protects portions of an *etching* plate from the corrosive action of the *mordant.*

rib In architecture a slender, arched structural element of a *vault,* a member of a skeletal system that is self-supporting and, forming a framework for the vault, carries the weight of the stone web that fills the *space* between the ribs.

ribbed vault A *vault* constructed on a system of self-supporting *ribs* and a web of thinner material filling the

spaces between the ribs. The ribbed vault differs from a regular vault, which uses stone of approximately the same weight throughout.

Rococo From the French for "rock work." A late *Baroque* style (c. 1715–75) that domesticated and made private, pretty, and diminutive the monumental theatricality of 17th-century Counter-Reformation and absolutist art and architecture. Its subject matter was often, but not inevitably, erotic and frivolous.

Romanticism A style of art whose period commenced about the middle of the 18th century and endured until well into the 19th century. A movement concurrent and closely interrelated with *Neoclassicism,* Romanticism emphasized the personal, the emotional, and the dramatic, often expressed through landscape and exotic, literary, and historical subject matter.

rosin (rah′zen) A resin derived from the sap of certain pine trees that is processed into a fine powder and dusted onto metal plates as a resist for tonal areas in *aquatint.*

rusticate To define or emphasize the joints between blocks of stone used in the exterior walls of buildings.

sanguine (sang′wen) A reddish-brown color often found in chalks or crayons.

saturation The measure of the *brilliance* or purity of a *color.* The saturation of a color decreases as the *hue* is neutralized. Also called *intensity.*

scale 1. The relative size of an object, viewed in relation to other objects of its kind, to the environment or format it occupies, or to human beings. 2. The apparent size of an object, regardless of its actual dimensions. 3. In architectural drawings a ratio that relates a measurement on the drawing to a measurement on the full-size building.

sculpture in the round An organization of three-dimensional *forms* capable of being seen from all sides.

secondary colors Those *hues* located midway between the *primary* hues on a traditional color wheel: orange, green, and violet.

section An architectural drawing representing a vertical slice through a building or structural member.

sepia (seep′yah) A warm dark-brown color often found in chalks, inks, and paint.

serigraphy A form of printmaking utilizing *stencils* attached to porous screens that support delicate areas of the cut design. Also called "silk screen" printing.

sfumato (sfoo-mah′toh) A hazy, "smoky," atmospheric blending of tonalities in a painting; the softening of edges to create a sensory ambiguity of *forms* and *spaces.*

shade A low-*value* color.

shading Graduated variations in *value,* often employed in painting to represent the play of light on a *form.*

shape 1. The configuration of a two- or three-dimensional *form.* Also a synonym for a two-dimensional form. 2. To form, build, or model a *medium* into an organized construct.

shaped canvas A *support* for a painting, employed by some contemporary artists, that varies from the traditional rectangular shape. Shaped canvases may be found in many geometric planar *forms;* they have also been designed to bulge out or otherwise take on some of the characteristics of simple *relief* surfaces.

silk screen See *serigraphy.*

silverpoint A drawing medium employing a silver wire that leaves a deposit as it is drawn across the surface of a *support* prepared with sufficient "tooth" to hold the metal.

After exposure to the air the silver in the line oxidizes, causing it to darken and change color.

sinopia (sigh-nohp′-yah) A preparatory drawing for a *fresco* made directly on the coat of plaster and eventually covered by the finished painting.

sketch A spontaneous, rapidly completed study of a *subject* or an idea.

slip A thin mixture of clay and water used to *cast* pottery forms or to coat the surface of clay objects already shaped.

slip forming *Casting* clay objects by pouring slip into *molds,* waiting until a shell of clay is formed adjacent to the walls of the mold, then pouring out the excess slip to leave a hollow *casting* when the mold is opened.

space 1. The *volume* occupied by a *form.* 2. The measurable linear and angular relationships between forms. 3. The volume enclosed by limiting walls or boundaries. 4. The area of the two-dimensional *plane* on which a painter places forms. 5. The representation of three-dimensional spatial relationships on a two-dimensional surface. 6. The creation of a psychological or optical spatial effect by the interaction of *colors* and forms in a painting.

spectrum Bands of colored light created when white light is passed through a prism. Also a range of *hues* in paint that approximates the spectral band.

squeegee A tool consisting of a long flexible rubber blade attached to a supporting wooden strip and a handle that is used to force paint through a silk screen *stencil* in *serigraphy.*

squinch A course, or courses, of *masonry* bridging the corner diagonally between adjacent walls of a square space to provide support for a circular *dome.* The squinch is often supported by a small arch under the horizontal stone courses.

steel-frame construction A technique of raising buildings on a skeletal structure of steel in an interconnected *post-and-lintel* system that is self-supporting and that provides support for walls, floors, roof, and all the internal components of the building.

stencil A method of producing repetitive images by cutting openings in a mask or matrix so that paint may be applied through the holes to a *support* underneath, in forms that are controlled by the shapes of the cutouts. See *serigraphy.*

still life A group of inanimate, commonly found objects—bottles, fabrics, fruit, flowers, silver, or ceramic—arranged on a surface as the *subject* of a painting.

stress An applied force or pressure placed on a structural member in a construction system.

string course A horizontal band or molding used as a *decorative element* on a wall.

structure 1. The *compositional* relationships in a work of art. 2. A building or other constructed architectural unit. 3. The operative framework that supports a building.

stucco A plaster or cement coating applied to *masonry* walls.

style 1. The characteristic manner or execution of a work of art, typical of a cultural group, a period of time, or the work of a single individual. 2. An aspect of individual taste suggesting the ability to make appropriate choices for the creation of a sophisticated and elegant solution to a problem.

stylization The simplification or generalization of *forms* found in nature for the purpose of increasing the *decorative* relationships in a work of art.

prepared
usually with a chalk coating.

subject That which is *represented* in a work of art, as opposed to *form* and distinct from *content*. Sometimes called *motif*. See *iconography*.

subtractive sculpture Sculpture formed by cutting into a block of stone and wood to remove the excess material; carving.

support The physical material serving as a base for and sustaining a two-dimensional work of art, such as paper in the instance of drawings and prints, and canvas and board panels in painting. In architecture, a sustaining structural member.

Surrealism Introduced c. 1917, Surrealism is an approach to the arts that was influenced by the psychology of Freud and others who emphasized the importance of unconscious forces in human experience. The movement existed in both the literary and visual arts. Initially surrealist painters experimented with chance and automatic drawing. Later, surrealists sought to represent or evoke the experience of dreams and hallucinations.

symbol A *form, image,* sign, or *subject* standing for something else. Often, a visible suggestion of something invisible.

symmetry A composition in which identical forms and colors are placed equal distances from a central axis to form a mirror image; *formal balance*.

tempera An aqueous paint whose *vehicle* is egg yolk. Some commercially made paints identified as tempera are actually *gouache*.

terra-cotta Baked clay used in sculpture and architectural decoration; also a reddish-brown color similar to the color of baked clay.

terrazzo (tehr-ah′zoh) A mixture of cement and colored marble chips used as a *decorative* floor-paving material.

tesserae (tess′er-ee) The bits of colored glass and stone used in *mosaic*.

texture The tactile quality of a surface or the representation of that surface.

thrust A force moving out from a central point or axis.

tint A high-*value* color.

tone Used broadly, the general coloristic character or quality of a *composition*. More specifically, the *value* of a *color* or group of colors.

tracery 1. A complicated, entwined linear *pattern* found in many *decorative arts*. 2. The ornamental stonework of linear design found in the upper portion of *Gothic* windows and, by extension, any interlaced, linear pattern of stonework.

transept In a *cruciform* church the part of the building whose axis is set at right angles to the main axis of the *nave* and which intersects the nave at the *crossing*.

trompe-l'oeil (trohmp luh′yuh) A type of representation in painting in which the *illusion* of *form, space*, light, and *texture* has been so cunningly contrived the observer may mistake the two-dimensional image for the real subject.

truss A structural unit built of wood or metal based upon a system of triangles joined at their apexes and used to span the *space* between walls or piers. Trusses are found in bridge design and in architecture where they serve to support roofs and floors.

type face An alphabet style or design used as the basis for a font of type.

unity The quality of similarity, shared identity, or consistency that can be recognized in the relationships between parts of a *composition*. A logical connection between separate *elements* in a work of art.

vacuum forming A method of shaping thin sheets of plastic into sculptural *forms,* requiring the material to be softened with heat and then sucked tightly against a mold by a vacuum system. The plastic cools quickly, permanently shaped to the configuration of the matrix.

value The measure of the lightness or darkness of a *color*.

vanishing point In *linear perspective* the point at which lines or edges parallel in nature converge on a *horizon line*.

vault A *masonry* or concrete roof constructed on the principles of an *arch*. See *barrel vault, groin vault,* and *dome*.

vehicle In paint the binding agent that holds the grains of pigment together and forms a film that adheres to a *support*.

vellum The treated skin of a calf processed to produce a smooth, flexible surface for manuscript writing. Also, an especially fine quality of *parchment*.

viewpoint 1. The position from which an observer perceives a scene. 2. The assumed position of an observer in the construction of a *linear perspective representation* of a *space* filled with *forms*. The viewpoint affects the position of the *horizon line* and *vanishing points*.

visual weight The psychological response to a *form* with regard to its importance in a *composition*. The weight is a function of the *size*, shape, *texture,* and *color* of the form, its position relative to the other components of the structure, and its metaphoric *content*.

volume 1. The measurable three-dimensional *space* enclosed by actual or visual boundaries. 2. The *representation* of a three-dimensional volume on a two-dimensional surface.

voussoirs (voo-swahr′) The wedge-shaped stone blocks used to construct an *arch*.

wainscot A facing of paneled wood covering a wall. Often, the lower portion of the wall that has been finished with a wainscot.

wall A vertical *plane* in architecture that functions in one or more of the following ways: as a structural *support* for the upper levels or the roof; as a protection from the weather; as a device to compartmentalize *space* and provide control of light and sound; and as a decorative *element*.

warm colors *Hues* or variations of hues in the red or orange section of the *spectrum*.

wash A thin, transparent layer of paint. Wash drawings combine thinly painted areas of *color* with linear *elements*.

watercolor Broadly, any paint that requires water as a *medium*. In a narrower sense, paint that uses gum arabic as a *vehicle* and water as a medium.

web The thin masonry surface between the *ribs* of a *vault*.

woodcut A relief *print* made from a design cut into the flat surface of a wooden block. Also, the carved wooden block from which the print is made.

wood engraving A relief *print* made from a design cut into the end grain of a laminated wooden block. Also, the block from which the print is taken.

Index

de Kooning, Willem, *Woman and Bicycle,* 12, 47, 81, 285, Pl. 3, p. 8

dell'Abate, Niccolò, *Rape of Prosepine,* 151, Pl. 12, p. 61

Derain, André, *London Bridge,* 47, Pl. 9, p. 43

Diebenkorn, Richard, *Ocean Park Series No. 94,* 66, 70, 85, Pl. 13, p. 61

direct-metal sculpture, 201

Disneyland, Anaheim, California, Sleeping Beauty Castle, 219, Fig. 302

di Suvero, Mark, *Mon Père, Mon Père,* 199, 206, 207, Figs. 283, 284

dome, 254, Figs. 374–378

Donatello, 167–170; *St. George,* 168, 169–170, 182, Figs. 221, 223–225

Dorazio, Piero, *Construction Eurasia,* 145, Pl. 29, p. 131

Doric capital, 248, 249, Fig. 359

dos Santos, Bartolomeu, *Figure in Space,* 105, Fig. 131

Doughty, Dorothy, *Male Redstart,* 56, Fig. 73

Douris, *Two Women Putting Away Clothes,* 143, Fig. 194

drawing, 87–94; charcoal, 91–92, Fig. 114; children, 19, Figs. 16–17; conté crayon, 91, Fig. 113; definition, 88; drybrush, 94; dry media 88–92; fluid media, 92–94; ink, 140–141, Fig. 190; pastel, 87, 90–91, 143, Pl. 28, p. 136, Figs. 111–113; pen, 92–93; pencil, 89–90, 112–113, Figs. 109, 110, 143–145; silverpoint, 88–89, Fig. 108; wax crayons, 92, Fig. 115

drybrush, 94

dry media in drawing, 88–92

drypoint engraving, 102, Fig. 128

Dubuffet, Jean, *Beard of Uncertain Returns,* 290, 291, Fig. 431

Duccio, *The Transfiguration of Christ,* 86, 147–148, Fig. 203

Duchamp, Marcel, memorial videotape, 45, Fig. 56

Duco paint, 93

Dupuy, Jean (with Ralph Martel and Harris Hymans), *Heart Beats Dust,* 209, Fig. 289

Dürer, Albrecht, 50, 51–52; *The Adoration of the Magi,* 51–52, 96, Figs. 62, 63; *Artist Drawing a Portrait of a Man,* 149, Fig. 204; *The Fall of Man,* 96, Fig. 123; *The Nativity,* 50–51, Figs. 60, 61; *Portrait of a Young Woman,* 144, Fig. 199

earthwork, Heizer, 23–24, Fig. 23

Edgerton, Harold E., *Swirls and Eddies of a Tennis Stroke,* 133–134, Fig. 184

egg tempera, *see* tempera

Egyptian art, encaustic mummy portrait, 86, Fig. 105; *Hunting Birds with a Throwing Stick,* 146, Fig. 201; *Priest of Osiris,* 55–57, Fig. 72; statue, Luxor, 190, 191, Fig. 259;

stylized sculpture, 273–274, Figs. 403–405; Temple of Karnak, Luxor, 246, Fig. 352; wall painting, 38, Fig. 45

electromicrography, 52, 53, Fig. 66

El Greco, *Christ Driving the Money Changers from the Temple,* 280–282, Fig. 417; *The Purification of the Temple,* 280–282, Fig. 416

Ellora, India, Kailasanatha Temple, 246, Fig. 351

encaustic, 86–87, Fig. 105

"energetic-synergetic geometry," 269

engraving, drypoint, 102, Fig. 128; Dürer, 50, 51–52, Figs. 60, 61; metal, 101–102; Pollaiuolo, 102, Fig. 127; wood, 101, Figs. 125, 126

entablature, 246–248

environmental constructions, 189

environmental function, of architecture, 215–216

equivalents, 33, 34–38

Erlebacher, Martha, *The Triumph of Nature,* 12, 13, Fig. 10

Ernst, Max, *Celebes,* 47, Fig. 58

Eskimo pipe, 298, 299, Fig. 440

etching, 102–104; Goya, 297, Fig. 438; Rembrandt, 32, 33, 103–104, Figs. 31–32, 129

Evans, Walker, *Subway Portrait,* 278, Fig. 410

Expo 67, Montreal, United States Pavilion, Fuller, 269, Fig. 402

Expo 70, Osaka, Swiss Pavilion, Walter, 236, Fig. 333; United States Pavilion, Davis, Brody & Associates, 268, 269, Fig. 401

Expressionism, 47, 282–285, Pl. 11, p. 44; Beckmann, 295; *Der Blaue Reiter* (The Blue Rider), 288; Kandinsky, 288; Kirchner, 284; Klee, 288

expressive art, 277; representational, 278–288

expressive function, of architecture, 216–224

fabric composition, 192–195, Fig. 264

Fauves, 47, Pl. 9, p. 43

Federal Reserve Bank Building, Minneapolis, Birkerts & Associates, 260, Figs. 389, 390

Fellig, Arthur, *see* Wee Gee

ferroconcrete construction, 263–267, Figs. 392–398

F:I ratio, 10

fiberglass, construction, 184, Pl. 43, p. 176, Pl. 44, p. 193; figures, 63, Pl. 43, p. 176, Fig. 82; Futuro II house, 268, Fig. 400

Fischer, Johann Michael, abbey church, Ottobeuren, Germany, 234, Pl. 48, p. 227

Fish, Janet, *Dark Mirror,* 76, 77, 85, Fig. 95

Florence, Palazzo Rucellai, Alberti,

233–234, 235, Fig. 329; Pazzi Chapel, Brunelleschi, 238–241, Figs. 338, 339, 340; San Lorenzo, Brunelleschi, 243, Fig. 345; San Miniato al Monte, 234, 235, Fig. 331

flying buttress, 252–253, Fig. 371

forces of compression, 243, 245, Fig. 349

forces of tension, 243, 245, Fig. 350

form, 73–74, Pl. 1, p. 7, Figs. 88, 93; by dark and light areas, 144, Figs. 198, 199; definition, 173; materials in sculpture, 172; and space, 74–75, Fig. 94; two-dimensional equivalents, 140–145

formal balance, 113, Fig. 146

Foster, Norman, Willis Faber Office, Ipswich, England, 231–232, Fig. 325

fountains, as kinetic art, 186, 187, Fig. 255

"Four First Dancers," American Indian sandpainting, 84, Fig. 104

Frankenthaler, Helen, *Essence Mulberry,* 96–101, Pl. 21, p. 99

French Republic, 59

French Revolution, 59

fresco, 86–87

Friess, Joachim, *Diana the Huntress,* 184, 185, 209, Fig. 252

Fuller, R. Buckminster, 269–270; quoted, 270; United States Pavilion, Expo 67, Montreal, 269, Fig. 402

Futurism, 160, Figs. 57, 219; Boccioni, 46, 47, Fig. 57

Futuro II house, 268, Fig. 400

Gauguin, Paul, *Crucifixion,* 40, Fig. 48; influence on, 40; *Poèmes Barbares,* 12, 284, Fig. 9

geodesic dome, 269–270

George Washington Bridge, Ammann and Gilbert, New York, 243, Fig. 348

Georges Pompidou National Art & Cultural Center, Paris, 237–238, Figs. 336, 337

Gérôme, Jean-Léon, *Gray Eminence* (L'Eminence Grise), 163, Pls. 36, 37, p. 157

Giacometti, Alberto, *Walking Man,* 198, 199, 201, Fig. 270

Ginnever, Charles, *Zeus,* 174, Fig. 232

glazes, 85

Gloucester Candlestick, The, 4, Fig. 3

González, Julio, *Torso,* 200, 201, Fig. 272

Goodyear, John, *Hot and Cold Bars,* 210, Fig. 291

"gothic system" of construction, 252–253, 258, Figs. 371–373

Goya, Francisco, *Tampoco* (*Nor These*), from *Disasters of War,* 105, 297, Fig. 438

Great Snake Mound, Adams County, Ohio, 23–24, Fig. 24

Greek art, Douris, 143, Fig. 194;

lift-ground aquatint, 105, Fig. 132
light and architecture, 234–236
Lincoln Memorial, Washington, D.C., Bacon, 217–218, Fig. 296
line, 32, 78–82, Figs. 30, 99, 100; in architecture, 233–234; in sculpture, 181–183; silhouette, 140–143; variations in quality, 288, 289, Fig. 427
linear perspective, 51–52, 143, 148–151, 152–154, Pl. 30, pp. 136–137, Figs. 197, 204–208, 209
Lipchitz, Jacques, *Figure*, 291–292, Fig. 432; *Man with Mandolin*, 205, Figs. 279, 280
Lipton, Seymour, *Defender*, 200, 201, Fig. 273
lithography, 106–107; Currier & Ives, 107, Fig. 134; Daumier, 59–60, Fig. 78; Matisse, 143, Fig. 196; Motherwell, 107, Pl. 22, p. 99; Rauschenberg, 107, Fig. 135; Toulouse-Lautrec, 39, 107, Fig. 47
local color, shaded, 161
Loebl, Schlossman & Bennett, Chicago Civic Center, 221–222, 237, Figs. 308, 309
Lorrain, Claude, *The Tiber above Rome*, 93–94, Fig. 119
Louis, Morris, *Saraband*, 85, Pl. 19, p. 98
low relief, 182

Madonna and Child, thirteenth-century Tuscan panel, 86, 145, Fig. 200
Magritte, René, *The Liberator*, 286, 287–288, Fig. 424
Maillol, Aristide, *The River*, 173–174, Fig. 231
manuscript illumination, 163; *Book of Durrow*, Ireland, Pl. 38, p. 158; *The Book of Kells*, 64, 65, Fig. 84
Manzù, Giacomo, *Death on the Earth*, study for *Doors of Death*, 181–182, Fig. 247
Maori figure, 197–199, Fig. 268
map, sixteenth-century, 52, 53, Fig. 64; Washington, D.C., 140, Fig. 189
Marshall Field Wholesale Store, Chicago, Richardson, 258, Fig. 384
Martel, Ralph, 209, Fig. 289
Martin, Agnes, *Night Sea*, 12, 66, Pl. 4, p. 8
masks, Bamileke, Cameroon Grosland, 188, 189, Fig. 256
mass, in architecture, 229–230; definition, 173
Matisse, Henri, 164; four states of *Pink Nude*, 119–123, Figs. 156–159; *Pink Nude*, 119–123, 160–161, Pl. 27, p. 135; *Upturned Head (Head of a Recumbent Figure)*, 143, Fig. 196
Matsuzaki-tenjin engi, 246, 247, Fig. 355
Maugham, W. Somerset, 60
Maxwell, James Clerk, 161
medium, 85

Mendelsohn, Eric, drawings for Temple Emanu-El, Dallas, 214, Fig. 294
metal casting, 56, Fig. 74
Mexican art, Orozco, 285, Fig. 422; Toltec rain god, 188, 189, Fig. 257
mezzotint, 104–105, Fig. 130
Michelangelo, 203; *Creation of Adam*, detail from *Sistine Chapel Ceiling*, 86, Fig. 106; *Deposition from the Cross*, 205–207, Figs. 281, 282; Palazzo Farnese, Rome, 235, Fig. 332; quoted, 295; studies for the *Libyan Sibyl* (*Sistine Chapel Ceiling*), 90, Fig. 111
Miës van der Rohe, Ludwig, quoted, 223; Seagram Building, New York, 229, 233, 236, Fig. 321
Milton, Peter, *Daylilies*, 105–106, Fig. 133
Minneapolis, Federal Reserve Bank Building, Birkerts & Associates, 260, Figs. 389, 390
mobiles, 184; *see also* kinetic art
modeling, 199
Modigliani, Amedeo, *Head*, 40, 41, Fig. 50
Mondrian, Piet, 37; *Composition in White, Black and Red*, 110, 111, 115, Pl. 23, p. 100; *Flowering Apple Tree*, 36, 37, Fig. 43; *Horizontal Tree*, 36, 37, Fig. 42; *Tree II*, 36, 37, Fig. 41
Monet, Claude, 37, 161–162; *Rouen Cathedral: Full Sunlight*, 47, 85, 116, 154, 162, Pl. 7, p. 26; *Rouen Cathedral: Sunset*, 47, 116, 162, Pl. 8, p. 26; *Sunflowers*, detail of, 162, 163, Pl. 35, p. 156, Fig. 220
monocoque construction, 267–268, Figs. 399, 400
Montreal, Expo 67, United States Pavilion, Fuller, 269, Fig. 402
Moore, Charles W., and Kent C. Bloomer, *Body, Memory and Architecture*, quoted, 216
Moore, Henry, 171–172; *Mask*, 40, 41, Fig. 52; *Reclining Figure*, 171, Fig. 227; *Reclining Figure, Internal-External Forms*, 171–172, 178, 191, Fig. 228; *Three Piece Reclining Figure No. 2, Bridge Prop*, 172, Fig. 229
Morandi, Richard, Rafael Urdaneta Bridge, Venezuela, 4, 5, Fig. 4
Morris, Robert, *Untitled*, 192–195, Fig. 264
Motherwell, Robert, *Bastos*, 107, Pl. 22, p. 99
Mu-Ch'i, *Six Persimmons*, 140–141, Fig. 190
multiple prints, 95
Munch, Edvard, *The Cry*, 284, 285, Fig. 421
Murphy, C. F., & Associates; Skidmore, Owings & Merrill; and Loebl, Schlossman & Bennett, Chicago

Civic Center, 221–222, Figs. 308, 309
Muybridge, Eadweard, *Walking, Hands Engaged in Knitting*, 160, Fig. 218

Nadelman, Elie, *Standing Female Nude*, 170–171, 172, 182, 183, Fig. 226; *Standing Female Nude*, linear axis in, 183, Fig. 250
Nakagin Capsule Tower, Tokyo, Kurokawa, 267, Fig. 398
Nakian, Reuben, *Voyage to Crete*, 172, 173, Fig. 230
Neb-Amun's Gratitude for His Wealth, Egyptian wall painting, 38, Fig. 45
neon sculpture, 184, Pl. 47, p. 194
Nervi, Pier Luigi, Palazetto dello Sport, Rome, 266, 267, Figs. 396, 397
New Canaan, Connecticut, Glass House, Johnson, 219, 225–226, Figs. 314, 315; guest house, Johnson, 226, Figs. 316, 317
New Haven, Connecticut, Knights of Columbus Office Building, Roche, Dinkeloo and Associates, 264, Fig. 393
New York City, Columbia Broadcasting System Building, Saarinen, 234, Fig. 330; George Washington Bridge, Ammann and Gilbert, 243, Fig. 348; Lever House, Skidmore, Owings & Merrill, 259, Fig. 387; rehabilitated apartment building, 215, Fig. 295; St. Patrick's Cathedral, Renwick, 230, Fig. 323; Seagram Building, Miës van der Rohe, 229, 233, 236, Fig. 321; Solomon K. Guggenheim Museum, Wright, 241–242, Figs. 341–344; Trans World Flight Center, Saarinen, 226, 230, Figs. 318, 322
niello engraving, 101
Noguchi, Isamu, *Black Sun*, 179–180, 183, Fig. 243; Dodge Fountain, Dodge Plaza, Detroit, 186, 187, Fig. 255
Nolde, Emil, *The Prophet*, 96, Fig. 124
nonrepresentational painting, 163–164
Notre Dame Cathedral, Paris, 253, Figs. 372, 373

oil paint, 85
Oldenburg, Claes, *Giant Soft Fan*, 293–294, Fig. 435
Old Sturbridge Village, Massachusetts, The Towne House, 225, Figs. 311–313
Op art, *see* "optical" art
open cross vaulting, 251, Fig. 366
operational function, of architecture, 213–215
"optical" (Op) art, 115–116
optical vibration, 162
order, sense of, 63–66
"original" print, 94

van Eyck, Jan, *Cardinal Niccolò Albergati*, 88–89, Fig. 108
van der Marck, Jan, 24, Fig. 24
van Gogh, Vincent, *Crows Over a Wheatfield*, 77, 277, Pl. 52, p. 261; *Starry Night*, 15, 19, 47, 77, Pl. 5, p. 25; *Sunflowers*, 77, 81, Fig. 101
van Rijn, Rembrandt, *see* Rembrandt
van Ruisdael, Jacob, *Wheatfields*, 276, 277, Fig. 408
variation, in color, 152, Pl. 31, p. 138; in design, 110, Figs. 138–141; in size, 146–147, Figs. 201, 202
vehicles, 84–85
Velázquez, Diego, *Surrender at Breda*, 151, Fig. 210
Venturi, Robert, *Complexity and Contradiction in Architecture*, quoted, 223; and John Rauch, proposal for Football Hall of Fame, pp. 223–224, Fig. 310
Vermeer, van Delft, Jan, *Girl Asleep*, 38, 39, Fig. 49
videotape, 45, Fig. 56
Vignola, Giacomo, Il Gesú, Rome, 243, Fig. 346
Virgin and Child, Gothic woodcarving, 184, Pl. 42, p. 176; *Virgin and Child*, thirteenth-century France, 197, Fig. 266

visual weight, 114–115, Figs. 148–151
Vitruvius, *Ten Books on Architecture*, 213
Vlaminck, Maurice, *Tugboat at Chatou*, 152, Pl. 31, p. 138
voussoirs, 249–251, Fig. 361

wall drawings, Le Witt, 112–113, Figs. 143–145
wall painting, Egyptian, 38, 146, Figs. 45, 201; Roman, 143, Fig. 197
Walter, Willi, Swiss Pavilion, Expo 70, Osaka, 236, Fig. 333
Washington, D.C., Lincoln Memorial, Bacon, 217–218, Fig. 296
watercolor, 85–86
Watteau, Jean-Antoine, *The Embarkation from the Island of Cythera*, 85, 161, Pl. 34, p. 156
wax sculpture, 179, Fig. 242
weaving, 21, Fig. 20
Wee Gee, *The Critic*, 60, Fig. 80
weight, visual, 114–115, Figs. 148–151
West Coast Transmission Company Building, Vancouver, B.C., Rohne and Iredale, 264–265, Figs. 394, 395
Willis Faber Office, Ipswich, England, Foster, 231–232, Fig. 325
Winogrand, Garry, *Metropolitan Opera Bar*, 133, Fig. 183

wood carving, Africa, 40, 41, Fig. 51; Hague, 203, Fig. 277; Marquesas Islands, 40, Fig. 49; *Virgin and Child*, 184, Pl. 42, p. 176
woodcuts, 95–101; block for making, 95, Fig. 122; Dürer, 51–52, 96, 149, Figs. 62, 63, 204; Frankenthaler, 96–101, Pl. 21, p. 99; Nolde, 96, Fig. 124; sixteenth-century map, 52, 53, Fig. 64; Utamaro, 143, Fig. 195
wood engraving, 101, Figs. 125, 126
wood sculpture, 201–202
Wright, Frank Lloyd, Kaufman House, Bear Run, Pennsylvania, 233, Fig. 328; Solomon K. Guggenheim Museum, New York, 241–242, Figs. 341–344; Taliesin West, Phoenix, Arizona, 219, 232, Fig. 326
Wyeth, Andrew, *Sleep*, 94, Fig. 120; *The Wood Stove*, 299–300, Fig. 441

Young, J. Z., 13
Youngerman, Jack, *Anajo*, 75, Fig. 94

Zimmerman, Johann Baptist, Mirror Room, Amalienburg Pavilion, Munich, 6–9, Figs. 5–6
Zorach, William, *Head of Christ*, 203–204, Fig. 278

Photographic Sources

References are to figure numbers unless indicated Pl. (plate).

Albright-Knox Art Gallery, Buffalo, N.Y. (Pl. 29); Chalmer Alexander (393); Alinari/Editorial Photocolor Archives, New York (7, 72, 106–107, 154, 208, 210, 281–282, 329, 331–332, 338–339, 345–346, 353); American Museum of Natural History, New York (257, 319); Wayne Andrews, Grosse Pointe, Mich. (324, 334, 337); Toni Angermayer, Munich (5); Masao Arai, *The Japan Architect,* Tokyo (401); Robert F. Arteaga, St. Louis, Mo. (15); Avery Architecture Library, Columbia University, New York (376); Morley Baer, Monterey, Calif. (388); Oliver Baker, New York (409); Oliver Baker, New York, and Betty Parsons Gallery, New York (94); Bibliothèque Nationale, Paris (383); Irving E. Blomstrann, New Britain, Conn. (Pl. 25); Lee Boltin, Croton-on-Hudson, N.Y. (413); Breger and Associates, Wheaton, Md. (54); Bob Brooks, New York (171, 180–182, 191–193); Rudolph Burckhardt, New York (230, 276); Rudolph Burckhardt, New York, and Leo Castelli Gallery, New York (264); Hillel Bürger, Cambridge, Mass. (440); Leo Castelli Gallery, New York (114); Centre National d'Art et de Culture Georges Pompidou, Paris (336); CFL-Giraudon, Paris (Pl. 34); Richard Cheek, Belmont, Mass. (Pl. 46); Chicago Architectural Photographing Co. (386); Geoffrey Clements, Staten Island, N.Y. (82, 275, Pl. 3); George Cserna, New York (303); Loomis Dean, *Life* magazine, © 1960 Time Inc., New York (Pl. 51); E. de Cusati, New Haven, Conn. (279–280); John Donat, London (325); Eastman Kodak Co., Rochester, N.Y. (67); Eeva-Inkeri, New York (10); Eeva-Inkeri, New York, and Martha Jackson Gallery, New York (97); Eeva-Inkeri, New York, and Kornblee Gallery, New York (95); Eliot Elisofon, *Life* magazine, © 1949 Time Inc., New York (351); Embassy of Venezuela, Washington, D.C. (4); William A. Farnsworth Art Library and Museum, Rockland, Me. (120); Mike T. Fletcher, Black Star, New York (297); Fototeca Unione, Rome (364); Alison Frantz, Princeton, N.J. (14, 356, 360); French Government Tourist Office, New York (1, 35, 262); General Electric Co., Cleveland (402); Alexandre Georges, Pomona, N.Y. (314); Girau-

don, Paris (109, 123, Pls. 8, 12); Giraudon/Art Reference Bureau, Ancram, N.Y. (76); Green Studio Ltd., Dublin (84, Pl. 38); Sherwin Greenberg, McGranahan and May, Inc., Buffalo, N.Y. (219); Pedro E. Guerrerro, New Canaan, Conn. (326); Solomon R. Guggenheim Foundation, New York (286–288, 341–344); Ernst Hahn, Zürich (256); Mamie Harmon, New York (16–17); Hedrich Blessing, Inc., Chicago (328, 347); Hirmer Fotoarchiv, Munich (6, 352, 378, 404); Institute of Art Research, Tokyo (190); Yale Joel, *Life* magazine, © 1965 Time Inc., New York (186); Bruce C. Jones, Centerport, N.Y. (143–145); Peter A. Juley and Son, New York (196); John King, New Canaan, Conn. (247, Pl. 39); Nathan Knobler, Philadelphia (211–215, 298–301); Balthazar Korab, Troy, Mich. (389–390); Kathy Landman, New York (56); Franz Lindner, Vancouver, B.C. (394–395); Juan Victor Arauz Lomelí, Guadalajara (422); Babette Mangolte, Performing Artservices, New York (26); Marburg/Art Reference Bureau, Ancram, N.Y. (34, 415); Marlborough Gallery, New York (118); Robert E. Mates and Mary Donlon, New York (249, Pl. 19); Herbert Matter, New York, and Museum of Modern Art, New York (253); Mrs. Eric Mendelsohn, San Francisco (294); Charles Milligan, Modesto, Calif. (295); Henry Moore Foundation, Much Hadham, Herts., Eng. (227); Museum of Modern Art, New York (80, 327, Pl. 26); National Air and Space Administration, Washington, D.C. (65); National Park Service, Washington, D.C., Branch of Still Pictures (433); Jan Nordahl, Sodertalje, Swed. (22); Old Sturbridge Village, Mass. (311–313); © 1979 Orion Press, Tokyo (398, Pls. 49–50); Photo Researchers, Inc., New York (185); Eric Pollitzer, Hempstead, N.Y. (Pls. 4, 15–16); © Andrew Popper 1978 (255); Port of New York Authority (348); Portland Cement Association, Chicago (392); Michel Proulx, Toronto (Pl. 47); H. Roger-Viollet, Paris (36, 38, 372); St. Patrick's Information Service, New York (323); Sandak, Inc., New York (Pl. 48); Scala/Editorial Photocolor Archives, New York (221, 223, 225); E. G. Schempf/Photowork, Kansas City, Mo. (Pl. 43); Elton Schnellbacher, Pittsburgh (Pls. 1, 54); Science Museum, London (382); Joseph E. Seagram and Sons, New York (321); Service de Documentation Photographique

de la Réunion des Musées Nationaux, Paris (209); Shunk-Kender, New York, Copyright Valley Curtain Corp. (25); Steven Sloman (121); William Stevenson Smith, Harvard University, Cambridge, Mass. (405); Society for the Preservation of New England Antiquities, Boston (354); Staempfli Gallery, New York (285); Walter Steinkopf, Berlin (77); Lt. Col. Albert W. Stevens, © 1948 National Geographic Society, Washington, D.C. (24); Ezra Stoller © ESTO, Mamaroneck, N.Y. (304, 315–318, 322); Soichi Sunami, New York (74, 217, 231, 419, 436); Werner Sutter, Osaka (333); Charles Swedlund, Cobden, Ill. (176–179); Charles Uht, New York (44, 243, 268–269); United Press International, New York (411); United States Department of Agriculture, Washington, D.C. (69); United States Department of the Interior, Washington, D.C., Geological Survey (188–189); United States Department of the Interior, Washington, D.C., National Park Service (296); David Vine, New York (173–175); Dr. Allen W. Wachtel, Storrs, Conn. (66); Samuel Wagstaff, Jr., New York (434); Clarence Ward, Oberlin, O. (37); Wide World Photos, New York (172, 396–397); A. J. Wyatt, Philadelphia (Pl. 10); C. Zagaurski, Musée Royal de L'Afrique Centrale, Tervuren, Belg. (293).

Fig. 85 reproduced by permission of Reinhold Publishing Corporation, from *The Universal Penman,* by Raymond A. Ballinger, copyright © 1965 by Litton Educational Publishing, Inc.

Works by Arp, Brancusi, Braque, Dali, Derain, Calder, Dubuffet, Giacometti, Gonzalez, Gris, Kandinsky, Magritte, Modigliani, Tàpies: © A.D.A.G.P., Paris 1980. Works by Mondrian: © Beeldrecht/V.A.G.A., New York. Works by Degas, Klee, Kokoschka, Maillol, Matisse, Monet, Picasso, Renoir, · Rodin, Schwitters, Vlaminck: © S.P.A.D.E.M., Paris/V.A.G.A., New York.

Pl. 26 © Anuszkiewicz 1980; Fig. 58 © Estate of Max Ernst 1980; Pl. 22 © Motherwell 1980; Figs. 98, 135 © Rauschenberg 1980; Fig. 233 © Serra 1980; Figs. 202, 439 © Estate of Ben Shahn 1980; Fig. 244 © Estate of David Smith 1980; Fig. 94 © Youngerman 1980. · Permission granted by V.A.G.A., New York.